AMERICAN ART

Readings from the
Colonial Era to the Present

American Art

READINGS FROM THE

COLONIAL ERA TO THE PRESENT

Edited by Harold Spencer

CHARLES SCRIBNER'S SONS: New York

Copyright © 1980 Charles Scribner's Sons

Library of Congress Cataloging in Publication Data
Main entry under title:

American Art.
Readings from the Colonial Era to the Present
 Bibliography: p. 362
 Includes index.
 1. Art, American—Addresses, essays, lectures.
I. Spencer, Harold, 1920–
N6505.A6188 709'.73 80–12325
ISBN 0–684–16608–9

This book published simultaneously in the
United States of America and in Canada -
Copyright under the Berne Convention

Printed in the United States of America

Lewis Mumford, selection from *Sticks and Stones,* reprinted from *Sticks and Stones,* copyright © by Lewis Mumford, reprinted by permission of the Hilda Lindley Literary Agency. First published by Boni and Liveright, 1924. Dover edition, 1955.

John Singleton Copley, "From the Correspondence of John Singleton Copley," reprinted from *Letters and Papers of John Singleton Copley and Henry Pelham,* edited by Guernsey Jones (Boston, 1914). Reprinted by permission of the Massachusetts Historical Society.

Horatio Greenough, selection from *The Travels, Observations, and Experience of a Yankee Stonecutter,* reprinted from Scholars' Facsimiles & Reprints, 1958. First published in 1852 by G. P. Putnam. "From the Correspondence of Horatio Greenough," reprinted from *Letters of Horatio Greenough, American Sculptor,* edited by Nathalia Wright, 1972. Copyright held by the Board of Regents of the University of Wisconsin System. Reprinted by permission of the University of Wisconsin Press.

Thomas Cole, from "Essay on American Scenery,"appeared in *The Atlantic Monthly Magazine,* I (January 1836).

James Jackson Jarves, selection from *The Art-Idea,* excerpted by permission of the publishers from *The Art-Idea* by James Jackson Jarves, edited by Benjamin Rowland, Jr., Cambridge, Mass.: The Bellknap Press of Harvard University Press, Copyright © 1960 by the President and Fellows of Harvard College.

John I. H. Baur, "American Luminism: A Neglected Aspect of the Realist Movement in Nineteenth-Century American Painting," reprinted from *Perspectives U.S.A.,* #9, Autumn 1954, by permission of the author.

iv

Lloyd Goodrich, "Realism and Romanticism in Homer, Eakins, and Ryder," reprinted from *The Art Quarterly,* Volume 12, Winter 1949, by permission of the publisher.

Leo Stein, "Albert Ryder," appeared in *The New Republic,* XIV (April 27, 1918).

Montgomery Schuyler, from "Last Words About the World's Fair," reprinted from *American Architecture and Other Writings* by Montgomery Schuyler, edited by William H. Jordy and Ralph Coe. Reprinted by permission of The Belknap Press of Harvard University Press. Copyright © 1961 by the President and Fellows of Harvard College.

Henry-Russell Hitchcock, selection from *The Architecture of H.H. Richardson and His Times,* reprinted from *The Architecture of H. H. Richardson and His Times* by Henry-Russell Hitchcock, revised edition copyright 1961 by The Shoe String Press, Inc.

Sadakichi Hartmann, from "A Plea for the Picturesqueness of New York," appeared in *Camera Notes and Proceedings,* IV (October 1900).

Stuart Davis, "Stuart Davis on Robert Henri," reprinted from *Art in America,* August-September 1965. Tape-recorder interview. Reprinted by permission of Mrs. Roselle Davis.

William Innes Homer, "Stieglitz and 291," copyright © July/August 1973 by *Art in America.* Reprinted by permission of the publisher and the author.

Milton W. Brown, selection from *American Painting from the Armory Show to the Depression,* from Milton W. Brown, *American Painting from the Armory Show to the Depression* (copyright 1955 by Princeton University Press; Princeton Paperback, 1970), pp. 47 through 50. Reprinted by permission of Princeton University Press.

William Murray Fisher, "The Georgia O'Keeffe Drawings and Paintings at '291'," reprinted from *Camera Work* 1917, Number 49/50.

Georgia O'Keeffe, from "About Myself," reprinted from *Georgia O'Keeffe: Exhibitions of Oils and Pastels (1939).* Copyright © by Georgia O'Keeffe. Reprinted by permission of the author.

Francis V. O'Connor, from "The New Deal Art Projects in New York," reprinted from *The American Art Journal* I, 2 (Fall 1969) by permission of the publisher.

Thomas Hart Benton, from *An Artist in America,* reprinted from *An Artist in America* by Thomas Hart Benton by permission of the University of Missouri Press. Copyright 1968 by the Curators of the University of Missouri.

Frank Lloyd Wright, selection from *A Testament,* reprinted from *A Testament* by Frank Lloyd Wright, copyright 1957, by permission of the publisher, Horizon Press, New York.

Alexander Calder, from "What Abstract Art Means to Me," from a statement by Alexander Calder first published in the Museum of Modern Art, New York, *Bulletin,* "What Abstract Art Means to Me," Vol. XVIII, No. 3, Spring 1951. All rights reserved. Reprinted by permission of the publisher.

Jackson Pollock, "Two Statements," reprinted from *Art and Architecture,* LXI, 2 (February, 1944) by permission of the publisher.

Robert Motherwell, from "What Abstract Art Means to Me," from a statement by Robert Motherwell first published in the Museum of Modern Art, New York, *Bulletin,* "What Abstract Art Means to Me," Vol. XVIII, No. 3, Spring 1951. All rights reserved. Reprinted by permission of the publisher.

David Smith, from "Thoughts on Sculpture," reprinted from *Art Journal,* Winter, 1954. Reprinted by permission of the College Art Association of America.

Robert Goldwater, from "Reflections on the New York School," reprinted from *Quadrum 8,* 1960. Reprinted by permission of Mrs. Robert Goldwater.

Clement Greenberg, from "Post Painterly Abstraction," reprinted from *Art International,* VIII, 5, 1964, by permission of the publisher and the author. From "Avant-Garde Attitudes: New Art in the Sixties," reprinted from the Power Lectures by permission of the author.

Lawrence Alloway, selection from *American Pop Art,* excerpted with permission of

Contents

CONTENTS

Contents

CONTENTS

Contents

xi

CONTENTS

Introduction

This anthology, intended as a handy supplement to assigned texts in courses on American art, brings together in convenient form a series of readings on various aspects of American art and architecture. Although compiled primarily for students of American art, it will also prove to be of interest to students of American culture generally, for the ideas and issues addressed in these selections often have relevance beyond the practice and history of art. There has been an attempt to set a reasonable balance among many interests that would conceivably turn to such a series of readings, but the contents do not, of course, constitute a survey of American art. Gaps are inevitable, in view of the diversity of the art, and unavoidable, in view of the limitations of space. If the anthology serves at least to whet the appetite of the reader for further explorations in the literature of American art, a commendable function will have been realized. It is hoped, too, that these selections, when only excerpts, will invite the reader to seek the full text.

The selections are arranged, overall, in approximate chronological order with respect to their subject matter, and grouped together in sections that emphasize, within each of these units, a sequence of developments or a particular period or aspect of American art. The range of the selections is such as to juxtapose recent scholarship or criticism to earlier documents, thus providing multiple perspectives for the reader's reflection, and through the variety of types—artists' correspondence and theoretical statements, reviews of exhibitions, essays by critics

and art historians, notices in periodicals, and autobiographical excerpts—to evoke now and then a sense of time and place in as much richness as space allows.

The headnotes serve as linking passages and as supplements to the content of the individual sections. The reader will also discover connective threads throughout the anthology, as certain themes reappear in different contexts. Artistic freedom and individualism, didactic and moralistic expectations, nationalism and European connections, the education of the American artist, and architecture as cultural expression are among these recurring themes. Many cross-references from selection to selection will be noted by the careful reader. Some of these will support one another, and others will reveal conflicting points of view, but collectively, they provide an undercurrent of continuity. Thus, discursive as it is by nature, the anthology can be read as an entity.

On principle, the editor feels that the reader should make personal discoveries within the texts of the various selections, but a few modest examples may be in order. When, for instance, one reads, in Washington Allston's posthumously published *Lectures,* that "one of the happier elements of our nature is that which continually impels it towards the indefinite and unattainable," and then encounters Albert Pinkham Ryder's remark that he is trying to find "something out there beyond" (quoted in the headnotes to Section Four), the romantic *je ne sais quoi* links these two artists across the generations between them. Elsewhere, Robert Motherwell's view that "one's art is just one's effort to wed oneself to the universe, to unify oneself through union" may recall Emerson's transcendental experience in the presence of nature, his head "bathed in the blithe air, and uplifted into infinite space," sensing that he is "part and particle" of the universe. The difference between these two existential positions, for those who will reflect upon it, measures the distance between Emerson's world and that of a century later, while, at the same time, the ideas share some common philosophic ground.

The intimate and necessary relationship between architecture and its environment—if a harmonic, sustaining spirit is to prevail—is a theme that surfaces in selections throughout the anthology: Mumford, Sullivan, Huxtable.

One related pair of themes will be found in section after section: the European inheritance and example as a bench

Introduction

mark for the American artist and the hankering, almost from the beginning, for an American identity expressed through the agency of form and content in the arts. The occasional tensive relationship between these two will be found in some of the pages that follow. It has been a chronic factor in the consciousness of writers on American art. Whether the issue is at root a fallacy is a point of controversy, and if a reading of the anthology enables the student to better assess the polarity, another useful purpose will have been served.

The final bibliographical section is keyed to the individual sections of the anthology, with one exception: the first part of the bibliography, after citing reference sources, lists in order of their publication a series of books on American art from the nineteenth century to the present, offering the student a convenient index to shifting tastes and evaluations brought to bear on American art over more than a century of commentary.

Although the illustrations are necessarily limited in number, it is hoped that they achieve some balance as a unit and contribute individually to the enrichment of the selections to which they relate. They are placed as close as possible to the relevant portions of the text.

Over the years one incurs many debts to the scholarship of others whose insights have quietly slipped into the pattern that has become one's own, and to the ongoing exchanges with one's teachers, colleagues, and students. These the editor gratefully acknowledges and, of this number, one teacher in particular, the late Benjamin Rowland, Jr., whose counsel and encouragement are affectionately remembered by this student of American art. The editor is also indebted to many individuals who have helped by encouraging this project and by assisting in the process of compiling and producing it. Special thanks are owed to Peter John Givler, Helen McInnis, Edith Poor, and Rebecca Greenberg, of Charles Scribner's Sons, and to Eleanor Kuhar for her help with the typing. And finally there is that enduring support of the editor's wife and family.

HAROLD SPENCER
University of Connecticut

AMERICAN ART

Readings from the
Colonial Era to the Present

1. THE COLONIAL ERA AND THE EARLY REPUBLIC: ARCHITECTURE AND PAINTING

When William Bradford, governor of the Plymouth colony from 1621 to 1656, wrote, in 1630, that the descendents of these pioneers should rightly say, "Our fathers were Englishmen which came over this great ocean and were ready to perish in the wilderness . . . ," he could be forgiven the sin of pride in view of what had been accomplished during the first decade of the colony's existence. It had survived its trial in the wilderness, could look ahead with hope, and reflect on the struggle with satisfaction. Europeans had brought to this new land their European inheritance. This cultural legacy was a continuity that sustained them through the test of survival in a strange and not always benign environment. The American continental experience of generations to come—native-born and immigrant alike—would shape a new nation and add its own increment to the old continuity; but, to whatever degree this experience might transform the inheritance, surely the Old World would continue to nurture the new land with its cultural riches.

Were Governor Bradford witness to a vision of the arts this new land would produce during the centuries that lay ahead, he would undoubtedly have been appalled. Puritan attitudes were far from favorably disposed towards the visual arts. Yet, reflecting on the implications of Bradford's remarks, one senses how truly they isolate two significant aspects of American beginnings that could be ex-

3

tended to define a fundamental dualism in the conditions attending the birth and development of American art. Attitudes and themes rooted in a national experience uniquely American are undeniably present in American art. Just as pervasive is the legacy from European traditions, and, like a magnet composed of both pragmatic and nostalgic fields, Europe would continue to attract the American artist ambitious to enhance his native gifts. The readings in this section of the anthology, while calling attention to transatlantic connections, provide glimpses of the singular circumstances under which American builders, artists, and craftsmen worked in the early years.

The selection from Lewis Mumford's pioneering study of American architecture in its cultural context weaves the continuities of European precedent into the innovations and compromises spun out of American conditions. The message in the anonymous pamphlet of 1719 indicates the persistent lack of esteem for the arts with which American artists would have to contend. Whereas, in a purely evaluative sense, it seems to affirm the old Puritan prejudice against the visual arts, its tone smacks more of the grimmer variety of Yankee materialism than of Puritan suspicions that "every diversion of the eye was a diversion from the Lord." In the series of notices advertising the services of artists, one gleans some notion of the catch-as-catch-can enterprise necessary for the artist and artisan in eighteenth-century America.

The selections from the correspondence of John Singleton Copley reveal the aspirations—and haunting self-doubt—that moved this early American master as he weighed a prospering career in Boston against the uncertainties of a career abroad. There he hoped to enlarge the scope of his art beyond the limitations imposed upon it by a provincial society interested only in his talents as a portrait painter. Settling in England was a natural choice, considering the still unbroken bond with the land of his cultural heritage and the established presence in England of another American-born artist, Benjamin West. West's kindly reception of aspiring American artists was well known, and would earn his circle of colonials an identity as "The American School." The exchanges between Copley and West are samples of evidence confirming the latter's key role in rendering helpful service to American artists throughout his career. Copley's letter to his half-brother, Henry Pelham, which concludes these selections from Copley's correspondence, illuminates another aspect of transatlantic attractions: the thirst of a colonial artist for first-hand knowledge of the great traditions of European art, without which he felt incomplete.

FROM *Sticks and Stones*

Lewis Mumford

1. THE MEDIEVAL TRADITION

For a hundred years or so after its settlement, there lived and flourished in America a type of community which was rapidly disappearing in Europe. This community was embodied in villages and towns whose mummified remains even today have a rooted dignity that the most gigantic metropolises do not often possess. If we would understand the architecture of America in a period when good building was almost universal, we must understand something of the kind of life that this community fostered.

The capital example of the medieval tradition lies in the New England village.

There are two or three things that stand in the way of our seeing the life of a New England village; and one of them is the myth of the pioneer, the conception of the first settlers as a free band of "Americans" throwing off the bedraggled garments of Europe and starting life afresh in the wilderness. So far from giving birth to a new life, the settlement of the northern American seaboard prolonged for a little while the social habits and economic institutions which were fast crumbling away in Europe, particularly in England. In the villages of the New World there flickered up the last dying embers of the medieval order.

5

Whereas in England the common lands were being confiscated for the benefit of an aristocracy, and the arable turned into sheep-runs for the profit of the great proprietors, in New England the common lands were re-established with the founding of a new settlement. In England the depauperate peasants and yeomen were driven into the large towns to become the casual workers, menials, and soldiers; in New England, on the other hand, it was at first only with threats of punishment and conscription that the town workers were kept from going out into the countryside to seek a more independent living from the soil. Just as the archaic speech of the Elizabethans has lingered in the Kentucky Mountains, so the Middle Ages at their best lingered along the coast of Appalachia: and in the organization of our New England villages one sees a greater resemblance to the medieval Utopia of Sir Thomas More than to the classic republic in the style of Montesquieu, which was actually founded in the eighteenth century.

The colonists who sought to establish permanent communities—as distinct from those who erected only trading posts—were not a little like those whom the cities of Greece used to plant about the Mediterranean and the Black Sea littoral. Like the founders of the "Ancient City," the Puritans first concerned themselves to erect an altar, or rather, to lay the foundations for an edifice which denied the religious value of altars. In the crudest of "smoaky wigwams," an early observer notes, the Puritans remember to "sing psalms, pray, and praise their God"; and although we of today may regard their religion as harsh and nay-saying, we cannot forget that it was a central point of their existence and not an afterthought piled as it were on material prosperity for the sake of a good appearance. Material goods formed the basis, but not the end, of their life.

The meeting-house determined the character and limits of the community. As William Weeden says in his excellent *Economic and Social History of New England,* the settlers "laid out the village in the best order to attain two objects: first, the tillage and culture of the soil; second, the maintenance of a 'civil and religious society.'" Around the meeting house the rest of the community crystallized in a definite pattern, tight and homogeneous.

The early provincial village bears another resemblance to the early Greek city: it does not continue to grow at such a

From *Sticks and Stones*

pace that it either becomes overcrowded within or spills beyond its limits into dejected suburbs; still less does it seek what we ironically call greatness by increasing the number of its inhabitants. When the corporation has a sufficient number of members, that is to say, when the land is fairly occupied, and when the addition of more land would unduly increase the hardship of working it from the town, or would spread out the farmers, and make it difficult for them to attend to their religious and civil duties, the original settlement throws out a new shoot. So Charlestown threw off Woburn; so Dedham colonized Medfield; so Lynn founded Nahant.

The Puritans knew and applied a principle that Plato had long ago pointed out in the *Republic*, namely, that an intelligent and socialized community will continue to grow only as long as it can remain a unit and keep up its common institutions. Beyond that point growth must cease, or the community will disintegrate and cease to be an organic thing. Economically, this method of community-development kept land values at a properly low level, and prevented the engrossing of land for the sake of a speculative rise. The advantage of the Puritan method of settlement comes out plainly when one contrasts it with the trader's paradise of Manhattan; for by the middle of the seventeenth century all the land on Manhattan Island was privately owned, although only a small part of it was cultivated, and so eagerly had the teeth of monopoly bitten into this fine morsel that there was already a housing shortage.

One more point of resemblance: all the inhabitants of an early New England village were co-partners in a corporation; they admitted into the community only as many members as they could assimilate. This co-partnership was based upon a common sense as to the purpose of the community, and upon a roughly equal division of the land into individual plots taken in freehold, and a share of the common fields, of which there might be half a dozen or more.

There were various local differences in the apportionment of the land. In many cases, the minister and deacons had a larger share than the rest of the community; but in Charlestown, for example, the poorest had six or seven acres of meadow and twenty-five or thereabouts of upland; and this would hold pretty well throughout the settlements. Not merely was membership in the community guarded: the right of occupying and transferring the land was also restricted, and

7

again and again, in the face of the General Assembly, the little villages made provisions to keep the land from changing hands without the consent of the corporation; "it being our real intent," as the burghers of Watertown put it, to "sitt down there close togither."

These regulations had a positive side as well; for in some cases the towns helped the poorer members of the corporation to build houses, and as a new member was voted into the community, lots were assigned immediately, without further ado. . . .

II

Since we are accustomed to look upon the village as a quaint primitive relic of a bygone age, we do not readily see that its form was dictated by social and economic conditions. Where the village had to defend itself against Indians, it was necessary to lay it out completely, so that it might be surrounded by a stockade, and so that the meeting-house might be such a rallying center as the bell-tower or the castle was in Europe, or as the high temple site was in classic times. But in the eighteenth century the Indian figured less in the scheme of colonial life, and along the seacoast and river—as at Wells Beach in Maine or Litchfield in Connecticut—the village became a long strip upon a highroad, and the arable land stretched in narrow plots from the house to the water, so that the farmer might better protect his crops and his livestock from the fox, the wolf, the woodchuck, the hawk, the skunk, and the deer.

I emphasize these points of structure because of the silly notion superficial observers sometimes carry away from the villages of Europe or New England; namely, that their irregularity is altogether capricious and uneconomical, associated only with the vagaries of the straying cow. It would be more correct to say that the precise reverse was true. The inequality in size and shape of plots shows always that attention was paid to the function the land was to perform, rather than to the mere possession of property. Thus, there was a difference in size between home lots, which were always seated in the village, and purely agricultural tracts of land, which were usually on the outskirts; and in Dedham, for example, married men had home lots of twelve acres, while bache-

lors received only eight. Another reason for the compactness of the village was a decree of the General Court in Massachusetts, in 1635, that no dwelling should be placed more than half a mile from the meeting-house in any new plantation. Even irregularities in the layout and placement of houses, which cannot be referred to such obvious points as these, very often derive from an attempt to break the path of the wind, to get a good exposure in summer, or to profit by a view.

All this was genuine community planning. It did not go by this name, perhaps, but it achieved the result.

III

We have learned in recent years to appreciate the felicities of eighteenth-century colonial architecture, and even the earlier seventeenth-century style is now coming into its own, in the sense that it is being imitated by architects who have an eye for picturesque effects; but we lose our perspective altogether if we think that the charm of an old New England house can be recaptured by designing overhanging second stories or panelled interiors. The just design, the careful execution, the fine style that brings all the houses into harmony no matter how diverse the purposes they served—for the farmhouse shares its characteristics with the mill, and the mill with the meeting-house—was the outcome of a common spirit, nourished by men who had divided the land fairly and who shared adversity and good fortune together. When the frame of the house is to be raised, a man's neighbors will lend him a hand; if the harvest is in danger, every man goes out into the fields, even if his own crop is not at stake; if a whale founders on the beach, even the smallest boy bears a hand, and gets a share of the reward. All these practices were not without their subtle effect upon craftsmanship.

Schooled in the traditions of his guild, the medieval carpenter pours his all into the work. Since sale does not enter into the bargain, it is both to his patron's advantage to give him the best materials, and to his own advantage to make the most of them. If at first, in the haste of settlement, the colonists are content with makeshifts, they are nevertheless done in the traditional fashion—not the log cabins of later days, but, more probably, wattle and daub huts like those of the charcoal burn-

ers in the English forests. In some points, the prevailing English tradition does not fit the raw climate of the north, and presently the half-timbered houses of some of the earlier settlers would be covered by clapboards for greater warmth, as in the eightheenth century their interiors were lined with panelled pine or oak, instead of the rough plaster. No matter what the material or mode, the carpenter works not simply for hire, but for dear life's sake, and as a baker's dozen numbers thirteen, so a piece of handicraft contains not merely the workmanship itself, but a bit of the worker's soul, for good measure. The new invention of the gambrel roof, which gave additional room to the second story without raising the roof-tree, is a product of this system; and the variation in its length and pitch in New England, New Jersey, and New York is a witness to the freedom of design that prevailed throughout the work.

These seventeenth-century houses, built at first with one or two rooms, and then as luxury increased and family needs multiplied with as many as four, would doubtless seem unspeakably crude and mean to the resident of Floral Heights; indeed, if our present requirements for housing were so simple it would not be quite so difficult to meet our perpetual shortage. As a matter of fact, however, these early provincial houses were well up to the standards for a similar homestead in England; and in some ways were a distinct advance. Just as all the separate courses on a restaurant menu were a few hundred years ago cooked in the same pot, so the different subdivisions of the modern house were originally combined into a single room, which was not merely kitchen, workroom, and living quarters, but which also, at least in winter, served as a stable for the more delicate members of the barnyard. By the time America was settled the division into rooms had just commenced among the better sort of farmer: the barn had split off from the rest of the house, and the bedchamber was becoming a separate apartment. As the seventeenth century lengthened, this division of functions became more familiar in the provincial house.

Let us take a brief look at one of these seventeenth-century buildings; let us say, the John Ward house in Salem [Fig. 1] which still survives as a relic. As one approaches the village on some November day, when the leaves are no longer on the trees to obscure the vista, one feels the dynamic quality of medieval architecture—a quality altogether different from the

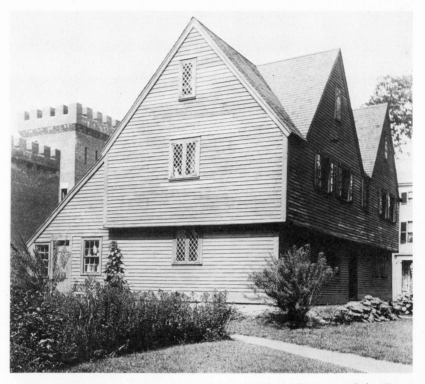

1. John Ward House, Salem, Massachusetts (1684). (Courtesy of the Essex Institute, Salem, Massachusetts)

prudent regularities of the later Georgian mode. It is not merely a matter of painted gables, leaded, diamond-paned windows, overhanging second stories, much as these would perhaps remind us of a medieval European town. What would attract one is the feeling, not of formal abstract design, but of growth: the house has developed as the family within it has prospered, and brought forth children; as sons and daughters have married, as children have become more numerous, there have been additions: by a lean-to at one end the kitchen has achieved a separate existence, for instance; and these un-painted, weathered oaken masses pile up with a cumulative richness of effect.

Every step that brings one nearer to the house alters the relation of the planes formed by the gable ends; and so one must have got the same effect in these old village streets as one gets today when one skirts around, let us say, Notre Dame in Paris, now overwhelmed by the towers at the front, and now

11

seeing them reduced to nothing by the tall spire in the rear. So the building seems in motion, as well as the spectator; and this quality delights the eye quite as much as formal decoration, which the architecture of the seventeenth century in America almost completely lacked.

The Puritan had his failings; and this lack of decoration was perhaps the most important one in architecture. In his devotion to books and in his love for music, even psalm-music, the Puritan was not immune to art; but he was suspicious of the image, and one is tempted to read into his idol-breaking a positive visual defect, akin to the Daltonism or color blindness of the Quakers. Whereas medieval architecture had cherished the sculptor and the painter, even in the commonest vernacular work, the Puritans looked upon every diversion of the eye as a diversion from the Lord, and, by forbidding a respectable union between the artist and the useful arts, they finally turned the artist out on the streets, to pander to the first fine gentleman who would give him a kind word or a coin. Whereas Puritan buildings in the seventeenth century were straightforward and honestly bent to fulfill their functions, the Puritan did not see that ornament itself may be functional, too, when it expresses some positive gesture of the spirit. The bareness of the seventeenth century paved the way for the finicking graces of the eighteenth.

IV

In essentials, however, both the life and the architecture of the first provincial period are sound. While agriculture is the mainstay of life, and the medieval tradition flourishes, the New England village reaches a pretty fair pitch of worldly perfection; and beneath all the superficial changes that affected it in the next century and a half, its sturdy framework held together remarkably well.

. . . Would it be an exaggeration to say that there has never been a more complete and intelligent partnership between the earth and man than existed, for a little while, in the old New England village? In what other part of the world has such a harmonious balance between the natural and the social environment been preserved? . . .

Wherever these villages were well-established, they kept

*sweet and sound over the centuries: in Connecticut, Sharon
and Litchfield and Old Lyme; in Massachusetts, Shirley Cen-
ter and Harvard and Andover; Manchester in Vermont, or
Thetford in New Hampshire, still bear testimony to the life-
wisdom and skill of their early planners and inhabitants. This
organic form of village, so far from disappearing with the
nineteenth century, provided a model for the new villages of
the early New England migration into Ohio; and some of their
rural charm was carried, at a later stage, into Wisconsin. In the
group of villages that forms the Amana Colony in Iowa, the
most sturdy and economically successful of religious utopias
after those of the Shakers, the original terms of the medieval
village were handsomely carried forward into the twentieth
century. Some of their essential form will underlie every sound
modern plan for a life that brings together rural and urban
functions, not to say felicities.*

2. THE HERITAGE OF THE RENAISSANCE

The forces that undermined the medieval civilization of
Europe sapped the vitality from the little centers it had depos-
ited in America. What happened in the course of three or four
centuries in Europe took scarcely a hundred years on this side
of the Atlantic.

Economically and culturally, the village community had
been pretty well self-contained; it scraped along on its immedi-
ate resources, and if it could not purchase for itself the "best
of everything" it at least made the most of what it had. In every
detail of house construction, from the setting of fireplaces to
the slope of the roof, there were local peculiarities which dis-
tinguished not merely the Dutch settlements from the En-
glish, but which even characterized several settlements in
Rhode Island that were scarcely a day's tramp apart. The limi-
tation of materials, and the carpenter's profound ignorance of
"style" made for freedom and diversity. It remained for the
eighteenth century to erect a single canon of taste.

With the end of the seventeenth century the economic basis
of provincial life shifted from the farm to the sea. This change
had the same effect upon New England, where the village-
community proper alone had flourished, that fur-trading had
had upon New York: it broke up the internal unity of the

village by giving separate individuals the opportunity by what was literally a "lucky haul," to achieve a position of financial superiority. Fishermen are the miners of the water. Instead of the long, watchful care that the farmer must exercise from planting time to harvest, fishing demands a sharp eye and a quick, hard stroke of work; and since what the Germans call *Sitzfleisch* is not one of the primary qualities of a free lad, it is no wonder that the sea weaned the young folks of New England away from the drudgeries of its boulder-strewn farms. With fishing, trading, and building wooden vessels for sale in foreign ports, riches poured into maritime New England; and what followed scarcely needs an explanation.

These villages ceased to be communities of farmers, working the land and standing squarely on their own soil: they became commercial towns which, instead of trading for a living, simply lived for trade. . . . For about a hundred years the carpenter-builder continued to remain on the scene, and work in his forthright and painstaking and honest manner; but in the middle of the eighteenth century he was joined, for the first time, by the professional architect, the first one being probably Peter Harrison, who designed the Redwood Library, which still stands in Newport. Under competition with architects and amateurs of taste, the carpenter-builder lost his position as an independent craftsman, building intelligently for his equals: he was forced to meet the swift, corrosive influences brought in from foreign lands by men who had visited the ports of the world; and he had to set his sails in order to catch the new winds of fashion.

What were these winds, and what effect did they have upon the architecture of the time?

Most of the influences that came by way of trade affected only the accent of architecture; the language remained a homely vernacular. In the middle of the eighteenth century China sent over wallpaper; and in the Metropolitan Museum there is an American lacquered cabinet dated as early as 1700, decorated with obscure little Chinese figures in gilded gesso. "China" itself came in to take the place of pewter and earthenware in the finer houses; while in the gardens of the great manors, pavilions and pagodas, done more or less in the Chinese manner, were fashionable. Even Thomas Jefferson, with his impeccably classical taste, designed such a pavilion for Monticello before the Revolution.

From *Sticks and Stones*

This specific Chinese influence was part of that large, eclectic Oriental influence of the eighteenth century. The cultural spirit that produced Montesquieu's *Lettres Persanes* also led to the translation of the Chinese and Persian and Sanskrit classics, and by a more direct route brought home Turkish dressing-gowns, turbans, and slippers to Boston merchants. In Copley's painting of Nicholas Boylston, in 1767, these Turkish ornaments rise comically against the suggestion of a Corinthian pillar in the background; and this pillar recalls to us the principal influence of the time—that of classic civilization. This influence entered America first as a motif in decoration, and passed out only after it had become a dominating motive in life.

II

The Renaissance was an orientation of the European mind towards the forms of Roman and Greek civilization, and towards the meaning of classical culture. On the latter side its impulse was plainly a liberating one: it delivered the human soul from a cell of torments in which there were no modulating interests or activities between the base satisfactions of the temporal life and the beatitudes of heaven. With the Renaissance the god-beast became, once again, a man. Moreover, just when the Catholic culture of Christendom was breaking down under the influence of heresy and skepticism, the classics brought to the educated men of Europe a common theme which saved them from complete intellectual vagrancy. The effect of classical civilization, on the other hand, was not an unmixed good: for it served all too quickly to stereotype in old forms a spirit which had been freshly reborn, and it set up a servile principle in the arts which has in part been responsible for the wreck of both taste and craftsmanship.

The first builders of the Renaissance, in Italy, were not primarily architects; they were rather supreme artists in the minor crafts; and their chief failing was, perhaps, that they wished to stamp with their personal imprint all the thousand details of sculpture, painting, and carving which had hitherto been left to the humble craftsman. Presently, the technical knowledge of the outward treatment of a building became a touchstone to success; and a literal understanding of the products of antiquity took the place in lesser men of personal

inspiration. The result was that architecture became more and more a thing of paper designs and exact archaeological measurements; the workman was condemned to carry out in a faithful, slavish way the details which the architect himself had acquired in similar fashion. So the architect ceased to be a master-builder working among comrades of wide experience and travel: he became a Renaissance gentleman who merely gave orders to his servants. . . .

Hereafter, architecture lives by the book. First it is Palladio and Vignola; then it is Burlington and Chambers; then, after the middle of the eighteenth century, the brothers Adam and James Stuart's *Antiquities of Athens.* Simpler works with detailed prescriptions for building in the fashionable mode made their way in the late seventeenth century among the smaller fry of carpenters and builders; and they were widely used in America, as a guide to taste and technique, right down to the middle of the nineteenth century. It was by means of the book that the architecture of the eighteenth century from St. Petersburg to Philadelphia seemed cast by a single mind. We call the mode Georgian because vast quantities of such building was done in England, as a result of the general commercial prosperity of that country; but it was common wherever European civilization had any fresh architectural effort to make, and if we call this style "colonial" in America it is not to mark any particular lapse or lack of distinction. . . .

III

The first effect of the Renaissance forms in America was not to destroy the vernacular but to perfect it; for it provided the carpenter-builder, whose distance from Europe kept him from profiting by the spirited work of his forbears, with a series of ornamental motifs. . . .

Classical motifs served to fill the blank in provincial architecture. As long as the carpenter worked by himself, the classic influence was confined to little details like the fanlights, the moldings, the pillars of the portico, and so on. In the rural districts of New England, from Maine to Connecticut, and in certain parts of New York and New Jersey and Pennsylvania, the carpenter kept on building in his solid, traditional manner down to the time that the jig-saw overwhelmed a mechanically

hynotized age; and even through the jig-saw period in the older regions, the proportions and the plan remained close to tradition. The classical did not in fact supplant the vernacular until the last vestiges of the guild and the village-community had passed away, and the economic conditions appropriate to the Renaissance culture had made their appearance.

The dwelling house slowly became more habitable during this period: the skill in shipbuilding which every sheltered inlet gave evidence of was carried back into the home, and in the paneling of the walls and the general tidiness and compactness of the apartments, a shipshape order comes more and more to prevail. The plastered ceiling makes its appearance, and the papered wall; above all, white paint is introduced on the inside and outside of the house.

Besides giving more light, this innovation surely indicates that chimney flues had become more satisfactory. Paint was no doubt introduced to keep the torrid summer sun from charring the exposed clapboards; and white paint was used, despite the expense of white lead, for the reason that it accorded with the chaste effect which was inseparable in the eighteenth-century mind from classic precedent. . . .

IV

. . . Coming to America in handbooks and prints, chastely rendered, the models of antiquity were, down to the Revolution, followed just so far as they conveniently served. Instead of curbing invention, they gave it a more definite problem to work upon.

It was a happy accident that made the carpenter-builders and cabinet makers of America see their China, their Paris, their Rome through a distance, dimly. What those who admire the eighteenth-century style do not, perhaps, see is that an accident cannot be recovered. However painstakingly we may cut the waistcoat, the stock, the knee-breeches of an eighteenth-century costume, it is now only a fancy dress: its "moment" in history is over. The same principle holds true for Georgian or colonial architecture, even more than it does for that of the seventeenth century; for one might, indeed, conceive of a breakdown in the transportation system or the credit system which would force a builder to rely for a while upon the

products of his own region; whereas, while our civilization remains intact there are a hundred handbooks, measured drawings, and photographs which make a naïve recovery of antiquity impossible.

Once we have genuinely appreciated the influence that created early colonial architecture, we see that it is irrecoverable: what we call a revival is really a second burial. . . .

3. THE CLASSICAL MYTH

. . . The first development of the grand style in the American renaissance was in the manors of Virginia and Maryland. It came originally through an imitation of the country houses of England, and then, after the Revolutionary War, it led to a direct adaptation of the Roman villa and the Greek temple. One does not have to go very deep to fetch up the obvious parallel between the land-monopoly and slavery that prevailed in the American manors and the conditions that permitted the Roman villa itself to assume its stately proportions; nor need one dwell too long upon the natural subordination, in this regime, of the carpenter-builder to the gentleman-architect. "In the town palaces and churches," as Mr. Fiske Kimball justly says, "there was a strong contradiction between modern conditions and ancient forms, so that it was only in the country that Palladio's ideas of domestic architecture could come to a clear and successful expression. These monuments, since so much neglected, served in Palladio's book expressly to represent the 'Antients' designs of country-houses. . . ."

At his death, Robert Carter, who had been Rector of the College, Speaker of the Burgesses, President of the Council, Acting Governor of Virginia, and Proprietor of the Northern Neck, was described in the *Gentleman's Magazine* of 1732 as the possessor of an estate of 300,000 acres of land, about 1,000 slaves, and ten thousand pounds. Pliny the Younger might well have been proud of such an estate. On a substantial basis like this, a Palladian mansion was possible; and up and down the land, wherever the means justified the end, Palladian mansions were built.

The really striking thing about the architecture of Manorial America with its great dignity and its sometimes striking beauty of detail or originality of design—as in the staircase at

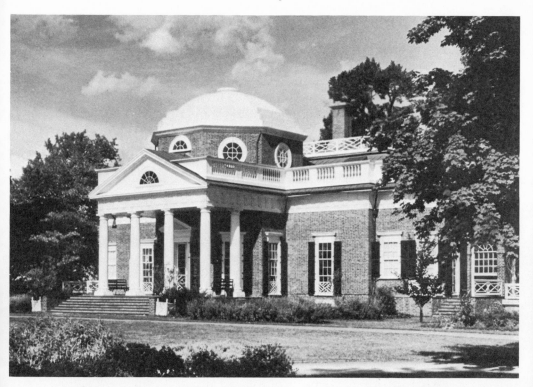

2. Thomas Jefferson, architect; Monticello, near Charlottesville, Virginia (1796–1805). (Thomas Jefferson Memorial Foundation)

Berry Hill which creates a flaring pattern like butterfly's wings —the striking thing is the fact that the work is not the product of a specialized education; it is rather the outcome of a warm, loving, and above all intelligent commerce with the past. . . .

These educated eighteenth-century gentlemen, these contemporaries of "Junius" and Gibbon, who had read Horace and Livy and Plutarch, had one foot in their own age, and the other in the grave of Rome. In America, Thomas Jefferson exemplified this whole culture at its best and gave it a definite stamp: he combined in almost equal degrees the statesman, the student, and the artist. Not merely did Jefferson design his own Monticello [Fig. 2]; he executed a number of other houses for the surrounding gentry—Shadwell, Edgehill, Farrington— to say nothing of the Virginia State Capitol and the church and university at Charlottesville. It was Jefferson who in America first gave a strict interpretation to classicism; for he had noth-

ing but contempt for the free, Georgian vernacular which was making its way among those who regarded the classical past as little more than a useful embellishment.

The contrast between the classical and the vernacular, between the architecture of the plantation and the architecture of the village, between the work of the craftsman, and the work of the gentleman and the professional architect, became even more marked after the Revolutionary War. As a result of that recrystallization of American society, the conditions of classical culture and classical civilization were for a short time fused in the activities of the community, even in the town. One may express the transformation in a crude way by saying that the carpenter-builder had been content with a classical finish; the architects of the early republic worked upon a classical foundation. It was the Revolution itself, I believe, that turned the classical taste into a myth which had the power to move men and mold their actions. . . .

1924, 1955

The Artist in the Eighteenth Century: Four Notices

... It's more noble to be employed in serving and supplying the necessities of others, than merely in pleasing the fancy of any. The Plow-Man that raiseth Grain, is more serviceable to mankind, than the Painter who draws only to please the Eye. The Carpenter who builds a good House to defend us from Wind and Weather, is more serviceable than the curious Carver, who employs his Art to please the Fancy. . . .

—From an anonymous pamphlet, *An Addition to the Melancholy Circumstances of the Province Considered* (1719)

The person, who has had the honour to wait upon you, with this letter, is a man, of a Good Family, but either by the Frowns of Fortune, or his own mismanagement, is obliged to seek his Bread, a little of the latest in a Strange Land. His name is Bridges, & His Profession, is Painting, and if you have any Employment for him in that way, he will be proud of obeying your commands. He has drawn my children, & several others in the neighborhood; & 'tho he have not the Masterly Hand of a Lilly, or a Kneller, yet, had he lived so long ago, as when places were given to the most Deserving, he might have pretended to be serjeant Painter of Virginia.

—From a letter by Colonel William Byrd to Alexander Spotswood (Virginia 1735) The artist is Charles

Bridges, who carried with him this letter of introduction.

... Painting done in the best manner, by Gustavus Hesselius, from Stockholm, and John Winter, from London, viz. Coats of Arms drawn on Coaches, Chaises, etc., or any other kind of Ornaments, Landskips, Signs, Shew-boards, Ship and House Painting, Gilding of all sorts, Writing in Gold or Colour, old Pictures clean'd and mended, etc. . . .

—From an advertisement in
Pennsylvania Gazette (December 11, 1740)

Lichfield [*sic*] May 18, 1796

Mr. *Ralph Earle,** the celebrated *Portrait Painter,* is now at New-Milford; where he will probably reside for some time. As we profess a friendship for Mr. *Earle,* and are desirous that the Public avail themselves of the abilities of this able artist, we feel a pleasure in making this communication; many gentlemen in this vicinity, having been disappointed of his services, and several of our friends being driven to accept of the paultry *daubs* of assuming pretenders. Mr. *Earle*'s price for a Portrait of full length is *Sixty Dollars,* the smaller size *Thirty Dollars;* the Painter finding his own support and materials.—Applications, by letter or otherwise, will be transmitted to Mr. *Earle* from this office, or the Post-master at New-Milford will take charge of all letters addressed to Mr. *Earle.*

—Advertisement in the Litchfield [Conn.] *Weekly Monitor* (1796).

*The artist signed his paintings as "Earl."

From the Correspondence
of John Singleton Copley

BOSTON, Sepr. 10, 1765.

DEAR SIR,

I have sent You the portrait of my Brother[2] [Fig. 3] by Mr. Haill,[3] who has been so kind to take the care of it and put it among his own baggage. Nothing would have been a sufficient inducement to have sent it so soon but the desire of confirming the good opinion You began to conceive of me before You left Boston which I would by no means forfeit, chusing rather to risque the Picture than the loss of Your esteem; indeed I believe it must be allowed I act with prudence in this respect if it is considered that should the Picture be unfit (through the changing of the colours) for the exhibition, I may not have the mortification of hearing of its being condemned. I confess I am under some apprehension of its not being so much esteem'd as I could wish; I dont say this to induce You to be backward in letting me know how far it is judged to deserve censure for I can truly say if I know my own heart I am less anxious to enjoy than deserve applause.

. . . I am Sir with all Sincerity Your Real Friend and Ser't.

JOHN: S: COPLEY.

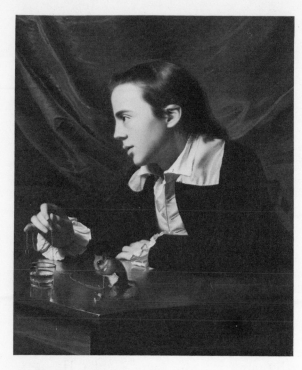

3. John Singleton Copley, *Portrait of Henry Pelham (The Boy with the Squirrel)* (ca. 1765). Oil on canvas, 30¼" × 25". (Courtesy Museum of Fine Arts, Boston. Anonymous gift)

NOTES

1. Captain of the *John and Sukey,* a merchant vessel.
2. "The Boy with the Squirrel," Copley's first picture to be exhibited in London, 1766. [of Henry Pelham, the artist's half-brother]
3. Mr. Roger Hale, Collector or Surveyor of the port of London.

CAPTAIN R. G. BRUCE TO COPLEY

LONDON, 4th August, 1766.

D'R COPLEY,

Dont imagine I have forgot or neglected your Interest by my long Silence. I have delayed writing to You ever since the Exhibition, in order to forward the inclosed Letter from Mr. West,[1] which he has from time to time promised me, but which his extreme Application to his Art has hitherto prevented his finishing.

What he says will be much more conclusive to You than anything from me. I have only to add the general Opinions which were pronounced on your Picture when it was exhib-

ited. It was universally allowed to be the best Picture of its kind that appeared on that occasion, but the sentiments of Mr. Reynolds, will, I suppose, weigh more with You than those of other Criticks. He says of it, "that in any Collection of Painting it will pass for an excellent Picture, but considering the Dissadvantages" I told him "you had laboured under, that *it was a very wonderfull Performance.*" "That it exceeded any Portrait that Mr. West ever drew." "That he did not know one Painter at home, who had all the Advantages that Europe could give them, that could equal it, and that if you are capable of producing such a Piece by the mere Efforts of your own Genius, with the advantages of the Example and Instruction which you could have in Europe, You would be a valuable Acquisition to the Art, and one of the first Painters in the World, provided you could receive these Aids before it was too late in Life, and before your Manner and Taste were corrupted or fixed by working in your little way at Boston. He condemns your working either in Crayons or Water Colours." Dont imagine I flatter You. I only repeat Mr. Reynolds's words, which are confirmed by the publick Voice. He, indeed, is a mere Enthusiast when he speaks of You. At the same time he found Faults. He observed a little Hardness in the Drawing, Coldness in the Shades, An over minuteness, all which Example would correct. "But still," he added, *"it is a wonderful Picture* to be sent by a Young Man who was never out of New England, and had only some bad Copies to study." I have beg'd of Mr. West to be copious in his Criticisms and Advices to You. Mr. Reynolds would have also wrote to You himself but his time is too valuable. The Picture is at his House where I shall leave it till I have your Directions how to dispose of it. I could sell it to advantage, but it is thought more for your Interest to keep it as a Specimen. You are greatly obliged to Lord Cardross,[2] a Friend of mine, to whom I first sent it. He showed it to the most eminent Conniseurs, then gave it to Mr. Reynolds, who sent it with his own Pictures to the Exhibition. You are best Judge of your own Affairs, and whether you can with propriety accomplish a Trip for a few Years to Europe. Should you take that Resolution, I believe I may venture to assure You, that You will meet with much Encouragment and Patronage. Should it be in my little power to be of the least use to You, you may command me to the utmost. I am already very happy in having contributed to make your Merit so far known to the World, and hope it has

laid the Foundation of your being the great Man Mr. Reynolds prognosticates. . . .

<div align="right">R. G. Bruce[3]</div>

NOTES

1. Benjamin West.
2. Title of the Erskines.
3. The letter was addressed to Mr. William Copley—Boston.

BENJAMIN WEST TO COPLEY

<div align="right">London, August 4th, 1766.</div>

Sir,

On Seeing a Picture painted by you and meeting with Captain Bruce, I take the liberty of writeing to you. The great Honour the Picture has gaind you hear in the art of Painting I dare say must have been made known to You Long before this Time. and as Your have made So great a Progr[e]ss in the art I am Persuaded You are the more desierous of hearing the remarks that might have been made by those of the Profession, and as I am hear in the Midst of the Painting world have the greater oppertunity of hearing them. Your Picture first fell into Mr. Reynolds' hands to have it Put into the Exhibition as the Proformanc of a Young American: he was Greatly Struck with the Piec, and it was first Concluded to have been Painted by one Mr. Wright,[1] a young man that has just made his appearance in the art in a sirprising Degree of Merritt. as Your Name was not given with the Picture it was Concluded a mistake, but before the Exhibition opened the Perticulers was recevd from Capt. Bruce. while it was Excibited to View the Criticizems was, that at first Sight the Picture struck the Eye as being to liney, which was judgd to have arose from there being so much neetness in the lines, which indeed as fare as I was Capable of judgeing was some what the Case. for I very well know from endevouring at great Correctness in ones out line it is apt to Produce a Poverty in the look of ones work. when ever great Desition [decision] is attended to they lines are apt to be to fine and edgey. This is a thing in works of great Painter[s] I have remark[ed] has been strictly a voyded, and have given Correctness in a breadth of out line, which is finish-

ing out into the Canves by no determind line when Closely examined; tho when seen at a short distanc, as when one looks at a Picture, shall appear with the greatest Bewty and freedom. for in nature every thing is Round, or at least Partakes the most of that forme which makes it imposeble that Nature, when seen in a light and shade, can ever appear liney.

As we have every April an Exhibition where our works is exhibitied to the Publick, I advise you to Paint a Picture of a half figure or two in one Piec, of a Boy and Girle, or any other subject you may fancy. And be shure take your Subjects from Nature as you did in your last Piec, and dont trust any resemblanc of any thing to fancey, except the dispositions of they figures and they ajustments of Draperies, So as to make an agreable whole. for in this Consists the work of fencey and Test [taste].

If you should do anything of this kind, I begg you may send it to me, when you may be shure it shall have the greatest justice done it. lett it be Painted in oil, and make it a rule to Paint in that way as much as Posible, for Oil Painting has the superiority over all other Painting. As I am from America, and know the little Opertunities is to be had their in they way of Painting, made the inducement the more in writeing to you in this manner, and as you have got to that lenght in the art that nothing is wanting to Perfect you now but a Sight of what has been done by the great Masters, and if you Could make a viset to Europe for this Porpase for three or four years, you would find yourself then in Possession of what will be highly valuable. if ever you should make a viset to Europe you may depend on my friendship in eny way thats in my Power to Sarve.

Your Friend and Humble Servent,

B. WEST.

my direction is Castle Street Leicester Fields.
[Addressed] To Mr William [sic] Copley Painter at Boston
[Endorsed] forwarded by Your Humbl Servt J. Loring.[2]

NOTES

1. Joseph Wright [of Derby] (1734–1797), who first exhibited in London in 1765. Not to be confused with Joseph Wright (1756–1793), son of Patience Wright.
2. Joshua Loring?

JOHN SINGLETON COPLEY

COPLEY TO BENJAMIN WEST

BOSTON, Novr. 12, 1766.

SIR,

Your kind favour of Augst. 4, 1766, came to hand. It gave me great pleasure to receive without reserve Your Criticisms on the Picture I sent to the Exibition. . . . It was remarkd the Picture was too lind. this I confess I was concious of my self and think with You that it is the natural result of two great presition in the out line, which in my next Picture I will indeavour to avoid, and perhaps should not have fallen into it in that, had I not felt two great timerity at presenting a Picture to the inspection of the first artists in the World, and where it was to come into competition with such masterly performancess as generally appear in that Collection. . . . Your c[a]utioning me against doing anything from fancy I take very kind, being sensable of the necessity of attending to Nature as the fountain head of all perfection, and the works of the great Masters as so many guides that lead to the more perfect imitation of her, pointing out to us in what she is to be coppied, and where we should deviate from her. In this Country as You rightly observe there is no examples of Art, except what is to [be] met with in a few prints indiferently exicuted, from which it is not possable to learn much, and must greatly inhanch the Value of free and unreserved Criticism made with judgment and Candor.

It would give me inexpressable pleasure to make a trip to Europe, where I should see those fair examples of art that have stood so long the admiration of all the world. the Paintings, Sculptors and Basso Releivos that adourn Italy, and which You have had the pleasure of making Your Studies from would, I am sure, annimate my pencil, and inable me to acquire that bold free and gracefull stile of Painting that will, if ever, come much slower from the mere dictates of Nature, which has hither too been my only instructor. . . .

But I shall be exceeding glad to know in general what the present state of Painting in Italy is, weither the Living Masters are excellent as the Dead have been. it is not possable my curiossity can be sattisfied in this by any Body but Yourself, not having any corraspondance with any whose judgment is sufficent to sattisfy me. . . .

I am Sir with all Sinceri[t]y Your friend and Humble Sert.

J: S: COPLEY.

From the Correspondence of John Singleton Copley

COPLEY TO BENJAMIN WEST[1]

BOSTON, Jany. 17th, 1768.

SIR,

. . . I should be glad to go to Europe, but cannot think of it without a very good prospect of doing as well there as I can here. You are sensable that three hundred Guineas a Year, which is my present income, is a pretty living in America, and I cannot think You will advise me to give it up without a good prospect of somthing at least equel to it, considering I must remove an infirm Mother, which must add to the dificulty and expenciveness of such [a] Voyage. And what ever my ambition may be to excell in our noble Art, I cannot think of doing it at the expence of not only my own happyness, but that of a tender Mother and Young Brother[2] whose dependance is intirely upon me.

. . . I beg You will continue Your remarks in the same friendly[3] maner You have hither too done, which will very much Oblige Your sincere friend And Humble Sert.

JOHN S: COPLEY.

NOTES

1. There are two drafts of this letter. The first one has many erasures.
2. First draft: "who I am bring[ing] up to [the] same study with myself."
3. First draft: "canded."

BENJAMIN WEST TO COPLEY

DEAR SIR,

Some days past Your Brother Mr. Clark delivered into my hands your letter of the 8th of Novr., Which informed me of your intended Tour into Italy, and the desier you express'd of receiveing my Opinion on that Subject. I am still of the opinion the going to Italy must be of the greatest advantage to one advanced in the arts as you are, As by that you will find what you are already in possession of, and what you have to acquier.

As your jurney to Italy is reather to finish a studye then to begin one; Your stay in that country will not requier that length of time that would be necessery for an Artist less advanced in the Arts then you are; But I would have that time

as uninterrupted as possible. . . . So my Advice is, Mrs. Copley to remain in Boston till you have made this Tour, After which, if you fix your place of reasidanc in London, Mrs. Copley to come over.

In regard to your studyes in Italy my advice is as follows: That you pursue the higher Exalances in the Art, and for the obtaining of which I recommend to your attention the works of the *Antiant Statuarys, Raphael, Michal Angilo, Corragio,* and *Titian,* as the Sorce from whance true tast in the arts have flow'd. . . . The works of the Antient Statuarys are the great original whare in the various charectors of nature are finely represented, from the soundest principles of Philosophi. What they have done in Statuary, Raphael, seems to have acquiered in painting. In him you see the fine fancey in the arraignment of his figures into groops, and those groops into a whole with that propriety and fitness to his subject, Joynd to a trouth of charector and expression, that was never surpass'd before nor sence. Michal Angilo in the knowledge and graundor of the Human figure has surpass'd all artists. his figures have the apearance of a new creation, form'd by the strength of his great amagination. in him you find all that is great in design. Corragio, whose obscurety in life deprived him of those aids in the art which Michal Angilo and Raphael had,[1] and which prevented his acquiering those Exalances, which so charec-toris'd them. But there are other beuties in the art he greatly surpass'd even those in and all others that came after him. Which was in the relieaf of his figures by the management of the clear obscure.* The prodigious management in foreshort-ning of figures seen in the air, The greacefull smiles and turnes of heads, The magickcal uniteing of his Tints, The incensable blending of lights into Shades, and the beautyfull affect over the whole arrising from thoss pices of management, is what charmes the eye of every beholder. Titian gave the Human figure that trouth of colour which surpass'd all other painters. His portraits have a particuler air of grandour and a solidity of colouring in them that makes all other portraits appear trifling. I recommend to your attention when in Italy the workes of the above artists, as every perfection in the art of painting is to be found in one or another of their works. I likewise recommend your going directly to Italy by sea as that will carry you through

*chiaroscuro.

in one voyage if you land in England first you will have to traval the Continant twice. . . .

The Honor your workes have allways done you in Our Exhibitions is the very reason you should perservear in the Tour to Italy. . . . Sir Joshua Reynold and other artists of distinguished merrit have the Highest esteem for you and your works.

I Wish you all Happyness and success, and am with great Friendship Your Obedt. Humble Sert.

BENJN. WEST.

LONDON, Jany. 6th, 1773.

N O T E S

1. The antique statues. [*West's note.*]

COPLEY TO HENRY PELHAM

PARIS, Sepr. 7, 1774

Sepr. 3d. Vissited the Luxemberg. this Gallery is intirely Painted by Rubens, but I think the Pictures very unequel in merrit. you have seen the prints; they give you the design, so I shall not enlarge on that; only observe, that it is of a great carractor. you must take notice how he combines his objects, with what an easey flowing out line he Draws his figures, smooth and easey as the flow of Homer's Verse. all this you have before you, but you have not the colouring. it is very brilliant, rich and tender. when you vew Poussins Sippeo you must have observed one general tint runing over the whole Picture, as if the Painter when his work was done had immersed it in a brown Varnish. but when you see one of Rubens's you cannot say his Picture is of any one Colour, so happily has he divided his Colours over his Picture, that it is neither read, blue, yellow, or Green, but one agreable whole, pertakeing of many tints so well proportioned to each other that none predominates. . . . Rubens is very carefull not to let any part of his Pictures look sad or heavy, nor does he make them gaudy, but brilliant Clear and harmonious. . . . he seems to me to have mixt his tints first very clean and Rich in colour, than to have lay'd on his lights as they were mixed on his pallet, than the next pure tint in like manner

and all the little musseling in the light parts of the body is only express'd by tints somthing reader, avoiding the gray tints. he only darkens with read those soft mussels and lines that fall in the mass of Light. even the extremitys next the back ground ar[e] carried off as much as possable by those clear Readish tints. I mean on the light side of his figures, for when he carrys his flesh into the shade, his first tint, after he leaves the pure carnation or the second tint above menshoned, he lays on one that pertakes of the blew, than follows his warm shade. but observe, the Demi or blew tint must be so far rendered harmonious by pertakeing of the Read and yellow that it makes an agreable whole. . . . The tone of his flesh, take an whole figure together, of one of his Weomen, and it is full and rich . . .

I think it would be worth your while to paint a Picture from one of his prints to try the effect from this Acct. of his Colours. I would further add that when the musling is so deep that read would Appear too flaming and make the flesh look fleed, he puts between the read in the bottum of the hollows and the Second tint above menshoned the blewish tint. this keeps the mass of flesh soft and harmonious in its Whole body. . . .

Sepr. 7. I have just returned from takeing a second Vew of the Luxembourg where I and my friend spent the afternoon, and I find my above observations all confirmed with respect to Rubens's colouring. only that somtimes, he has thrown some little dashes of blewish tint (to take off a rawness that might otherwise arrise). I mean in the Light masses of his flesh. he has been however very sparing of all but the pure Carnation. Mr. Carter thinks this Account I have given you is so just that it is equel to your seeing the Pictures, and that you cannot mistake his Colouring. . . . you cannot imagine the pleasure that this Tour affoards me, but I miss the Language extreemly. I find was my stay here any length of time, I mean 2 or 3 Months, I should possess a great Deal of it. but Adieu, Dear Harry, and believe me yours,

J. S. COPLEY.

COPLEY TO HENRY PELHAM
[Excerpt from Letter Dated "Rome, 14. of March, 1775"]

. . . Could anything be more fortunate than the time of my leaveing Boston? poor America! I hope the best but I fear the

worst. yet certain I am She will finially Imerge from he[r] present Callamity and become a Mighty Empire. and it is a pleasing reflection that I shall stand amongst the first of the Artists that shall have led that Country to the Knowledge and cultivation of the fine Arts, happy in the pleasing reflection that they will one Day shine with a luster not inferior to what they have done in Greece or Rome in my Native Country.

I shall now proceed to give you some reflections on the Works of the Great Masters. I shall begin with Raphael as I think him the greatest of The Modern Painters. take his excellences altogether and they will out weigh those of any other master. yet I must joyn in the general oppinion that he has more faults than Dominicino. Raphael has studied the life very carefully. his Transfiguration, after he had got the composition of it on the Canvis, he has painted with the same attention that I painted Mr. Mifflins portrait and his Ladys.[1] [Fig. 4] in that determined manner he has painted all the heads, hands, feet, Draperys, and background, with a plain simple body of Colours and great precision in his out line, and all parts of it from nature. I think his chief excellencys are, his composition, the manner in which he tells you a peace of History, and the gracefullness of his figures and force of expression. he leaves nothing unexpressed that is necessary to the Subject. . . . every part of the Story is expressed, and that in as simple a manner as possable. after this full and expressive manner of relating the Story what remains to be done is to give Carracter to the figures that compose the Picture. this consists chiefly in making that variety which we find in the life; and making the heads to think agreable to the subject that is before them and ingages their attention and agreable to their attitudes. this part is Ideal, tho the Variety is not. I will not contend with those that say a man may paint from his Ideas only, for I will admit it; I will admit that all men do; only I will observe that the memory of all men is not equilly retentive. one man shall see an object, and twelve months after shall have as perfect a knowledge of it as another that has seen the same object only a few Days; but yet the man who would see an object with an intention to paint it in a few Days still paints as much from Idea as the one who retains a remembrance of it a year. for all our Ideas of things is no more than a remembrance of what we have seen. so that when the Artist has a model in his Appartment and Views it, than turns to his picture and marks whatever he wishes to express on his Picture, what is it but remembrance of what he

4. John Singleton Copley, *Mr. and Mrs. Thomas Mifflin* (1773). Oil on canvas, $61\frac{1}{2}'' \times 48''$. (The Historical Society of Pennsylvania)

has seen? at the same time I will allow the man whose memory is such as to retain what he has seen a year or two before as perfectly as I can one or two Seconds, is on a footing with me when he paints not having the life before him. But this I beleive no Man can do. hence we see all Ideal performances of but little merrit, and those who have made the great figure in the Arts are those that have shewn more jeloussy of the goodness of their memory and refreshed it by having the life by them, by which they secured to themselves that truth of Imitation (and veriety which in Nature is Infinite) that their Works appear a kind of Second nature that delights the Spectator. ... But I must leave this Digression and Raphael: and proceed to Titiano, whose excellencys are very great at the same time of a different kind from those of Raphael.

I immagine by reflecting on the Ideas I had imbibed from the Discription of writers before I had seen any of Titianos Works, that you may be utterly unacquainted with his manner of Painting. taking it for granted that my Ideas and yours being

grounded on the same information must be nearly the same, those who have wrote on the subject seem always to suppose their Readers to have the Works of the Great Masters before them; hence they are very defective and convey little or no Idea, at least no just Idea, of their Works. my business has been to convey to you such an account of the Works of Art as will give you the best you can have till you see them with your own eyes. . . .

Before I saw the Works of Titiano, I [s]uposed them Painted in a Body of Oyl Colours with great precision, smooth, Glossy and Delicate, somthing like Enamil wrought up with care and great attention to the smallest parts, with a rich brilliantcy that would astonish at first sight. but I found them otherwise.

. . . He seems to me to have had his Cloath first Passed over (with Whiting, White Lead, or Plaster of Paris, mixed with sise) with a Brush, and no other preparation or Priming; perhaps not even pumissed: only the Cloath pretty even thread[ed] and fine. this done he painted his Picture with a broad light and very little shadow, so that I think they somtimes Want foarce. his lights are Scarcely predominant and where ever you see shade, it is only a little below the general tint. so that you see it flesh throughout the light and shade is what you see in thee Street, nothing black or heavy in the shade, nothing White or stairing in the lights, the flesh of a full tint rather rather brown or Read than Pale or Cold. at the same time his Pictures are generally rather Grave, Dark, and Warm than faint or Chalkey. with respect to light and shade you see the Prints of his Venus and Danea. they have little shade. the Danea has the most. over her face it is very warm and transparent, and all flesh, his tints very Clear and Perlly but never muddy or Gray. . . . I am inclined to think Plain oyl Colours will not produce the effect of Titianos Colouring. there is somthing too Dauby in it. as soon as I can spare a few Days I shall try an experiment or two. I will tell you what I propose; first to prepare my Cloath as above, than Dead Colour my Picture. the Ground will imbibe the Oyl. When it is Dry Pass over it with some Gum Mastick Dissolved in Turpentine, which I shall let Dry, than finish my Picture with Glasing boath in the lights and shades. The Gum is to prevent the Dead Colour imbibeing the Oyle, so it will appear through the last Glasings with great Brilliancy. another method I shall try is to lay in the Dead Colours with Turpintine and than apply the Gum before the

35

finishing: which should be by Glasings only. but when I have made the experiment I shall let you know its success. Titiano is no ways minute, but sacrifices all the small parts to the General effect. his hands and feet are hardly made out till you see them at a Distance. . . .

NOTES

1. Samuel and Rebecca Mifflin.

2. EARLY NINETEENTH-CENTURY VIEWPOINTS: ALLSTON, GREENOUGH, AND EMERSON

Whatever contrary realities might rear themselves from time to time in the American social, economic, and political ambience, the natural disposition of the young nation in the early nineteenth century was romantic and idealistic. The political revolutions of the previous century had promoted a social and intellectual climate idealistic in temper and imbued with a sense of unlimited possibilities for the improvement of society and human nature. An old order had been overturned and adventuruous prospects lay ahead.

One of the distinctive turns in American art that accompanied a new romantic outlook was the expansion of its repertoire. Portraiture, while not the absolutely exclusive focus of colonial painting, was clearly its dominant one. There had been little patronage in America for any other genre. Abroad, however, American-born painters like West and Copley were able to extend their artistry into the then prestigious territory of history painting, as West did in his recreation of an event in North American history, *The Death of General Wolfe* (1770), and Copley in his *Watson and the Shark* (1778), depicting an unfortunate episode in the life of a London acquaintance of the artist. Here Copley applied the dramatic machinery of history painting to a subject of individual as opposed to national significance. The theatrical staging and emotional tone of each of these works mark them as romantic well in advance of the heyday of the movement. Since

these works soon became well known, they can also be credited with providing some impetus to a growing romantic spirit in western art that would reach its climax during the first half of the nineteenth century.

This spirit defies tidy definition, as Arthur O. Lovejoy pointed out many years ago, suggesting that the term "romanticism" would be better employed in the plural. But, however various the forms of *romanticisms,* certain aspects tend to surface as fairly common properties among them: the importance given to imagination and originality—implying a kind of creative insatiability—and the ascendancy of emotional expression and individuality.

A paradox of romanticism was that, while seeming to yearn for the new and vivid experience (exemplified in its fascination with exotic peoples and places), it frequently reached back nostalgically to revive or reconstitute the past, a past idealized by its distance. Related to this nostalgia for some age past was the romantic image of unspoiled nature as the embodiment of a grand and pure harmony, incorporating the pantheistic idea of God and all nature as one, and the natural setting thus a sacred precinct—in its virgin state an echo of Eden.

In this section and the one that follows, various romanticisms affecting American art will be apparent.

The first American artist who can be called a romantic in the fullest sense was Washington Allston. His career as a painter began in earnest when, in 1801, he sailed for England and two years of study with Benjamin West. Before returning to America in 1808, he was several months in Paris, prior to a residence in Italy from 1804 to 1808. Between 1811 and 1818 he was once again in England, visiting Paris briefly in 1817, before returning to America and settling for his remaining years in Boston and Cambridgeport. These years abroad, necessary still for an American artist desirous of thorough professional training, left an indelible imprint on the artist that would invest his work with reminiscences of European traditions from the Venetian Renaissance to the Baroque era and would also lay the foundations for his romantic idealism. As Edgar P. Richardson has pointed out, American art had in Allston, for the first time, an artist who would explore a full range of painting: monumental works and narrative painting touching on the inner life, ideas, memories, dreams; portraiture and landscape. And he brought to American painting that dark, brooding mood that had its literary counterparts in Hawthorne, Melville, and Poe, and would later find expression in the poetic paintings of Albert Pinkham Ryder.

Allston's idealistic philosophy was formed in part out of his friendship with the English poet, Samuel Taylor Coleridge, whom he had met in Rome during his first sojourn abroad. It was thoroughly ro-

mantic in its emphasis on imagination and individuality, on that ⟵
peculiar "something from ourselves"—a "self-projecting, realizing
power"—that bridges the gap between art and life, and on nature as
the "sensuous ground of art."

The selection from Allston's *Lectures on Art* reveals the artist's
thoughtful cast of mind and remains one of our most eloquent state-
ments of an early nineteenth-century romantic point of view.

The esteem in which Allston was held by young American artists
is evident in the warmth of sculptor Horatio Greenough's letter to
him written from Paris in 1831, portions of which are reprinted in
this section. There is a refreshing eagerness in Greenough's commu-
nication to Allston of his responses to the art he was viewing in Paris
and in his report of the progress of his own work. His remarks on
architecture draw attention to the revivals of both classical and
Gothic idioms that dominated architectural styles in the early nine-
teenth century. He voices ambitions for an American architecture
"on a footing with that of other nations," and touches on the theme
of functionalism which he will later expand in the selection from *The
Travels, Observations, and Experience of a Yankee Stonecutter*.
Greenough's letters relating to his heroic statue of George Washing-
ton delineate the artist's intention to present a *concept* of Washing-
ton as a historical presence, not a mere likeness.

Taken as a unit, these selections relating to Allston and Greenough
—representing two generations of American artists—evoke a fair
portion of the aesthetic ground of American art of the period.

The philosophical ground of American romanticism, which would
culminate in a national landscape tradition, was pantheistic and tran-
scendental. Emerson's *Nature*, incorporating ideas that had been
gathering for years in his journals and lectures, is its author's initial
statement of the principles of his New England transcendentalism.
A twentieth-century writer has called it "a little manual of panthe-
ism." Two years before its publication, Emerson had returned from
Europe. There he had met Carlyle, Coleridge, and Wordsworth.
Traces of their ideas, together with varieties of Platonism, the mysti-
cism of Swedenborg, and more, have been noted as ingredients in
the transcendental ideology of this little book. Of more immediate
significance for American art is the fact that this document of Emer-
son's transcendentalism was fashioned in conjunction with a direct
and radiant experience of the natural world—the sensuous proving-
ground of his philosophy—wherein his vision of a sacred wholeness
of the universe found its microcosmic channel of awareness in the
individual human soul made one with nature. It may be more a
collateral creation than a seminal document for American landscape
painting, but its eloquent—and elusive—message amplifies the po-
etic and pantheistic tone to be found in much of that art.

FROM *Lectures on Art and Poems*

Washington Allston

PRELIMINARY NOTE.

... What true artist was ever satisfied with any idea of beauty of which he is conscious? From this approximated form, however, he doubtless derives a high degree of pleasure, nay, one of the purest of which his nature is capable; yet still is the pleasure modified, if we may so express it, by an undefined yearning for what he feels can never be realized. And wherefore this craving, but for the archetype of that which called it forth?—When we say not satisfied, we do not mean discontented, but simply not in full fruition. And it is better that it should be so, since one of the happiest elements of our nature is that which continually impels it towards the indefinite and unattainable. . . .

ART.

In treating on Art . . . in its highest sense, and more especially in relation to Painting and Sculpture . . . the first question that occurs is, In what consists its peculiar character? or rather, What are the characteristics that distinguish it from Nature, which it professes to imitate?

To this we reply, that Art is characterized,—

From *Lectures on Art and Poems*

First, by Originality.

Secondly, by what we shall call Human or Poetic Truth; which is the verifying principle by which we recognize the first.

Thirdly, by Invention; the product of the Imagination, as grounded on the first, and verified by the second. And,

Fourthly, by Unity, the synthesis of all.

. . . If it be true . . . that no two minds were ever found to be identical, there must then in every individual mind be *something* which is not in any other. And, if this unknown something is also found to give its peculiar hue, so to speak, to every impression from outward objects, it seems but a natural inference, that, whatever it be, it *must* possess a pervading force over the entire mind,—at least, in relation to what is external. But, though this may truly be affirmed of man generally, from its evidence in any one person, we shall be far from the fact, should we therefore affirm, that, otherwise than potentially, the power of outwardly manifesting it is also universal. We know that it is not,—and our daily experience proves that the power of reproducing or giving out the individualized impressions is widely different in different men. With some it is so feeble as apparently never to act. . . . When it acts in the higher degrees, so as to make another see or feel *as* the Individual saw or felt,—this, in relation to Art, is what we mean, in its strictest sense, by Originality. He, therefore, who possesses the power of presenting to another the *precise* images or emotions as they existed in himself, presents that which can be found nowhere else, and was first found by and within himself; and, however light or trifling, where these are true as to his own mind, their author is so far an originator. . . .

That an absolute identity between any natural object and its represented image is a thing impossible, will hardly be questioned by any one who thinks, and will give the subject a moment's reflection; and the difficulty lies in the nature of things, the one being the work of the Creator, and the other of the creature. We shall therefore assume as a fact, the eternal and insuperable difference between Art and Nature. That our pleasure from Art is nevertheless similar, not to say equal, to that which we derive from Nature, is also a fact established by experience; to account for which we are necessarily led to the admission of another fact, namely, that there exists in Art a *peculiar something* which we receive as equivalent to the

41

admitted difference. Now, whether we call this equivalent, individualized truth, or human or poetic truth, it matters not; we know by its *effects*, that some such principle does exist, and that it acts upon us, and in a way corresponding to the operation of that which we call Truth and Life in the natural world. . . .

But it must not be inferred that originality consists in any contradiction to Nature; for, were this allowed and carried out, it would bring us to the conclusion, that, the greater the contradiction, the higher the Art. We insist only on the modification of the natural by the personal; for Nature is, and ever must be, at least the sensuous ground of all Art: and where the outward and inward are so united that we cannot separate them, there shall we find the perfection of Art. So complete a union has, perhaps, never been accomplished, and *may* be impossible; it is certain, however, that no approach to excellence can ever be made, if the *idea* of such a union be not constantly looked to by the artist as his ultimate aim. Nor can the idea be admitted without supposing a *third* as the product of the two,—which we call Art; between which and Nature, in its strictest sense, there must ever be a difference; indeed, a *difference with resemblance* is that which constitutes its essential condition.

. . . In what consists the poetry of the natural world, if not in the sentiment and reacting life it receives from the human fancy and affections? . . . And the answer is returned in the form of a question,—May it not be something *from ourselves,* which is reflected back by the object,—something with which, as it were, we imbue the object, making it correspond to a *reality* within us? . . . that self-projecting, realizing power. . . .

. . . Among the innumerable emotions of a pleasurable kind derived from the actual, there is not one, perhaps, which is strictly confined to the objects before us, and which we do not, either directly or indirectly, refer to something beyond and not present. Now have we at all times a distinct consciousness of the things referred to? Are they not rather more often vague, and only indicated in some *undefined* feeling? Nay, is its source more intelligible where the feeling is more definite, when taking the form of a sense of harmony, as from something that diffuses, yet deepens, unbroken in its progress through endless variations, the melody as it were of the plea-

5. Washington Allston, *Moonlight Landscape* (1819). Oil on canvas, 24″ × 35″. (Courtesy Museum of Fine Arts, Boston. Gift of Dr. W.S. Bigelow)

surable object? Who has never felt, under certain circumstances, an expansion of the heart, an elevation of mind, nay, a striving of the whole being to pass its limited bounds, for which he could find no adequate solution in the objects around him,—the apparent cause? Or who can account for every mood that thralls him,—at times like one entranced in a dream by airs from Paradise,—at other times steeped in darkness, when the spirit of discord seems to marshall his every thought, one against another?

Whether it be that the Living Principle, which permeates all things throughout the physical world, cannot be touched in a single point without conducting to its centre, its source, and confluence, thus giving by a part, though obscurely and indefinitely, a sense of the whole,—we know not. But this we may venture to assert, and on no improbable ground,—that a ray of light is not more continuously linked in its luminous particles than our moral being with the whole moral universe. If this be

43

so, may it not give us, in a faint shadowing at least, some intimation of the many real, though unknown relations, which everywhere surround and bear upon us? In the deeper emotions, we have, sometimes, what seems to us a fearful proof of it. . . .

. . . Why is it that our own works do not always respond with equal veracity? Simply because we do not always *see* them,—that is, as they are,—but, looking as it were *through them,* see only their originals in the mind; the mind here acting, instead of being acted upon. And thus it is, that an Artist may suppose his conception realized, while that which gave life to it in his mind is outwardly wanting. But let time erase, as we know it often does, the mental image, and its embodied representative will then appear to its author as it is,—true or false. . . .

Nor does it in any wise affect the essential nature of the Principle in question, or that of the other Characteristics, that the effect which follows is not always of a pleasurable kind; it may even be disagreeable. What we contend for is simply its *reality;* the character of the perception, like that of every other truth, depending on the individual character of the percipient. . . . Temperament, ignorance, cultivation, vulgarity, and refinement have all, in a greater or less degree, an influence in our impressions; so that any reality may be to us either an offence or a pleasure, yet still a reality. In Art, as in Nature, the True is imperative, and must be *felt,* even where a timid, a proud, or a selfish motive refuses to acknowledge it.

These last remarks very naturally lead us to another subject, and one of no minor importance; we mean, the education of an Artist; on this, however, we shall at present add but a few words. We use the word *education* in its widest sense, as involving not only the growth and expansion of the intellect, but a corresponding developement of the moral being; for the wisdom of the intellect is of little worth, if it be not in harmony with the higher spiritual truth. Nor will a moderate, incidental cultivation suffice to him who would become a great Artist. He must sound no less than the full depths of his being ere he is fitted for his calling; a calling in its very condition lofty, demanding an agent by whom, from the actual, living world, is to be wrought an imagined consistent world of Art,—not fantastic, or objectless, but having a purpose, and that purpose, in all its figments, a distinct relation to man's nature, and all that pertains to it, from the humblest emotion to the highest aspira-

tion; the circle that bounds it being that only which bounds his spirit,—even the confines of that higher world, where ideal glimpses of angelic forms are sometimes permitted to his sublimated vision. Art may, in truth, be called the *human world;* for it is so far the work of man, that his beneficent Creator has especially endowed him with the powers to construct it; and, if so, surely not for his mere amusement, but as a part (small though it be) of that mighty plan which the Infinite Wisdom has ordained for the evolution of the human spirit; whereby is intended, not alone the enlargement of his sphere of pleasure, but of his higher capacities of adoration;—as if, in the gift, he had said unto man, Thou shalt know me by the powers I have given thee. The calling of an Artist, then, is one of no common responsibility; and it well becomes him to consider at the threshold, whether he shall assume it for high and noble purposes, or for the low and licentious.

FORM.

. . . The notion of one or more standard Forms, which shall in all cases serve as exemplars, is essentially false, and of impracticable application for any true purpose of Art. . . . The only efficient Rule must be found in the Artist's mind,—in those intuitive Powers, which are above, and beyond, both the senses and the understanding; which, nevertheless, are so far from precluding knowledge, as, on the contrary, to require, as their effective condition, the widest intimacy with the things external,—without which their very existence must remain unknown to the Artist himself. . . .

. . . His own consciousness informs him, that, besides an animal nature, there is also a moral intelligence, and that they together form the man. . . . We find him accordingly in the daily habit of mentally distinguishing this person from that, as a moral being, and of assigning to each a separate character; and this not voluntarily, but simply because he cannot avoid it. . . . Man does not live by science; he feels, acts, and judges right in a thousand things without the consciousness of any rule by which he so feels, acts, or judges. And, happily for him, he has a surer guide than human science in that unknown Power within him,—without which he had been without knowledge. . . .

Though the medium through which the soul acts be . . . elusive to the senses,—in so far as to be irreducible to any distinct form,—it is not therefore the less real, as every one may verify by his own experience. . . . Who can look into the human eye, and doubt of an influence not of the body? The form and color leave but a momentary impression, or, if we remember them, it is only as we remember the glass through which we have read the dark problems of the sky. But in this mysterious organ we see not even the signs of its mystery. We see, in truth, nothing; for what is there has neither form, nor symbol, nor any thing reducible to a sensuous distinctness; and yet who can look into it, and not be conscious of a real though invisible presence? In the eye of a brute, we see only a part of the animal; it gives us little beyond the palpable outward; at most, it is but the focal point of its fierce, or gentle, affectionate, or timorous character,—the character of the species. But in man, neither gentleness nor fierceness can be more than as relative conditions,—the outward moods of his unseen spirit; while the spirit itself, that daily and hourly sends forth its good and evil, to take shape from the body, still sits in darkness. Yet have we that which can surely reach it; even our own spirit. By this it is that we can enter into another's soul, sound its very depths, and bring up his dark thoughts, nay, place them before him till he starts at himself; and more,—it is by this we *know* that even the tangible, audible, visible world is not more real than a spiritual intercourse. And yet without the physical organ who can hold it? . . . We cannot even conceive of a soul without a correlative form,—though it be in the abstract; and *vice versa.*

. . . No poetic being, supposed of our species, ever lived to the imagination without some indication of the moral; it is the breath of its life: and this is also true in the converse; if there be but a hint of it, it will instantly clothe itself in a human shape; for the mind cannot separate them. . . .

. . . We may, indeed, successively think first of the form, and then of the moral character, as we may think of any one part of either analytically; but we cannot think of the *human being* except as a *whole.* It follows, therefore, as a consequence, that no imitation of man can be true which is not addressed to us in this double condition. And here it may be observed, that in Art there is this additional requirement, that there be no discrepancy between the form and the character intended,—or

46

rather, that the form *must* express the character, or it expresses nothing. . . .

Man has been called a microcosm, or little world. And such, however mean and contemptible to others, is man to himself; nay, such he must ever be, whether he wills it or not. He may hate, he may despise, yet he cannot but cling to that without which he is not; he is the centre and the circle, be it of pleasure or of pain; nor can he be other. Touch him with misery, and he becomes paramount to the whole world,—to a thousand worlds; for the beauty and the glory of the universe are as nothing to him who is all darkness. Then it is that he will *feel*, should he have before doubted, that he is not a mere part, a fraction, of his kind, but indeed a world; and though little in one sense, yet a world of awful magnitude in its capacity of suffering. In one word, Man is a whole, *an Individual*. . . .

We have now to consider how far the Correspondence between the outward form and the inward being, which is assumed by the Artist, is supported by fact.

. . . It cannot be denied that with the mass of men the outward intimation of character is certainly very faint, with many obscure, and with some ambiguous, while with others it has often seemed to express the very reverse of the truth. Perhaps a stronger instance of the latter could hardly occur than . . . where it was shown that the first and natural impression from a beautiful form was not only displaced, but completely reversed, by the revolting discovery of a moral discrepancy. But while we admit, on the threshold, that the Correspondence in question cannot be sustained as universally obvious . . . our argument . . . is yet supported by other evidences, which lead us to regard all such discrepancies rather as exceptions, and as so many deviations from the original law of our nature, nay, which lead us also rationally to infer at least a future, potential correspondence in every individual. . . . Should we assume, then, the Correspondence as a primeval law, who shall gainsay it? It is not, however, so asserted. We may nevertheless hold it as a matter of *faith;* and simply as such it is here submitted. But faith of any kind must have some ground to rest on, either real or supposed, either that of authority or of inference. Our ground of faith, then, in the present instance, is in the universal desire amongst men to *realize* the Correspondence. Nothing is more common than, on hearing or reading of any remarkable character, to find this instinc-

tive craving, if we may so term it, instantly awakened, and actively employed in picturing to the imagination some corresponding form. . . . Nor is its action dependent on our caprice or will. Ask any person of ordinary cultivation, not to say refinement, how it is with him, when his imagination has not been forestalled by some definite fact; whether he has never found himself *involuntarily* associating the good with the beautiful, the energetic with the strong, the dignified with the ample, or the majestic with the lofty; the refined with the delicate, the modest with the comely; the base with the ugly, the brutal with the misshapen, the fierce with the coarse and muscular, and so on; there being scarcely a shade of character to which the imagination does not affix some corresponding form.

In a still more striking form may we find the evidence of the law supposed, if we turn to the young, and especially to those of a poetic temperament,—to the sanguine, the open, and confiding, the creatures of impulse. . . . What is more common than implicit faith in their youthful daydreams,—a faith that lives, though dream after dream vanish into common air when the sorcerer Fact touches their eyes? And whence this pertinacious faith that *will* not die, but from a spring of life, that neither custom nor the dry understanding can destroy? . . . There are some hearts that never suffer the mind to grow old. And such we may suppose that of the dreamer. If he is one, too, who is accustomed to look into himself,—not as a reasoner,— but with an abiding faith in his nature,—we shall, perhaps, hear . . . —Experience, it is true, has often brought me disappointment; yet I cannot distrust those dreams, as you call them, bitterly as I have felt their passing off; for I feel the truth of the source whence they come. They could not have been so responded to by my living nature, were they but phantoms; they could not have taken such forms of truth, but from a possible ground.

By the word *poetic* here, we do not mean the visionary or fanciful,—for there may be much fancy where there is no poetic feeling,—but that sensibility to *harmony* which marks the temperament of the Artist, and which is often most active in his earlier years. And we refer to such natures, not only as being more peculiarly alive to all existing affinities, but as never satisfied with those merely which fall within their experience; ever striving, on the contrary, as if impelled by instinct,

to supply the deficiency wherever it is felt. From such minds proceed what are called romantic imaginings, but what we would call—without intending a paradox—the romance of Truth. . . .

. . . It is not from nothing that man can produce even the *semblance* of any thing. The materials of the Artist are the work of Him who created the Artist himself; but over these, which his senses and mind are given him to observe and collect, he has a *delegated power,* for the purpose of combining and modifying, as unlimited as mysterious. It is by the agency of this intuitive and assimilating Power . . . that he is able to separate the essential from the accidental, to proceed also from a part to the whole; thus educing, as it were, an Ideal nature from the germs of the Actual. . . .

And now the question will naturally occur, Is all that has been done by the learned in Art, to establish certain canons of Proportion, utterly useless? By no means. If rightly applied, and properly considered,—as it seems to us they must have been by the great artists of Antiquity,—as *expedient fictions,* they undoubtedly deserve at least a careful examination. And, inasmuch as they are the result of a comparison of the finest actual forms through successive ages, and as they indicate the general limits which Nature has been observed to assign to her noblest works, they are so far to be valued. . . . Still is every class and race composed of *Individuals,* who must needs, as such, differ from each other; and though the difference be slight, yet is it "the little more, or the little less," which often separates the great from the mean, the wise from the foolish, in human character;—nay, the widest chasms are sometimes made by a few lines: so that, in every individual case, the limits in question are rather to be departed from, than strictly adhered to.

The canon of the Schools is easily mastered by every student who has only memory; yet of the hundreds who apply it, how few do so to any purpose! Some ten or twenty, perhaps, call up life from the quarry, and flesh and blood from the canvas; the rest conjure in vain with their canon; they call up nothing but the dead measures. Whence the difference? The answer is obvious,—In the different minds they each carry to their labors. . . .

It would appear, then, that in the Mind alone is to be found the true or ultimate Rule,—if, indeed, that can be called a rule which changes its measure with every change of character. It

49

is therefore all-important that every aid be sought which may in any way contribute to the due developement of the mental powers; and no one will doubt the efficiency here of a good general education. As to the course of study, that must be left in a great measure to be determined by the student; it will be best indicated by his own natural wants. We may observe, however, that no species of knowledge can ever be *oppressive* to real genius, whose peculiar privilege is that of subordinating all things to the paramount desire. But it is not likely that a mind so endowed will be long diverted by any studies that do not either strengthen its powers by exercise, or have a direct bearing on some particular need. . . .

It cannot be supposed that an Artist, so disciplined, will overlook the works of his predecessors,—especially those exquisite remains of Antiquity which time has spared to us. But to his own discretion must be left the separating of the factitious from the true,—a task of some moment; for it cannot be denied that a mere antiquarian respect for whatever is ancient has preserved, with the good, much that is worthless. . . . It is a common thing to hear such and such statues, or pictures, recommended as *models:* If the advice is followed,—as it too often is *literally,*—the consequence must be an offensive mannerism; for, if repeating himself makes an artist a mannerist, he is still more likely to become one if he repeat another. There is but one model that will not lead him astray,—which is Nature: we do not mean what is merely obvious to the senses, but whatever is so acknowledged by the mind. So far, then, as the ancient statues are found to represent her,—and the student's own feeling must be the judge of that,—they are undoubtedly both true and important objects of study, as presenting not only a wider, but a higher view of Nature, than might else be commanded, were they buried with their authors; since, with the finest forms of the fairest portion of the earth, we have also in them the realized Ideas of some of the greatest minds.

In like manner may we extend our sphere of knowledge by the study of all those productions of later ages which have stood this test. There is no school from which something may not be learned. . . .

1850

FROM *The Travels, Observations,*
and Experience of a
Yankee Stonecutter

Horatio Greenough

We are still imbued, deeply imbued, with the stern dis-
regard of everything not materially indispensable,
which was generated by ages of colonial, and border,
and semi-savage life. We have imported writings on art in
abundance, and there is scarcely a scholar in the land who
cannot wield the terms of dilettantism as glibly as e'er a Euro-
pean professor; but unfortunately for us, the appreciation of an
æsthetical theory without substantial art, is as difficult as to
follow a geometric demonstration without a diagram. It is ster-
ile and impotent, as is all faith without works.

If the arts of design could have simply remained in a nega-
tive state, like seeds buried in autumn, to await the action of
a more genial season, we should be justified in postponing,
even now, their cultivation. But like the *B[o]urgeois gentil-
homme,* who talked prose from his boyhood, without being
aware of it, we have been compelled, both to design and to
adorn, and our efforts, from their nature, must remain monu-

ments of chaotic disorder in all that relates to Æsthetics. In a word, we have negative quantities to deal with, before we can rise to zero. I do not mean to say that the beautiful has not been sought and found amongst us. I wish, and I hope to show, that we have done more, in a right direction, than has been appreciated, much in a wrong direction that must be examined and gotten rid of. . . .

I wish not to be misunderstood for a moment as recommending a Smithsonian school, with a hierarchy of dignitaries in art. I have elsewhere stated my conviction that such a system is hostile to artistic progress. I desire to see working Normal schools of structure and ornament, organized simply but effectively, and constantly occupied in designing for the manufacturers, and for all mechanics who need æsthetical guidance in their operations—schools where emulation shall be kindled by well considered stimuli, and where all that is vitally important in building or ornament shall be thoroughly taught and constantly practised. I know not how far the limit of congressional action may admit the founding of such schools by the central government. Should it be impossible to interest Congress in the matter, I am not without hope that some, at least, of the State legislatures may effect it; and, failing this resource, I hope that associated individuals will combine for this object. . . .

It surely cannot be asking too much that the seat of Government, where the national structures rise, and are yearly increasing in number and importance, should present a specimen of what the country can afford in material and workmanship, in design and ornament. If this were resolved on, a stimulus would be given to exertion, while the constant experience here acquired would soon perfect a school of architectural design. . . .

In all remarks upon important public edifices, there is a twofold subject under contemplation. First: The organic structure of the works. Second: Their monumental character. To plant a building firmly on the ground—to give it the light that may, the air that must be needed—to apportion the spaces for convenience—decide their size—and model their shapes for their functions—these acts organize a building. No college of architects is a quorum to judge this part of the task. The occupants alone can say if they have been well served—time alone can stamp any building as solid. The monumental character of a building has reference to its site—to its adaptation in size and

From *The Travels, Observations, and Experience of a Yankee Stonecutter*

form to that site. It has reference also to the external expression of the inward functions of the building—to the adaptation of its features and their gradation to its dignity and importance, and it relates, moreover, to that just distinction which taste always requires between external breadth and interior detail.

To ascertain what the organic requirements of a building like the Capitol are, is, in itself, a most laborious task. To meet them requires all the science we possess. . . . I have been assured by one of the chief officers of a department, that one-half of the employés of his section of the administration, were required only by the blundering and ignorant arrangement of the edifice. To say that such oversights are inevitable, is an unjust accusation of the art. When those who are called to the task of lodging one of the departments of the Government, shall make organization the basis of their design, instead of a predetermined front, which often deserves to have the inverted commas of quotation affixed to it, we shall hear no such complaints as I have above related.

The men who have reduced locomotion to its simplest elements, in the trotting wagon and the yacht America, are nearer to Athens at this moment than they who would bend the Greek temple to every use. I contend for Greek principles, not Greek things. If a flat sail goes nearest the wind, a bellying sail, though picturesque, must be given up. The slender harness, and tall gaunt wheels, are not only effective, they are beautiful for they respect the beauty of a horse, and do not uselessly task him. The English span is a good one, but they lug along more pretension than beauty; they are stopped in their way to claim respect for wealth and station; they are stopped for this, and, therefore, easily passed by those who care not to seem, but are. To prefer housings to horseflesh, and trappings to men, is alike worthy of a SAVAGE.

From the Correspondence
of Horatio Greenough

TO WASHINGTON ALLSTON

PARIS—Oct'r 1831.

TO WASHINGTON ALSTON ESQRE—
MY DEAR SIR—

The intention I have had for several months of making this journey and the preparation for it must be my excuse for not having written you in the interim—Since my arrival here I have had leisure in abundance, still I was unwilling to write untill I had given a glance at the treasures of Art for which Paris is noted. . . . I passed the Alps at Mont Cenis; don't think that I'm going to inflict a description—One may as well be silent about them unless one could employ their own language of waterfall and avalanche and thunder—I will only say that as I walked among the higher hills with each of the four seasons in sight, under a quick succession of shadow and sun light it seemed as if God had spoken his last word to this world and all was hurrying back to Chaos[1]—The ocean's self never produced on my imagination any thing like the effect of those first born of creation. . . .

I have found a great deal to delight me at the Louvre. Paolo was surely one of the grandest fellows that ever breathed—It's useless to tell me that the figures are heterogeneous etc etc, in short to criticise the magician of Venice by rules drawn from

54

From the Correspondence of Horatio Greenough

Raphael—He that has eyes to see and can feel, will love Paolo too well to dissect him in that cool manner. He held his broad mirror up and a world is there with gleams of exquisite feeling and truth that would seem out of the reach of art—things Sir not dreamt of in the philosophy of the Roman School—He reminds me of Shakespeare. . . . As a frenchman addressing himself to frenchmen I think we must allow David great cleverness at least. The french-greek physiog of his ideal figures is nauseous—I felt however that the cold, grey ground-glass atmosphere in his pictures prevented my allowing them their full merit—One feels the want of a great coat and a cigar in looking at them—I didn't know Poussin until now—He felt the Italians to the core as well as the greek. . . . Art seems at a pretty low ebb here just now. The number of clever men employed in twiddle-twaddle, caricature, indecent pictures etc is quite surprising. . . . I have on the whole been so well pleased with Paris that I propose residing here a few months at some future period, before returning to America—

Since I have been here I have remodelled Mr Cooper's bust[2] —I have also modelled a bust of a young N Yorker who is here[3] —one of the Princess Belgoioso of Milan[4] a very pretty and a very clever woman—and have commenced one of Gen'l Lafayette. Mr. Morse[5] who sits here by my side (having just finished his cigar) thinks it the strongest likeness I've made— I hope to send you a lithographic print of it before long[6]—

In the many conversations we had on Art when I was last in America though you expressed much pleasure at the efforts that were making in Architecture among us, yet I remember you fully agreed with me that broader principles of art and a more intelligent imitation were necessary to the formation of a pure and masculine style of building—This remembrance of your sympathy induces me to communicate to you a few thoughts of this art, as I have had opportunity to observe it, my impressions with regard to its present state among us and what it strikes me may be done to improve it—I will give you briefly my opinion of what I have seen and in suggesting any thing I beg to have it understood that I do it with my hat in my hand, —with a deep sense of the merit of those who have modelled our later buildings and a wish that it may be reciprocated by a frank expression of the views taken of my art of its capabilities among us and the hopes of its advancement.[7]

Architecture seems to me to have been enthralled ever

since a claim to *universal* and *indiscriminate* admiration has
been established for the Greek school—I shall join you of
course in excepting the Gothic which by throwing out the
greek canons and recurring to nature to express a new senti-
ment got a new style, at once grand and pathetic as a whole
and harmoniously rich in detail—The Gothic embodied the
poetry of religion and triumphed over matter to deify spirit—
The Greek adored matter and instead of sending towers high
into the blue as twere to seek a heaven or to shew it when
found it kept every member of its temples where the eye
might taste their beauty and so proportioned and posed that
it should be not only safe but strong—The Gothic by a mysteri-
ous combination of lines seems to lift the spirit from earth and
shew her her home—The Greek woos the eye and lulls us into
content below while its horizontal lines seem to measure the
steps the mind may take beyond which all is dark. The uses for
which the Greek temple were made were one—the form was
unity itself—its parts harmonized with the whole—

The attempts in Italy to graft the christian sentiment on the
greek stock—to expand the Pantheon to hold the Hebrew
God, to recombine the greek elements into a new form for a
new worship seem to me to have produced but a bastard result
—No one is readier than myself to admit how much there is
for the heart as well as for the imagination and the eye in the
Italian church—I love their vast hushed interiour, their mild
air and their mellow light—Their historic and poetic shadow-
ings of art which seem as the incense rises and the chant peals,
to take life and join in the worship. . . . Our church is but an
oratory a lecture room—We do not make it too large to be
filled by one human voice—it possesses but two important
features—the pulpit whence issues the word of God to man—
The organ loft whence earth answers to heaven—Here is great
simplicity of worship yet do I think these elements capable of
very grand combinations—

In America we have since we began to look for art in build-
ings, made several attempts more or less successful, to place
our Architecture on a footing with that of other nations—We
have built combinations, Italian in intention at least if not in
feeling—but they seem not to have satisfied any one—We have
made pointed windows and clustered columns, but the small
proportion of our means devoted to this end, have not allowed
us either the vastness or the rich detail of the gothic—so that

our happiest efforts in this way are as far from their models as is a horseshed from the temple of Venus—In our despair we have recurred to ancient Greece the mother of art—We have warmed at the praises bestowed on her buildings and have resolved to take to ourselves by a *coup de main* both the style and the praise. . . . The parthenon in Philadelphia,[8] shoved in between the common buildings of a street—shorn of its lateral colonnades and pierced every where for light reminds us of a noble captive stripped alike of arms and ornaments and set at work with the other drudges of his conqueror. If his grand air be not quite gone, if some vestige of his former comeliness or some badge of office be still visible about him they only serve to render his present degradation more apparent—

In a letter which I wrote to the committee of the Bunker Hill monument, I endeavoured to shew that by taking a member —a dependent part and making of it a monument, an inconsequent and unmeaning whole would result—for if that member be fitted for its situation all those features which connect it with the surrounding parts become absurd when it stands alone—T'is a limb without a body, a sentence without a verb, a tune broken off in the middle—As a column was in Greece organized to pose upon the earth and to support an entablature; so was the whole fabric constructed with an eye to its exposure and the worship for which it was intended—if well adapted to that exposure and that worship how shall it be fitted for a climate and a service so different?

Let us turn now to Nature the only true school of art—Has she ever been the slave of any one idea of beauty or of grandeur? Her sublimity is manifest alike in the sailing eagle, the bounding lion and the rolling whale—Her beauty asks no sacrifice of the existence or even of the comfort of its wearer— There's scarse a member which may not be found enlarged or annihilated by turns in the animal creation, as the wants of the creature demand. She always organizes the frame for its exposure and its work yet always leaves it beautiful—We propose then that she be imitated in this important respect more compleatly than has been done, we would recommend the use of the combinations we have inherited from preceding schools whenever they will serve our turn and harmonize with the plan of our work—Nor do we mean merely that the object for which a building is constructed shall be nowise sacrificed to an abstract idea of form—we would that the shell of each fabric

be as it were, moulded on the wants and conveniences desired —Such has been the case with naval architecture—and he who has seen a ship at sea will confess that in that work man has approached nearest his maker—Our fleets alone can shew that the world is not retrograde—

In a bank for instance where the business transacted requires light we propose to get it not by stealth as if we were ashamed of it, but as openly as tis given by the creator to our own brain and that without fear of consequences—Where the business done within is so much connected with what is abroad as in a Bank we propose to render ingress and egress as convenient as possible to numbers, and so on with every want that those employed in such buildings may have experienc'd—And we shall receive all condemnation of such art as we would the complaint that the greyhound is too light for beauty, the horse too heavy. . . . In our political institutions we have dared to be new—Can we not shew that art too has a reason as well as government? and that no model of past times when science was less and superstition reigned has a prescriptive right to cramp our convenience or to repress our invention?

That no one individual can accomplish the task we have thus planned is clear at a glance—It requires all the knowledge among us—all the light which can be thrown on the requisites of a building by those who are to occupy it, all the science of our engineers and mathematicians to find the most direct rout to their attainment, all the feeling and the imitation of our architects and painters to give a harmonious connection to the parts thus assembled—that these different bodies of men are equal to it is shewn by what they have already achieved in their various departments, for as we are [we] have no reason to decline a comparison with the present nations of Europe as far as *taste* in Architecture is concerned—

As for what painting and Sculpture are to do among us it seems to me that they will depend entirely on our love for our institutions—if we continue to stand tip-toe along the Atlantic shore endeavouring to catch the last word from Europe nothing great will surely be done—But if we will turn our eyes inward a little, calculate results and embody principles then art becomes important and we shall have it for we seldom long feel the want of any thing in America.

I see by some of the papers that some well intentioned persons have been shocked by the nudity of my cherub-boys[9]—I

From the Correspondence of Horatio Greenough

had thought the country beyond that—There is a nudity which is not impure—there is an impurity which pierces the most cumbrous costume—Let my group be compared with hundreds of prints which are to be seen in the English french and american annuals and which are put into the hands of our sisters and wives and I leave it to any conscientious man to say whether I have gone to the full length of the letter with which modern delicacy has measured the range of art—With love to Master Edmund and Richard and respectful compliments to Mrs Alston[10] I remain Dear Sir Yours truly—

HORATIO GREENOUGH—

NOTES

This letter must have been written after October 13; Greenough had his first sitting from Lafayette, which he mentions in this letter, on that date (*Letters*, p. 87).

Manuscript: Dana Papers, MHS.

1. Some of the same images as those in this description of the Alps occur in Greenough's letter to his brother Henry, 9 September 1831 (*Letters*, p. 84).

2. It was put in marble in 1832–33. It is now in the Boston Public Library.

3. Albert Brisbane (1809–90), social philosopher and Fourierite. Greenough's bust of him has apparently been destroyed.

4. Princess Christina Belgiojoso-Trivulzio (1808–71) was a disciple of Mazzini and an ardent supporter of the Italian Revolutionary movement (see H. Ramsen Whitehouse, *A Revolutionary Princess: Christina Belgiojoso Trivulzio* [London, 1906]). Greenough's bust of her was probably not put in marble, since about this time her fortune was confiscated by the Austrian government. The bust has apparently been destroyed.

5. Morse arrived in Paris from Germany shortly after Greenough, and the two took rooms at 25 rue de Surène.

6. No such print seems to have been made. The bust was put in marble probably in 1833 and 1834. It is now in the Pennsylvania Academy of Fine Arts, Philadelphia; two other busts from the same model are in the Museum of Fine Arts and the Senate Chamber of the State House, Boston. An engraving of the work was made in 1834.

7. Essentially the same ideas and some of the same phrases contained in the rest of this letter occur in Greenough's essay "American Architecture," in the *United States Magazine and Democratic Review* 13 (1843):206–10.

8. The Second Bank of the United States in Philadelphia, erected between 1818 and 1824, was designed by William Strickland to resemble the Parthenon. Presumably Greenough saw it in 1828.

9. During the third week of the Boston exhibition of *The Chanting Cherubs*, the figures were outfitted with dimity aprons. Correspondents in the

59

6. Horatio Greenough, *George Washington* (1840). Marble, 136″ × 102″ × 82½″. (Courtesy of National Collection of Fine Arts, Smithsonian Institution; transfer from U.S. Capitol)

Boston Courier for 9 and 11 May, the *New York Evening Post* for 17 and 24 May, and *Niles' Weekly Register* for 18 June 1831 protested vigorously, and the aprons were subsequently removed.

10. Martha Remington Dana (1784–1862), Allston's second wife, married him 1 June 1830. She was a sister of Edmund T. and R. H. Dana, and first cousin of Allston's first wife. (Edgar P. Richardson, *Washington Allston* [Chicago, 1948], pp. 97, 134.)

TO EDWARD LIVINGSTON

FLORENCE. Jan'y 28. 1834.

SIR

Agreeably to instructions received from the Department of State, I transmit you a drawing from the small sketch in clay of the Statue of Washington [Fig. 6] on which I am employed.[1] I trust it will be needless to explain at large that this drawing

is not intended to shew what the statue will be in its several parts, but only to convey a general idea of the position, action and sentiment of the figure, its dress and the nature of its accessories.

I have not represented any one action of the man, but have given him a movement which seems to me characteristic of his whole life. I wish while I impress the beholder with the idea of Washington, to remind him that Washington was an agent. I have chosen the seated posture as giving a repose not incompatible with expression. To have represented any one action would have been difficult from the nature of our art, its limits and the unity of person prescribed by the subject. For historic sculpture, bas reliefs and medals have great advantages over single figures, nor indeed can these be forced into that walk, without a sacrifice of their proper value and beauty.

In the dress I have endeavoured to make the figure decent, dignified and simple. If on the one hand it be not the dress of Washington's time or nation, neither is it peculiarly the dress of any age or people. It has not been without much reflection that I have set aside the dress of Washington's time. I am aware of the value of truth in the representation of the person of a great man—I feel that as an honour to his memory it ought to perpetuate all that was really his in his appearance; but it seems to me that the fashion of his dress cannot be considered as such and where that fashion would interfere with the main object of the work, by calling the attention to trifles, I think it should give way to considerations of what is natural and permanent. In looking at the portraits of some of the kings of France, we forget the man in wonder at the size and structure of the wig. And when we remark the volume and weight of the robes, the inconvenient and uncouth forms given to every portion of the attire, it is not our taste only that is shocked, our sense also suffers.[2] Such in kind if not in degree must be the sensations of posterity in looking at a literal representation of the dress of Washington's time. To yield to scruples about misrepresentation and to follow out the principle, would be to confine ourselves to the size of life instead of a colossal dimension—to place the statue on a low platform instead of elevating it on a pedestal, nor would the work be compleat until it were coloured to the life. Wax figures dressed in real clothes but satisfy these cravings after reality and how far they fully represent a person dead or absent, may be left to the warmest

advocate for matter of fact to decide. We have lately seen that the popular feeling in France required a literal representation of Napoleon in the statue placed upon the column of the Place Vendome[3]—The case however was different. Napoleon affected a practical simplicity of costume. The dress became then a feature of character—The imperial robes had been quite as literal in point of fact. Still I believe that when years shall have passed away and the idea of the man shall have been condensed to the conciseness of a maxim (like that of Alexander or Caesar) in the minds of the many, this costume will stand between the beholder and the object of his interest and become disguise.

A middle course has also been recommended between the literal and the ideal. It is said that the garments of the time may be sculptured, but so masked in the detail as not to be recognized at a certain distance and thus it is affirmed, that we have the advantage of breadth and simplicity at a distance, with all that is so dear to the antiquarian on a close examination. This however plausible seems to me a mistaken view of the matter. No skill of the sculptor can make such a statue at any distance, comparable in effect to one in which the drapery is arranged for the relief and harmony of the composition, while antiquarian curiosity is as much interested in the prominence of a buckle or a button as in its mere outline.

I consider my work therefore as addressing itself to a people who are familiar with the facts of Washington's life, with his character and its consequences, who have learned from books and tradition all that is to be known about him and I would fain sculpture an image that shall realize in form that complex of qualities which is our idea of the man, apart from what was common to him with other gentlemen of his day.

The square columns which support the chair behind, as also the continuation of the same above the cushion, are ornamented severally with garlands of fruit and flowers—military and naval trophies—implements of agriculture—commerce and manufactures. Since this drawing was made I have thought proper to change the footstool for a step—which will occupy the same space in breadth but will extend in length from one to the other side of the chair in front. I think also of changing the position of the left arm for a more extended one. In the head you will not look for a portrait as the drawing is made from a rapid sketch. In the statue itself I propose to give the hair its natural direction, as in the drawing it discords with

the figure and in that form constitutes a portion of the costume of Washington's time.

I have to request that the drawing which accompanies this letter, may not fall into the hands of any engraver or lithographic draftsman, as it might if multiplied, give general false impressions of what the work will be. With a request that I may be favoured with such observations as may occur to the several gentlemen to whom you may shew this sketch

> I remain Sir
> With respect
> Your most ob't Serv't
> HORATIO GREENOUGH

Addressed: Secretary of State/Department of State—/Washington.
Endorsed: Rec'd May 14.

NOTES

Manuscript: RG 59, General Records of the Department of State, Accession 161, Item 135, NA.

1. In his letter to Greenough of 30 March 1833 (copy in RG 59, General Records of the Department of State, Domestic Letters, NA), Livingston had written that it would be "agreeable to the President" for Greenough to furnish the Department of State with drawings of his design for the statue from time to time.

2. Probably Greenough refers chiefly to portraits of Louis XIV. Hyacinthe Rigaud's painting in the Louvre and Bernini's bust at Versailles show him with an elaborate wig and voluminous garments.

3. The first statue of Napoleon I placed on top of the column, designed by Pierre-Nolasque Bergeret and erected between 1806 and 1810, represents the subject in imperial robes, resembling Caesar. It was taken down by the Royalists in 1814 and replaced by a large fleur-de-lis surmounted by a white flag. In 1831 Louis Philippe had a new statue put up, by Charles Émile Marie Seurre, representing Napoleon in a greatcoat and three-cornered hat. In 1863 this statue was replaced by a copy of the original one.

TO SAMUEL F. B. MORSE

FLORENCE, May 24, 1834.

MY DEAR MORSE:

I am not displeased that my statue calls forth remarks;[1] now is the time to hear and profit by them. I trust I shall be found

open to conviction and desirous to learn; but I fear the making
a statue of this kind, requires more attentive and instructed
thought than most of our able men can spare from their occu-
pations. I am pleased that the *artists* find my design significant.
Your hint, or rather Mr. King's hint, about the constitution, is
surely valuable; and if the object of the statue were to *instruct*
people about Washington, it might have been anticipated by
me. To put into his hand a scroll or a book would be easy; but
as books are very like each other on the outside the meaning
would be uncertain; and doubt in a statue is feebleness. We
raise this monument because Washington's face and form are
identified with the salvation of our continent. That sword, to
which objections are made, cleared the ground where our
political fabric was raised. I would remind our posterity that
nothing but that, and that wielded for years with wisdom and
strength, rescued our rights, and property, and lives from the
most powerful as well as most *enlightened* nation of Europe.
I look on the military career of Washington as being, though
not perhaps *his* highest glory—*our* greatest obligation to him.
I can conceive of his having died at the close of that struggle
without any very bad consequences to our institutions. But a
sword in the hand is an access[o]ry which adds little to the
contents in any way; in art it is important. If people would
consider the abstract nature of sculpture—its elements—its
limits—they would cease to look to it for information on points
which are better explained by other arts in other ways. They
would as soon expect to hear Washington's dress described in
a 4th of July oration as to see it sculptured in an *epic* statue.
It is to the *man* and not to the gentleman that [w]e would do
honor. To embody in the work the abstract of a political creed,
or the principles of a political party, might ensure protection
for my work just now. But just now I can do without it.—I am
pleased that you and your friends think my composition, in the
main, significant.[2] Those who imagine that I would dress Wash-
ington in a Roman costume misunderstand me. The time is
past when civilized nations are distinguished by their dress.—
If the United States ever had a national garb, I can conceive
patriotic zeal interested in its preservation. But what distin-
guished the dress of Washington from that of Peter, Leopold,
or Voltaire, or Burke? In many statues the dress of the time is
most useful. In a statue of Howard,[3] or Fulton, or Watt, or any
other simple improver of the arts or institutions of society, I
should think it very proper then to mark the date of his career,

by exhibiting him in that circle of usages where he merely served. But the man who overthrew a tyranny, and founded a Republic, was a hero. When he sits down in marble immortality in the Hall of the Capitol, his dress should have reference to the future rather than the past; there should be about him nothing mean and trifling, or above all, ridiculous; which latter adjective, I hold to apply in its full extent, to the modern dress generally, and to that of Washington's time particularly. Three statues have been made of Washington: one by Houdon, representing the General, made with every advantage, and with an accuracy of detail that will ensure it, in its way, the first place among the representatives of the man: one by Canova representing a Roman in the act of thinking what he shall write: one by Chantry, representing him holding a scroll in one hand and a piece of his cloak in the other. I have heard these statues, in their time, examined and criticized by the country. I find nothing in the interest they excite to tempt me to follow either. I choose to make another experiment. If it fails, the next sculptor who attempts the subject will have another beacon in this difficult navigation: the rocks will not increase: the sooner light-houses are on them the safer. Only don't send us landsmen for pilots. I am, my dear Morse, yours,

H. GREENOUGH.

NOTES

Source: *New York American,* 4 August 1834. A few minor spelling errors have been corrected.

1. The excerpt from Greenough's Letter 69 which appeared in the *New York Journal of Commerce* on 11 March 1834 brought forth a letter, published on 2 April, to the editor of the *New York American.* The author, Senator John Pendleton King of Georgia, objected to the sword and the costume of Greenough's figure, declaring that Washington's hand should be laid "upon the book of the Constitution" and suggesting that a suit of Washington's clothes be sent Greenough for use as a model. Morse had sent a copy of King's letter to Greenough, seconding the suggestion of substituting the Constitution for the sword, though he disagreed in general with King (*New York American,* 4 August 1834).

2. According to William Dunlap, Morse called the sketch Greenough sent him "sublime" (*Diary of William Dunlap,* ed. Dorothy C. Barck [New York, 1931], 3:777).

3. John Howard (1726–90) was an English prison reformer.

TO LADY ROSINA WHEELER BULWER-LYTTON
[Before May 8, 1841]

MY DEAR LADY BULWER

I cannot express to you how much I have been gratified by the indulgent opinion you have expressed of my efforts in Sculpture—Living, as I have done amid a people whose *sympathy* for Art is nearly exhausted, while their connoisseurship is in full vigor, I should have contented myself (I fear) like their own artists with the sleepy and indifferent toil of the *studio*, had not the confidence of my countrymen (who you know are unrivalled in hoping great things)[1] called me to the execution of a monument which awoke every stronger and better feeling in me—

My wife has told me that you wished an explanation of the details of the Statue of Washington and I hasten to give them as briefly as I can, begging you meanwhile to excuse any wrong I may do the Queen's English, because I have dabbled so much in foreign tongues as to lose somewhat of my vernacular—

Being intended to fill a central position in the Capitol of the U.S. I have thought fit to address my Statue of Washington to a distant posterity and to make it rather a poetical abstract of his whole career than the embodying of any one deed or any one leading feature of his life—I have made him *seated* as *first magistrate* and he extends with his left hand the emblem of his military command toward the people as the sovereign—He points heavenward with his right hand. By this double gesture my wish was to convey the idea of an entire abnegation of Self and to make my hero as it were a *conductor* between God and Man—Though the Presidential chair is very like any other chair, I have thought it my duty to make that on which Washington is seated mean something with reference to the country —It is too large to be left dumb—I have represented the superior portion richly ornamented with acanthus and garlands of flowers while the body is solid and massive—by this I meant to hint at high cultivation as the proper *finish* for sound government and to say that man when well planted and well tilled must flower as well as grow—By the figure of Columbus who leans against the back of the chair on the left side I wished to connect our history with that of Europe—By that of the Indian chief on the right to shew what state our country was in when

civilization first raised her standard there—The bas relief on the right side of the chair represents the Rising Sun which was the first crest of our national arms—under this will be written "Magnus ab integro saec[u]lorum nascitur ordo—" In that on the left side I have represented the Genii of North and South America under the forms of the infants Hercules and Iphiclus —the latter shrinking in dread while the former struggles successfully with the obstacles and dangers of an incipient political existence.*

Such is my invention—The Italians have been indulgent in their opinion of the *work*, but I am not the less anxious for its fate in my own country—Here it has been like an *opera* of which they do not understand or feel the words—there it will be the words that will be thoroughly examined for of music they have less knowledge—Let me enjoy this opportunity of assuring you that the approval of such as yourself would console me under any condemnation on either side of the water for I know not whether I could derive more inspiration from the sight of your loveliness or strength and hope from the approval of your taste & judgment. Pray excuse my slovenly writing—my orthography is my own and I punctuate by the grace of God as the Kings say which means in a graceless manner. My wife means to kidnap you for a drive if possible on this day—I am vexed that I cannot join you.

<div style="text-align:center">

I am Dear Lady Bulwer
With sincere respect
yours
HORATIO GREENOUGH

</div>

Friday morn'g[2]

Rosina Wheeler Bulwer-Lytton, Lady Lytton (1802–82), wife of the first Baron Bulwer-Lytton, lived much of her life on the Continent. She was in Florence in the spring of 1841. She drew on this letter for her article "Modern Arts and Artists in Italy," *Court Journal,* 8 May 1841, pp. 1186–87.

Manuscript: Miscellaneous Manuscript Collection, LC.

1. At this point in the manuscript, Lady Lytton drew two asterisks and wrote at the bottom of the page: "Then decidedly my dear Isaac Ironside

*Motto for left hand Bas relief "Incipe parve puer cui non risere parentes."

you also are an American!" Whom Lady Lytton meant by "Isaac Ironside" is not known.

2. On the last page Lady Lytton wrote: "To I. I. Read this letter of Greenough's the great American Sculptor and you will see that you *must* be an American! It was written while he was Still engaged on his Colossal Statue of Washington at Florence which is now at Washington."

FROM *Nature*

Ralph Waldo Emerson

To go into solitude, a man needs to retire as much from his chamber as from society. I am not solitary whilst I read and write, though nobody is with me. But if a man would be alone, let him look at the stars. . . . One might think the atmosphere was made transparent with this design, to give man, in the heavenly bodies, the perpetual presence of the sublime. . . . Nature never wears a mean appearance. Neither does the wisest man extort all her secret, and lose his curiosity by finding out all her perfection. Nature never became a toy to a wise spirit. The flowers, the animals, the mountains, reflected all the wisdom of his best hour, as much as they had delighted the simplicity of his childhood.

When we speak of nature in this manner, we have a distinct but most poetical sense in the mind. . . . It is this which distinguishes the stick of timber of the wood-cutter, from the tree of the poet. The charming landscape which I saw this morning, is indubitably made up of some twenty or thirty farms. Miller owns this field, Locke that, and Manning the woodland beyond. But none of them owns the landscape. There is a property in the horizon which no man has but he whose eye can integrate all the parts, that is, the poet. This is the best part of these men's farms, yet to this their land-deeds give them no title.

To speak truly, few adult persons can see nature. . . . The

lover of nature is he whose inward and outward senses are still truly adjusted to each other; who has retained the spirit of infancy even into the era of manhood. . . . In the woods, is perpetual youth. Within these plantations of God, a decorum and sanctity reign, a perennial festival is dressed. . . . In the woods, we return to reason and faith. . . . Standing on the bare ground,—my head bathed by the blithe air, and uplifted into infinite space,—all mean egotism vanishes. I become a transparent eye-ball. I am nothing. I see all. The currents of the Universal Being circulate through me; I am part or particle of God. The name of the nearest friend sounds then foreign and accidental. To be brothers, to be acquaintances,—master or servant, is then a trifle and a disturbance. I am the lover of uncontained and immortal beauty. In the wilderness, I find something more dear and connate than in streets or villages. In the tranquil landscape, and especially in the distant line of the horizon, man beholds somewhat as beautiful as his own nature. . . .

COMMODITY.

. . . The misery of man appears like childish petulance, when we explore the steady and prodigal provision that has been made for his support and delight on this green ball which floats him through the heavens. . . .

Nature, in its ministry to man, is not only the material, but is also the process and the result. . . . The wind sows the seed; the sun evaporates the sea; the wind blows the vapor to the field; the ice, on the other side of the planet, condenses rain on this; the rain feeds the plant; the plant feeds the animal; and thus the endless circulations of the divine charity nourish man. . . .

BEAUTY.

A nobler want of man is served by nature, namely, the love of Beauty. . . . The sky, the mountain, the tree, the animal, give us a delight *in and for themselves;* a pleasure arising from outline, color, motion, and grouping. This seems partly owing to the eye itself. The eye is the best of artists. By the mutual

action of its structure and of the laws of light, perspective is produced, which integrates every mass of objects, of what character soever, into a well colored and shaded globe, so that where the particular objects are mean and unaffecting, the landscape which they compose, is round and symmetrical. And as the eye is the best composer, so light is the first of painters. There is no object so foul that intense light will not make beautiful. . . .

For better consideration, we may distribute the aspects of Beauty in a threefold manner.

1. First, the simple perception of natural forms is a delight. The influence of the forms and actions in nature, is so needful to man, that, in its lowest functions, it seems to lie on the confines of commodity and beauty. To the body and mind which have been cramped by noxious work or company, nature is medicinal and restores their tone. . . .

But in other hours, Nature satisfies the soul purely by its loveliness, and without any mixture of corporeal benefit. I have seen the spectacle of morning from the hilltop over against my house, from day-break to sun-rise, with emotions which an angel might share. The long slender bars of cloud float like fishes in the sea of crimson light. From the earth, as a shore, I look out into that silent sea. I seem to partake its rapid transformations: the active enchantment reaches my dust, and I dilate and conspire with the morning wind. . . .

2. . . . Beauty is the mark God sets upon virtue. . . . Nature stretcheth out her arms to embrace man, only let his thoughts be of equal greatness . . . of equal scope, and the frame will suit the picture. A virtuous man is in unison with her works, and makes the central figure of the visible sphere. . . . And in common life, whosoever has seen a person of powerful character and happy genius, will have remarked how easily he took all things along with him,—the persons, the opinions, and the day, and nature became ancillary to a man.

3. There is still another aspect under which the beauty of the world may be viewed, namely, as it becomes an object of the intellect. . . . The intellect searches out the absolute order of things as they stand in the mind of God. . . . The intellectual and the active powers seem to succeed each other in man, and the exclusive activity of the one, generates the exclusive activity of the other. . . . They are like the alternate periods of feeding and working in animals; each prepares and certainly

will be followed by the other. Therefore does beauty, which, in relation to actions . . . comes unsought, and comes because it is unsought, remain for the apprehension and pursuit of the intellect; and then again, in its turn, of the active power. . . . The beauty of nature reforms itself in the mind, and not for barren contemplation, but for new creation.

All men are in some degree impressed by the face of the world. Some men even to delight. This love of beauty is Taste. Others have the same love in such excess, that, not content with admiring, they seek to embody it in new forms. The creation of beauty is Art.

The production of a work of art throws a light upon the mystery of humanity. A work of art is an abstract or epitome of the world. It is the result or expression of nature, in miniature. . . . Thus is Art, a nature passed through the alembic of man. Thus in art, does nature work through the will of a man filled with the beauty of her first works. . . . Beauty, in its largest and profoundest sense, is one expression for the universe. God is the all-fair. Truth, and goodness, and beauty, are but different faces of the same All. But beauty in nature is not ultimate. It is the herald of inward and eternal beauty. . . .

LANGUAGE.

A third use which Nature subserves to man is that of Language. Nature is the vehicle of thought. . . .

1. Words are signs of natural facts. . . . Every word which is used to express a moral or intellectual fact, if traced to its root, is found to be borrowed from some material appearance.

2. . . . Every natural fact is a symbol of some spiritual fact. Every appearance in nature corresponds to some state of the mind. . . . Light and darkness are our familiar expression for knowledge and ignorance; and heat for love. Visible distance behind and before us, is respectively our image of memory and hope.

Who looks upon a river in a meditative hour, and is not reminded of the flux of all things? Throw a stone into the stream, and the circles that propagate themselves are the beautiful type of all influence. . . . The moment our discourse rises above the ground line of familiar facts, and is inflamed with passion or exalted by thought, it clothes itself in images.

From *Nature*

A man conversing in earnest, if he watch his intellectual processes, will find that always a material image, more or less luminous, arises in his mind, cotemporaneous with every thought, which furnishes the vestment of the thought. . . . It is the blending of experience with the present action of the mind. It is proper creation. It is the working of the Original Cause through the instruments he has already made. . . . The poet, the orator, bred in the woods, whose senses have been nourished by their fair and appeasing changes, year after year. . . . shall not lose their lesson altogether, in the roar of cities or the broil of politics. Long hereafter . . . these solemn images shall reappear in their morning lustre, as fit symbols and words of the thoughts which the passing events shall awaken. At the call of a noble sentiment, again the woods wave, the pines murmur, the river rolls and shines, and the cattle low upon the mountains, as he saw and heard them in his infancy. And with these forms, the spells of persuasion, the keys of power are put into his hands.

3. We are thus assisted by natural objects in the expression of particular meanings. But how great a language to convey such pepper-corn informations! . . . Have mountains, and waves, and skies, no significance but what we consciously give them, when we employ them as emblems of our thoughts? The world is emblematic. Parts of speech are metaphors because the whole of nature is a metaphor of the human mind. The laws of moral nature answer to those of matter as face to face in a glass. "The visible world and the relation of its parts, is the dial plate of the invisible." . . .

. . . A life in harmony with nature, the love of truth and of virtue, will purge the eyes to understand her text. By degrees we may come to know the primitive sense of the permanent objects of nature, so that the world shall be to us an open book, and every form significant of its hidden life and final cause. . . .

DISCIPLINE.

. . . Every property of matter is a school for the understanding,—its solidity or resistance, its inertia, its extension, its figure, its divisibility. The understanding adds, divides, combines, measures, and finds everlasting nutriment and room for

its activity in this worthy scene. Meantime, Reason transfers all these lessons into its own world of thought, by perceiving the analogy that marries Matter and Mind. . . .

. . . Nature is thoroughly mediate. . . . It offers all its kingdoms to man as the raw material which he may mould into what is useful. Man is never weary of working it up. He forges the subtile and delicate air into wise and melodious words, and gives them wing as angels of persuasion and command. More and more, with every thought, does his kingdom stretch over things, until the world becomes, at last, only a realized will,— the double of the man.

. . . All things are moral; and in their boundless changes have an unceasing reference to spiritual nature. Therefore is nature glorious with form, color, and motion. . . . Therefore is nature always the ally of Religion: lends all her pomp and riches to the religious sentiment. Prophet and priest, David, Isaiah, Jesus, have drawn deeply from this source.

This ethical character so penetrates the bone and marrow of nature, as to seem the end for which it was made. Whatever private purpose is answered by any member or part, this is its public and universal function, and is never omitted. Nothing in nature is exhausted in its first use. . . .

. . . The moral law lies at the centre of nature and radiates to the circumference. It is the pith and marrow of every substance, every relation, and every process. . . .

. . . Every particular in nature, a leaf, a drop, a crystal, a moment of time is related to the whole, and partakes of the perfection of the whole. Each particle is a microcosm, and faithfully renders the likeness of the world. . . .

IDEALISM.

. . . To the senses and the unrenewed understanding, belongs a sort of instinctive belief in the absolute existence of nature. In their view, man and nature are indissolubly joined. . . . The first effort of thought tends to relax this despotism of the senses, which binds us to nature as if we were a part of it, and shows us nature aloof, and, as it were, afloat. Until this higher agency intervened, the animal eye sees, with wonderful accuracy, sharp outlines and colored surfaces. When the eye of Reason opens, to outline and surface are at once added, grace and

expression. . . . If the Reason be stimulated to more earnest vision, outlines and surfaces become transparent, and are no longer seen; causes and spirits are seen through them. The best, the happiest moments of life, are these delicious awakenings of the higher powers, and the reverential withdrawing of nature before its God.

. . . The sensual man conforms thoughts to things; the poet conforms things to his thoughts. The one esteems nature as rooted and fast; the other, as fluid, and impresses his being thereon. . . . The imagination may be defined to be, the use which the Reason makes of the material world. . . .

. . . Seen in the light of thought, the world always is phenomenal; and virtue subordinates it to the mind. Idealism sees the world in God. It beholds the whole circle of persons and things, of actions and events, of country and religion, not as painfully accumulated, atom after atom, act after act, in an aged creeping Past, but as one vast picture, which God paints on the instant eternity, for the contemplation of the soul. . . .

SPIRIT.

. . . The aspect of nature is devout. . . . The mind is a part of the nature of things; the world is a divine dream, from which we may presently awake to the glories and certainties of day. . . .

But when, following the invisible steps of thought, we come to inquire, Whence is matter? and Whereto? many truths arise to us out of the recesses of consciousness. We learn that the highest is present to the soul of man, that the dread universal essence, which is not wisdom, or love, or beauty, or power, but all in one, and each entirely, is that for which all things exist, and that by which they are; that spirit creates; that behind nature, throughout nature, spirit is present; that spirit is one and not compound; that spirit does not act upon us from without, that is, in space and time, but spiritually, or through ourselves. Therefore, that spirit, that is, the Supreme Being, does not build up nature around us, but puts it forth through us, as the life of the tree puts forth new branches and leaves through the pores of the old. As a plant upon the earth, so a man rests upon the bosom of God; he is nourished by unfailing fountains, and draws, at his need, inexhaustible power. Who can set

bounds to the possibilities of man? Once inspire the infinite, by being admitted to behold the absolute natures of justice and truth, and we learn that man has access to the entire mind of the Creator, is himself the creator in the finite. . . .

The world proceeds from the same spirit as the body of man. It is a remoter and inferior incarnation of God, a projection of God in the unconscious. But it differs from the body in one important respect. It is not, like that, now subjected to the human will. Its serene order is inviolable by us. It is therefore, to us, the present expositor of the divine mind. It is a fixed point whereby we may measure our departure. As we degenerate, the contrast between us and our house is more evident. We are as much strangers in nature, as we are aliens from God. We do not understand the notes of birds. . . .

PROSPECTS.

. . . Empirical science is apt to cloud the sight, and, by the very knowledge of functions and processes, to bereave the student of the manly contemplation of the whole. The savant becomes unpoetic. But the best read naturalist who lends an entire and devout attention to truth, will see that there remains much to learn of his relation to the world, and that it is not to be learned by any addition or subtraction or other comparison of known quantities, but is arrived at by untaught sallies of the spirit, by a continual self-recovery, and by entire humility. He will perceive that there are far more excellent qualities in the student than preciseness and infallibility; that a guess is often more fruitful than an indisputable affirmation, and that a dream may let us deeper into the secret of nature than a hundred concerted experiments. . . .

I shall therefore conclude this essay with some traditions of man and nature, which a certain poet sang to me; and which, as they have always been in the world, and perhaps reappear to every bard, may be both history and prophecy.

'The foundations of man are not in matter, but in spirit. But the element of spirit is eternity. To it, therefore, the longest series of events, the oldest chronologies are young and recent. In the cycle of the universal man, from whom the known individuals proceed, centuries are points, and all history is but the epoch of one degradation.

From *Nature*

'We distrust and deny inwardly our sympathy with nature. We own and disown our relation to it, by turns. We are, like Nebuchadnezzar, dethroned, bereft of reason, and eating grass like an ox. But who can set limits to the remedial force of spirit?

'A man is a god in ruins. When men are innocent, life shall be longer, and shall pass into the immortal, as gently as we awake from dreams. Now, the world would be insane and rabid, if these disorganizations should last for hundreds of years. It is kept in check by death and infancy. Infancy is the perpetual Messiah, which comes into the arms of fallen men, and pleads with them to return to paradise.

'Man is the dwarf of himself. . . .'

At present, man applies to nature but half his force. He works on the world with his understanding alone. He lives in it, and masters it by a penny-wisdom; and he that works most in it, is but a half-man, and whilst his arms are strong and his digestion good, his mind is imbruted and he is a selfish savage. His relation to nature, his power over it, is through the understanding. . . . Meantime, in the thick darkness, there are not wanting gleams of a better light,—occasional examples of the action of man upon nature with his entire force,—with reason as well as understanding. . . .

The problem of restoring to the world original and eternal beauty, is solved by the redemption of the soul. The ruin or the blank, that we see when we look at nature, is in our own eye. The axis of vision is not coincident with the axis of things, and so they appear not transparent but opake. The reason why the world lacks unity, and lies broken and in heaps, is, because man is disunited with himself. He cannot be a naturalist, until he satisfies all the demands of the spirit. Love is as much its demand, as perception. Indeed, neither can be perfect without the other. In the uttermost meaning of the words, thought is devout, and devotion is thought. Deep calls unto deep. . . . Is not prayer also a study of truth,—a sally of the soul into the unfound infinite? No man ever prayed heartily, without learning something. But when a faithful thinker, resolute to detach every object from personal relations, and see it in the light of thought, shall, at the same time, kindle science with the fire of the holiest affections, then will God go forth anew into the creation.

. . . The invariable mark of wisdom is to see the miraculous in the common. . . .

RALPH WALDO EMERSON

So shall we come to look at the world with new eyes. . . .
Then shall come to pass what my poet said; 'Nature is not fixed
but fluid. Spirit alters, moulds, makes it. . . . Every spirit builds
itself a house; and beyond its house, a world; and beyond its
world, a heaven. Know then, that the world exists for you.
. . . Build, therefore, your own world. . . .'

<div align="right">1836</div>

3. AMERICAN LANDSCAPE:

THE HUDSON RIVER SCHOOL

AND THE LUMINISTS

If the idea of an "American identity" in the nineteenth century could be given something like an encompassing dimension, it would be fixed as a spatial, rather than temporal, border. The continental experience of a transplanted European culture set the territorial phenomenon as a central reality in American history. During the nineteenth century the process of reaching across, filling up, and exploiting this continental space was the dynamic ingredient in the shaping of a national selfhood and purpose. The material wealth the land gave up to the expanding nation created, in turn, powerful social and economic forces that would eventually acquire a more universal than continental dimension, but still at the generative center lay the land itself. The aggressive frontier pushed into and overran a primordial wilderness, as the painter Thomas Cole put it, "a shoreless ocean un-islanded by the recorded deeds of man." Here there were no deep perspectives of human history with which the new American of European antecedents could identify—only the alien wilderness ways of a people to be subjugated by the Book or the rifle. The westward movement and the national destiny seemed inextricably joined. So it was that the most evocative image of American nationalism could be found in the landscape itself; and landscape painting joined with American poetry in the expression of nationalistic, religious, and moral sentiments linked in varying degrees to the abun-

dance and promise of the land. Thus the American landscape be-
came the subject matter for a new variety of history painting and the
symbol of a national adventure.

In 1836 Ralph Waldo Emerson's *Nature* and Cole's "Essay on
American Scenery" were published, Emerson's anonymously. The
American novelist James Fenimore Cooper was idealizing the
American wilderness (and condemning the inroads of a frontier that
seemed bent on destroying it) in the three of his "Leatherstocking
Tales" published by this time: *The Pioneers* (1823), *The Last of the
Mohicans* (1826), and *The Prairie* (1827). And artists like Cole and
Thomas Doughty, leaders in what was to be called "The Hudson
River School" of landscape painting, had for over a decade been
celebrating American scenery in their paintings.

Cole's essay begins in praise of the beauty, magnificence, and sub-
limity of American scenery, and turns quickly to the spiritual and
moral bounty its richness affords. He offers a vision of the land as a
purifying antidote to "a meagre utilitarianism" that threatens in the
name of "improvement" to crush "the bright and tender flowers of
the imagination . . . beneath its iron tramp." He fears, in the end, that
the beauty of nature will be destroyed, that ignorance and folly will
shut us out of this purifying Eden. Cole's essay is thus not only a plea
for the appreciative recognition of the richly varied aspects of Ameri-
can scenery, but is equally a sermon on the spiritual content of a
communion with this natural world.

Durand's "Letters on Landscape Painting" were published se-
quentially in several issues of *The Crayon,* an American art journal.
Although these epistles, addressed to an imaginary art student, are
instructional in purpose, containing the kind of technical advice the
artist deems essential to the goal of representing the "true" land-
scape, they are underlaid with ideas similar to those of Emerson and
Cole. Readers will find Durand's comments on color and light worthy
of note, in view of developments in painting during the course of the
nineteenth century.

The anecdotal letter to *The Crayon,* written by Albert Bierstadt
during his first trip to the Rocky Mountains, is interesting for its
relatively matter-of-fact descriptions divested of the pantheistic tone
of earlier selections on the landscape, for comparisons with eastern
and European scenery, and for its references to a new form of image-
making—the photograph. Bierstadt's remarks on the Indians echo
somewhat more prosaically the concern for their future expressed in
the 1830s by George Catlin, whose paintings in the Indian territories
of the West conscientiously recorded a vanishing way of life.

The selection chosen from *The Art-Idea,* by James Jackson Jarves,
is a contemporary account of American painting in the middle
decades of the nineteenth century. As a critic, Jarves was influenced

The Hudson River School and the Luminists

by the ideas of John Ruskin, particularly the latter's medievalism (Jarves himself was a collector of Italian "primitives") and his predilection for an emphasis on moral content in art, but, in these comments on the American art of his own time, Jarves displays some independent acuity. Like Greenough, he looks forward to an eventual flowering of American art. Of particular interest to the reader will be his discussion of the relationships between American painting and various European schools, his opinions on academies, and the significant place he gives to American landscape.

The last selection in this section is a twentieth-century essay on a vein of American landscape painting that was prevalent in the middle decades of the previous century. John I. H. Baur's "American Luminism" (which may be paired with his "Early Studies in Light and Air by American Landscape Painters," *Brooklyn Museum Bulletin* LX, Winter, 1948) is a work of fundamental importance to recent scholarship, as many historians of American art, taking their cue from Baur's definition of "luminism," have expanded the concept into a pervasive principle.

FROM *Essay on American Scenery*

Thomas Cole

The essay, which is here offered, is a mere sketch of an almost illimitable subject—American Scenery; and in selecting the theme the writer placed more confidence in its overflowing richness, than in his own capacity for treating it in a manner worthy of its vastness and importance.

It is a subject that to every American ought to be of surpassing interest; for, whether he beholds the Hudson mingling waters with the Atlantic—explores the central wilds of this vast continent, or stands on the margin of the distant Oregon, he is still in the midst of American scenery—it is his own land; its beauty, its magnificence, its sublimity—all are his; and how undeserving of such a birthright, if he can turn towards it an unobserving eye, an unaffected heart!

Before entering into the proposed subject, in which I shall treat more particularly of the scenery of the Northern and Eastern States, I shall be excused for saying a few words on the advantages of cultivating a taste for scenery, and for exclaiming against the apathy with which the beauties of external nature are regarded by the great mass, even of our refined community.

It is generally admitted that the liberal arts tend to soften our manners; but they do more—they carry with them the power to mend our hearts.

Poetry and Painting sublime and purify thought, by grasping

From *Essay on American Scenery*

the past, the present, and the future—they give the mind a foretaste of its immortality, and thus prepare it for performing an exalted part amid the realities of life. And *rural nature* is full of the same quickening spirit—it is, in fact, the exhaustless mine from which the poet and the painter have brought such wondrous treasures—an unfailing fountain of intellectual enjoyment, where all may drink. . . .

. . . From the indifference with which the multitude regard the beauties of nature, it might be inferred that she had been unnecessarily lavish in adorning this world for beings who take no pleasure in its adornment. Who in grovelling pursuits forget their glorious heritage. Why was the earth made so beautiful, or the sun so clad in glory at his rising and setting, when *all* might be unrobed of beauty without affecting the insensate multitude, so they can be "lighted to their purposes?"

It *has not* been in vain—the good, the enlightened of all ages and nations, have found pleasure and consolation in the beauty of the rural earth. Prophets of old retired into the solitudes of nature to wait the inspiration of heaven. It was on Mount Horeb that Elijah witnessed the mighty wind, the earthquake, and the fire; and heard the "still small voice"—that voice is YET heard among the mountains! St. John preached in the desert; —the wilderness is YET a fitting place to speak of God. The solitary Anchorites of Syria and Egypt, though ignorant that the busy world is man's noblest sphere of usefulness, well knew how congenial to religious musings are the pathless solitudes.

He who looks on nature with a "loving eye," cannot move from his dwelling without the salutation of beauty; even in the city the deep blue sky and the drifting clouds appeal to him. And if to escape its turmoil—if only to obtain a free horizon, land and water in the play of light and shadow yields delight —let him be transported to those favored regions, where the features of the earth are more varied, or yet add the sunset, that wreath of glory daily bound around the world, and he, indeed, drinks from pleasure's purest cup. The delight such a man experiences is not merely sensual, or selfish, that passes with the occasion leaving no trace behind; but in gazing on the pure creations of the Almighty, he feels a calm religious tone steal through his mind, and when he has turned to mingle with his fellow men, the chords which have been struck in that sweet communion cease not to vibrate.

In what has been said I have alluded to wild and uncul-

tivated scenery; but the cultivated must not be forgotten, for it is still more important to man in his social capacity—necessarily bringing him in contact with the cultured; it encompasses our homes, and, though devoid of the stern sublimity of the wild, its quieter spirit steals tenderly into our bosoms mingled with a thousand domestic affections and heart-touching associations—human hands have wrought, and human deeds hallowed all around. . . .

In this age, when a meager utilitarianism seems ready to absorb every feeling and sentiment, and what is sometimes called improvement in its march makes us fear that the bright and tender flowers of the imagination shall all be crushed beneath its iron tramp, it would be well to cultivate the oasis that yet remains to us, and thus preserve the germs of a future and a purer system. . . .

There are those who through ignorance or prejudice strive to maintain that American scenery possesses little that is interesting or truly beautiful—that it is rude without picturesqueness, and monotonous without sublimity—that being destitute of those vestiges of antiquity, whose associations so strongly affect the mind, it may not be compared with European scenery. But from whom do these opinions come? From those who have read of European scenery, of Grecian mountains, and Italian skies, and never troubled themselves to look at their own; and from those travelled ones whose eyes were never opened to the beauties of nature until they beheld foreign lands, and when those lands faded from the sight were again closed and forever; disdaining to destroy their transatlantic impressions by the observation of the less fashionable and unfamed American scenery. Let such persons shut themselves up in their narrow shell of prejudice—I hope they are few,—and the community increasing in intelligence, will know better how to appreciate the treasures of their own country.

I am by no means desirous of lessening in your estimation the glorious scenes of the old world—that ground which has been the great theater of human events—those mountains, woods, and streams, made sacred in our minds by heroic deeds and immortal song—over which time and genius have suspended an imperishable halo. No! But I would have it remembered that nature has shed over *this* land beauty and magnificence, and although the character of its scenery may differ from the old world's, yet inferiority must not therefore be

From *Essay on American Scenery*

inferred; for though American scenery is destitute of many of those circumstances that give value to the European, still it has features, and glorious ones, unknown to Europe.

A very few generations have passed away since this vast tract of the American continent, now the United States, rested in the shadow of primæval forests . . . or lay in those wide grassy plains called prairies. . . . And, although an enlightened and increasing people have broken in upon the solitude, and with activity and power wrought changes that seem magical, yet the most distinctive, and perhaps the most impressive, characteristic of American scenery is its wildness.

It is the most distinctive, because in civilized Europe the primitive features of scenery have long since been destroyed or modified—the extensive forests that once overshadowed a great part of it have been felled—rugged mountains have been smoothed, and impetuous rivers turned from their courses to accommodate the tastes and necessities of a dense population —the once tangled wood is now a grassy lawn; the turbulent brook a navigable stream—crags that could not be removed have been crowned with towers, and the rudest valleys tamed by the plough.

And to this cultivated state our western world is fast approaching; but nature is still predominant, and there are those who regret that with the improvements of cultivation the sublimity of the wilderness should pass away: for those scenes of solitude from which the hand of nature has never been lifted, affect the mind with a more deep toned emotion than aught which the hand of man has touched. Amid them the consequent associations are of God the creator—they are his undefiled works, and the mind is cast into the contemplation of eternal things. . . .

In the Forest scenery of the United States we have that which occupies the greatest space, and is not the least remarkable; being primitive, it differs widely from the European. In the American forest we find trees in every stage of vegetable life and decay—the slender sapling rises in the shadow of the lofty tree, and the giant in his prime stands by the hoary patriarch of the wood—on the ground lie prostrate decaying ranks that once waved their verdant heads in the sun and wind. These are circumstances productive of great variety and picturesqueness—green umbrageous masses—lofty and scathed trunks—contorted branches thrust athwart the sky—the moul-

7. Thomas Cole, *The Oxbow (The Connecticut River Near Northampton)* (1836). Oil on canvas, $51\frac{1}{2}$" × 76". (The Metropolitan Museum of Art, Gift of Mrs. Russell Sage, 1908)

dering dead below, shrouded in moss of every hue and texture, from richer combinations than can be found in the trimmed and planted grove. It is true that the thinned and cultivated wood offers less obstruction to the feet, and the trees throw out their branches more horizontally, and are consequently more umbrageous when taken singly; but the true lover of the picturesque is seldom fatigued—and trees that grow widely apart are often heavy in form, and resemble each other too much for picturesqueness. Trees are like men, differing widely in character; in sheltered spots, or under the influence of culture, they show few contrasting points; peculiarities are pruned and trained away, until there is a general resemblance. But in exposed situations, wild and uncultivated, battling with the elements and with one another for the possession of a morsel of soil, or a favoring rock to which they may cling—they exhibit striking peculiarities, and sometimes grand originality.

For variety, the American forest is unrivalled: in some districts are found oaks, elms, birches, beeches, planes, pines, hemlocks, and many other kinds of trees, commingled—clothing the hills with every tint of green, and every variety of light and shade. . . .

There is one season when the American forest surpasses all the world in gorgeousness—that is the autumnal;—then every hill and dale is riant in the luxury of color—every hue is there, from the liveliest green to deepest purple—from the most golden yellow to the intensest crimson. The artist looks despairingly upon the glowing landscape, and in the old world his truest limitations of the American forest, at this season, are called falsely bright, and scenes in Fairy Land.

The sky will next demand our attention. The soul of all scenery, in it are the fountains of light, and shade, and color. Whatever expression the sky takes, the features of the landscape are affected in unison, whether it be the serenity of the summer's blue, or the dark tumult of the storm. It is the sky that makes the earth so lovely at sunrise, and so splendid at sunset. In the one it breathes over the earth the crystal-like ether, in the other liquid gold. The climate of a great part of the United States is subject to great vicissitudes, and we complain; but nature offers a compensation. These very vicissitudes are the abundant sources of beauty—as we have the temperature of every clime, so have we the skies—we have the blue unsearchable depths of the northern sky—we have the

unheaped thunder-clouds of the Torrid Zone, fraught with gorgeousness and sublimity—we have the silver haze of England, and the golden atmosphere of Italy. And if he who has travelled and observed the skies of other climes will spend a few months on the banks of the Hudson, he must be constrained to acknowledge that for variety and magnificence American skies are unsurpassed. Italian skies have been lauded by every tongue, and sung by every poet, and who will deny their wonderful beauty? At sunset the serene arch is filled with alchemy that transmutes mountains, and streams, and temples, into living gold.

But the American summer never passes without many sunsets that might vie with the Italian, and many still more gorgeous—that seem peculiar to this clime.

Look at the heavens when the thunder shower has passed, and the sun stoops behind the western mountains—there the low purple clouds hang in festoons around the steeps—in the higher heaven are crimson bands interwoven with feathers of gold, fit for the wings of angels—and still above is spread that interminable field of ether, whose color is too beautiful to have a name.

It is not in the summer only that American skies are beautiful; for the winter evening often comes robed in purple and gold, and in the westering sun the iced groves glitter as beneath a shower of diamonds—and through the twilight heaven innumerable stars shine with a purer light than summer ever knows.

I will now venture a few remarks on what has been considered a grand defect in American scenery—the want of associations, such as arise amid the scenes of the old world.

We have many a spot as umbrageous as Vallombrosa, and as picturesque as the solitudes of Vaucluse; but Milton and Petrarch have not hallowed them by their footsteps and immortal verse. He who stands on Mont Albano and looks down on ancient Rome, has his mind peopled with the gigantic associations of the storied past; but he who stands on the mounds of the West, the most venerable remains of American antiquity, *may* experience the emotion of the sublime, but it is the sublimity of a shoreless ocean un-islanded by the recorded deeds of man.

Yet American scenes are not destitute of historical and leg-

From *Essay on American Scenery*

endary associations—the great struggle for freedom has sanctified many a spot, and many a mountain, stream, and rock has its legend, worthy of poet's pen or the painter's pencil. But American associations are not so much of the past as of the present and the future. Seated on a pleasant knoll, look down into the bosom of that secluded valley, begirt with wooded hills —through those enamelled meadows and wide waving fields of grain, a silver stream winds lingeringly along—here, seeking the green shade of trees—there, glancing in the sunshine: on its banks are rural dwellings shaded by elms and garlanded by flowers—from yonder dark mass of foliage the village spire beams like a star. You see no ruined tower to tell of outrage— no gorgeous temple to speak of ostentation; but freedom's offspring—peace, security, and happiness, dwell there, the spirits of the scene. On the margin of that gentle river the village girls may ramble unmolested—and the glad school-boy, with hook and line, pass his bright holiday—those neat dwellings, unpretending to magnificence, are the abodes of plenty, virtue, and refinement. And in looking over the yet uncultivated scene, the mind's eye may see far into futurity. Where the wolf roams, the plough shall glisten; on the gray crag shall rise temple and tower—mighty deeds shall be done in the now pathless wilderness; and poets yet unborn shall sanctify the soil.

. . . Yet I cannot but express my sorrow that the beauty of such landscapes are quickly passing away—the ravages of the axe are daily increasing—the most noble scenes are made desolate, and oftentimes with a wantonness and barbarism scarcely credible in a civilized nation. The wayside is becoming shadeless, and another generation will behold spots, now rife with beauty, desecrated by what is called improvement; which, as yet, generally destroys Nature's beauty without substituting that of Art. This is a regret rather than a complaint; such is the road society has to travel; it may lead to refinement in the end, but the traveller who sees the place of rest close at hand, dislikes the road that has so many unnecessary windings.

I will now conclude, in the hope that, though feebly urged, the importance of cultivating a taste for scenery will not be forgotten. Nature has spread for us a rich and delightful banquet. Shall we turn from it? We are still in Eden; the wall that

shuts us out of the garden is our own ignorance and folly.
. . . May we at times turn from the ordinary pursuits of life to
the pure enjoyment of rural nature; which is in the soul like
a fountain of cool waters to the way-worn traveller; and let us

 Learn
 The laws by which the Eternal doth sublime
 And sanctify his works, that we may see
 The hidden glory veiled from vulgar eyes.

 1835–1836

FROM *Letters on*

Landscape Painting

Asher B. Durand

LETTER I.

[January 3, 1855]

... You need not a period of pupilage in an artist's studio to learn to paint; books and the casual intercourse with artists, accessible to every respectable young student, will furnish you with all the essential mechanism of the art. . . . Then, let me earnestly recommend to you one STUDIO which you may freely enter, and receive in liberal measure the most sure and safe instruction ever meted to any pupil . . . —the STUDIO of Nature.

Yes! go first to Nature to learn to paint landscape, and when you shall have learnt to imitate her, you may then study the pictures of great artists with benefit. They will aid you in the acquirement of the knowledge requisite to apply to the best advantage the skill you possess—to select, combine and set off the varied beauty of nature. . . .

... I would urge on any young student in landscape painting, the importance of painting direct from Nature as soon as he shall have acquired the first rudiments of Art. . . . Let him scrupulously accept *whatever* she presents him, until he shall,

91

in a degree, have become intimate with her infinity. . . . but never let him profane her sacredness by a wilful departure from truth. . . . If abused and adulterated by the poisons of conventionalism, the result will be the corruption of . . . the simple truths of Nature, which constitute the true Religion of Art, and the only safeguard against the inroads of heretical conventionalism. If you should ask me to define conventionalism, I should say that it is the substitution of an easily expressed falsehood for a difficult truth. . . .

LETTER II.

[January 17, 1855]
. . . Form is the first subject to engage your attention. Take pencil and paper, not the palette and brushes, and draw with scrupulous fidelity the outline or contour of such objects as you shall select, and, so far as your judgment goes, choose the most beautiful or characteristic of its kind. . . .

I know you will regard this at first thought as an unnecessary restriction, and become impatient to use the brush. . . . Slovenly and imperfect drawing finds but a miserable compensation in the palpable efforts to disguise or atone for it, by the blandishments of color and effect.

Practice drawing with the pencil till you are sure of your hand. . . .

There is yet another motive for referring you to the study of Nature early—its influence on the mind and heart. It is impossible to contemplate with right-minded, reverent feeling, its inexpressible beauty and grandeur . . . without arriving at the conviction . . . that the Great Designer of these glorious pictures has placed them before us as types of the Divine attributes. . . .

Thus regarding the objects of your study, the intellect and feelings become elevated and purified; . . .

. . . If it be true—and it appears to be demonstrated, so far as English scenery is concerned—that Constable was correct when he affirmed that there was yet room for a natural landscape painter, it is more especially true in reference to our own scenery; for although much has been done, and well done, by the gifted Cole and others, much more remains to do. Go not abroad then in search of material for the exercise of your pen-

8. Asher B. Durand, *In the Woods* (1855). Oil on canvas, $60\frac{3}{4}'' \times 48\frac{5}{8}''$. (The Metropolitan Museum of Art, Gift in memory of Jonathan Sturges by his children, 1895)

cil, while the virgin charms of our native land have claims on your deepest affections. . . . the ocean prairies of the West, and many other forms of Nature yet spared from the pollutions of civilization, afford a guarantee for a reputation of originality that you may elsewhere long seek and find not.

I desire not to . . . require that the artist shall sacrifice aught

to patriotism; but . . . why should not the American landscape painter, in accordance with the principle of self-government, boldly originate a high and independent style, based on his native resources? . . .

LETTER III.

[January 31, 1855]

. . . Although there are certain principles which constantly guide the hand of the true artist . . . yet the whole history of Art from the beginning, does not present a single instance where a thorough and scientific knowledge of these principles has of itself been able to produce a truly great artist. . . .

I caution you, therefore, against reliance on any theoretical or technical directions which I or any one else may give in the course of your studies, further than as means which you are to employ subject to your own feeling. . . .

LETTER IV.

[February 14, 1855]

. . . It is better to make shoes, or dig potatoes, or follow any other honest calling to secure a livelihood, than seek the pursuit of Art for the sake of gain. . . . The great law that provides for the sustenance of the soul through the ministry of spiritual things, has fixed an immovable barrier between its own pursuits and those which supply our physical wants. For this reason, we cannot serve God and mammon, however specious our garb of hypocrisy; and I would sooner look for figs on thistles than for the higher attributes of Art from one whose ruling motive in its pursuit is money.

. . . To those whom even a competency has released from the great world-struggle, so far as to allow a little time to rest and reflect in, Landscape Art especially appeals—nor does it appeal in vain. There are some . . . that look to it as an oasis in the desert, and there are more who . . . trace their first enjoyment of existence, in childhood and youth . . . to some pleasant landscape scenery; to such the instinct of nature thus briefly impressed, is seldom or never overcome. . . . To him who

From *Letters on Landscape Painting*

preserves the susceptibility to this instinctive impulse . . . the true landscape becomes a thing of more than outward beauty, or piece of furniture.

It becomes companionable, holding silent converse with the feelings, playful or pensive—and, at times, touching a chord that vibrates to the inmost recesses of the heart, yet with no unhealthy excitement, but soothing and strengthening to his best faculties. . . .

LETTER V.

[March 7, 1855]

. . . When you shall have acquired some proficiency in foreground material, your next step should be the study of the influence of atmosphere—the power which defines and measures space—an intangible agent, visible, yet without that material substance which belongs to imitable objects, in fact, an absolute nothing, yet of mighty influence. It is that which above all other agencies, carries us into the picture, instead of allowing us to be detained in front of it; . . . You will perceive that similar objects to those nearest you, at a few hundred yards distant, have undergone considerable change, and that change becoming more and more apparent with every step beyond. . . . First direct your attention to the *dark* portions of the scene. . . . In the first place you will find these darks have lost something in strength, and not only are they weaker but less distinctly marked with details, and more negative in color, as if by the infusion of a bluish gray, scarcely perceptible at first, but more obvious further on. . . . At every remove, then, the darks become weaker and weaker, and their details or markings within them fainter and fainter.

. . . The lights . . . also undergo material changes, gradually losing their details, becoming softer in texture, and weaker, though not so essentially changed, in color; till at length, when individual form is no longer distinguishable, the mingling light and dark are resolved into one mass of comparatively uniform color, as in the far distant mountain. The sum of all this is simply the natural gradation from darker to lighter, stronger to weaker, on a principle as fixed as the chromatic scale in music. . . .

... Atmosphere is ... a veil or medium interposed between the eye and all visible objects. ... It is *felt* in the foreground, *seen* beyond that, and *palpable* in the distance. It spreads over all objects the color which it receives from the sky in sunlight or cloudlight; and the only rule I can furnish you for the expression of its hue, is, that it partakes more and more the color of the sky. Thus far the expression of atmospheric space, according to the distance of objects from the foreground, is comparatively easy; but when considered under the influence of a variable sky, cloud shadows, and drifting vapor, it becomes more complex. ...

The degrees of clearness and density, scarcely two successive days the same—local conditions of temperature—dryness and moisture—and many other causes, render anything like specific direction impracticable. I can do little more than urge on you the constant study of its magic power, daily and hourly, in all its changes. ...

LETTER VI.

[April 4, 1855]

... As the atmosphere is less pure near the earth, so the sky is less blue at the horizon, thence gradually increasing to the zenith. The blueness of the distant mountain and the intermediate gradation, are subject to this law.

... Let us take into consideration the influence of sunlight. ...

It is first declared by light and shade, but its full expression depends on color. Simple light may be represented without color, but sunshine never. ... Reds and yellows form the basis of all warm color, and blue that of the cold—an equal admixture of the three forms the neutral. This division will serve our present purpose. And we learn from it that the color of sunlight is either red or yellow, or compounded of both, being warm, and that its absence or shade must present a predominance of blue, expressive of its coldness. ...

The best time to observe the ordinary effect of sunshine on the landscape, is to watch the gradual clearing up of a cloudy day, when its presence is first announced by occasional patches of light. ... You will find that around the light the shadow appears cooler, owing to the suddenness of contrast; but, as the

openings overhead widen, the cold light from the clear blue sky is reflected into the shadow, and the entire mass of it becomes colder even to a greater degree than the unpracticed eye readily admits. . . .

. . . You find another agency employed of great value, that is, the force of strong reflections from contiguous objects at times materially affecting the quality of the color of the shadow. Whenever the sun's rays strike an object within the margin of a shadow, according as that object is elevated above the plane of the shadow, it will reflect those rays modified by its own color and peculiar surface, into the ground of the shadow, often giving positive warmth to its coolness, thus becoming the exception above mentioned to the principle I have laid down; so that when such shadow is very circumscribed, it becomes warm throughout, and even hot where the reflecting cause is very warm and glowing in color. . . . In the midst of sunlight and its shadows, look out then for the sly agents of reflection. . . .

In consequence of the prevalence of green in our summer landscape, the presence of sunlight becomes indispensable as the best means to counteract monotony. . . .

. . . The local green of foliage, grass and plants, varies perpetually according to species and locality—tints of every shade, with mosses and lichens, diversify the surface of rocks —mineral and vegetable dyes mottle the bare earth, while water, in its transparency, mobility and mimic reflections, appropriating to itself the diversity of all. . . .

. . . I am persuaded, therefore, that the prejudice against green pictures, or rather the supposed impracticability of all efforts to render them pleasing, arises more from failure to represent their greenness truly, than from any inherent objection. . . .

. . . Nature has so varied her greens with an infinity of different shades . . . that strictly speaking there is no monotony in *her* forests, and the same variety exists in the surface of her green fields—in the hues of the various grasses, and the tinting of numerous flowers.

. . . Let the golden sunshine fall on given portions, and the sea of emerald will at once become redolent with life and beauty. . . .

LETTER VII.

[May 2, 1855]

. . . I have said that light develops color, so the weaker the light the less apparent the color; at the same time the brightest light is most destructive of all color, as seen in its climax on rounded or curvilinear surfaces—on glossy or shining objects becoming white. . . .

. . . In some degree grey is almost always present; at times so delicately seen as scarcely to be perceptible . . . It is the summer breeze that chastens the heat of all warm colors, and tempers the cold ones into an harmonious union with them. . . .

Simple grey is perfectly neutral; it becomes warm or cool as it inclines to either of those departments. . . . It is local when it constitutes the actual color of objects, as in rocks and trunks of trees, and circumstantial when produced by atmosphere and light, as in the shadows of receding objects. It is indeed the principal ingredient in atmospheric tone. . . .

Its great value, and the principal test of its admirable quality, consists, first, in its adaptation, that is, to modify the local color of objects according to distance, without supplanting it; or, in other words, to represent local color under the influence of atmosphere. . . .

. . . There is not a tint of color, nor phase of light and dark, force or delicacy, gradation or contrast, or any charm that the most inventive imagination ever employed . . . that is not to be seen in Nature, more beautiful and more fitting than Art has ever realized or ever can; and there is no acknowledged excellence in any picture extant, which justly commands our admiration, which has not been transcribed, more or less faithfully, from her glorious volume. . . .

LETTER VIII.

[June 6, 1855]

. . . Let us briefly examine the conventional distinctions of Idealism and Realism, together with the action of the imagination in connection with them, and which seems to have given rise to these distinctions.

From *Letters on Landscape Painting*

What then is Idealism? According to the interpretation commonly received, that picture is ideal whose component parts are representative of the utmost perfection of Nature, whether with respect to beauty or other considerations of fitness in the objects represented, according to their respective kinds, and also the most perfect arrangement or composition of these parts so as to form an equally perfect whole. . . . In order to compose the ideal picture, then, the artist must know what constitutes the perfection of every object employed, according to its kind, and its circumstances, so as to be able to gather from individuals the collective idea. . . .

Realism, therefore, if any way distinguishable from Idealism, must consist in the acceptance of ordinary forms and combinations as found. If strictly confined to this, it is, indeed, an inferior grade of Art; but as no one contends that the representation of ordinary or common-place nature is an ultimatum in Art, the term Realism signifies little else than a disciplinary stage of Idealism, according to the interpretation given, and is misapplied when used in opposition to it, for the ideal is, in fact, nothing more than the perfection of the real.

. . . But the ideal of Landscape Art does not end here; it embraces, and with even higher meaning, the application of these perfections to the expression of a particular sentiment in the subject of the picture,—whether it be the representation of the repose and serenity of Nature in quiet and familiar scenes, or of her sterner majesty in the untrodden wilderness, as well as of her passional action in the whirlwind and storm —each has its own distinctive ideality. In this direction we come to the action of the imaginative faculty, which perfects the high Ideal.

In so far as we have arrived at any understanding of the term[s] Idealism and Realism, there does not appear any definite line of distinction between them . . . nor can I discern wherein the imaginative faculty exercises an influence independent of the perfect ideal of representative truth, but only in extending its meaning to the utmost limit, spiritualizing, as it were, the images of inanimate objects, and appealing through them to the inmost susceptibility of the mind and heart. . . . Hence its legitimate action is not seen as creating an imaginary world, as some suppose; but in revealing the deep meaning of the real creation around and within us. . . .

... With the faculty to perceive and select from the infinite beauty and significance of Nature broadcast throughout her wide domain, surely no artist can reasonably complain for lack of unbounded liberty. Let him take the pains to store his memory with the unlimited *material* thus furnished, and the inventive and imaginative faculties will have enough to do in developing every conceivable result, and in ample measure for the supply of the most insatiate desires of Art. . . .

Let us . . . be thankful in the assurance that it is by reverent attention to the realized forms of Nature alone, that Art is enabled by its delegated power to reproduce some measure of the profound and elevated emotions which the contemplation of the visible works of God awaken.

LETTER IX.

[July 11, 1855]

... Art transcribes Nature, not only selecting her most beautiful and expressive forms, but choosing with equal care among the various influences by which they are affected in relation to each other, and it may be also taken as a hint in reference to what are termed licences of Art. . . .

But I believe that none are desirable which oppose any of the great truths of Nature, and that it is rather permission to exaggerate certain points in order to represent their real importance, as by increasing the warmth of light to express its glow, or to give more than natural intensity to a dark, in order to express the force of surrounding light, and, if needs be, to keep subordinate objects from impertinent obtrusiveness, by subduing their natural attractiveness, whether of details, color, or magnitude. To express the apparent height of a mountain, it is found necessary to exaggerate the real elevation in the representation: this is a license not opposed to truth, but essential to its realization. . . . It can never be profitably exercised but for the more complete expression of the sentiment of Nature, material and spiritual, wherein we discern the true mission of Art.

The reverent imagination ceases to exult in its own conscious power to change and recreate, while it contemplates the great miracle of God's creation, "which still goes on in silence" —where all deficiency in picturesqueness is more than sup-

From *Letters on Landscape Painting*

plied by that "freshness of the far-beginning" of things which connects us with the past, and symbolizes our immortality.

I would not limit the creative power of Art, nor undervalue its importance; it may not be possible to define or know its limit. . . .

FROM *The Crayon*

Albert Bierstadt on Rocky Mountain Scenery

ROCKY MOUNTAINS, July 10, 1859.

DEAR CRAYON:

If you can form any idea of the scenery of the Rocky Mountains and of our life in this region, from what I have to write, I shall be very glad; there is indeed enough to write about— a *writing* lover of nature and Art could not wish for a better subject. I am delighted with the scenery. The mountains are very fine; as seen from the plains, they resemble very much the Bernese Alps, one of the finest ranges of mountains in Europe, if not in the world. They are of a granite formation, the same as the Swiss mountains and their jagged summits, covered with snow and mingling with the clouds, present a scene which every lover of landscape would gaze upon with unqualified delight. As you approach them, the lower hills present themselves more or less clothed with a great variety of trees, among which may be found the cotton-wood, lining the river banks, the aspen, and several species of the fir and the pine, some of them being very beautiful. And such a charming grouping of rocks, so fine in color—more so than any I ever saw. Artists would be delighted with them—were it not for the tormenting swarms of mosquitoes. In the valleys, silvery streams abound, with mossy rocks and an abundance of that finny tribe that we all delight so much to catch, the trout. We see many spots in the scenery that remind us of our New Hampshire and Catskill

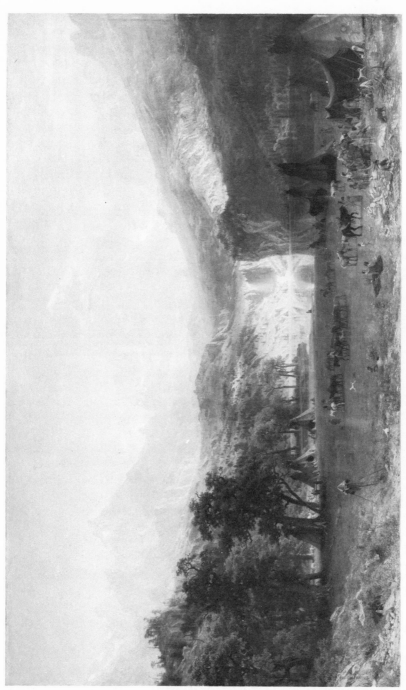

9. Albert Bierstadt, *The Rocky Mountains* (1863). Oil on canvas, $73\frac{1}{4}$" × $120\frac{3}{4}$". (The Metropolitan Museum of Art, Rogers Fund, 1907)

hills, but when we look up and measure the mighty perpendic-
ular cliffs that rise hundreds of feet aloft, all capped with snow,
we then realize that we are among a different class of moun-
tains; and especially when we see the antelope stop to look at
us, and still more the Indian, his pursuer, who often stands
dismayed to see a white man sketching alone in the midst of
his hunting grounds. We often meet Indians, and they have
always been kindly disposed to us and we to them; but it is a
little *risky*, because being very superstitious and naturally dis-
trustful, their friendship may turn to hate at any moment. We
do not venture a great distance from the camp alone, although
tempted to do so by distant objects, which, of course, appear
more charming than those near by; also by the figures of the
Indians so enticing, travelling about with their long poles trail-
ing along on the ground, and their picturesque dress, that
renders them such appropriate adjuncts to the scenery. For a
figure-painter, there is an abundance of fine subjects. The
manners and customs of the Indians are still as they were
hundreds of years ago, and now is the time to paint them, for
they are rapidly passing away, and soon will be known only in
history. I think that the artist ought to tell his portion of their
history as well as the writer; a combination of both will as-
suredly render it more complete.

We have taken many stereoscopic views, but not so many of
mountain scenery as I could wish, owing to various obstacles
attached to the process, but still a goodly number. We have a
great many Indian subjects. We were quite fortunate in get-
ting them, the natives not being very willing to have the brass
tube of the camera pointed at them. Of course they were
astonished when we showed them pictures they did not sit for;
and the best we have taken have been obtained without the
knowledge of the parties, which is, in fact, the best way to take
any portrait. When I am making studies in color, the Indians
seem much pleased to look on and see me work; they have an
idea that I am some strange medicine-man. They behave very
well, never crowding upon me or standing in my way, for
many of them do not like to be painted, and fancy that if they
stand before me their likenesses will be secured.

I have above told you a little of the Wind River chain of
mountains, as it is called. Some seventy miles west from them,
across a rolling prairie covered with wild sage, the soap-
plant(?) and different kinds of shrubs, we come to the Wah-

From *The Crayon*

satch, a range resembling the White Mountains. At a distance, you imagine you see cleared land and the assurances of civilization, but you soon find that nature has done all the clearing. The streams are lined with willows, and across them at short intervals they are intersected by the beaver dams; we have not yet, however, seen any of their constructors. The mountains here are much higher than those at home, snow remaining on portions of them the whole season. The color of the mountains and of the plains, and, indeed, that of the entire country, reminds one of the color of Italy; in fact, we have here the Italy of America in a primitive condition.

We came up here with Col. F. W. Lander, who commands a wagon-road expedition through the mountains. At present, however, our party numbers only three persons; Mr. F———, myself, and a man to take charge of our animals. We have a spring-wagon and six mules, and we go where fancy leads us. I spend most of my time in making journeys in the saddle or on the bare back of an Indian pony. We have plenty of game to eat, such as antelope, mountain grouse, rabbit, sage-hens, wild-ducks, and the like. We have also tea, coffee, dried fruits, beans, a few other luxuries, and a good appetite—we ask for nothing better. I enjoy camp-life exceedingly. This living out of doors, night and day, I find of great benefit. I never felt better in my life. I do not know what some of your Eastern folks would say, who call night air injurious, if they could see us wake up in the morning with the dew on our faces!

We are about to turn our faces homeward again, the season being a short one here, and to avoid the fall deluge on the plains, which renders the roads almost impassable.

Yours,

B.

FROM *The Art-Idea*

James Jackson Jarves

I t is comparatively easy to decide upon a completed career, for the evidence is all gathered in. But in treating the works of living men, the material is partial and incomplete. Our best artists have scarcely formed their styles, still less shown the full measure of their talents. New names come forward so rapidly, exhibiting much that is meritorious, that it is perplexing to do adequate justice to all. . . . The semi-courtly manners of our more polished ancestors have been swept away in the flood of democratic habits of the later generation. Their art partook of the aristocratic colonial element, born of European social ideas. But to the masses it was an exotic. They admired it as they did fine manners and polite learning. America was then as much under bondage to Europe in these respects as she had been before in political matters. Herein lies the cause of the failure of its early art in a national sense. It had no root in the people. . . . No art can long live which does not represent the actual vitality of a nation. . . .

The Düsseldorf gallery, a speculation of an enterprising German, a score or more years ago, had a marked influence on our artists. Its historical, *genre,* and religious pictures were new and striking, while their positive coloring, dramatic force, and intelligible motives were very pleasurable to spectators in general. To our young artists they afforded useful lessons in the rudiments of painting and composition. They were, indeed, of no higher order than furniture paintings, being mechanical

and imitative in feature, seldom rising above illustrative art. The masterpiece, Lessing's immense Martyrdom of Huss, is only a fine specimen of scientific scene-painting. With these pictures there came a popular class of artists, trained in their school. . . .

Leutze[1] is the representative painter of the American branch of this school, and stands the highest in popular esteem. He manifests some originality of thought, much vigor, over-much dramatic force, and has abundance of executive skill, but is spasmodic and unequal. *Tours de force* delight him. He has the vicious coloring of the Düsseldorf school in its fullest extent. The Rotunda painting in the Capitol of the Star of Empire is his most ambitious work. This, the well-known Washington crossing the Delaware, the Storming of the Teocalli at Mexico, and the portrait of General Burnside, are striking examples of his epic style. Bad taste in composition overpowers much that is meritorious in design and execution. Leutze is the Forrest of our painters . . . exaggerated and sensational, cultivating the forcible, common, and striking, at the expense of the higher qualities of art.

The English school has ceased to exercise any influence over ours, unless a crude interpretation of its Pre-Raphaelitism by a few young men may be considered as such. . . .

There is as little affinity between the art of England and that of America as between their politics. Our artists rarely go to London to study. If they do, they speedily become English, or else make haste to leave England for the more congenial atmospheres of France and Italy. Aside from the waning popularity of the Düsseldorf school, these two countries alone exercise any distinctive influence over American art. But the Italian schools are too much of the past, too exclusively an expression of classicalism and mediævalism, to give a positive direction to ours. Their lofty principles, noble elements, and consummate technical skill, must make them always of inestimable value to appreciative minds. But their most seductive influence over modern art springs from the solemn splendor and deep significance of their varied systems of coloring. Even in this respect their power is but lightly felt here. To comprehend the full meaning of color, and assimilate its joyous dignity or sensuous delight, it requires a temperament and training akin to those of the old masters themselves. Few Americans develop in this direction. . . .

. . . But it is the French school that mainly determines the

character of our growing art. In some respects New York is only an outgrowth of Paris. Every year witnesses a marked increase of the influence of the metropolis of France in matters of art, taste, and fashion, on the metropolitan city of America. So powerful, indeed, is its influence in Europe, that the hope of the English school now lies in the example and teaching of its rival. Exhibitions and sales of fine specimens of the French school have already vastly benefited us. Owing to the concentration of our most promising artists at New York, it has grown to be the representative city of America in art, and indeed for the present so overshadows all others that we should be justified in speaking of American painting, in its present stage, as the New York school, in the same light that the school of Paris represents the art of France. This predominance is more likely to increase than decrease, owing to growing professional facilities and the encouragement derived from a lavish patronage. It is particularly fortunate for the American school that it must compete at its own door with the French. The qualities of French art are those most needed here, in a technical point of view, while its motives and character generally are congenial to our tastes and ideas. The Düsseldorf was an accidental importation. That of Paris is drawn naturally to us by the growth of our own. Were the French school what it was under the Bourbons, or the Empire even, conventional, pseudo-classical, sensual, and sentimental, deeply impregnated with the vices of a debauched aristocracy and revolutionary fanaticism, we should have been less inclined towards it than to any other. But it crosses the Atlantic refined, regenerated, and expanded by the force of modern democratic and social ideas. The art of France is no longer one of the church or aristocracy. It is fast rooting itself in the hearts and heads of the people, with nature as its teacher. The primary tendency of what may be called the democratic art-instinct, as distinguished from that founded on the ideas of an aristocracy of blood, is to materialistic expression. This, in turn, gravitates toward the animal, sensational, and common, from a disposition to please the masses. In no democratic community, as yet, have they been elevated in æsthetic refinement and taste to the standard of the aristocratic sentiment. That they may and will be, we devoutly believe. To this end, we cannot watch too closely the training of our youthful school. In art as well as literature the most enduring things and endearing are those which best intimate an

existence above the level of the worldly and vulgar. Next in value is that which eliminates from man's nature the coarse, sensual, and superficial, substituting the beautiful, good, and permanent in their stead. Any art which bases itself upon the purer instincts of humanity at large, such as a healthful enjoyment of nature, domestic love, and the sentiments and passions that dignify the human race, holding fast the great principle of elevating the entire people to the full stature of manhood,—such an art is, in virtue of its birthright, essentially democratic. The progress of French art being in this direction, it is the natural friend and instructor of American art; and, while it remains true to its present renovating principle, we cannot have too much of it. If our art relied solely on its own intuitive popular instincts for its development, its inclination would be too much toward the low and common, or purely external, as we see in those artists who are averse to studying foreign examples. Their proclivities naturally return towards their source, in the vast underlying materialism of the present stage of our civilization. France holds a check over democratic vulgarity which we lack. This exists in the standards of refinement, elegance, and finish, the perfection of styles and details as fine art, which an aristocracy accumulates as evidence of its intrinsic superiority of position and education. We have the reflected influence of this in the works and pupils of the French school. Without this living, refining element, destitute as we are of museums and galleries of classical and mediæval art, our progress would not merely be less rapid, but would be mainly in a direction not the most desirable.

The chief evidence of the growing value of the French school to ours is shown in the development of a taste for something beside landscape. As yet we borrow motives and styles somewhat lavishly, and put them into American types, with a moiety only of French skill and feeling. In time, imitation will weary alike the painter and buyer, and a more laudable ambition possess them. Thanks to French incitement, the dawn of a respectable school of *genre* and home painting is nigh at hand. We say "home," because there is no other word which includes so entirely, to the Anglo-Saxon ear, all those feelings, sentiments, and ideas which have their origin and growth under the family roof and in social training. Its motives are healthful, aims excellent, spirit patriotic; but as yet the flesh is weak to execute. . . .

Having shown the various foreign elements that influence American painting, we now turn to its more indigenous phases. The conventional or academic branch has nothing very distinctively local in tone, original in conception, or distinguished in feature. Like its fellows everywhere, it is eclectic by principle, deriving its instruction from older schools, and assimilating, as well as possible, the scientific learning of art. It has developed clever men, but they have too much the character of artists made to order. An academy, as commonly conducted, is too literally a pedantic *school*. It trains many minds of average abilities into certain styles, with an amiable indifference as to what they paint, so that they please patrons and grow famous. In undergoing this sort of discipline, individualism must be sturdy not to sink into conventionalism, and accredit the grammar of art as of more value than its spirit. Artists educated after this manner never wholly free themselves from the bondage of an imposed style and outside dictation. The picture is the chief aim. It comes to be with them as with a certain class of literary men: elegance of expression takes precedence of originality of idea. Each phrase is composed by rhetorical rule, and marshalled into place by bugle-call. The painting of France flourishes, because it is the free growth of studios and nature. Individual genius has liberty of choice and nutriment. Democracy favors the system of free competition. Aristocracies found academies, and seek to bind art down to rule, or guide it by favoritism and patronage. America is too democratic to yield up hers solely to such guidance. The academic influence is already undermined. In future, it will have little weight either with the intelligent public or young artists; for it has small cohesive force, and no strong outside pressure, as in England, to give it strength of resistance. So far as it affords facilities of elementary instruction, keeps alive the traditions of art, collects, preserves, and disseminates knowledge, and promotes a more intimate union between artists and the public, it is useful. But the inherent tendency of an academy, under present forms of organization, is to exclusivism, dictation, and narrowness. A few are petted; the many pine. In the end, New York will boast one more handsome building in its Academy of Design, controlled by a *dilettante* clique,—of qualified benefit, but having no life-giving control over the young democratic art of the land. . . .

The thoroughly American branch of painting, based upon

From *The Art-Idea*

the facts and tastes of the country and people, is the landscape. It surpasses all others in popular favor, and may be said to have reached the dignity of a distinct school. Almost everybody whose ambition leads him to the brush essays landscape. To such an extent is literalness carried, that the majority of works are quite divested of human association. "No admittance" for the spirit of man is written all over them. Like the Ancient Mariner's "painted ship upon a painted ocean," they both pall and appall the senses. Their barrenness of thought and feeling become inexpressibly wearisome after the first shock of rude or bewildering surprise at overstrained atmospherical effects, monotonous in motive, however dramatically varied in execution. The highest aim of the greater number of the landscapists seemingly is intense gradations of skies and violent contrasts of positive color. The result is destructive of any suggestion of the variety and mystery of nature. We get coarse paintings, pitched on a wrong key of light or color, hastily got up for a market, and sold by scores, often all by one hand, at cheap auction-sales. The more common features of nature are so easily given on canvas as they appear to the undiscerning eye that the public is deluged with a sort of trash-literature of the brush, which ought to be consigned to oblivion so far as it attempts to pass itself off for true art.

Furthermore, we are undergoing a virulent epidemic of sunsets. Despite that one of our transcendental painters says there can be no great work without the three fundamental qualities of "rest, repose, and tranquillity," our bias is rather in the direction of exaggerated action and effects. In accordance with his scale of definition, he might have added three others much in vogue, namely, "bigness, greatness, largeness," culminating in what an artist wittily calls full-length landscapes. To be added to these foibles are slipshod work, repetition, impatient execution, and an undue self-estimate, arising from want of competitive comparison with better-instructed men. Numbers of pictures seem painted for no other purpose than to display the painter's autograph. We have noticed this even in portraits, the artist's name being more conspicuous than the sitter's features. Thus much for the weaknesses of our landscape art. Now for its strong points.

Church[2] leads or misleads the way, according as the taste prefers the idealistic or realistic plane of art. Certain is it that Church has achieved a great popular success in his tropical

scenery, icebergs, and Niagaras,—success which brings him orders for pictures as fast as he can produce them, at prices heretofore fabulous in his branch of art. Dr. Johnson says he who writes otherwise than for money is a fool. For "writes" read "paints," and we get a primary motive-power for any school of artists. Not that true artistic ambition does not here exist, but a sudden success, measured by pecuniary gain and sensational effect, is not the most wholesome stimulant for youthful art.

No one, hereafter, may be expected to excel Church in the brilliant qualities of his style. Who can rival his wonderful memory of details, vivid perception of color, quick, sparkling, though monotonous touch, and iridescent effects, dexterous manipulation, magical jugglery of tint and composition, picturesque arrangements of material facts, and general cleverness? With him color is an Arabian Nights' Entertainment, a pyrotechnic display, brilliantly enchanting on first view, but leaving no permanent satisfaction to the mind, as all things fail to do which delight more in astonishing than instructing. Church's pictures have no reserved power of suggestion, but expend their force in *coup-de-main* effects. Hence it is that spectators are so loud in their exclamations of delight. Felicitous and novel in composition, lively in details, experimentive, reflecting in his pictures many of the qualities of the American mind, notwithstanding a certain falseness of character, Church will long continue the favorite with a large class.

But a competitor for the popular favor in the same direction has appeared in Bierstadt.[3] He has selected the Rocky Mountains and Western prairies for his artistic field. Both these men are as laborious as they are ambitious, regarding neither personal exposure nor expense in their distant fields of study. Each composes his pictures from actual sketches, with the desire to render the general truths and spirit of the localities of their landscapes, though often departing from the literal features of the view. With singular inconsistency of mind they idealize in composition and materialize in execution, so that, though the details of the scenery are substantially correct, the scene as a whole often is false. Neither manifests any grand conception of nature, nor appreciation of its poetry. Graphic beauty of composition and illustration are their chief points. Bierstadt uses the landscape also to illustrate Indian life. His figures are picturesquely grouped, prosaically true to actual life, giving

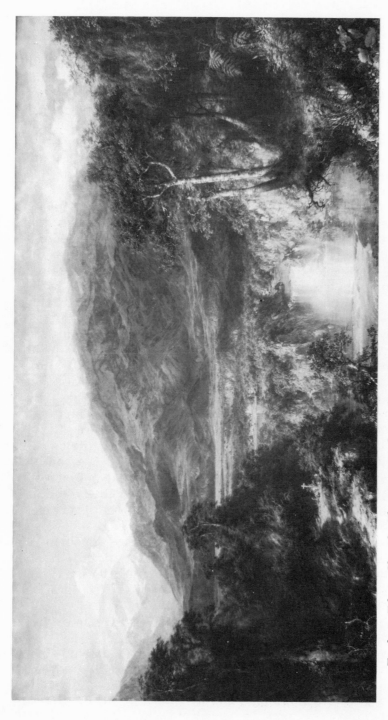

10. Frederic Edwin Church, *The Heart of the Andes* (1859). Oil on canvas, $66\frac{1}{8}'' \times 119\frac{1}{4}''$. (The Metropolitan Museum of Art, Bequest of Mrs. David Dows, 1909)

additional interest to most observers, though rendering his great work, the Rocky Mountains, confused, and detracting from its principal features, beside making it liable to the artistic objection of two pictures in one, from different points of view. We form our estimate of him from this picture. It is to be welcomed, because it recalls one from the delusive enchantments of the Church style to a more strictly scientific expression of nature. Titian and Correggio in their backgrounds give us the highest qualities of the landscape, by a broad and noble suggestion of its forms, in tone and meaning subordinated to their chief motive. But this grandly simpl[e] treatment finds few friends in America. Its practical life demands absolute truth of representation. In many respects Bierstadt has been very successful. If he has no liking for the broad, imaginative treatment of Titian, neither has he any more for the conventional lifelessness of the mechanical Düsseldorf school. He seeks to depict the absolute qualities and forms of things. The botanist and geologist can find work in his rocks and vegetation. He seizes upon natural phenomena with naturalistic eyes. In the quality of American light, clear, transparent, and sharp in outlines, he is unsurpassed. Cloud-shadows flit and play over sunlit hills and distant snow-peaks, rising clear and cold against the lofty horizon, with truthful effect. But his light is pitched on too high a key, which leaves his color cold and glaring, and produces overmuch transparency of atmosphere, whereby distances are in some degree confused and deceptive. As a colorist, Bierstadt appears to better advantage in his Sunshine and Shadow, a reminiscence of the Rhine. On the whole, however, he has well depicted the silvery clearness and translucency of the mountain-air of the West, and managed to avoid the prominent defects of the school in general. At the same time, we must confess that our taste has but transient sympathy with its hard-featured rationalism, no matter to what degree it compels admiration of its executive qualities.

Kensett[4] is more refined in sentiment, and has an exquisite delicacy of pencil. He is the Bryant of our painters,—a little sad and monotonous, but sweet, artistic, and unaffected. In his later pictures there is a phantom-like lightness and coldness of touch and tint, which give them a somewhat unreal aspect. But they take all the more hold on the fancy for their lyrical qualities.

From *The Art-Idea*

Gifford[5] has an opulent sense of color, but its tone is artificial and strained, often of a lively or deep brimstone tint, as if he saw the landscape through stained glass. His touch is vigorous, his design more forcible than accurate, and his style, as a whole, conventional and untrue, but manifesting qualities attractive to those who, having outgrown the merely mechanical and literal, have not yet familiarized their minds with the highest aims and efforts of art. . . .

[Heade's][6] speciality is meadows and coast-views, in wearisome horizontal lines and perspective, with a profuse supply of hay-ricks to vary the monotony of flatness, but flooded with rich sun-glow and sense of summer warmth. . . .

The prominent characteristics of the American landscape school are its realism, vigor, enterprise, and freshness. Partaking of the spirit of our people, it is dexterous, quick to seize upon new points, intellectual, and mechanical, viewing nature rarely in other than external and picturesque aspects, and little given to poetry or ideas. Aspiring to the natural only in motive, it looks as earnestly to the practical in result. If it be deceptive, it is so only as trade is, from ambition of success and fervor of competition. Partaking of the enterprise of commerce, it sends its sons to Brazil, to the Amazon, to the Andes, beyond the Rocky Mountains; it orders them in pursuit of icebergs off frozen Labrador; it pauses at no difficulties, distance, expense, or hardship in its search of the new and striking. The speculating blood infuses itself into art. Within proper limits, the zest of gain is healthful; but if pushed to excess, it will reduce art to the level of trade.

But landscape does not wholly go in this direction. Inness[7] is a representative man of an altogether different aspect. He influences art strongly in its imaginative qualities and feeling; impersonating in his compositions his own mental conditions, at times with a poetical fervor and depth of thought that rises to the height of genius, and at others with a chaotic wildness and disregard of law or fact, though never without a disclosure of original power, that causes one to pause before deciding upon his final position. Wildly unequal and eccentric as he is, recklessly experimentive, indulging in sameness of ideas, often destroying good work by bad, lawless in manner, using pigments sometimes as though they were mortar and he a plasterer, still there is ever perceptible in his works imagination, feeling, and technical instinct of a high order, which need only

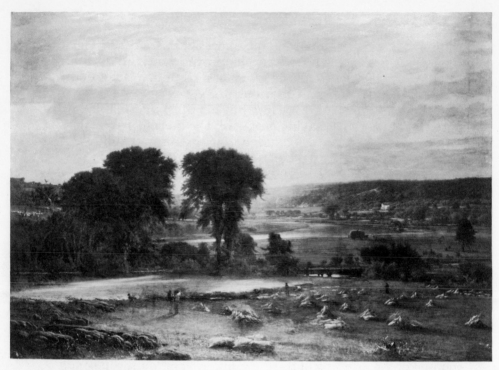

11.　George Inness, *Peace and Plenty* (1865). Oil on canvas, $77\frac{5}{8}''$ × $112\frac{3}{8}''$. (The Metropolitan Museum of Art, Gift of George A. Hearn, 1894)

the balancing power of experience and a steady will to raise their possessor to the rank of a master. The French school has tempered his style, but he is by no means a mechanical follower of it. He can be as sensitive as he is powerful in his rendering of nature's phenomena. The aërial distances and perspective of his best moods are subtile and delicate, like nature herself. We can breathe in his atmosphere, and travel far and wide in his landscape. At times his skies are tough, woolly, and opaque, from carelessness of brush in details, while infusing the whole with vital life and action. His trees sway; his leaves play in the breeze; his clouds lower and are rainladen; water sparkles and ripples in limpid, rhythmic joy; vegetation has the qualities of tender growth; the earth has a sense of maternity; mountains, hills, and meadows, sunlight and shadow, all gleam with conscious existence, so that, unlike the generality of our landscape art, his does not hint a picture so much as a living realization of the affluence of nature. Inness gives with equal facility the drowsy heat, hot shimmer, and

From *The Art-Idea*

languid quiet of a summer's noon, or the storm-weighed atmosphere, its dark masses of vapor, and the wild gathering of thunder-clouds, with their solemn hush before the tempest breaks. He uses sunlight sparingly, but it glows on his canvas, and turns darkness into hope and joy. His is, however, a stormy nature, pantheistic in feeling with a naturalistic expression, brooding over the changeful scenes of earth, rejoicing in the gorgeous mysteries or wild mournfulness of glowering sunsets, or clouds radiant with rainbow-promise of final peace. There is nothing of terror or the grotesque in his imagination. It speaks rather of the mourner who faints and hopes. This overflow of sadness is almost epic in expression, and is heightened by his intense idealism of color. . . . The spirit of his landscapes alone is American. Their tone is not Venetian, nor wholly French, but partakes of that fervid warmth with which we love to invest the heart's creations. Gold and purple, intense greens, crimsons, hues that melt and harmonize into liquid warmth, vigor, daring, intensity, poetry, a passionate delectation in nature, as if he were born of her untutored, irrepressible emotions: such are his characteristics, varied with startling inequalities and wantonness of brush, making Inness the Byron of our landscapists. . . .

Looking back, we find the American school of painting in its first phase foreign and aristocratic in sentiment. The paintings of the early masters soon passed into the quiet repose of old families, whence the best specimens should be culled for public galleries.

Their lineal successors are our academicians, whom fashion rules instead of the loftier feeling which animated the art of Stuart, Trumbull, and Allston. Academic art is deceptive, shallow, and showy by nature. Ours has no fixed prestige of rank and cultivation to guide and sustain it, but fluctuates with the fickleness of its presiding divinity. It strives for the appearance of things, rather than their fundamental qualities, and is content with making pretty pictures and babbling light sentiment. Primary instruction or elegant illustration is its highest effort. The first impression is ever the best, like that of fine manners united to an empty head. Deception and disappointment are ambushed in it; for, concentrating whatever ability it has on the surface, it risks all to catch the eye and make the false seem true.

All men are either spiritualists or materialists, in philosophy,

temperament, and faith, so that art must partake of one pro-
clivity or the other. Realism, as they term it, best satisfies those
who confide in what they consider as the substantial and tangi-
ble in nature, holding to epidermal representation as the end
and aim of art; while idealism alone will content those who
believe that its legitimate purpose is the expression of inner
life or the soul of things. The art which most happily combines
the two is the most successful with mankind at large. Whether
they comprehend its principles or not, their instincts recog-
nize them. But mere materialists find so many snares in the
exercise of the spiritual, creative, or interpenetrative faculty,
that they seek to confine themselves to the direct facts of
nature, avoiding other idealism than that of the naked eye in
its recognition of integumentary beauty. Naturalism readily
degenerates into matter-of-fact realism, or delights in inferior
truths and subordinate aims. It is, then, objective in character,
and confines itself mainly to illustration. We cannot, however,
classify either art or artists with unerring fidelity. . . .

Idealism tends to subjective treatment. It awakens that
inner consciousness of things which responds with telegraphic
alacrity to the spiritual faculties. Realists love facts; idealists
clutch at the soul of the fact. The English school is strongly
realistic, and deficient in the sense of color, which is more
particularly the language of idealism. We have eminent exam-
ples of each kind.

Beginning with our academicians, we have only to recall the
. . . lackadaisical sentimentalism of the most hollow kind, mere
soap-bubbles of art . . . in fine, the general mediocrity of execu-
tion, lack of original inspiration, and absence of nature's utter-
ance, for proving the inability for great art of academic real-
ism.

Academic teaching in some sort does recognize the ideal,
but fails in its method of attaining it. . . .

Continuing the comparison, as regards fundamental quali-
ties, between the realists and idealists, let us contrast the warm
magnificence of tone and poetical significance of a landscape
by Inness with the spotty, staring, obtrusive coarseness and
materialistic objectiveness of one by Brown, or turn to his
semi-ideal composition of Rome, and put it beside Church's
Heart of the Andes or Bierstadt's Rocky Mountains, all three
composed on the principle of rendering the general truths of
landscape in the most picturesque and characteristic manner,

without regard to absolute fidelity of local detail, so that a true impression of the spirit and appearance as a whole is given. The radical difference between the antagonistic styles of these masters will be felt at once. However much our admiration is captivated for a season by the dramatic spectacular touch of Church and his gem-like, flaming brilliancy of color, or the broader, less artificial, colder tinting of Bierstadt, the rich harmony of Inness and attendant depth of feeling, with his perfect rendering of the local idea of the City of the Cæsars, seize fast hold of the imagination, and put the spectator on his feet in the very heart of the scene. He becomes an integral part of the landscape. In the other paintings he is a mere looker-on, who, after the surprise of novelty is gone, coolly or impatiently criticises the view. The countryman that mistook the Rocky Mountains for a panorama, and after waiting awhile asked when *the thing was going to move,* was a more sagacious critic than he knew himself to be. All this quality of painting is more or less panoramic, from being so material in its artistic features as always to keep the spectator at a distance. He never can forget his point of view, and that he is looking at a painting. Nor is the painter himself ever out of mind. The evidences of scenic dexterity and signs of his labor-trail are too obvious for that; indeed, with too many the value attached to his work is in the ratio of their display. But the effect of high art is to sink the artist and spectator alike into the scene. It becomes the real, and, in that sense, true realistic art, because it realizes to the mind the essential truths of what it pictorially discloses to the eye. The spectator is no longer a looker-on, as in the other style, but an inhabitant of the landscape. His highest faculties are stimulated to action, using the external senses as servants, not masters. He enjoys it with the right of ownership by the divine seisin of kindred thought and desire, not as a stranger who for a fee is permitted to look at what he is by its very nature debarred from entering upon and possessing. We dwell strongly upon the underlying characteristics of these two styles, because true progress and enjoyment are so dependent upon a correct estimate of their relative values in art. The artist who first suggests himself, no matter with what degree of talent, has only achieved a subordinate success. Noble art is ideal at root, and the idea should be so treated, in accordance with the requirements of beauty, as to absorb the spectator primarily in the subject. First, the thought; then, the thinker:

such is the correct progress of artistic perception.

If we look at our painting as a whole, we find, that, though indebted in many respects to the French school, it has some characteristics more promising than those of its master. The French manner is too intellectual, too realistic, too little spiritual and idealistic, wanting also in passion and the language of color. Delacroix is exceptional, and not to be cited against this view. He was unrecognized in his time, and even now has no positive influence, though a giant of original force and vehemence. Indeed, his nature was too deep and intense to mix with the natures about him. A fresh revelation he is and will ever remain. So we cannot cite him, nor can we the Englishman Turner, as evidence of general qualities. Such men serve rather to show the lack of generic virtues than the presence of them. The French school is not one of powerful color, like that of Venice, or the Spanish. Its chief defect, aside from spirituality, is in this direction. Its color is more the result of scientific calculation than of feeling or instinct. Now, American art, though in intellectual knowledge and technical ability so greatly behind it, has actually given hints of ideas . . . that belong to and express thoughts of the living nineteenth century. Imperialism in France will not permit art to become the language of social and political hopes and aspirations. But there is no reason why the art of democratic America shall not. What lessons might not be taught out of the demoniac passions that give birth to New York riots, if their true origin, spirit, and intent were exhibited realistically or symbolically.[8] . . .

No nation can turn to a more heroic or grander record of sacrifice, suffering, and triumph. We are now passing through the transition period of unformed youth, with its raw impulses, weak compromises, and hasty decisions, into the fuller wisdom of ripe manhood, tried by an ordeal of the greatest civil war the earth has ever seen, and for the greatest ideas and largest liberty to the human race. Ours is the victory for all humanity. Out of this war for equality, exaltation, and unity of peoples, must spring up a school of art of corresponding nobleness. The people's Future is its field. A great work is before it. Little is done,—nothing, compared to what there is to do. But slight as is the showing of our art in a national sense, it still precedes the popular taste. Art awaits a valid public opinion to inspire it, and to be amenable to. The common taste rests upon the level of materialistic landscape. It is just expanding into a liking for

From *The Art-Idea*

dead game and ordinary *genre* subjects. To it, the sublime, impassioned, or spiritual, is an unknown tongue. It has not even learned the true definition of art, much less comprehended its entire spirit and purpose. There is a crude liking of prettiness, mistaken for beauty, but no deep conviction of our æsthetic poverty, still less any such fixed faith in art as we have in science. Art itself has not grown into a faith. It aspires overmuch to dollars and praise. Although leading public taste, it stoops to it. Knowing the right, it hints at better things, but hesitates to do them. It wants backbone; has no lofty conception and belief in its own future. But, full of young blood, the dawn of its morning twilight tinges the horizon with far-off golden light.

1864

NOTES

1. Emanuel Leutze (1816–1868), German historical painter, studied in Düsseldorf under Lessing. He first came to the United States in 1851. His most famous work is Washington Crossing the Delaware (Metropolitan Museum of Art).
2. Frederic Edwin Church (1826–1900), pupil of Thomas Cole, was an extremely successful landscape painter, famous for his spectacular panoramic views of South American and Mediterranean scenery. [See Fig. 10]
3. Albert Bierstadt (1830–1902) studied in Düsseldorf. He joined an expedition to the Rockies in 1858. He is distinguished for his huge canvasses of Western scenery. [See Fig. 9]
4. John Frederick Kensett (1818–1872) trained first as an engraver, went to Europe with Durand in 1840, and studied for seven years in England, Germany, Switzerland, and Italy. He had a successful career as a landscape painter in the Hudson River tradition.
5. Sanford Robinson Gifford (1823–1880), who painted landscapes of American and Mediterranean scenes, was influenced by Thomas Cole.
6. Martin Johnson Heade (active 1847–1884) was an American landscape painter who is especially noteworthy for his luminous marines. [See Fig. 12] He also did sketches of hummingbirds and flowers during an expedition to Brazil.
7. George Inness (1825–1894) studied briefly under Gignoux, but was practically self-taught. He made several trips to Europe, mainly Rome and Paris, beginning in 1847, and was influenced by the Barbizon School. [See Fig. 11]
8. Jarves is referring to the draft riots of July 1863.

American Luminism:

A Neglected Aspect of the Realist

Movement in Nineteenth-Century

American Painting

John I. H. Baur

Shortly after Theodore Robinson returned to America from his years in France, he was puzzled to find that his landscape paintings seemed both solider and cruder than those he had done abroad, "and this," he confided to his journal in 1894, "is perhaps partly an affaire of difference in climate, atmosphere . . ." Some sixty years earlier a young English painter, George Harvey, was so deeply impressed by the character and the variety of light on this side of the ocean that he undertook a series of water colors which he called the "Atmospheric Landscapes of North America." Whether the scientist agrees or not, there is ample evidence that, to the artist, American light *looks* different from that of Europe. Long before the impressionists of the late nineteenth century, who are generally considered the official painters of light, a group of

obscure American artists made this discovery and turned it to a quietly poetic use. Technically they were extreme realists, relying on infinitely subtle variations of tone and color to capture their magical effects. Spiritually they were the lyrical poets of the American countryside and the most sensitive to its nuances of mood. In both respects they were quite different from their better remembered contemporaries of the Hudson River school, who were freer in their handling, more romantic in their compositions, and a little operatic in their celebration of native scenery.

One might say, of course, that the early luminists deserved small credit for recording something that was all about them, but the truth is that the artist sees nature with a far from innocent eye, and his vision is conditioned by the artistic conventions which he inherits. Since landscape painting was not a popular branch of art in America until the rise of the Hudson River school about 1825, we had no native traditions to guide us in the discovery of our own qualities of light and atmosphere. . . . Pioneer landscape painters, like Samuel Morse and Henry Inman, were raised in the eighteenth-century portrait tradition; the light in their landscapes is the same studio illumination that they manipulated so skillfully in their portraits, and has little relation to nature. Even in the work of Thomas Cole and the other Hudson River school painters, light was apt to be a tool for dramatic and romantic effects, borrowed from Salvator Rosa and other European sources. This is not universally true, for many of the Hudson River men gained new insight through observation. Speaking of American atmosphere, Asher B. Durand urged on an imaginary pupil "the constant study of its magic power, daily and hourly, in all its changes," but Durand himself made rather a timid use of atmospheric effects, and the school as a whole was more interested in panoramic and picturesque effects than it was in light.

The beginnings of American luminism were everywhere and nowhere. It was never an organized movement and it had no founders or acknowledged leaders. It arose spontaneously in the second quarter of the nineteenth century, at the same time that American landscape painting began to flourish. Its earliest manifestations during the 1830's are tentative and can be found in the work of many artists, including George Harvey, Robert Salmon, Thomas Birch, John S. Blunt, Charles Codman, Joshua Shaw, and doubtless several dozen more still-

obscure painters. Of these, Salmon is perhaps the most important, if only for his influence on Fitz Hugh Lane. Like Harvey, Salmon was English born and English trained, his style being fully formed by the time he settled in Boston in 1828. His rather metallic realism, which recorded correctly all the complicated detail in the rigging of ships, also caught, at times, some of the brilliance of sunlight on water and sails, though one suspects that this may have been more accident than the result of a conscious interest in such effects.

Luminism reached its fullest expression during the 1850's and 60's, particularly in the work of two men, Fitz Hugh Lane and Martin J. Heade. Lane was the elder, born in 1804, trained as a lithographer in Boston, living most of his life as a cripple in an odd stone house overlooking the harbor at Gloucester, Massachusetts. Early in his career he is known to have copied a painting by Salmon, whose influence is quite apparent in some of Lane's harbor and shipping scenes. But Lane went far beyond the older artist, both in his perception of light and in his poetic use of it. Time of day and kind of day are always recognizable in Lane's work. In one of his earliest pictures, *A Maine Inlet,* the dusk of evening fills the painting like a palpable presence. More often his placid coastal scenes are bathed in sunlight, sometimes the clear, crisp illumination of early morning, again the hot glare of midday or the hazy atmosphere of a humid afternoon. He painted the sun rising through mist, he painted it setting, with its red glow coloring the whole landscape, and he painted moonlight long before that subject was generally considered paintable. Like that of others in the movement, Lane's technique was a polished and meticulous realism in which there is no sign of brushwork and no trace of impressionism, the atmospheric effects being achieved by infinitely careful gradations of tone, by the most exact study of the relative clarity of near and far objects and by a precise rendering of the variations in texture and color produced by direct or reflected rays.

Lane was not much interested in composition; indeed there is evidence to show that he scarcely composed at all except to choose, like a photographer, his place in the landscape and the extent of his view. The hushed stillness that reigns in so many of his pictures and that gives them their serene, poetic quality springs almost entirely from light and atmosphere, somewhat reinforced by his preference for scenes of considerable depth

and long, horizontal lines. Exactly the same spirit was caught by the young Henry James in one of his earliest stories, "A Landscape Painter," published in *The Atlantic Monthly* in 1866, the year after Lane died. "I shall never forget the wondrous stillness which brooded over earth and water," says James's artist . . . "The deep, translucent water reposed at the base of the warm sunlit cliff like a great basin of glass, which I half expected to hear shiver and crack as our keel ploughed through it. And how color and sound stood out in the transparent air! . . . The mossy rocks doubled themselves without a flaw in the clear, dark water . . . There is a certain purity in this Cragthorpe air which I have never seen approached—a lightness, a brilliancy, a *crudity,* which allows perfect liberty of self-assertion to each individual object in the landscape. The prospect is ever more or less like a picture which lacks its final process, its reduction to unity."

Heade, who was born in Lumberville, Pennsylvania, in 1819, may never have known Lane's work, but he painted numerous landscapes in a very similar vein and with a similar technique. They have, perhaps, less lyrical intensity, but they show an equal if not greater concern with light and atmosphere. Like Monet later, Heade did a series of haystack paintings, depicting the same subject under varying conditions of light and weather, one of the most daring being the portrayal of a rain squall sweeping across the meadow, while beyond it the sky clears to a brilliant blue and the sun dispels the cloud shadows. . . .

Heade was a rolling stone. . . . His known voyages took him through many parts of the United States, to Europe, Central and South America, and he may have gone even further afield. His range of subjects and effects . . . included several exotic studies of orchids and hummingbirds seen in the mysterious, filtered light of the tropical forest. His character seems also to have had a marked romantic streak, which emerged in several extraordinary pictures like the *Approaching Storm: Beach Near Newport* [Fig. 12] with its weirdly pinnacled rocks, its metallic water and threatening, green-tinged light. There have been more dramatic storms painted, but seldom has the sense of foreboding been more ominously realized, or the implication of impending catastrophe.

Heade and Lane have emerged today as the most skillful and sensitive luminists of the mid-century. But in their own time

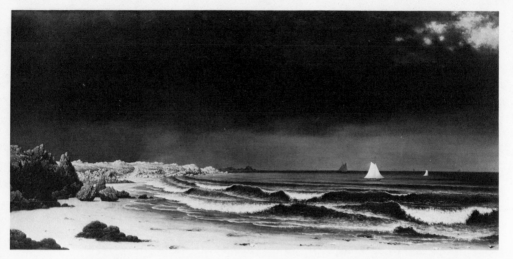

12. Martin Johnson Heade, *Approaching Storm: Beach Near Newport* (ca. 1860–70). Oil on canvas, 28" × 58¼". (Courtesy, Museum of Fine Arts, Boston. Mr. and Mrs. Karolik Collection)

they enjoyed no such commanding position and were scarcely better known than several other artists who shared their atmospheric and their realistic technique. One of the most interesting of these was James Augustus Suydam (1819–65), a wealthy merchant who turned to painting in the last ten years of his short life and whose work is known today only through a handful of pictures. Among them, however, are several spacious, light-filled panoramas which relate Suydam closely to Lane in both method and feeling. . . .

In the Middle West another long-forgotten painter, Joseph Rusling Meeker (1827–89), . . . apparently much impressed by the mysterious bayou country . . . painted the subject in a series of romantic canvases. . . . Like Heade's tropical landscapes, these pictures combine the utmost realism of detail with a romantic mood created largely by the subdued radiance of sunlight sifting through the surrounding gloom.

Fascination with American light was not limited to any one class of artists. It is strongly marked in the work of several mid-century genre painters, such as Mount, Clonney, Ranney, Durrie; and only slightly less so in that of Bingham. Even a few primitive painters struggled with the problem, though they did not generally have sufficient skill to capture the difficult and elusive effects of atmosphere. However, some semi-primi-

tive artists with greater technical resources, like the still obscure George Tirrell of California, made more successful headway. And finally, a number of the Hudson River school painters contributed notably to the luminist movement. Of these, John F. Kensett and Albert Bierstadt were the most important, but in both cases their experiments with light were embodied principally in small paintings and studies done directly from nature, rather than in their big exhibition pieces. As a result, this aspect of their work has remained slightly known until recent years—especially Bierstadt's, since he refused to exhibit or sell the brilliant little oils, many of them on paper, which he considered only notes for future elaboration.

Luminism of the extreme realist variety was carried on by a few artists, including Heade himself, to the very end of the century, and it found a late echo in the work of Charles Herbert Moore. But its heyday was over with the end of the Civil War, after which it was transformed by a new generation into a kind of limited impressionism which culminated in the majestic seascapes of Winslow Homer. The meticulous technique of Heade and Lane had its limitations in the transcription of light, and as early as the 1850's a few more daring artists, including Jasper F. Cropsey, George Loring Brown, and especially James Hamilton (called by his contemporaries "the American Turner"), began to experiment with a freer handling of paint, aimed principally at catching the brilliance of sunlight as it obliterates detail and forces the eye to accept a more generalized vision—in other words, an impression rather than a description. During the next two decades many more painters, such as George Inness, John La Farge, William Morris Hunt, and W. Allan Gay, moved in the same direction—largely under the foreign influence of the Barbizon school.

Despite these complicating factors, the main and the peculiarly native line of luminism's development in America led directly from the descriptive realism of Heade and Lane to the visual realism of Homer. This is apparent in the work of several transitional men. William Stanley Haseltine's *After a Shower— Nahant* can be taken as a halfway point, about equidistant from the two extremes. In the hard precision of its rocks it proclaims its allegiance to the first group; in the freely brushed reflections of sun on water it points to the new direction. Eastman Johnson developed from the earlier to the later style, and Homer himself traversed a similar course. His *Waiting for*

Dad, painted in 1873, is still close to the tradition of Heade and Lane but it also forecasts his broader, more painterly handling. Homer was to carry impressionism much further in his later seascapes, but his world always remained a notably solid one, and his visual effects never destroyed a deep sense of nature's material reality.

Homer's compromise between knowledge and vision had, in turn, a sobering effect on our orthodox impressionists of the 1890's—that small group which first came under the influence of French impressionism and introduced its system of broken color to this country. Despite the American artists' admiration for their French masters, not one of them followed French example to the point of dissolving form in a sensuous haze of light and color, as Monet did in his cathedral series. All of them were too deeply imbued with the long realist tradition of American art, which remained nearly as firm in their philosophy as it had been in that of the earlier men.

Luminism was only one aspect of that tradition, but it was an exceptionally important one because of the originality and freshness of vision which it evoked. . . .

. . . These painters were not much concerned with design, with color for its own sake, with expressive distortion or, in other words, with the usual language of art. Their quality lies in an entirely different quarter. It lies in their intensity of seeing and of feeling and in the profound identification of the artist with what he portrayed. Writing of Lucretius, Santayana said, "The greatest thing about this genius is its power of losing itself in its object, its impersonality. We seem to be reading not the poetry of a poet about things, but the poetry of things themselves. That things have their poetry, not because of what we make them symbols of, but because of their own movement and life, is what Lucretius proves once for all to mankind." And this was what the best of the American realists proved again nineteen centuries later.

This, too, explains an almost anonymous quality in their work (even in that of as strong an individual as Homer) and why it is diametrically opposed to the conception of art as "nature seen through a temperament." The principal requirement in realism of this kind is not the assertion of personality, but that the artist must see freshly, as if the world were new born; that he must feel deeply; that his hand must preserve the

freshness of his image and understanding with a maximum of skill and a minimum of idiosyncracy.

Of course there were bound to be differences between individual painters for no art is completely impersonal, and the temper of an age also colors its artistic response. Heade and Lane, living at a time when pantheism was a genuine force, found in nature a presence and a spirit. Like Emerson, they became before her "a transparent eyeball," losing themselves completely in her moods. Their art is rapt, lyrical, filled with a sense of awe. . . .

Today, when art's formal values weigh so heavily in our critical scales, it is worth recalling that an entirely different system produced creative work of lasting vitality. "Naturalism," said Santayana in his same essay on Lucretius, "is a philosophy of observation, and of an imagination that extends the observable," divining "substance behind appearance, continuity behind change, law behind fortune." In American art it produced a poetic image of nature's deepest meaning, as the nineteenth century understood it.

1954

4. EUROPEAN ATTRACTIONS AND

AMERICAN MASTERS:

WHISTLER, EAKINS, HOMER,

AND RYDER

Historians, when generalizing about the decades following the Civil War, have often characterized the latter half of the century as a time when acquisitiveness and material expansion were the prime forces on the American scene. The accelerated growth of railroads, industry, and urban population was altering the substance of American realities, even as popular sentiments, conditioned, among other things, by a moralistic strain in public education, lingered still with affection on the romantic vision of a sacred land and the virtues that localized agrarian and village ways of life were thought to promote. To many observers in the nineteenth century, the machine and the dollar were nourishing acquisitive impulses that could only inhibit the evolution of true cultural refinement in America and, consequently, a widespread, genuine love for the arts. Ironically, many of the great fortunes amassed during the century after the Civil War would eventually play important roles in the welfare of the arts, not the least of which was the acquisition of vast amounts of art from abroad, works varying widely in quality, but including many masterpieces—bringing at last to the United States and its new museums what it was once necessary to cross an ocean to view. As collecting

art became fashionable among the wealthy, the contemporary American artist was not, however, a conspicuous beneficiary as compared with the European, who seemed to attract the greater share of Gilded Age acquisitiveness. There were also other developments that went hand in hand with the increasing wealth of the nation: the foundation of numerous professional schools of art, making possible a higher level of training at home than was formerly available, and considerable individual and corporate patronage underwriting the creation of much that was good (and, it must be admitted, much that was questionable, as well) in both commercial and domestic architecture. Few blessings were, of course, unmixed.

For the student of American art of the middle decades of the nineteenth century, the issues of *The Crayon* (published from January 3, 1855 to July 1861) are valuable sources of information concerning art opinions and activities of the time. Its cofounders and editors were William J. Stillman and John Durand, the latter an art critic and son of the engraver and painter, Asher B. Durand, whose "Letters on Landscape Painting" were featured in the early numbers of the publication. Stillman had studied painting with Frederic Church and shortly thereafter, in 1849, went abroad for further study. In England he met Dante Gabriel Rossetti and John Ruskin, and became acquainted with the precepts of the Pre-Raphaelite Brotherhood, of which Rossetti was one of the founders. The latter's brother, William M. Rossetti, a spokesman for the Pre-Raphaelites, would be an occasional contributor to *The Crayon,* and Ruskin would be quoted or echoed throughout its publication. Thus *The Crayon,* apart from its commentary on art events in America, became a channel for Ruskinian and Pre-Raphaelite ideas. *The Crayon* in reprinting art news from Europe was also a means for artists in America to keep somewhat in touch with the current art scene abroad.

Reprinted in this section is a small sampling of items from *The Crayon.* The two selections on Düsseldorf provide an intimate picture of a European art milieu to which many Americans flocked to study in the middle of the nineteenth century, resulting in a realistic, anecdotal—and frequently sentimental—vein in American painting, exemplified by such artists as Richard Caton Woodville and some phases of Eastman Johnson's work. Both of these artists studied in Düsseldorf. George Caleb Bingham, who is mentioned in the second of the Düsseldorf letters, came there after his career had already matured in the United States. Bierstadt studied at the Düsseldorf Academy under Lessing and Achenbach, and Emmanuel Leutze lived in Düsseldorf for many years. His well-known *Washington Crossing the Delaware* (1851) was painted there. The selection on Paris and the milieu of Thomas Couture's school provides an interesting glimpse of the American art student's life in the French capital

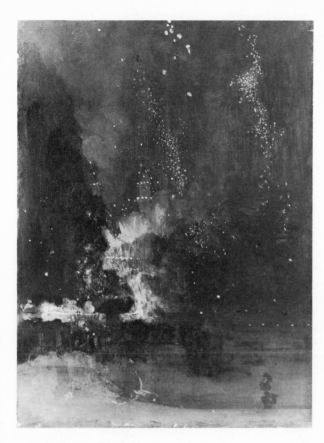

13. James McNeill Whistler, *Nocturne in Black and Gold: The Falling Rocket* (ca. 1874). Oil on wood panel, $23\frac{3}{4}'' \times 18\frac{3}{8}''$. (Courtesy of The Detroit Institute of Arts. Purchase: The Dexter M. Ferry, Jr. Fund)

during the last half of the nineteenth century.

Although the latter half of the nineteenth century gradually provided the country with an environment that could substantially enhance the fine arts through the new schools, professional societies, and museums, most of those who became well known as artists had still gone abroad to study or to complete training begun in America, some even to remain abroad as expatriates. Of the principal American artists whose careers lie chiefly in this era, four painters—James McNeill Whistler, Thomas Eakins, Winslow Homer, and Albert Pinkham Ryder—warrant special emphasis.

Whistler was the complete expatriate, American by birth but not by choice of residence or return visit, elegant stylist, international figure, and proponent of an art-for-art's-sake attitude in many ways evocative of modern viewpoints. He was active in many developments at the leading edge of European art of his time: he had worked alongside of Courbet; participated with such as Manet and Pissarro in the famous Salon des Refusés of 1863; and was acquainted with Degas, to whose work his own figurative compositions have some

affinity. Like Mary Cassatt, another American expatriate who was a close friend of Degas, and like Degas himself and other French artists of the period, Whistler was attracted to the decorative refinements of the Japanese print. His own elegant harmonies and compositional arrangements owe something to both the Orient and the tonal control of Velasquez, whom he, like Manet, so much admired. The quietude and grace his work developed, together with the aesthetic exclusiveness fostered by his art-for-art's-sake philosophy, had some effect on a vein of American art that sought to be fashionable. But such delicate wine does not travel well, and in lesser hands the quietude turned to lassitude and the grace to cloying sweetness. For the America of his day, Whistler was a source of uneasy pride: an American artist who had achieved serious recognition abroad to the extent that his work was purchased for the Louvre, but one whose slashing wit and perverse combativeness may have made the Atlantic seem a comforting buffer zone. Whistler's personality was the aggressive embodiment of his view that the superiority of the artist over other beings was an unassailable fact. His sly pleasure in his own abrasiveness is confirmed in the title of his book, *The Gentle Art of Making Enemies* (1890). Probably the most familiar portion of this book is the artist's account of the Whistler-Ruskin trial in London in 1878. John Ruskin, writing of Whistler's *Nocturne in Black and Gold —The Falling Rocket* [Fig. 13] (ca. 1874), called the artist "a coxcomb" who had flung "a pot of paint in the public's face." Whistler sued for libel, received an insulting one farthing for damages, and was bankrupted by the affair. Selected for this anthology are excerpts from other portions of the book which reveal his aesthetic point of view—and some of his barbs. Communication of one important facet of Whistler's viewpoint often emerges from the titles he gave his works—as in the picture mentioned above, for instance. Precedence was given to the portion of the title that included such words as "Nocturne," "Symphony," or "Arrangement," words with musical connotations—in short, the stress is placed not on what is represented in the picture but on that "abstract" part of the image which suggests a parallel between the artist's deployment of colors and shapes and the composer's manipulation of musical notes and intervals. Yet Whistler's art was based on reality and retained its linkage to it, a fact sometimes cited as evidence that he belongs to the American tradition—but the same could be said for Monet.

Unlike Whistler, the other artists featured in this section pursued their careers in the United States, and of them only one—Thomas Eakins—had training abroad. After studying at The Pennsylvania Academy of Fine Arts and doing work in anatomy at Jefferson Medical College in Philadelphia, he went to France in 1866, where he became a pupil of Gérôme and others at the École des Beaux-Arts

in Paris. While in Europe he traveled to Italy and Germany and, in 1869, to Spain, where he spent about six months and discovered new lessons in the works of the seventeenth-century Spanish realists, Ribera and Velasquez. In 1870 he returned to the family residence in Philadelphia, which remained his home for life.

Eakins stands at the opposite extreme from Whistler's aestheticism. Eakins's art was frankly rooted in the commonplace and did not court elegance or beauty. It was a strong, candid, sober brand of realism, dignified and monumental, without clever replication of the surfaces of things. Eakins was incapable of flattery, but he was remarkably sensitive to human character, to "the life behind the eyes," and in his best portraits the sense of truth prevails over likeness. In *The Gross Clinic* (1875) he carried his realism into the operation theater of a hospital, an unusual and repelling subject for the Philadelphia of his day, so much so that it was not permitted to be shown in the art section of the Philadelphia Centennial Exposition, but displayed instead in the medical section. This dramatic tribute to a surgeon and his work evokes another aspect of Eakins's career: his scientific interests in the functioning of muscular systems, in locomotion, and in photography.

Of the four artists in this section, Eakins alone was a teacher—and a dedicated one—for most of his professional career. The ten years he taught at The Pennsylvania Academy of Fine Arts (1876–86) established it as a model for sound professional training, one indication of the improving character of artistic education in the United States during the latter part of the nineteenth century. Unwilling, however, to submit to the prudery that objected to nude male models posing before female students, Eakins finally left the Academy post, but continued to function as a teacher at the newly formed Art Students League of Philadelphia and, from 1888, with lectures at the National Academy of Design.

Winslow Homer's art, like that of Eakins, was drawn from the ordinary world around him, but more than Eakins he was a recorder of the moment-to-moment odds and ends of daily life: children resting in a field or playing snap-the-whip at school recess; young ladies playing croquet or strolling at the summer resort by the edge of the sea; sturdy young women watching the grey breaking seas for the return of the boats; seamen and fishermen in their routines of contest with the sea; Adirondack guides and hunters in their element; black divers in the sun-bright waters of the Caribbean; and finally the sea itself, dashing on the shore at Prout's Neck, Maine, where the artist lived between excursions after 1883.

Homer, apart from his early apprenticeship in a Boston lithographer's studio and brief periods of study in Brooklyn and New York, was self-taught, building his skills by doing. Beginning in 1857, he

contributed illustrations to *Harper's Weekly,* including an assign-
ment as artist-reporter with the Union Army during the Civil War.
He ceased illustrating for *Harper's Weekly* after 1875, but the anec-
dotal aspect of illustration would continue to be a recurrent element
in his art. Gradually, however, narrative detail became subservient
to an increasingly dominant pictorial structure, spare in its reduction
to essentials.

Homer's trip to France, from late in 1866 until October 1867, has
raised many questions about the effect of the experience on his own
work, whose parallels with early impressionist developments in
France have often been noted, but so little is positively established
regarding his movements and pertaining to the art he saw there that
most of the commentary on this episode in Homer's life remains
speculative. The Paris Universal Exposition of 1867 featured a sec-
tion of American art, including two paintings by Homer, whose work
lost out to Frederic E. Church in the gold medal awards. Whistler
and George Inness were also represented in the exhibition. Presuma-
bly Homer saw this American section, but whether he also saw the
works of Courbet and Manet exhibited outside the exposition
grounds is not known. Speculations about possible influences from
Japanese prints have some support from visual evidence in Homer's
work, but one of the consistent factors in his career was his stubborn
Yankee independence. As Goodrich notes in his book on Homer
(1944), "his work was based on an unusually direct relation to nature,
with less outside influence than almost any painter of his genera-
tion." If Homer's was an "extrovert art," as Goodrich has asserted,
then Albert Pinkham Ryder's was thoroughly introverted, a subjec-
tive vision of singular concentration. The real world is present in his
imagery only as distilled to some fundamental essence beyond which
the linkage to that world would be lost. An air of mystery pervades
the dark tonalities of his paintings, with their looming masses of
uncertain boundary relieved by moonlight or veiled with an elusive
autumnal glow. His themes were drawn from the Bible, mythology,
legend, literature, and his own poetic reveries which touched them
all. Now and then there would be something at hand: a view on
Martha's Vineyard, the Connecticut orchard of his American impres-
sionist friend, J. Alden Weir, or the poignant fragility of a small dead
bird he brought home and painted. Many of his works were painted
so slowly, worked and reworked, that they were literally years in the
making—"ripening", as he put it. He expressed very well the spirit
of his art when he wrote, "Have you ever seen an inch worm crawl
up a leaf or twig, and there clinging to the very end, revolve in the
air, feeling for something to reach something? That's like me. I am
trying to find something out there beyond the place in which I have
a footing." His footing was mainly within.

Whistler, Eakins, Homer, and Ryder

Ryder had very little formal instruction and what he saw of the Old World's art on trips abroad apparently had little effect on his work. His pattern was already set—he was thirty—when he made his first voyage across the Atlantic. On later trips, in 1887 and 1896, he appears to have sailed primarily for the voyage itself, staying in port only about two weeks and returning on the same vessel. The sea alone must have been one of the incentives for these voyages. He grew up in New Bedford, Massachusetts, his birthplace and, during his youth, a great whaling port. Some of his family were seafarers, including two of his brothers. And no artist has surpassed Ryder in evoking the indeterminate, enveloping presence of the sea at night.

The selection by Leo Stein was written only a year after Ryder's death. Although the artist's activity had fallen off since the turn of the century, he was one of the exhibitors in the American section of the famous New York Armory Show of 1913, which, together with the efforts of Alfred Stieglitz through exhibitions in his gallery at 291 Fifth Avenue, brought the latest developments in European art to America. Leo Stein belonged to the influential circle of supporters of modern art that gathered around his sister, the poet Gertrude Stein. His article is still one of the most sensitive assessments of Ryder's art.

Düsseldorf

May 4, 1857.

DEAR CRAYON:

DÜSSELDORF is a rather small town, of about twenty-five thousand inhabitants, numbering among these more than four hundred artists. Whole streets in the suburbs are lined with studios, and a walk through a dozen of them in a couple of hours pays well for the trouble. Though I remember many names of artists, I intend to mention but the most prominent ones. During my visit LESSING was absent. His studio stands in the rear of his residence, the hall of which was lined with antlers of all sizes, which are displayed as trophies of his hunting excursions. Lessing enjoys the privilege of hunting in the royal forests wherever and whenever he chooses, and a very good marksman he is. His studio is fitted up with every description of materials, indispensable to an historical painter; bishops' dresses, mitres, crooked staves, doublets, and knights' cloaks, old weapons, rifles, and swords. The models were only wanting to represent the group, that stood portrayed in rough outlines on the large canvas covering the back part of his large studio, the subject of which was "Pope Pachalis Quarrelling with Henry V." In landscape painting Lessing is surpassed by none in Düsseldorf.

In ACHENBACH'S studio everything was neat and fashionable. A male servant opened the door; inquiring my business

with many bows, and having announced my name to his master, he conducted me upstairs with many more bows. Achenbach, in a dress coat, was stepping forward and backward before a picture of a "Dutch Coast Scene," eyeing it with certain graceful motions, and touching it up, as he studied and tacked.

Quite different was BLEIBTREU'S studio—a real lumber-room of deserted barracks. Old saddles and harnesses, pistol-holsters, queer stirrups and strange spurs and bridles; dirty cloaks, that had seen service, and swords and firearms of all ages and all sizes, were lying and hanging about. Skulls of horses and of men looked grinning down from the walls, and on a big heavy log, with four outstretched legs, hung a wooden figure, in the attitude of a fighting position. In the midst of this *pêle-mêle* of rubbish sat young Bleibtreu, with a jovial laughing face, besmeared all over with colors, before a canvas of small size, on which the bustle of a fighting crowd was depicted with great truthfulness. His figures are characterized by the youthful expression of the faces, so full of life and spirit. I suggested to him the study of American history. The pictures on his easel were orders received from the king, representing scenes in Napoleon's war, in which, of course, the French went off second best. Bleibtreu is, without doubt, one of the most gifted talents to be found, in this line of painting. He is an artist of great promise. He yet lacks that finer execution, which makes Camphausen superior to him; the latter paints faithfully after models always before him, while Bleibtreu consults more his imagination and memory. Camphausen, it is said, will take a horse to an appropriate place, and having arranged carefully easel and canvas, will shoot the beast, and then faithfully sketch the dying animal.

TIEDEMAND, the master in Norwegian figure-pieces, is the most amiable and unpretending young man I met at Düsseldorf. His pictures are simple scenes, representing the home life of the Scandinavians; for instance, husband and wife are seen engaged in some domestic work, conversing with a man leaning upon a partly-opened door, who is a hunter, relating his adventures with a bear, that lies dead in the midst of the room. He smiled in reply to my question, how he could find so many new subjects for his paintings without going every year to the land of his birth? I could not imagine how any Düsseldorfer could paint without having his models constantly before him. Drawing a curtain aside, he brought out a little fellow, a

neighbor's son, with a Norwegian fur cap on his head, who was his model. Tiedemand had several pupils, who preferred his instruction to that of the Academy.

The Academy is situated on the banks of the Rhine, free on all sides. Once a princely chateau, it contains a great number of spacious rooms and halls. My guide called it the "menagery" on account of the strange beings that inhabited it, among whom the students, with long flowing hair, figured as lions, and some of the professors as grumbling bears. The high windows of the rooms are separated by screens, and every partition is occupied by numerous students. The visitor cannot help laughing when entering these rooms. Caricatures cover the walls, the doors, and the screens, giving in this way a history of the occupants, both professors and students, for many years past: paint, inch thick, covers every other accessible part of the room. Other rooms of the building are occupied by the Academy professors, who, receiving a certain salary, have to devote certain hours to the students engaged there. The city's gallery, in the same building, is open to the visitor for a small fee. The pictures have been purchased out of some particular fund, and among them are master-pieces by Sohn, Lessing, and many other masters of this school.

The Academy is no longer what it used to be years ago. Many artists becoming disgusted with the strict rules of the professors, have taken rooms for themselves, and have at the same time opened them for the reception of pupils. There is this advantage growing out of this state of things: we no more find that intolerable Düsseldorfer sameness, that universal monotony of color and style which characterizes the former productions of this school. The year 1848 made among the artists great changes for the better, rendering them more independent. The old fogies lost their influence by the artists founding the "Mahlkasten;" this place of union being for the advantage of the younger class. There exists a kind of fellowship among artists in Düsseldorf, that is highly praiseworthy, and ought to be imitated everywhere. Great encouragement is given by them to young beginners; they are sustained by the whole body, and while receiving instruction from one, they find board with another. The artists, when speaking of their exhibitions and the sale of their pictures there, use constantly the word *we*, meaning the contributors as a whole, "*We* have sent there so many pictures," "*We* have received there so much

money." They have a common purse, to which every one contributes quarterly a small fee. Out of this purse are paid the expenses of packing, forwarding, insuring, and other small items, relieving the artist of much anxiety and trouble, and saving him time and labor.

The various exhibition places in Germany, I understood, have a certain arrangement for exhibition, called Northern, Southern, and Rhenish exhibitions. A number of cities and towns have united, agreeing to open their galleries at different times, so as not to interfere with each other. As soon as a society has been formed with sufficient funds for bearing the expenses of an exhibition, they may become a part of the association. The picture, always enclosed in a nice casing, to protect the frame from handling, is sent from place to place, and is restored to its owner after a certain time, when not disposed of.

D.

DÜSSELDORF, 16th October, 1857.

The city of Düsseldorf is, at present, known the world over for its Art schools. We see it mentioned in the current prints of the day, and read long chapters concerning it in books. Among its fifty thousand inhabitants there are some six hundred artists, of all nations, and nearly three hundred Art students. Those of the artists who have attained some considerable degree of excellence, and are more or less known over Europe and America, live here like a family. It is a pleasing aspect of life to contemplate a number of the best living artists residing together, keeping up a spirit of emulation amongst themselves and their brother artists of other nations, which, while it spurs them on to greater efforts, never degenerates into envy. This is the chief benefit arising from living here: one breathes, as it were, an aesthetical atmosphere; artists interchange visits, and mutually enjoy the benefit of each other's thought; they see how special effects are produced, and by constantly having the productions of others forced upon their observation, they are in no danger of contracting dangerous peculiarities.

There are, at present, two separate and distinct schools of painting in this city; the Academy, with its adherents, attendant professors and students, forming one school; and the independent artists another. The Academicians seem to imagine

that the greatest perfection of Art is the minute and truthful imitation of Nature; accordingly all their work is microscopic. They paint fruit-pieces and still-life generally with wonderful fidelity; no photograph could render it with greater truth. Some endeavor to paint history in this style. There are several pictures of this kind on exhibition, and, as might be expected, they are entire failures: each lock of hair, each finger, every thread of drapery is perfect, but altogether they are devoid of impressive effect. The generality of this school choose subjects in accordance with their ideas of Art; hence we have a great number of trifling things, fitted only to display the skill of the painter and his want of reflection. Of this species of Art we have a Dutchman smoking a pipe in bed; a man shooting a cat; an unfortunate servant who has broken her tray of dishes; a boy smoking his first cigar, and so forth. The other school is constituted of the "Artists of Düsseldorf," and embraces Lessing, Sohn, Köeler, and kindred spirits. They look down on the Academy with something strongly resembling contempt; nor can this be wondered at, for, when we reflect on the manner in which the Academy students are educated, the time required, and the result, it seems strange that it does not call forth something stronger than a sneer.

The Gallery of Old Masters, which was once such an attraction at this place, was removed some twenty years ago to Munich. There are, however; three galleries open to the public; one permanent, the other two annual. The permanent exhibition is an excellent arrangement for the accommodation of artists and persons purchasing works of Art, and is constantly open, either for the sale or exhibition of paintings. At the present time there are about two hundred pictures on exhibition, two-thirds of these being landscapes, fruit-pieces, and still-life. Among the first-mentioned is a landscape, by Oswald Achenbach, of a sunset on Roman scenery, which is remarkable for its effect on the mind; it is one of those things over which a poet would love to dream. In the whole exhibition only three paintings represent noble effort; they are the "Concealment of Moses," by Köeler; the "Departure of Columbus for America" by Leutze; and a sketch by Lessing of his "Martyrdom of Huss." Three pictures by Heildemann, and two by Ti[e]demand of domestic incidents are excellent. In the other two exhibitions, composed of several hundred pictures, from all Europe, there are not more than ten worth

14. George Caleb Bingham, *The Jolly Flatboatmen in Port* (1857, painted in Düsseldorf). Oil on canvas, $46\frac{1}{4}''\times 68\frac{15}{16}''$. (The St. Louis Art Museum)

mentioning; of those one-half are *genre* pictures, and two are landscapes; of the remaining three, one is a Syren, by Sohn; a large picture of Christ on the Water, by the same artist; and a girl imploring pardon of her mother, by one of the professors.

Contemplated from your point of view across the Atlantic, it may seem impossible that in three exhibitions, in the very centre of an æsthetical country, so few should even pretend to high Art; such, however, is the case. Taken altogether, the pictures show a lack of comprehension of the object of Art, with a wonderful power of execution. Nearly all their subjects are used as mere vehicles to display their knowledge of the means of Art, to hold a beautiful arrangement of color, of light, and shade, or to astonish by the perfection of a foreshortened limb. Very few of the *genre* pictures reach above this standard, and excite either a touch of feeling, or call forth the tribute of a smile. The same is true of the majority of their landscapes; some are as perfect imitations of Nature as could be desired,

but it is Nature as most men see it—unadorned, barren, and without ideality.

It may be interesting to your readers, particularly those of the West, to know that Mr. Bingham and his family are residing here. He came to Europe about a year ago, in order to have his last picture ("The People's Verdict") engraved. At first he went to Paris, but not finding an engraver to his taste, came here. He has engaged Mr. Brurnye to make a lithograph of it; it will be done in nine months. Since coming here he has painted a composition of the "Jolly Flat-boatmen," [Fig. 14] a scene of Western life, and it is creditable to his reputation. His portrait of Washington, for the Missouri State House, is completed, and that of Jefferson commenced. Mr. Bingham will probably remain here for another year.

L.* *

FROM *The Crayon*

American Students in Paris

[January 1857]

T he following extracts from a private letter contain information which will be acceptable to our readers generally, especially to students of Art who desire to pursue their studies abroad. The writer dates from Paris, and says:

We are studying in the atelier of *Couture,* that is his pupils' atelier which is a large, well-lighted room in the Rue Fontaine. There are in all about sixty students, but not more than one-half of these attend regularly; this week however, they number more than usual, and as cold weather comes on they will begin to throng in from the country, and we will have a house full. Shortly after my arrival we called upon Couture. We were received by a little fat man with black hair, keen black eyes and a tremendous black moustache. In his room was an immense canvas upon which was the charcoal sketch of "The Baptism of the Imperial Infant," a commission from Louis Napoleon upon which he is at present engaged. We paid him sixty francs each which is for six months' tuition, and an entrance fee of thirty francs. At the end of three months we are to pay thirty francs more, and at the end of six months the remaining thirty, which complete the one hundred and twenty francs, the price for a year's tuition, which gives you the use of the model including easel, chairs, etc.

The following paragraph will interest none but those who appreciate technical matters:

We go to the atelier at seven o'clock in the morning at which hour the pose commences, and we work until twelve. The pose then ceases for the day, but students have the liberty of working in the atelier the remainder of the day if they choose to do so, and often several club together and keep the model an hour or two beyond the regular time. The price of model hire is one franc an hour. I believe this is the established rate. The pose lasts a week. Our manner of working according to Couture's system is very simple. A drawing is made, and the frotta is made very warm and rich with the shadows darker than in reality. Upon this preparation you paint, using your color with as little vehicle as possible, and not brushing it at all. The preparation is calculated to show through, in order to give transparency and richness to the shadows: the shadows are painted thin, and the lights are heavily loaded. The palette for flesh is very simple: white, Naples-yellow, yellow-ochre, vermilion, brown-red, cobalt, and bitumen; no cadmium or veronese green as we used to think. They say, however, that Couture has changed his system of color of late years. Notwithstanding its simplicity, I find it extremely difficult to make anything but *mud* in my color. Unless the color is of the proper hue, tone, and purity and laid upon the exact spot, you can do nothing, as all modelling with the brush destroys purity of color. I don't know whether I can do anything with it or not. The great majority of his pupils are the most servile copyists of his worst faults. I believe Couture is the only man living who can paint well in his manner, and he does wonderful things with it. Some of his pupils get good, pure qualities of color, but they paint no more what they see in the model than if there was no model before them. Week after week they reproduce the same stereotyped color, and draw the same *graceful*, characterless figures. They are crazy after color, and sacrifice form, texture, and everything else to attain that alone. I still adhere to a conscientious rendering of the model as near as I can, and intend to let all *systems* slide, and keep the early teachings of Hicks ever before me. I think a year in Couture's atelier will be profitable, as drawing and painting from life every day, cannot fail to prove beneficial.

In the above allusion to Mr. Hicks we are not sorry to see an endorsement of home instruction, for, taking all things into consideration, we believe it to be adequate to the wants of any young artist, without going abroad, certainly until an advanced period of a professional career. Intending, however, to say more upon this subject at some future time, we pass on to other

portions of the letter. We are glad to have an opportunity to show the moderate cost of living in Paris:

We are going to move. T———H——— and I have rented a fine large atelier, with a chamber attached, which we get for 800 francs per annum. We had to pay six months rent in advance to secure it. We get it unfurnished, but furniture of all kinds is cheap in Paris, and we save a great deal by the arrangement, as the lights and fire for one answers for three. I can live here in that way upon four hundred dollars a year. I think I can pay all expenses with that amount; after I learn to speak the language better, I can get along cheaper.

As to Paris, there is no doubt of its being the greatest city in the world: there is the least annoyance of any kind here that can be found anywhere. The city is clean and healthy. Everything is attended to, and the comfort of the individual is *well* attended to. I can compare living here to nothing so illustrative as a piece of perfect and well-oiled machinery, every part performing its function with precision, without noise or interference with any other portion. Paris is a city of Art; you see evidences of taste and cultivation everywhere; in the houses and their decorations, inside and out; in the gardens and public places; in the numerous statues, and fountains, and bridges, and streets. Paris is very brilliant at night, especially upon the Boulevards. We often take long strolls after supper up and down these thoroughfares, and through the brilliantly-lighted passages, where are displayed the most attractive goods of every description.

In the afternoons we generally go to the Louvre until four o'clock, at which hour it closes, and then walk to some of the gardens, or turn over the many portfolios of engravings to be found along the quays opposite the Louvre and Tuileries. Second-hand engravings are very cheap, and I occasionally pick up something very good. There are portions of Paris we have not yet visited, and we are taking it leisurely. The Louvre alone is a good six months' work to study. My opinion of the "old masters" is about the same. Undue praise and exaltation had led me to expect too much of them, and consequently I was disappointed; but many of them are very great (when viewed as old masters, and with no reference to Nature) as far as execution goes. There are in the Louvre several galleries of the drawings by the celebrated old masters that interest me much more than their pictures. The collection of antique sculpture is very fine; the Venus of Milo, the Fighting Gladiator, and many other old acquaintances are there. Besides the antique there are galleries

of Renaissance and modern French sculpture, together with casts of all the celebrated antiques not at the Louvre. In the Renaissance department are two figures by Michael Angelo, two prisoners, that are very great. If one did not improve with all the advantages that are to be had in this city of Art, the fault would rest with himself, and it would be wiser in him to quit at once, and find some work better suited to him. We in the United States can have no conception of the extent to which the Fine Arts have been carried until we see with our own eyes. Books can give no idea of the vast wealth of pictures, statues, bas-reliefs, and the immense accumulation of Art-treasures in this Old World. It requires talent of a high degree to enable an artist to make a name in this country; there are thousands of men in Paris who draw the human figure beautifully, but who are scarcely ever heard of.

We spent a day at Versailles about six weeks ago. Among others there is a fine picture there by Delaroche, of "Charlemagne Crossing the Alps." You have ere this heard with regret of the death of this great man, which happened some two weeks ago. I attended his funeral, which was a very large one. The procession of artists and students that followed the hearse on foot, filled up the entire street for a long distance. The students from the different ateliers were present. I had a good view of Horace Vernet as we were going to the cemetery. He looks much younger than he really is, and is of a wiry, energetic temperament. He is now over seventy years of age. All the celebrated men here in the Fine Arts are well advanced in years. Ary Scheffer's atelier is but a moment's walk from our room. He receives company, I understand, on Wednesdays, and we intend to go some day to call on him, as he speaks English, and is very kind to strangers. I have been told that many of his great pictures are in his room, such as his "Francesca di Rimini," and others familiar to us all in engravings.

FROM *The Gentle Art of Making Enemies*

James Abbott McNeill Whistler

Why should not I call my works "symphonies," "arrangements," "harmonies," and "nocturnes"? I know that many good people think my nomenclature funny and myself "eccentric." Yes, "eccentric" is the adjective they find for me.

The vast majority of English folk cannot and will not consider a picture as a picture, apart from any story which it may be supposed to tell.

My picture of a "Harmony in Grey and Gold" is an illustration of my meaning—a snow scene with a single black figure and a lighted tavern. I care nothing for the past, present, or future of the black figure, placed there because the black was wanted at that spot. All that I know is that my combination of grey and gold is the basis of the picture. . . .

. . . The picture should have its own merit, and not depend upon dramatic, or legendary, or local interest.

As music is the poetry of sound, so is painting the poetry of sight, and the subject-matter has nothing to do with harmony of sound or of colour.

The great musicians knew this. Beethoven and the rest

wrote music—simply music; symphony in this key, concerto or sonata in that.

On F or G they constructed celestial harmonies—as harmonies—as combinations, evolved from the chords of F or G and their minor correlatives.

This is pure music as distinguished from airs—commonplace and vulgar in themselves, but interesting from their associations, as, for instance, "Yankee Doodle," or "Partant pour la Syrie."

Art should be independent of all clap-trap—should stand alone, and appeal to the artistic sense of eye or ear, without confounding this with emotions entirely foreign to it, as devotion, pity, love, patriotism, and the like. All these have no kind of concern with it, and that is why I insist on calling my works "arrangements" and "harmonies."

Take the picture of my mother, exhibited at the Royal Academy as an "Arrangement in Grey and Black." [Fig. 15] Now that is what it is. To me it is interesting as a picture of my mother; but what can or ought the public to care about the identity of the portrait?

The imitator is a poor kind of creature. If the man who paints only the tree, or flower, or other surface he sees before him were an artist, the king of artists would be the photographer. It is for the artist to do something beyond this: in portrait painting to put on canvas something more than the face the model wears for that one day; to paint the man, in short, as well as his features; in arrangement of colours to treat a flower as his key, not as his model.

This is now understood indifferently well—at least by dressmakers. In every costume you see attention is paid to the key-note of colour which runs through the composition, as the chant of the Anabaptists through the *Prophète,* or the Huguenots' hymn in the opera of that name.

CRITIC'S ANALYSIS

In the "Symphony in White No. III." by Mr. Whistler there are many dainty varieties of tint, but it is not precisely a symphony in white. One lady has a yellowish dress and brown hair and a bit of blue ribbon, the other has a red fan, and there are

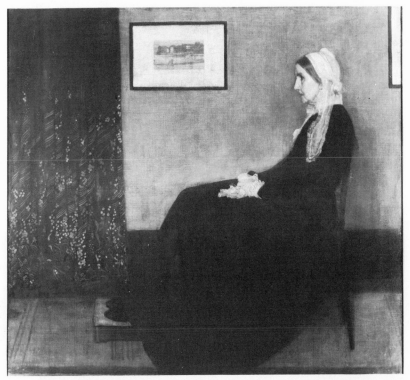

15. James McNeill Whistler, *Arrangement in Grey and Black No. 1: The Artist's Mother* (1872). Oil on canvas, $57\frac{7}{8}'' \times 64\frac{5}{8}''$. (Louvre: courtesy of the Musées Nationaux, Paris)

flowers and green leaves. There is a girl in white on a white sofa, but even this girl has reddish hair; and of course there is the flesh colour of the complexions.

THE CRITIC'S MIND CONSIDERED

How pleasing that such profound prattle should inevitably find its place in print! "Not precisely a symphony in white. ... for there is a yellowish dress. ... brown hair, etc..... another with reddish hair ... and of course there is the flesh colour of the complexions."

Bon Dieu! did this wise person expect white hair and chalked faces? And does he then, in his astounding conse-

quence, believe that a symphony in F contains no other note, but shall be a continued repetition of F, F, F? Fool!

CHELSEA,
June 1867.

(published 1890)

FROM *Whistler's "Ten O'Clock" Lecture*

James Abbott McNeill Whistler

. . . I mean to talk about Art. Yes, Art—that has of late become, as far as much discussion and writing can make it, a sort of common topic for the tea-table.

Art is upon the Town!—to be chucked under the chin by the passing gallant—to be enticed within the gates of the householder—to be coaxed into company, as a proof of culture and refinement.

If familiarity can breed contempt, certainly Art—or what is currently taken for it—has been brought to its lowest stage of intimacy.

The people have been harassed with Art in every guise, and vexed with many methods as to its endurance. They have been told how they shall love Art, and live with it. Their homes have been invaded, their walls covered with paper, their very dress taken to task—until, roused at last, bewildered and filled with the doubts and discomforts of senseless suggestion, they resent such intrusion, and cast forth the false prophets, who have brought the very name of the beautiful into disrepute, and derision upon themselves.

Alas! ladies and gentlemen, Art has been maligned. She has

naught in common with such practices. She is a goddess of dainty thought—reticent of habit, abjuring all obtrusiveness, purposing in no way to better others.

She is, withal, selfishly occupied with her own perfection only—having no desire to teach—seeking and finding the beautiful in all conditions and in all times, as did her high priest, Rembrandt, when he saw picturesque grandeur and noble dignity in the Jews' quarter of Amsterdam, and lamented not that its inhabitants were not Greeks.

As did Tintoret and Paul Veronese, among the Venetians, while not halting to change the brocaded silks for the classic draperies of Athens.

As did, at the Court of Philip, Velasquez, whose Infantas, clad in inæsthetic hoops, are, as works of Art, of the same quality as the Elgin marbles.

No reformers were these great men—no improvers of the way of others! Their productions alone were their occupation, and, filled with the poetry of their science, they required not to alter their surroundings—for, as the laws of their Art were revealed to them they saw, in the development of their work, that real beauty which, to them, was as much a matter of certainty and triumph as is to the astronomer the verification of the result, foreseen with the light given to him alone. In all this, their world was completely severed from that of their fellow-creatures with whom sentiment is mistaken for poetry; and for whom there is no perfect work that shall not be explained by the benefit conferred upon themselves.

Humanity takes the place of Art, and God's creations are excused by their usefulness. Beauty is confounded with virtue, and, before a work of Art, it is asked: "What good shall it do?"

Hence it is that nobility of action, in this life, is hopelessly linked with the merit of the work that portrays it; and thus the people have acquired the habit of looking, as who should say, not *at* a picture, but *through* it, at some human fact, that shall, or shall not, from a social point of view, better their mental or moral state. So we have come to hear of the painting that elevates, and of the duty of the painter—of the picture that is full of thought, and of the panel that merely decorates.

Nature contains the elements, in colour and form, of all pictures, as the keyboard contains the notes of all music.

But the artist is born to pick, and choose, and group with

science, these elements, that the result may be beautiful—as the musician gathers his notes, and forms his chords, until he bring forth from chaos glorious harmony.

To say to the painter, that Nature is to be taken as she is, is to say to the player, that he may sit on the piano.

That Nature is always right, is an assertion, artistically, as untrue, as it is one whose truth is universally taken for granted. Nature is very rarely right, to such an extent even, that it might almost be said that Nature is usually wrong: that is to say, the condition of things that shall bring about the perfection of harmony worthy a picture is rare, and not common at all.

This would seem, to even the most intelligent, a doctrine almost blasphemous. So incorporated with our education has the supposed aphorism become, that its belief is held to be part of our moral being, and the words themselves have, in our ear, the ring of religion. Still, seldom does Nature succeed in producing a picture.

The sun blares, the wind blows from the east, the sky is bereft of cloud, and without, all is of iron. The windows of the Crystal Palace are seen from all points of London. The holiday-maker rejoices in the glorious day, and the painter turns aside to shut his eyes.

How little this is understood, and how dutifully the casual in Nature is accepted as sublime, may be gathered from the unlimited admiration daily produced by a very foolish sunset.

The dignity of the snow-capped mountain is lost in distinctness, but the joy of the tourist is to recognise the traveller on the top. The desire to see, for the sake of seeing it, is, with the mass, alone the one to be gratified, hence the delight in detail.

And when the evening mist clothes the riverside with poetry, as with a veil, and the poor buildings lose themselves in the dim sky, and the tall chimneys become campanili, and the warehouses are palaces in the night, and the whole city hangs in the heavens, and fairy-land is before us—then the wayfarer hastens home; the working man and the cultured one, the wise man and the one of pleasure, cease to understand, as they have ceased to see, and Nature, who, for once, has sung in tune, sings her exquisite song to the artist alone, her son and her master—her son in that he loves her, her master in that he knows her.

To him her secrets are unfolded, to him her lessons have become gradually clear. He looks at her flower, not with the

enlarging lens, that he may gather facts for the botanist, but with the light of the one who sees in her choice selection of brilliant tones and delicate tints, suggestions of future harmonies.

He does not confine himself to purposeless copying, without thought, each blade of grass, as commended by the inconsequent, but, in the long curve of the narrow leaf, corrected by the straight tall stem, he learns how grace is wedded to dignity, how strength enhances sweetness, that elegance shall be the result.

In the citron wing of the pale butterfly, with its dainty spots of orange, he sees before him the stately halls of fair gold, with their slender saffron pillars, and is taught how the delicate drawing high upon the walls shall be traced in tender tones of orpiment, and repeated by the base in notes of graver hue.

In all that is dainty and lovable he finds hints for his own combinations, and *thus* is Nature ever his resource and always at his service, and to him is naught refused.

Through his brain, as through the last alembic, is distilled the refined essence of that thought which began with the Gods, and which they left him to carry out.

1885

Realism and Romanticism in Homer, Eakins and Ryder

Lloyd Goodrich

It is often asserted that the dominant trend in American art is realism, which is supposedly in accord with the practical and materialistic character of our culture. How far this is from the truth may be shown by an analysis of the varying proportions of realism and romanticism in three of our leading painters of the last third of the nineteenth century—Winslow Homer, Thomas Eakins and Albert Ryder.

Homer and Eakins were the chief American figures in the world-wide naturalistic revolt against romanticism and neo-classicism about the mid-century. Though both had foreign experience, they spent most of their lives in America and drew the material for their art from American life. In their hands the picturing of the American scene that had existed from early days was brought to maturity.

From Homer's beginnings as an illustrator his subject-matter was contemporary life, seen with the naturalist's direct vision. But it was the idyllic side of contemporary life that he chose to paint. Though he lived in New York over twenty years he never painted a city scene. In this he was not alone. American cities were far from the civilized harmony of Paris or Rome, and to picture them as they were required a candor rare

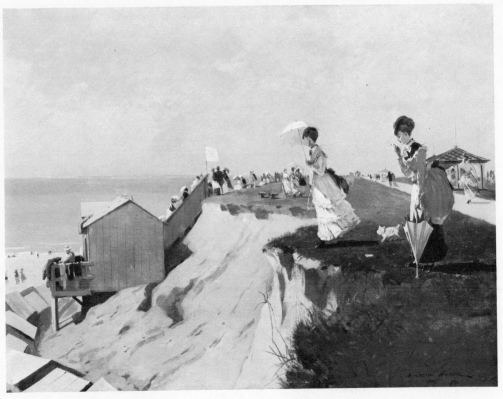

16. Winslow Homer, *Long Branch, New Jersey* (1869). Oil on canvas, 16″ × 21¾″. (Courtesy Museum of Fine Arts, Boston. Charles Henry Hayden Fund)

among our nineteenth-century artists. Until the turn of the century, with the appearance of the Eight, hardly a painter of standing attempted honestly to portray the American city nor what man had made of much of the American land.

Country life was Homer's almost exclusive theme in early years. His delightful pictures of summer resorts (Fig. 16), in which women played the leading roles, reveal an admiration for feminine beauty and an eye for fashion. He was one of the first and most sympathetic painters of the American girl. But a certain aloofness as compared to the intimacy of Courbet, Renoir or even Degas, revealed a typically American romanticism in his attitude towards women.

More often he turned to the simpler life of the farm. These rural scenes showed a love of outdoors, of good-looking young men and women, of all the healthy and pleasant aspects of

Realism and Romanticism in
Homer, Eakins and Ryder

Yankee farm life. They were the most authentic expressions of the nostalgia for the farm that was so important a part of the American consciousness in the nineteenth century. In many of them children played the chief parts, as they had in most American genre painting from Mount on. Homer's deep sympathy with childhood had no trace of Victorian sentimentality. He had retained both the child's sense of wonder and the child's realism; his art was the world as a boy saw and felt it, painted with a man's grasp of actuality. This self-identification with childhood appeared also in much American literature of the period; our writers and artists of the Gilded Age often understood children better than the bewildering industrialized world in which they found themselves.

Thus Homer's early work, with its avoidance of the uglier aspects of the American scene, its focussing on country life, its tone of reserved idyllicism, was a blend of naturalism and romanticism. More purely naturalistic was his style, with its innocent eye, its directness and its utter veracity.

When Homer was approaching fifty his life and art underwent a fundamental change. He left New York and settled in a lonely spot on the Maine coast, where he lived the rest of his life, absolutely alone. What lay behind this withdrawal from civilization we shall never know. An unhappy love affair must have deeply affected his attitude towards women and society. But equally important was his growing love of solitude and of the elements of nature least touched by man—the sea, the forest, the mountains.

From this time on his subjects changed. Childhood and pastoral life disappeared, and women were less and less evident. His chief themes became the sea and the wilderness and the hardy men who made their living out of them. A series of famous sea stories such as *The Life Line* and *Eight Bells* [cover illustration] pictured the peril of the sea and the drama of man's struggle against it, and celebrated the elemental masculine virtues of physical strength and courage. Homer had turned his back definitely on the modern world, yet characteristically he remained faithful to actual life—but of the most primitive kind. The romanticism that had marked him from the first was now more fully developed.

The few women he now pictured were no longer the elegant young ladies of earlier years but sturdy outdoor women, robust as men. His earlier sentiment had disappeared. One thinks of

the sensuous warmth of Manet and Renoir, the humanity of Eakins, and one sees that with Homer the element of sex, one of the motivating forces of all vital art, had become sublimated out of all recognition. To this sexlessness, typical of most American painting of the day, we can ascribe the externality of his art and its limitations in plasticity and movement.

With the passing of the solitary years face-to-face with the ocean, humanity gradually disappeared from his art, and his chief subject became the sea. The drama of man's struggle against nature was replaced by the drama of the sea itself and its never-ending battle with the land. Not the sea at peace, but at its stormiest and most dangerous. His great marines and his grim Maine winter scenes contrasted strongly with most American landscapes of the time, devoted to the tender, smiling moods of nature. Homer was concerned with nature in some of her loneliest, most desolate and most perilous aspects. By contrast with the prevailing feminine conception of landscape, his conception was masculine, dramatic, and often tragic.

Homer's conscious artistic philosophy was naturalistic, as were his vision and style. But the content of his art revealed a strong admixture of romanticism. He ignored the central social forces of his period and place, and devoted himself to nature and the most primitive forms of contemporary life. He became the painter of solitude, of the drama and danger of the sea, the wild freshness of forest and mountain, and the hardy life of outdoor men. In this he continued in a more naturalistic form the romanticism of the Hudson River school and of Inness, Martin and Wyant—that romanticism which was one of the two chief driving forces of nineteenth-century American art. If one contrasts this with the attitude towards the modern world of a present-day painter like Edward Hopper, in many ways akin to Homer, with a similar deeply-concealed romanticism, but who paints the American city and the realities of the American landscape with a completeness of acceptance that no nineteenth century painter showed, one is aware of a fundamental change in the contemporary artist's attitude towards the world we live in.

A more thoroughgoing realist than Homer was Eakins. Eakins took the ordinary middle-class city life of his period and built his whole art out of it. In a day when most American painting was a sentimental idyll of sunlight and pretty faces, he

concentrated on certain basic realities of the life around him —on men and women, their faces and bodies and clothes, their houses and furniture, their occupations and recreations. His art was centered on the human being. Nature to him was a setting for man. Although he painted many outdoor scenes, they included only one pure landscape.

Few artists have been more complete realists. Every figure was a portrait, every scene an actual one, every object real. His attitude towards his material was objective, with little direct expression of subjective emotion. Beauty as an end in itself, distinct from or opposed to objective truth, was inconceivable to him. The beauty that his work did unquestionably achieve was a by-product of his search for essential realities. This devotion to actuality excluded any fantasy. He was not even interested in new places, as Homer was; his own community sufficed.

Like Homer, Eakins in his youth showed a wider interest in the contemporary scene than later. In early manhood he painted many aspects of the life around him—outdoor and sporting scenes, domestic genre, ambitious subject pictures like the *Gross* and *Agnew Clinics.* These works showed a healthy extroverted interest in the life of his community, a love of outdoor activities, a sense of man in his relation to nature, even a note of grave paganism. Domestic subjects like *The Chess Players* had an undertone of intense feeling for family life; with all their objectivity they were rich in humanity. In his two great paintings of surgical clinics he attacked a theme that few artists up to that time had, but a theme of central importance in the modern age—the drama of science and its battle against disease and death.

To Eakins, as to many great artists, the human figure was the very basis of art. Thorough training in a medical college had given him a knowledge of anatomy greater than any contemporary's in America. But there was nothing coldly academic in his attitude; underlying his science was that deep sensuousness that is the basis of all plastic art. His figures had an energy and a largeness of form that made him the most powerful figure painter of his time in America. As a teacher his whole system was founded on the nude. Yet he seldom painted it. A deep conflict existed between his interest in the nude and his realism. Realism limited him to what he saw in the life around him, and Philadelphia of the late nineteenth century was not

Greece. The human form was well hidden by voluminous skirts and bustles, drab business suits and high collars. Sports like swimming, rowing and prize fighting, it is true, did offer opportunities to paint the male body. But Eakins was incapable of fancy; like Courbet, who said that he would paint angels if anybody showed him one, he would paint the nude only if he saw it. Often he asked women sitters to pose for him nude —a habit that caused scandal.

Among his few pictures of the female nude were his various versions of the William Rush story (Fig. 17). Rush, the early American sculptor, had used as a model a young Philadelphia belle who had consented to pose nude. This theme appealed so strongly to Eakins that he painted it no less than four times. That he came consciously to identify himself with Rush is shown by the fact that in one of the last versions he substituted himself for the sculptor.

When Eakins was in his early forties his insistence on the complete nude in teaching anatomy led to a conflict with the directors of the Pennsylvania Academy and his resignation as head of the school—a severe blow to his career and his art. There had been other discouragements. His work had met with hostility or neglect from the official art world. Even his genre pictures, lacking Homer's more obvious sentiment, had failed to appeal to the public. By the age of thirty-six he had sold only eight paintings, for a total of $2,000. Any artist is to some extent dependent on a sense of solidarity with society. If he is a realist, drawing his material entirely from the life around him, unable to live in a world of fantasy, lack of this solidarity may be serious, even for so strong a character as Eakins.

When he was about forty Eakins abandoned the broader subject-matter of his early years, except occasionally, and devoted himself almost entirely to portraiture. Shutting out the outside world, he concentrated on the individual human being. This was curiously parallel to Homer's withdrawal from civilization about the same time. But Eakins remained a realist, and humanity remained the center of his art. He simply limited his field of vision to a narrower focus.

Within this more restricted field he attained a new mastery. Since he was never successful in a worldly way, his sitters were almost all people whom he asked to pose—his family, friends or pupils, or people who interested him—so that his portraits

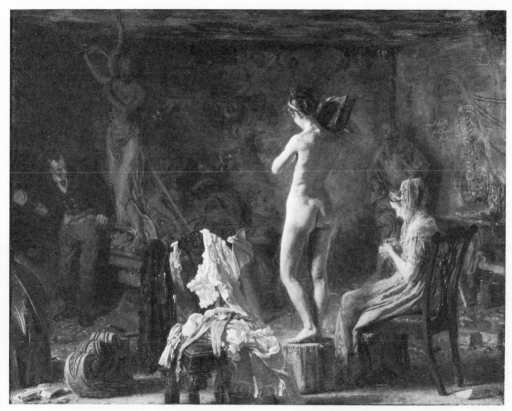

17. Thomas Eakins, *William Rush Carving His Allegorical Figure of the Schuylkill River* (1876). Oil on canvas, 20⅛″ × 26⅛″. (collection of the Philadelphia Museum of Art: Given by Mrs. Thomas Eakins and Miss Mary A. Williams)

were labors of love. To him a man's work was an essential part of him, and he liked to show him engaged in it—a more realistic conception than the conspicuous leisure favored by most portraitists. His interest was above all in character, and in his relentless search for it he disregarded the charms of youth, fashion and conventional ideas of beauty. Like Rembrandt he loved old age, and he often made his sitters less young and attractive than they actually were. His passion for character made him give them more than they actually possessed—an urge towards plastic creation of which he was probably not conscious. Though never glamorized, his women had a flesh-and-blood quality and a sense of sex quite different from the etherealism with which most of his American contemporaries pictured women. His people are alive; attractive or ugly, they exist, they are individuals like no one else in the world. They

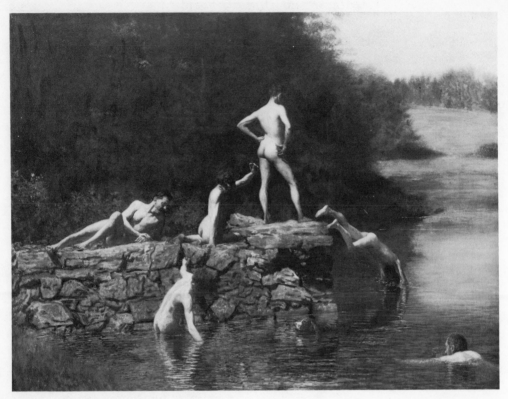

18. Thomas Eakins, *The Swimming Hole* (1883). Oil on canvas, 27″ × 36″. (Collection of The Fort Worth Art Museum)

are seen with a humanity, a depth of insight, an inner life, that make almost every portraitist of the time seem superficial. Within its narrow range his portraiture is the most penetrating and revealing pictorial record of America of the period.

One cannot but regret, however, the lack of the broader subject-matter of his early years. Portraiture did not offer the emotional and plastic possibilities of freer subjects. In his few paintings in which the nude had played a part, such as *The Swimming Hole* (Fig. 18), he had achieved the freest movement and the richest design. Had he not confined himself to portraiture he might have added to his naturalistic power and his mastery of the single figure a plastic completeness beyond any American of the time except Ryder. The deep and healthy sensuousness of his nature never fully expressed itself. The limitations of his environment, combined with his own realistic limitations, prevented full realization of his potentialities.

Realism and Romanticism in
Homer, Eakins and Ryder

One might sum up the differences between the realism of Homer and Eakins by saying that Homer was a romantic naturalist, who enjoyed the spectacle of the external world, its light and color, the comeliness of men and women, and the wildness and force of nature, and painted these things in a vigorous masculine style, with a strong sense of decorative values; while Eakins was an almost pure realist, picturing only the realities around him, interested above all in the human being, concentrating on character and organic structure, and to this austere purpose sacrificing extraneous charm. Homer's naturalism was free, varied and colorful; Eakins' was concentrated, powerful and profound.

At the opposite extreme from Eakins' realism was the romanticism of Albert Ryder. A New Englander of long ancestry, like Homer, he was born and brought up in New Bedford, then the greatest whaling port in the world, and the sea must have played a large part in his consciousness from the first. Living like a hermit in New York City, he created an art that had no direct relation to the world around him. His early works were mostly small landscapes, reminiscences of the country around New Bedford with its secluded pastures, old stone walls and grazing horses and cows. The hours are seldom full daylight, but golden afternoon, twilight or moonlight. There is a strangeness in these little canvases; they seem memories of the landscapes of childhood, transformed by the mind into scenes akin to those in dreams. Here was an utterly personal art, product of a mind that lived in a world of its own.

In his thirties Ryder left behind the relative naturalism of these subjects and embarked on more imaginative themes. For many of them he drew on the Bible, on mythology, on the great poetical literature of the world—Chaucer, Shakespeare (his favorite poet), and the nineteenth-century romantics, Byron, Moore, Campbell, Poe, Tennyson; and on the music of Wagner—*Siegfried* and *The Flying Dutchman.* On the other hand his simpler fantasies such as his seascapes had no literary sources, and one of his most extraordinary conceptions, *The Race Track,* was entirely personal, resulting from the suicide of a friend who had lost his life's savings on a horse race. Ryder's works were never literary in the ordinary sense; they were pictorial dramas inspired by great themes, and the themes were transformed into something purely individual.

In all his work nature played an essential part, as in *Macbeth*

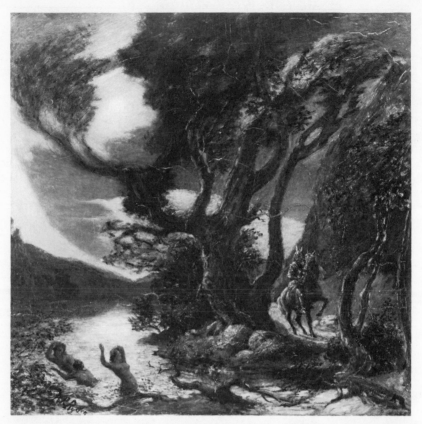

19. Albert Pinkham Ryder, *Siegfried and the Rhine Maidens* (1888–91). Oil on canvas, 19⅞″ × 20½″. (National Gallery of Art, Washington. Andrew Mellon Collection)

and the Witches, where the blasted heath under the wind-torn moonlit sky is not a background but a leading actor, as eloquent of dread and doom as the human actors. To Ryder as to all romantics, nature was not an external phenomenon but an embodiment of man's subjective self. The sea, which has always meant so much to New England, haunted this transplanted New Englander. He never forgot its vastness, its eternal rhythmic flow, its loneliness, and its profound peace. In his frequent concept of a lone boat sailing moonlit waters he gives us the sea as it lives in the mind, an image of infinity and eternity, amid which the boat seems a symbol of man's journey through life.

Ryder was more than a simple nature poet; always the

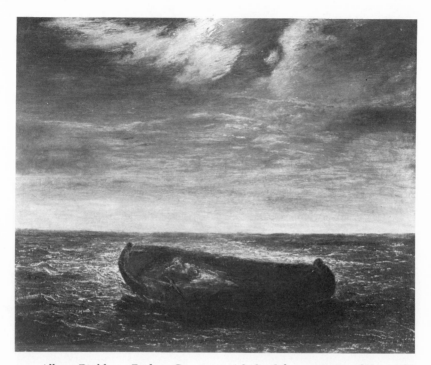

20. Albert Pinkham Ryder, *Constance* (1896). Oil on canvas, $28\frac{1}{4}'' \times 36''$. (Courtesy Museum of Fine Arts, Boston. Abraham Shuman Fund)

human or the superhuman were the center of his conceptions. Often the human being is shown at the peril of nature's forces, but under divine guardianship, as in *Jonah,* where God is visibly watching over his prophet, or in *Constance* (Fig. 20), where the mother and child lie in their sailless, rudderless boat in the waste of waters, miraculously preserved and guided towards home. To Ryder such themes were not outworn legends but living poetic truth. He was one of the few religious painters of modern times in whom one feels not mere conformity but profound personal emotion. Though his art lacked the tremendous range of a Delacroix, it had the emotional depth and integrity, the unconsciousness, and the belief, of the great age of romanticism.

Ryder was a visionary, one who lived in a dream world and to whom that world had more reality than his actual surroundings. The word "dream" has been sentimentalized out of all meaning, but in the scientific sense of imagery arising out of the unconscious mind, his art was literally the repre-

167

sentation of dreams. In his mind actuality went through a long process of transformation, emerging as the inner image of the mind's eye. This purity of the inner image is a quality as precious as it is rare in modern painting. With all its visionary character, his art carries the conviction of something seen and experienced, which gives it an intense and haunting reality.

Though he seldom painted direct from nature, like Homer and Eakins, he did much looking at and absorbing of external reality, especially in long walks on moonlit nights, when as he said he "soaked in the moonlight." There was a definite element of naturalism in his work; his strange cloud shapes were well observed, and few have painted the colors of moonlight so accurately. His pictures were always in essential harmony with natural laws; his distortions seem to have been largely unconscious. But he was never bound by the doctrine of literal faithfulness to nature that governed his older American contemporaries. As he said: "The artist should fear to become the slave of detail. He should strive to express his thought and not the surface of it. What avails a storm cloud accurate in form and color if the storm is not therein?" He used the elements of reality far more freely than any painter of his time in this country. He not only simplified them to their essentials, he remoulded them, making them obey the rhythms of his instinctive sense of design. His art possessed that plastic freedom and creativeness which Homer altogether lacked and which in Eakins was inhibited by realism. Its qualities of musical form and color, and above all of design, place him among the purest plastic creators of his century.

Though Ryder's art had little to do with the dominant naturalistic trend of his period, it had much to do with the future. When the modern movement reached these shores it became apparent that he had anticipated certain of its tendencies—its freedom from literal naturalism, its sense of plastic design, its discovery of the subconscious mind.

Homer the romantic naturalist, Eakins the realist, Ryder the romantic, were the three American painters of their time who have the most meaning for us today. All three were strong individualists, spending most of their lives in this country, relatively little affected by influences from abroad, and more or less opposed to the surface currents of their period. Few artists can be called more "American." Viewed together, they dis-

168

prove the assumption that the most characteristically "American" art is realistic, showing that on the contrary romanticism is as characteristic if not as frequent, and that the two strains intermingle, sometimes in the same individual.

<div align="right">1949</div>

Albert Ryder

Leo Stein

Among American painters of importance, Albert Ryder is the most obviously individual. He belongs to no pictorial group and does not carry with him the suggestion even of a social solidarity. He has nothing of the technical ability which many of his more distinguished countrymen show, nor has he the attitude toward the American scene which made the great majority of his contemporaries either portrait or landscape painters. These men had, in the main, gotten beyond story pictures and were engaged in setting forth the things before their eyes. Also they were much occupied in learning to paint, through having been impressed by the magniloquent but ineffectual performance of the Hudson River school that mere splendor of subject matter was not in itself accomplishment. They were not joined by Ryder in this quest for mastery, for he was more intent on satisfying his immediate need of utterance than concerned about the manner of it. His was a strange life of sparse, contracted solitude, of living careless in the midst of filth and utter disorder, of rapt indifference to what went on about him, while he was singing in his soul the old, old tunes of life and love and hope and joy. Hence he found expression to be all-important, for expression through his art was to this man of genius the only mode of realizing the good all men desire. Ryder was deeply sentimental, and it is therefore something of a paradox that, excepting perhaps only

Albert Ryder

Winslow Homer, his art is notably less sentimental than that of any important man who worked mainly in America. This paradox, like a dark lantern, has illumination hidden in it and deserves discussion.

The sentimental nature of Ryder's themes is obvious. One finds but few exceptions. In fact one gets the impression that anything that is emotionally suggestive might become the subject of his next picture. Here are landscapes simply pastoral: the brown cow, the farm house and the shady trees, all calm in the suffused light of afternoon or evening; others are romantic with winding streams, gnarled trunks and mystery-haunted title; there are nocturnes of the sea, tranquil or turbulent, in some the heavens barred with clouds lit by the sailing moon, in others clouds, portentously black, that throw dark shadows on the laboring boats; then there are a number of pictures of lovers: Florizel and Perdita, King Cophetua and the Beggar-maid, or simply, Lovers; and besides there are Shakespearian illustrations and mythologizing themes. Merely to hear the titles and descriptions of the pictures might suggest that Ryder was a negligible painter, one of the kind that has long made the Royal Academy infamous.

The facts are curiously otherwise. As a plain citizen Ryder might seem sloppy with sentimentality, but this sentimentalist was by the wayward determination of nature a powerful artist, and so he has created things that have existence in their own right; and in its own right nothing is sentimental. The essence of sentimentality is, indeed, exactly the reverse of this. If, for instance, some one on board a ship, in the open sea, looks out upon the water at bright noonday, he finds himself ringed by the world's end, where, at the horizon, water and sky meet with sharp definition. But at the sunset hour he is set free, his eyes which by an inevitable compulsion follow, follow on, no longer are restrained, for the world's end has melted into infinite distance, and sky and water, even when they have not actually become as one, play into each other for the annihilation of all measure. The mind follows the lead given by the eye, and as it is not held up by bright and single particularities, it wanders freely and vaguely into all related fields of emotional response and gathers up a plentiful harvest.

All this time, however, the ostensible objects of contemplation have been the sea and sky, which thus are made responsible for all the added meanings that have been gathered by the

wandering mind. But though even the most seductive sunset-light on waters can be looked at as so much sheer, hard fact, only a very few have self-restraint enough to keep the actual object single before them when the inducements to relaxation are so unbounded. This then is sentimentality, the unacknowledged substitution of related values, especially emotional values, for those deriving from the object that is supposedly before the mind. A perfectly non-sentimental work of art would be one whose form is made so adequate in its expressiveness as to prevent the attention from wandering elsewhere for the satisfaction of its needs. Therefore it happens that even sentimentality, as in the best of Laurence Sterne or Samuel Richardson, can be the stuff of an unsentimental art.

A landscape by Ryder has precisely this character beyond most of those which are more realistic in their intention. The crepuscular scenes that are so frequently painted, the autumnal afternoons, the carefully devised perspectives that lead into the pictures and beyond, all these are just inducements, as are their equivalents in nature, to such a passage from the thing before the eye, and its intrinsic values, to a remoter field of emotional stimulation. Among our older landscape painters, it is perhaps only in the case of Winslow Homer that there is prevalently, as in all truly great artists, a grip upon the form that is strong enough to hold the mind of the observer down to the actualities presented. Only in such rare cases does the landscape function as an intrinsic and sufficient form, nor send the mind off for a richer harvest of induced emotions.

Ryder created such objectively valid forms despite the fact that he was not a realist, that is, one essentially interested in the structure of things. He was rarely, if ever, interested in the mere scene before him, but he was exceedingly responsive to the feelings that the thing aroused. If he had been a lesser man, his lovers, his moonlights, and his Shakespearian scenes would have been sentimental illustrations, but in fact his sentimental reactions are embodied in a form as solid and enduring as only a great artist can ever make it. His real subject was a mood and not a fact copied from nature, but this mood had found for itself a form, from which, for the time being, it is inseparable.

It is quite common to assert that Ryder's special merit as distinguished from many others, is that he is a poet, but this explanation is quite false. There are no end of poets in the art

of painting as in the art of words. Ryder's distinction is that he is a good poet, and he is the more especially rare since more of the noticeably bad poets are sentimentalists than realists. Realistic painting carries a kind of conviction that often goes far beyond the work's real worth and gains additional support from its capacity of suggesting sentimental values. All the greatest poets, however, whether with paint or words, are realists in the sense that Giotto, Rubens, Rembrandt were, that Shakespeare, Homer, Dante also were. They, other things being equal, see more, know more, feel more, than the sentimentalist, for sentimentality is the property of all and so the realist is more inclusive. Ryder was indeed a poet but he was conspicuously limited in his poetic range as well as in his technical equipment. His mastery of form and movement was restricted, and it was only at the cost of enormous effort that he achieved his purpose far enough to satisfy his need of giving body to the enchantments of his soul. Within his practicable limits, however, he succeeded splendidly. His moonlight scenes, for instance, are not pictures of the moon trembling behind a veil of tenuous cloud, and faintly shedding light upon a vague horizon. Instead the clouds are solid, the sea is solid, the moon is solid; everything is wrought to a substantial coherence. Such clouds as Ryder painted were never seen, nor such a sea, but the effect that he successfully embodied has been felt by many. He made a universal appeal by the elementary simplicity of his sentiment, which is the sentiment of all the world in the presence of moon and sea and lovers and romantic drama. But to have given to that sentiment a form, substantial as that of the most definite realities, is an achievement of quite superlative distinction.

It is the final substantiality of his form that marks out Ryder from the many excellent poetic illustrators. It takes him quite out of the class of such men as Rossetti and Burne-Jones, or of the Siennese painters with perhaps one or two exceptions. And then he not only gives to his conceptions a powerful material embodiment, but in addition he keys his compositions up to a pitch of such intensity as to make them rhythmically quite singularly self-sufficing, and independently alive. They never rest on a dead centre, the fault of so much painting that tries to juggle with the delicacies of intricate poise but is not sensitive enough in its placements to avoid the pitfall of an immo-

bile solution. Ryder in this matter seems infallible, so exquisitely has he maintained the interplay of mutually supplementary balances.

At the same time he has given to his pictures a maximum of concentration, and thus has shown relationship with things that are among the greatest. His tiny canvases are often so massive in their structure that they become, like those of Daumier, quite deceptive as to their real size. And at the same time the masses are so gracefully fluent that the weight seems almost self-supporting. It was a supreme merit on the part of Ryder to have appreciated the significant value of his masses and to have striven so unceasingly to get them into perfect organization. Without sacrificing one ounce of their essential heaviness, he has effected their adjustment till, like some of the great rocks left poised by glaciers on the hilltops, they respond to every lightest touch, though anchored solidly against the heaviest impacts.

These splendid major qualities in Ryder's work get no considerable reinforcement from the minor ones. His fancies are not, in general, more profound or rich than those of other men. He is in respect of his inventions, no Blake, nor even a Rossetti. He has few evident originalities except some touching on the sea, but he was quite obviously much influenced by the pictures that he had seen. There are things that are certainly reminiscences of Corot and of Turner, and there are many compositions and color schemes that are conventional commonplaces. What makes them different and important is that Ryder brought them so near pictorial completion, that, while keeping all that there was in them of the plain man's elementary romantic appeal, he yet made them so vitally self-sustaining. He added to their obviousness his painfully acquired poise which slowly raised them from the chaos of diffuse, involved emotion, to the perfect, tempered discipline of freedom.

1918

5. ASPECTS OF NINETEENTH-CENTURY ARCHITECTURE IN AMERICA: TRADITIONS, INNOVATIONS, AND TECHNOLOGY

Throughout the nineteenth century, architecture on both sides of the Atlantic experienced a series of stylistic revivals and fanciful borrowings. In the United States, a classical spirit prevailed in new architecture at the beginning of the century. For some time it had been a quiet, dignified presence in the details of both Georgian (ca. 1700-1800) and Federal (ca. 1780-1820) styles. A new and more self-assertive classicism could be said to have begun in America when Thomas Jefferson (with the aid of a French architect, C. L. Clérisseau) utilized the form of a Roman temple—the Maison Carrée at Nîmes —as the basis of his design for the Virginia Capitol (1785-98) at Richmond. Fostered by generations of classical education and inspired by notions of Roman virtue and grandeur commonly evoked as models for the conduct and forms of the new republic, this classical spirit continued in architecture to the Civil War era. Its initial Roman phase had, however, developed into a Greek Revival by about 1820.

A new romanticism in the form of a Gothic Revival was introduced around 1830 and flourished alongside classicism, ending about the same time as the latter. Even Egyptian and mixtures of exotic Eastern forms found their place in an architectural climate of romantic associations. Revivals would continue throughout the century as, among others, the Venetian Gothic (reflecting Ruskin's taste), the Romanesque, the Italian Renaissance, and a late flurry of academic classicism (encouraged by the Chicago World's Fair of 1893) added their supplements to other fancies in the medley of Victorian styles.

In the meanwhile, the century of the Industrial Revolution, which began in England around 1750, had been creating dramatic technological and economic changes. From this quarter—as the building arts began to utilize ferrous metals in construction and to accommodate the functional demands of a new era of industrial and commercial enterprise—there gradually emerged an innovative thrust in architecture that would oppose the prevalent pattern of historical revivalism. But it was slow to arrive in full force, and even in the twentieth century revivalistic architecture would still be built. At the end of the Civil War, when the cast-iron dome of the U. S. Capitol [Fig. 21] at Washington was being completed, the metal framework of the dome was hidden, in deference to the historicism of the building's style, behind a classicized outer surface of the same material.

The possibilities of ferrous metal being frankly used as the basis of a structural system had been demonstrated on a large scale in Sir Joseph Paxton's cast-iron and glass Crystal Palace, built in 1851 for the Great Exposition at Hyde Park in London. New York City had its offspring version in 1853. By the 1850s, architectural cast iron (generally cast in forms imitative of historical styles born of other materials) was extensively employed on both sides of the Atlantic. In the United States, it was particularly in evidence on commercial facades, many of which still remain. As a primary structural material, however, cast iron had unfortunate characteristics: brittleness and susceptibility to collapse under the extreme heat generated by urban fires. Although Sir Henry Bessemer invented in 1855 a process whereby the more fire-resistant steel could be fabricated in quantities that made its use for architectural components practicable, only during the last two decades of the century would architectural design begin to promise its ascendancy in a structural system.

The controversy over the use of cast iron for architectural purposes was the issue at the meetings of the American Institute of Architects during the winter of 1858–59. Excerpts from the proceedings of these meetings comprise the first portion of this section of the anthology. It will be apparent to the reader that there is more here than a debate on the properties and use of cast iron, as the arguments reveal sharp confrontations of conservative and innovative points of view.

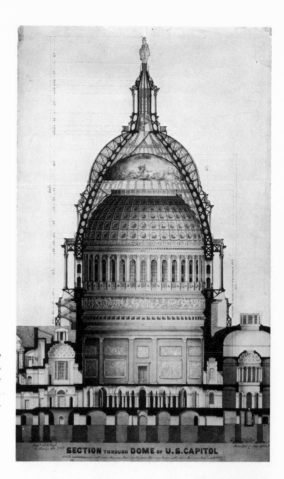

21. Thomas U. Walter, U.S. Capitol Building, cross-section of cast-iron dome (1855–64). (Courtesy of the Library of Congress)

SECTION THROUGH DOME OF U.S. CAPITOL

The next two selections belong together as a unit, since they address the significance of the Chicago World's Fair (or World's Columbian Exposition) as an architectural happening. The remarks of Montgomery Schuyler, America's foremost architectural critic of the time, seek a sober middle-ground of judgment, accepting the predominant classicism of the enterprise's style as a necessary factor in achieving a measure of unity among a multiplicity of elements; but he also recognizes that the illusionary nature of this temporary architectural fantasy contains dangers for architects should they succumb to its temptations. The remarks of Louis Sullivan are the impassioned reactions of this great American architect to the affair in Chicago. He had by this time already contributed to the development of modern commercial architecture in the United States through such important works as the Chicago Auditorium Building (1887-89) and the Wainwright Building (1890-91) in St. Louis, and his Transportation Building for the Chicago exposition displayed an originality that ran against the grain of the fair's academic classicism.

177

ASPECTS OF NINETEENTH-CENTURY ARCHITECTURE IN AMERICA

It is worth noting here that although modern eyes tend to seek out the innovative and prophetic aspects of American architecture of the 1880s and the 1890s, most eyes of that era looked with greater respect on the traditionalists, the most important of whom is the subject of the final selection in this section.

From the beginning of the post-Civil-War period until his death in 1886, Henry Hobson Richardson was America's most important architect. He has sometimes—erroneously—been called a Romanesque revivalist. Although Romanesque elements do appear in his work, he could best be called a "reform traditionalist," as the excerpts from the definitive study of this architect by Henry-Russell Hitchcock make clear.

After Richardson, there begins a steady line of development towards the skyscraper concept that would revolutionize urban architecture. The towering skyline of the American metropolis has since spread around the world, a triumphant expression of the technological and economic forces evolving from the old Industrial Revolution, but equally—it seems now, in the last quarter of the twentieth century—a conspicuous indulgence with grave implications.

FROM *The Crayon*

Discussions of Cast-Iron Architecture

AMERICAN INSTITUTE OF ARCHITECTS.

Meeting of December 7, 1858.—. . . The general business of the evening transacted, Mr. Henry Van Brunt read the following paper, on

CAST IRON IN DECORATIVE ARCHITECTURE.

It cannot be doubted that the purest eras of architecture have been those in which building material has been used with the most honest regard for its nature, attributes and capacities.
. . . The aggregate growth of the human mind constantly develops out of nature new means and appliances, new mechanical resources and constructive materials. . . . Architects become antiquaries when they feed exclusively upon the past, and are content to reproduce archæological curiosities and copy shapes, however beautiful, of a fossil art, without reanimating them with the breath and spirit of the present. . . . The result is necessarily that architecture exists merely as a cold respectful reminiscence, a lifeles[s] system of imitation and eclecticism. . . .

It becomes *us* then to look around us, and to ask ourselves with special solicitude if in our architectural works we are

expressing the character of the age in which we live. . . . The rapid advancement of mechanical and constructive science has opened an immense field for all the imaginative activity and inventive skill which can be brought to bear on architecture. And many of the requirements of modern buildings are such as cannot fairly be met without constructive devices and corresponding architectural features, for which precedent cannot be found in mediæval or classic times. This is true not only of commercial, but of domestic and, in a measure, of ecclesiastical buildings. . . . Our tendency, instead of being eclectic and conservative, should be inventive and reformative. . . .

This is called an *iron* age—for no other material is so omnipresent in all the arts of utility. Whether moulded from the furnace, battered on the anvil, or rolled in the mill, it is daily developed for new forms and new uses. Its strength, its elasticity, its ductility, its malleability, its toughness and its endurance render it applicable to a thousand exigencies of manufactures. . . . It has been again and again offered to the fine arts. But architecture, sitting haughtily on her acropolis, has indignantly refused to receive it, or receiving it, has done so stealthily and unworthily, enslaving it to basest uses and denying honor and grace to its toil. None can have failed to remark with what a storm of anathema and abuse the use of iron in decorative construction has been welcomed by every writer on the fine arts and by nearly all architects; yet they will avail themselves of it in trusses, they will use it in concealed construction, in anchors and ties, secretly to strengthen walls and relieve arches. . . . But as for making an honest system of architecture out of a material which is found so invaluable in the gravest exigencies of construction, this is quite out of the question. For how degrading and pernicious, they will cry, are its decorative uses! . . . Where, in short, are all those qualities by which our ancestors have rendered architecture an ennobling and sanctified art to us? It is in this spirit that critics on art have been accustomed to speak of this material as applied to decorative architecture. . . . They have called this in derision "a cast iron age." What if it is? Let us then make a cast iron architecture to express it; and if we set about it earnestly and thoughtfully, it is certainly within the bounds of possibility to ennoble that much reviled material.

Of all the arguments which have been urged against the decorative use of iron in architecture, perhaps the most spe-

cious have been those with reference to *machine ornament* and cast iron work generally, as entirely at variance with all preconceived notions of what ornament should express, viz.: the happiness or the sacrificial spirit of the workman, his individual thought and personal presence, as it were, in his work. . . . The greatest peculiarity of Gothic times was personal labor and enterprise. . . . All industrial arts were, in the most proper use of the word, *handicrafts.* The Gothic spirit then was a *handicraft spirit,* and, to be expressed in a noble architecture, demanded the sacrifice and thought of a varied ornamentation. Now the age which we are called upon to express is not one of individualities, but of aggregates. . . . Science has nearly destroyed personal labor, and has substituted the labor of machinery, and almost all the industrial arts are carried on not by hands but by machines. In fact, we have mechanics now, not handicraftsmen, who work not so much out of devotion to any craft, as for the homely necessities of life. Labor now is the means and not the end of life. Therefore the architecture, to express our spirit best, is . . . rather one of system. . . .When from amid the great bustle and activity of our times, we look back upon the Gothic age, and contemplate its serenity and statuesque repose, its deliberate and dreamy thoughtfulness, as it were, in all those matters of science and art embodied in architecture; when we behold how slightly time and labor were considered in questions of high art, how years passed by as days, and all effort was patient, simple, earnest and slow, we at once comprehend the secret of the success of Gothic art. Yet may not our own spirit, though apparently prosaic and leaning too much towards mere utilities, though rejoicing in clamor and hurry, may it not have its own peculiar high capacities for artistic expression? . . . Our new conditions demand new standards and new principles.

The cheapness of iron, its rapidity and ease of workmanship, the readiness with which it may be made to assume almost any known form . . . are qualities which, in the present state of society, render that metal especially precious as a means of popular architecture. . . . Let us not, then, shrink from cast iron as too base and cheap to be translated into a noble architecture, as too common for such elegant uses; but as this art is our symbolic and monumental language, let us rather consider that the more common and available its elements are, the more truthful and just will it be in this high capacity. . . .

. . . The natural color of iron, besides being unsuited to decorative uses, is liable to the disagreeable changes of oxidation and rust, which also impair its strength and durability. The application of external color, therefore, is very essential to its preservation, and as such, may be used with all the license which art may desire. . . . Color, in these uses of it, would afford a sensitive test to distinguish the artist from the pretender, and present to all an evident proof of the refinement of the one and the vulgarity of the other. . . . The old principles of mural construction, requiring a piling of masses perpendicularly upon each other, requiring a careful economy and division of weight upon its arches, requiring moderation in the width of all openings, especially lintelled ones, and requiring a very strict observance of the necessity of placing the light and airy upon the heavy and massive—these have created in decorative architecture those exact laws of superimposition, intercolumniation, proportion by module, and the like, which have hitherto held tyrannical sway over all our composition. But it is evident that an iron construction does not call so imperatively for a strict observance of these laws, as its properties are such as to admit masses over voids as well as voids over masses, to admit downward thrusts of almost any force upon any point of its arches without fear of fracture, to admit almost any width of aperture, and almost any slenderness of supports. . . .

It is evident that an architecture so *new* as this . . . would exercise a direct active influence over the minds of men. . . . A new object or a new thought, if it appeals to any of the higher sentiments of humanity, strikes deep into our being. . . . How grateful then the task thus opened to the artist, of creating new things for the surprise of men; of writing a new chapter in the history of architecture, and thereby adding to the happiness and comfort of mankind!

Regular Meeting of December 21*st*, 1858.— . . . The general business of the evening being finished, L. Eidlitz read the following paper:

CAST IRON AND ARCHITECTURE.

The paper read before you at the last regular meeting of the Institute must be pronounced a literary production of rare

merits. Written with an earnestness and vigor worthy of a better cause, it betrays not only extensive reading but also laborious thinking on the part of its author. The materials for the basis of a most ingenious argument are collected with exhaustless industry, and arranged with the skill of a finished writer.

. . . Where the conclusions drawn are less satisfactory to the discriminating sense of the learned author, Poetry, with her brightest colors, is forced into service, to paint the liveliest and most pleasing scenery for display on a barren stage, ever ready for the performance of tragedy, vaudeville, or, ballet, as may suit the brilliant and versatile genius of a skillful manager, who knows his audience, and thinks it his province to please.

. . . But while paying my tribute of admiration to the *manner,* I feel constrained to question the *matter* enlarged upon in the paper before you, and I do so with the confidence that a mind capable of constructing so skillful an argument, will not be discouraged even when convinced of error. . . .

. . . I hardly know what Architecture, "sitting haughtily on her acropolis," is disposed to do with reference to the Iron question; but I do know that architects humbly sitting in their offices in the fourth story of some down-town building, are daily making extensive contracts for iron-work and materials moulded from the furnace, battered on the anvil, and rolled in the mill, amounting even to 33 per cent of the cost of structures that are erected of stone and brick; not to be used for *secret construction,* but *avowed* in broad daylight as an essential feature and preponderating element of modern structures. For a building material introduced to our notice but yesterday, as it were, I must confess I think this is doing marvellously well. . . .

But iron *never can,* and *never will* be, a suitable material for forming the main walls of architectural monuments. The only material for *that* purpose always has been, and now is, *stone;* and I believe it *always* will be. As for brick they are artificial stone, and only differ from stone in their limited dimensions. Wood, it will be conceded, is only used for temporary purposes, and has never been admitted but as a secondary material for the formation of roofs and for furniture, etc., in monumental art. Nature herself has made all her strongholds of stone; and *we,* of necessity, have always done, and always will

do the same with our structures. We need the effect of its weight, and bulk, and impenetrableness, which qualities are not to be replaced by any other material now known. . . .

. . . Wherever iron has been the most suitable material a wonderful variety of new and beautiful forms have sprung into existence; for instance, those of the steam-engine, forms which are beautiful because they bear the impress of their purpose, and because the material is eminently adapted to that purpose. In the construction of buildings, the rolled iron beam and box-girder have been received with eagerness by the profession, and forms have been invented to make them presentable to the eye. Iron has been substituted with great success for inferior materials, such as wood; and I hope the day is not far distant, when it will entirely usurp the place of it. . . . Where economy of space is a special object, cast iron columns are in many cases excellent substitutes for stone. Inclosures, stairs, sashes, doors, shutters, etc., heretofore formed of wood, are now almost exclusively and *very successfully* made of iron, and much has been done to perfect the architectural features developed by these changes.

But iron is not a suitable material, *alone* and *unassisted* by stone, to form the main walls of a building, nor any *considerable portion* of the same, for the following reasons:

1st. If used economically; that is, so as not to cost more than stone—it has not substance, nor weight, nor rigidity enough in itself to maintain its position.

2d. It is too great a conductor of heat.

3d. It is combustible. In the fullest sense of the word, iron not only loses its stability at a moderately high temperature, but is entirely consumed by exposure to heat for a moderate space of time, say the duration of a fire opposite. . . . Then, I ask the question—what is the use of the iron? There is no absolute use for it! The real materials used for construction, and in themselves entirely sufficient, are the stone or brick. . . .

I am willing to admit that iron can be cast cheaply in fanciful forms, perfectly beautiful, but I should never think of covering my homely brick house with iron in order to add to its beauty. . . . The best building is a stone building, the next best to it is brick, and lastly, wood. . . .To show that I am not exclusively possessed by antique prejudices, I am willing to compromise by accepting a good stone house, with iron beams, an iron roof, and iron sashes.

. . . Because iron has been found eminently useful in the building of steam-engines, suspension bridges, and railroads; we are asked to commemorate that fact . . . by placing pretty ornaments cast in that material somewhere—we do not exactly know where—about our dwelling houses, which will find their way into the junk-shop before another decade has passed away, or to erect cast iron steeples, a prey to the first hurricane that sweeps the country. . . .

I yield to a temptation here to give an oft-repeated definition of architecture. It is the art of expressing in the construction of a building the uses and purposes for which it is erected. The answer which a building bedizened with cast iron ornaments would give to the question, for what purpose the building is erected, would be to me as plain as though it was written upon it with large cast iron letters:

"FOR SHOW, MORE THAN ANY OTHER PURPOSE."

. . .

Iron will before long divide with stone the realm of legitimate building material, and its study must form a highly important part of our efforts, but it never will supplant stone. . . .

R. M. Hunt, in reply, stated that he was glad to see that Mr. Van Brunt's paper had called forth an elaborate reply from so distinguished a member of the Institute. . . . Iron, employed either alone or in connection with other materials, such as stone and brick, was, in many instances (in shop and store fronts, for example), the *most appropriate material* that could be used. Where land is exceedingly valuable, the whole lot is often built over for economy of space, and in the absence of interior courts and areas, it is necessary that the facade should become, as it were, one immense window for the sake of light. In employing stone, a great deal of this light would necessarily be excluded. . . . That iron had not been architecturally used to the extent of its capacities was by no means a proof that it could not be so used. . . .

Calvert Vaux, while he thought that eventually iron might be more generally employed, saw one great defect in it as an architectural agent, that of its *destructibility* by corrosion and otherwise. The necessity of painting it would in a great measure, he thought, do away with our respect for it. If it could be

vitrified or otherwise prepared to guard against the influence of the elements, it might be more acceptable.

Mr. Hunt thought that if iron were more generally employed in architecture, the inventive minds of the day would soon find means to obviate this difficulty—in fact, on the continent it was already obviated. . . . With regard to the use of color, Mr. H. remarked that our respect for the architecture of the ancients was not lessened by their frequent and almost invariable employment of polychromatic effects. If they considered it so *necessary,* why should we despise the use of color in our monuments? . . . Color he thought as great an aid to architecture as to the sister arts of painting and sculpture.

R. G. Hatfield and J. W. Ritch, in reply to an objection raised to the use of iron on account of its contraction and expansion, stated that in buildings of great extent constructed by them, no objection could be found on that score.

Mr. Hatfield thought that simple effects of mass might be produced in iron—effects by some considered impossible. The objection raised on account of its destructibility could not be supported. Again, hollow walls, so desirable for many reasons, could be erected with economy in this material. He had found no necessity to make use of backing.

The discussion having occupied the attention of the Institute to a late hour of the evening, upon motion, the meeting adjourned.

By order,
R. M. HUNT,
Secretary.

Regular Meeting of January 4, 1859.—. . . The general business of the evening having been attended to, Mr. Henry Van Brunt read the following paper:

In the paper read before you at our last meeting by a distinguished member of the Institute, there appears to have been a general misapprehension of my intention when opening this discussion on iron. It was not an attempt to prove that iron should supersede stone as a building material, or that stone in any respect should lose that monumental eminence which through all the centuries of architecture it has so proudly earned. Far from it. My object was to prove that, as iron was a material peculiarly adapted to meet many modern emergen-

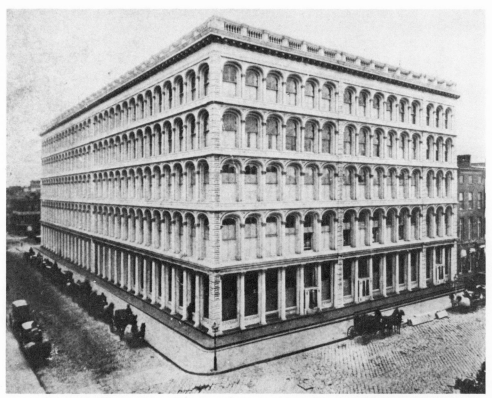

22. A.T. Stewart Store (Broadway between 9th and 10th Streets, New York) (1862, demolished 1956). J.B. and W.W. Cornell foundry manufactured the cast iron; Peter Cooper foundry made wrought-iron beams for interior, used with cast iron interior columns. (Collection of Margot Gayle)

cies of practical building, so it contained within itself a facility for *pure architectural decoration,* which, notwithstanding the obloquy heaped on the very name of cast iron, should recommend it to the peculiar study of architects.

. . . He has attacked only those most apparent and popular aspects of it, which are too frequently fit subjects for generous scorn, without examining into its hidden capacities, and fairly analyzing its possible applications. . . .

I have ever acknowledged and, I think, felt that architecture was the "art of expressing in the construction of a building the uses and purposes for which it is erected.". . . I do not propose to *conceal* construction, but to *illustrate* it and give it honor, and in thus emphasizing that construction I assist in its expression. I would use iron as a decorative language. . . .

I am aware that many practical considerations, such as durability, etc., have not been touched upon in my paper; but I shall be content if I have succeeded in seriously awakening this Institute as a body to this subject, and I am sure that a careful and thorough consideration of it here cannot but have a good influence upon ourselves and upon architecture in this country.

FROM *Last Words About*
the World's Fair

Montgomery Schuyler

1

Whether the cloud-capped towers and the gorgeous pal-
aces of the World's Fair are to dissolve, now that the
insubstantial pageant of the Fair itself has faded, and
to leave not a rack behind, is a question that is reported to
agitate Chicago. There is much to be said, doubtless, on both
sides of it. While it is still unsettled seems to be a good time to
consider the architecture which it is proposed to preserve for
yet awhile longer, in order to determine, so far as may be, what
influence the display at Chicago is likely to have upon the
development of American architecture, and how far that influ-
ence is likely to be good and how far to be bad. . . . Absolutely
without influence such a display can hardly be. . . .

Doubtless the architecture of the Exposition will inspire a
great many classic buildings, which will be better or worse
done according to the training of the designers, but it is not
likely that any of these will even dimly recall, and quite impos-
sible that they should equal the architectural triumph of the
Fair. The influence of the Exposition, so far as it leads to direct
imitation, seems to us an unhopeful rather than a hopeful sign,

not a promise so much as a threat. Such an imitation will so ignore the conditions that have made the architectural success of the Fair that it is worth while to try to discern and to state these conditions. . . .

In the first place the success is first of all a success of unity, a triumph of *ensemble.* The whole is better than any of its parts and greater than all its parts, and its effect is one and indivisible. . . . The landscape plan of the Fair, with the great basin, open at one end to the lake and cut midway by canals, may be said to have generated the architecture of the Court of Honor [Fig. 23]. Any group of educated architects who had assembled to consider the problem presented by the plan must have taken much the same course that was in fact taken. The solution of the problem presented by the plan was in outline given by the plan. That the treatment of the border of this symmetrical basin should be symmetrical, that the confronting buildings should balance each other, these were requirements obviously in the interest of unity and a general unity was obviously the result to be sought and the best result that could be attained. . . . Variety enough had been secured by the selection of an individual designer for each of the great buildings, and the danger was that this variety would be excessive, that it would degenerate into a miscellany. Against this danger it was necessary to guard if the buildings should appear as the work of collaborators rather than of competitors, and it was guarded against by two very simple but quite sufficient conditions. One was that there should be a uniform cornice-line of sixty feet, the other that the architecture should be classic. The first requirement, keeping a virtually continuous skyline all around the Court of Honor, and preventing that line from becoming an irregular serration, was so plainly necessary that it is not necessary to spend any words in justifying it. The second may seem more disputable, but in reality it was almost as much a matter of course as the first. Uniformity in size is no more necessary to unity than uniformity in treatment, and classic architecture was more eligible than any other for many tolerably obvious reasons. There are perhaps no effects attained in the exhibition that could not have been attained in other architecture. . . .

Nevertheless, the choice of classic architecture was almost as distinctly imposed upon the associated architects as the choice of a uniform cornice-line. In the first place, the study of classic

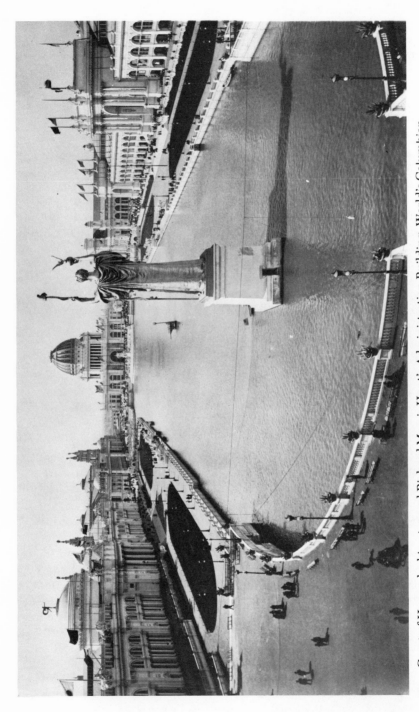

23. Court of Honor, looking toward Richard Morris Hunt's Administration Building, World's Columbian Exposition, Chicago, 1893. (Courtesy of The Art Institute of Chicago)

architecture is a usual, almost an invariable part of the profes-
sional training of the architects of our time. It is an indispens-
able part, wherever that training is administered academ-
ically, and most of all at Paris, of which the influence upon our
own architecture is manifestly increasing and is at present
dominant. Most of the architects of the World's Fair are of
Parisian training, and those of them who are not have felt the
influence of that contemporary school of architecture which is
most highly organized and possesses the longest and the most
powerful tradition. Presumably, all of them were familiar with
the decorative use of "the orders" and knew what a module
meant. What most of them had already practiced in academic
exercises and studies, they were now for the first time permit-
ted to project into actual execution. . . .

That would be one good reason for the adoption of a given
style—that all the persons concerned knew how to work in it.
Another is that the classic forms, although originally developed
from the conditions of masonic structure, have long since, and
perhaps ever since they became "orders," been losing touch
with their origin, until now they have become simply forms,
which can be used without a suggestion of any real structure
or any particular material. We know them in wood and metal,
as well as in stone. They may be used, as they are used in
Jackson Park, as a decorative envelope of any construction
whatever without exciting in most observers any sense of in-
congruity, much less any sense of meanness such as is at once
aroused by the sight of "carpenter's Gothic." A four-foot col-
umn, apparently of marble, may have aroused such a senti-
ment during the process of construction, when it might have
been seen without a base and supported upon little sticks, with
its apparent weight thus emphatically denied. Such a senti-
ment may have been aroused again in the closing days of the
Fair, when it was no longer thought necessary to repair defects
as fast as they showed themselves, and where the apparent
masonry disclosed in places the lath-backing. But when the
buildings were ready for the public no such incongruity was
forced upon the observer. . . . The alternative to the use of
classic architecture was the development in a few months of
an architecture of plaster. . . .

It is not to be supposed for a moment that the architects of the
Fair would have attained anything like the success they did
attain, if instead of working in a style with which all of them

were presumably familiar, they had undertaken the Herculean task of creating a style out of these novel conditions....

. . . In the Transportation building alone has it been undertaken architecturally to treat the material of which all the buildings are composed. . . . One cannot fail to respect the courage and sincerity with which the architects of the Transportation building [Adler and Sullivan] tackled their task, even though he find in the result a justification for the architects who have forborne the attempt. It was here a perfectly legitimate attempt, since the Transportation building does not form part of an architectural group, and a separate and distinctive treatment was not a grievance to the spectator, nor to the architects of any other buildings, though it was rather curiously resented by some of these. That it is a plaster building is entirely evident, as evident in a photograph as in the fact. It cannot be called an "incoherent originality," for its departures from convention are evidently the result of a studious analysis. A plaster wall is especially in need of protection by an ample cornice, and the ample cornice is provided. . . . The most pretentious and perhaps the most successful feature of it—the famous Golden Doorway—suffers from being an isolated fragment, entirely unrelated to the general scheme, and its admirable detail does not for this reason excite the admiration it deserves. The moulded ornament in this, however, is less successful than the moulded ornament elsewhere in the building, which is charged with an astonishing spirit and inventiveness and which is, moreover, unmistakably moulded ornament, neither imitative of nor imitable by the work of the chisel. There is certainly no better detail than this in the Fair grounds, but it also loses much of the effect to which it is entitled by its surroundings, and especially by its association with the queerest sculpture that is to be seen on the grounds, and that is saying a great deal.... The condition upon which the effectiveness of the whole depends is that there shall be a whole, that there shall be a general plan to the execution of which every architect and every sculptor and every decorator concerned shall contribute. That condition has been fulfilled in the architecture of the Exposition, at least in the architecture of the "Court of Honor," which is what everybody means when he speaks of the architecture of the Exposition, and it is by the fulfillment of this condition that the success of the Fair has been attained. That success is, first of all, a success of unity.

2

Next after unity, as a source and explanation of the unique impression made by the World's Fair buildings, comes magnitude. It may even be questioned whether it should not come first in an endeavor to account for the impression. If it be put second, it is only because unity, from an artistic point of view, is an achievement, while magnitude from that point of view, is merely an advantage. The buildings are impressive by their size, and this impressiveness is enhanced by their number. . . .

. . . It is only with the influence of what has been done in Jackson Park upon the architecture of the country that we are now concerned; with the suitableness of it for general reproduction or imitation, and with the results that are likely to follow that process, if pursued in the customary manner of the American architect. The danger is that that designer, failing to analyze the sources of the success of the Fair will miss the point. The most obvious way in which he can miss it is by expecting a reproduction of the success of one of the big buildings by reproducing it in a building of ordinary dimensions. It is necessary, if he is to avoid this, that he should bear in mind how much of the effect of one of the big buildings comes from its very bigness, and would disappear from a reproduction in miniature.

3

There is still another cause for the success of the World's Fair buildings, a cause that contributes more to the effect of them, perhaps, than both the causes we have already set down put together. It is this which at once most completely justifies the architects of the Exposition in the course they have adopted, and goes furthest to render the results of that course ineligible for reproduction or for imitation in the solution of the more ordinary problems of the American architect. The success of the architecture at the World's Fair is not only a success of unity, and a success of magnitude. It is also and very eminently a success of illusion.

What the World's Fair buildings have first of all to tell us, and what they tell equally to a casual glimpse and to a prolonged

From *Last Words About the World's Fair*

survey is that they are examples not of work-a-day building, but of holiday building, that the purpose of their erection is festal and temporary, in a word that the display is a display and a triumph of occasional architecture. . . . It is an illusion that has here been provided for our delight. It was the task of the architects to provide the stage-setting for an unexampled spectacle. They have realized in plaster that gives us the illusion of monumental masonry a painter's dream of Roman architecture. In Turner's fantasias we have its prototype much more nearly than in any actual erection that has ever been seen in the world before. . . .

. . . It is a seaport on the coast of Bohemia, it is the capital of No Man's Land. It is what you will, so long as you will not take it for an American city of the nineteenth century, nor its architecture for the actual or the possible or even the ideal architecture of such a city. To fall into this confusion was to lose a great part of its charm, that part which consisted in the illusion that the White City was ten thousand miles and a thousand years away from the City of Chicago, and in oblivion of the reality that the two were contiguous and contemporaneous. . . .

1893

FROM *The Autobiography of an Idea*

Louis H. Sullivan

. . . The Bessemer process of making "mild" steel had for some time been in operation in the Pennsylvania mills, but the output had been limited to steel rails; structural shapes were still rolled out of iron. . . .

Now in the process of things . . . the tall commercial building arose from the pressure of land values, the land values from pressure of population, the pressure of population from external pressure. . . . But an office building could not rise above stairway height without a means of vertical transportation. . . . The passenger elevator . . . when fairly developed as to safety, speed and control, removed the limit from the number of stories. But it was inherent in the nature of masonry construction, in its turn to fix a new limit of height, as its ever thickening walls ate up ground and floor space of ever increasing value, as the pressure of population rapidly increased.

Meanwhile the use of concrete in heavy construction was spreading, and the application of railroad iron to distribute concentrated loads on the foundations, the character of which became thereby radically changed from pyramids to flat affairs, thus liberating basement space; but this added basement space was of comparatively little value owing to defi-

ciency in headroom due to the shallowness of the street sewers. Then joined in the flow an invention of English origin, an automatic pneumatic ejector, which rendered basement depths independent of sewer levels. But to get full value from this appliance, foundations would have to be carried much deeper, in new buildings. With heavy walls and gravity retaining walls, the operation would be hazardous and of doubtful value. It became evident that the very tall masonry office building was in its nature economically unfit as ground values steadily rose. Not only did its thick walls entail loss of space and therefore revenue, but its unavoidably small window openings could not furnish the proper and desirable ratio of glass area to rentable floor area.

So in this instance, the Chicago activity in erecting high buildings finally attracted the attention of the local sales managers of Eastern rolling mills; and their engineers were set at work. The mills for some time past had been rolling those structural shapes that had long been in use in bridge work. Their own ground work thus was prepared. It was a matter of vision in salesmanship based upon engineering imagination and technique. Thus the idea of a steel frame which should carry *all* the load was tentatively presented to Chicago architects. . . .

. . . The tall steel-frame structure may have its aspects of beneficence; but so long as a man may say: "I shall do as I please with my own," it presents opposite aspects of social menace and danger. For such is the complexity . . . of modern feudal society . . . that not a move may be made in any one of its manifold activities . . . without creating risk and danger in its wake. . . .

The architects of Chicago welcomed the steel frame and did something with it. The architects of the East were appalled by it and could make no contribution to it. In fact, the tall office buildings fronting the narrow streets and lanes of lower New York were provincialisms, gross departures from the law of common sense. For the tall office building loses its validity when the surroundings are uncongenial to its nature; and when such buildings are crowded together upon narrow streets or lanes they become mutually destructive. The social significance of the tall building is in finality its most important phase. In and by itself, considered *solus* so to speak, the lofty steel frame makes a powerful appeal to the architectural imag-

ination . . . The appeal and the inspiration lie, of course, in the element of loftiness, in the suggestion of slenderness and aspiration, the soaring quality as of a thing rising from the earth as a unitary utterance, Dionysian in beauty. . . .

The construction and mechanical equipment soon developed into engineering triumphs. Architects, with a considerable measure of success, undertook to give a commensurate external treatment. The art of design in Chicago had begun to take on a recognizable character of its own. The future looked bright. The flag was in the breeze. Yet a small white cloud no bigger than a man's hand was soon to appear above the horizon. The name of this cloud was eighteen hundred and ninety-three. . . .

. . .It was deemed fitting by all the people that the four hundredth anniversary of the discovery of America by one Christopher Columbus, should be celebrated by a great World Exposition, which should spaciously reveal to the last word the cultural status of the peoples of the Earth; and that the setting for such display should be one of splendor, worthy of its subject.

Chicago was ripe and ready for such an undertaking. It had the required enthusiasm and the will. It won out in a contest between the cities. The prize was now in hand. It was to be the city's crowning glory. A superb site on the lake adjoined the southern section of the city. This site was so to be transformed and embellished by the magic of American prowess, particularly in its architectural aspects, as to set forth the genius of the land in that great creative art. It was to be a dream city, where one might revel in beauty. It was to be called The White City by the Lake. . . .

At the beginning it was tentatively assumed that the firm of Burnham & Root might undertake the work in its entirety. The idea was sound in principle—one hand, one great work—a superb revelation of America's potency—an oration, a portrayal, to arouse that which was hidden, to call it forth into the light. But the work of ten years cannot be done in two. It would require two years to grasp and analyze the problem and effect a synthesis. Less than three years were available for the initiation and completion of the work entire, ready for the installation of exhibits. The idea was in consequence dismissed. As a matter of fact there was not an architect in the land equal to the undertaking. No veteran mind seasoned to the strategy

From *The Autobiography of an Idea*

and tactics involved in a wholly successful issue. Otherwise there might have arisen a gorgeous Garden City, reflex of one mind, truly interpreting the aspirations and the heart's desire of the many, every detail carefully considered, every function given its due form, with the sense of humanity at its best, a suffusing atmosphere; and within the Garden City might be built another city to remain and endure as a memorial, within the parkland by the blue waters, oriented toward the rising sun, a token of a covenant of things to be, a symbol of the city's basic significance as offspring of the prairie, the lake and the portage.

But "hustle" was the word. Make it big, make it stunning, knock 'em down! The cry was well meant as things go.

So in the fall of 1890 John Root was officially appointed consulting architect, and Daniel Burnham, Chief of Construction.

Later, with the kindly assistance of Edward T. Jefferey, Chairman of the Committee on Buildings and Grounds, Burnham selected five architects from the East and five from the West, ten in all. . . .

A gathering of these architects took place in February, 1891. After an examination of the site, which by this time was dreary enough in its state of raw upheaval, the company retired for active conference. John Root was not there. In faith he could not come. He had made his rendezvous the month before. Graceland was now his home. Soon above him would be reared a Celtic cross. Louis missed him sadly. Who now would take up the foils he had dropped on his way, from hands that were once so strong? There was none! The shadow of the white cloud had already fallen.

The meeting came to order. Richard Hunt, acknowledged dean of his profession, in the chair, Louis Sullivan acting as secretary. Burnham arose to make his address of welcome. . . .

A layout was submitted to the Board as a basis for discussion. It was rearranged on two axes at right angles. The buildings were disposed accordingly. By an amicable arrangement each architect was given such building as he preferred, after consultation. The meeting then adjourned.

The story of the building of the Fair is foreign to the purpose of this narrative, which is to deal with its more serious aspects, implications and results. Suffice it that Burnham performed in

a masterful way, displaying remarkable executive capacity. He became open-minded, just, magnanimous. He did his great share.

The work completed, the gates thrown open 1 May, 1893, the crowds flowed in from every quarter, continued to flow throughout a fair-weather summer and a serenely beautiful October. Then came the end. The gates were closed.

These crowds were astonished. They beheld what was for them an amazing revelation of the architectural art, of which previously they in comparison had known nothing. . . . They went away, spreading again over the land, returning to their homes, each one of them carrying in the soul the shadow of the white cloud, each of them permeated by the most subtle and slow-acting of poisons; an imperceptible miasm within the white shadow of a higher culture. A vast multitude, exposed, unprepared, they had not had time nor occasion to become immune to forms of sophistication not their own. . . . Thus they departed joyously, carriers of contagion, unaware that what they had beheld and believed to be truth was to prove, in historic fact, an appalling calamity. For what they saw was not at all what they believed they saw, but an imposition of the spurious upon their eyesight. . . .

. . . There came a violent outbreak of the Classic and the Renaissance in the East, which slowly spread westward, contaminating all that it touched, both at its source and outward. . . .

The damage wrought by the World's Fair will last for half a century from its date, if not longer. It has penetrated deep into the constitution of the American mind. . . .

Meanwhile the architectural generation immediately succeeding the Classic and Renaissance merchants, are seeking to secure a special immunity from the inroads of common sense, through a process of vaccination with the lymph of every known European style, period and accident, and to this all-around process, when it breaks out, is to be added the benediction of good taste. Thus we have now the abounding freedom of Eclecticism. . . .

. . . There is now a dazzling display of merchandise, all imported, excepting to be sure our own cherished colonial, which maintains our Anglo-Saxon tradition in its purity. We have Tudor for colleges and residences; Roman for banks, and railway stations and libraries,—or Greek if you like—some cus-

From *The Autobiography of an Idea*

tomers prefer the Ionic to the Doric. We have French, English and Italian Gothic, Classic and Renaissance for churches. In fact we are prepared to satisfy, in any manner of taste. Residences we offer in Italian or Louis Quinze. We make a small charge for alterations and adaptations. . . .

In the better aspects of eclecticism and taste, that is to say, in those aspects which reveal a certain depth of artistic feeling and a physical sense of materials, rather than mere scene-painting or archæology, however clever, there is to be discovered a hope and a forecast. For it is within the range of possibilities, one may even go so far as to say probabilities, that out of the very richness and multiplicity of the architectural phenomena called "styles" there may arise within the architectural mind a perception growing slowly, perhaps suddenly, into clearness, that architecture in its material nature and in its animating essence is a *plastic art.* . . .

1924

FROM *The Architecture of H. H. Richardson and His Times*

Henry-Russell Hitchcock

Note: Bracketed sections represent 1961 amendments to 1936 text.

. . . The centrifugal and disintegrating forces in American architecture, which reached a climax of effectiveness in the late fifties, had been suspended during the years of the Civil War. The architectural design books published just at the end of the War, and, even more, the few buildings built during the course of the War, indicate a suspension of that process of borrowing and modifying and inventing new stylistic types which had gone on for a generation. All the manners of the fifties continued to be practiced down to the end of the decade without important modifications. But the popular Italian Villa and the Swiss Chalet manners of the fifties, for example, although still acceptable in the rural vernacular, were deader in the cities and in the practice of professional architects than the national Greek Revival of the thirties. The Barryesque High Renaissance style and the more academic Classicism initiated by Walter's additions to the Capitol were donning French roofs. Thus they were merging imperceptibly with the newer manner derived from the Tuileries and the new Louvre for use

in public buildings and houses. The simpler, more cardboard-like Gothic of the thirties and forties had advanced under English inspiration to extraordinary freedom and complexity, both in ecclesiastical and civil design. It made use of motifs predominantly of Italian origin, grafted on to the underlying English fourteenth century types in the fashion which we have called High Victorian.

The tendency to subdivide and multiply the acceptable manners of design with new borrowings from the past and meaningless differentiations and combinations was now definitely counterbalanced by a tendency to gather together the elements of "modern" design under two headings, the English Victorian Gothic and the French Second Empire. There was not a French School separate and distinct from an English School. Indeed . . . the manner that is identified as Second Empire in this country was hardly in as current use in Paris in the fifties and sixties as it was in England.

The same architects, moreover, used both manners. . . .

Richardson, by his Parisian training, was in theory better prepared to serve the rising "new men" of the business world. In actuality, because of his temperament and his Harvard associations, his personal friends were rather among the gentlemen of culture. But until he found his personal style at the end of the decade, his relation to the two dominant architectural currents of the day really did not differ from that of his contemporaries: like most of them, he selected a manner from the wide range of either the Victorian Gothic or the Second Empire—whichever the context seemed to demand. As soon as he felt himself established, however, he showed an increasing boldness in attempting to merge the two. So, indeed, did many other American architects of the time.

In retrospect, the modern student has great difficulty in distinguishing Richardson's earliest work from the work around it. His work of the sixties, like that of most of his compatriots, is full of things which may be described either as original or corrupt in terms of the architecture of the past or of his European contemporaries. What is interesting is to see how the quirks of style in his early buildings, each in itself apparently negligible, led gradually to an originality, positive and not negative, which could never be described as corruption. In other words, he turned the tide of stylistic disintegration, at that time only a little less sweeping than in the fifties, and

began the process of reclaiming the solid architectural land which had been so largely frittered away by the wavelets of Late Romantic exoticism and pure vagary.

There was never a time, perhaps, in which an architect was freer to create a personal style. Anything, essentially, was permitted, except a return to the Greek Revival. Criticism, whether lay or professional, having given up the criterion of archaeological correctness, which had hardly been applied in America except to Greek forms, was ready to defend or attack any sort of architecture on the basis of metaphysical sophistries without force or widely accepted authority. To return from abroad to such an environment, to be by one's age and one's economic situation a growing part of it, was a stimulus in any field of material and intellectual activity.

Richardson had ambition. He had also the assurance that his training was unsurpassed by that of any American rival. Thus his naturally sanguine character, his strongly personal taste, and his sympathetic acceptance of the commissions which he was able almost at once to obtain were never tempered by a sense of inferiority or of doubt. Such a sense was (and still is) as much an essential weakness in the more cultivated American as a compensatory brashness is a kind of strength in the American who is lacking in formal education and knowledge of the European world.

Richardson undoubtedly felt within himself the strength of genius, a feeling which is often enough the guarantee of nothing more than a psychopathic condition. But Richardson was not in the least neurotic. His genius, to call it that quite simply, was not a cross he had to bear, or a light hidden under a bushel: it was quite recognizable to his contemporaries.

Although Richardson was no mediaevalist and not particularly interested in problems of construction, he had a matter-of-fact and craftsmanlike attitude toward his architectural work. He knew he could do such work better than anyone else —later he was even to charge accordingly. But he knew it with the same simple and unromantic instinct as Poole, the English tailor he patronized even when he was poorest.

Thus, when he began to work, he did not force any greater novelties on his clients than his most conventional rivals would have done. While he was feeling this way, often very awkwardly and with results which must have distressed him very soon afterward, he felt no shame or inadequacy. He had the

justifiable conviction that at least he was offering as much as anyone else in America. He knew also that he could only find out in stone and brick what the lines he drew on paper meant.

The years between 1870 and 1877 are perhaps the most important of Richardson's career. They established him justly as the most brilliant American architect of his day. Later he was to do far more work and far more finished work. But the series of buildings built between the time he was thirty-two and the time he was forty have a freshness that is later lost. These are also perhaps the most profitable of his works to study. In them we can piece together his personal style step by step, almost as he found it himself. In detailed examination their virtues are the more remarkable for being associated with equally conspicuous vices. His work is almost done before our eyes and the contribution of his most able assistant, [Stanford] White, can be determined with some accuracy. Later, when he was doing much more work than in these years, there is rarely the same personal quality. His office staff learned to be "Richardsonian"; the machinery of production became smoother, the results were usually easier to foretell.

Yet none of the buildings before 1878 are, perhaps, among his very greatest. They are generally more interesting than altogether fine. The course of his genius was still rising. Had his career ended here, books would hardly have been written about his architecture.

Richardson had not been very busy through the seventies. After 1872, only in 1877 did he have more than one new commission in any single year. But by 1880 the number of his new commissions had risen to five, one more than in the last pre-depression year. Within a few years he had twice as much work each year. As his popularity increased, therefore, he could not give to all his work the same attention he had lavished on the few commissions of his early maturity. A critical study must distinguish between the really creative work, still almost wholly his own, and other commissions which the office staff developed under his supervision. This distinction is not very important, however, before 1883. It was, indeed, in the five years between 1878 and 1883 that Richardson did most of his finest and most finished work. . . .

It was not impossible for one man to control five new commissions a year, together with the projects that were not built, and the completion of earlier work which was also occupying

the office. But it is obvious that no single architect could handle up to a score of jobs, as Richardson eventually was doing, without delegating to someone the responsibility for many.

. . . Even when he knew he was dying, in the mid-eighties, he gloried in the amount of work that was going on in his office. Although he knew well enough that the Pittsburgh buildings and the Marshall Field Store were the things he wanted time to complete, he never saved himself, and often disobeyed medical orders. He might have prolonged his life considerably and lived to do other work as fine or finer than the Field Store if he had not so readily accepted himself as a sort of legendary hero. . . .

The men in the office were not unsympathetic to Richardson's style. Indeed, left to themselves, they tended to produce exaggerated parodies, like all followers *plus royalistes que le roi.* But they were, of course, much younger. They had known neither the stimulating stylistic confusion of the sixties in America, nor the sound traditional training which the Ecole des Beaux Arts still offered when Richardson was in Paris. They came from the new American architectural schools or from other architects' offices. Architecture to them was designing on paper. Style was something borrowed out of the past from books, or, worse, from photographs which were becoming more available. Their taste was not, like Richardson's, wrought personally out of surrounding chaos, but something learned almost by rote. In their ideology, the Richardsonian style had to be a Romanesque Revival if it were of any worth at all.

In recalling the documents already in Richardson's library and noting the new acquisitions made from this time on, it is not enough to consider the inspiration they could offer to a great creative mind. The facility with which the men in the office could crib from them must perpetually be borne in mind.

For cribbing was in increasingly good repute about 1880. . . .

There is little to indicate that Richardson himself ever came to seek "correctness" of style. There is nothing to justify the contention that in the seventies he desired to be a Romanesque Revivalist in the sense of the earlier Gothic Revivalists of the forties, or even of the imitators of the Renaissance styles who came after him. It is true that the source of certain details can be traced with some precision to the plates of Revoil's

From *The Architecture of H. H. Richardson and His Times*

Architecture Romane du Midi de la France. But even these borrowings are probably more due to White than to Richardson himself. Nor were Romanesque sources the only ones from which Richardson drew inspiration. His use of French Renaissance detail on the Albany Capitol, of tall Late Gothic dormers elsewhere, and of Queen Anne detail on his houses, all indicate that he by no means restricted himself to the study of Southern French Romanesque design in the mid-seventies. . . . ["Shavian",* not "Queen Anne", at least before 1878. Actually the contemporary stylistic term in England was "Old English."]

The source from which Richardson drew the most assistance in the seventies was still the modern architecture of England, at this time growing suaver and more eclectic as the Queen Anne movement gained force. There is hardly a building by him in the seventies that would not be considered rather typically late Victorian Gothic if only its arches were pointed and its masonry less rugged. . . . Richardson's personal style was chiefly characterized by a predilection for massive walls, lintel-covered openings, and broad low arches, none of which is particularly derived from the Romanesque. The most characteristic type of arch, which he began to use only in late 1877, was specifically Syrian.[1] Even his solid mass composition is rarely related to Romanesque types of mass composition, except in the special case of the crossing tower [and the rear] of Trinity.

The formation of Richardson's style took place when he designed the Brattle Square Church and the Buffalo State Hospital. Trinity . . . was something of a side track. His style, however, continued to develop through the seventies, reaching complete maturity by about 1878. . . .

The increasingly archaeological character of Richardson's detail after 1880, in contrast to the more vigorous and original carving of the seventies, is probably due to the attempts that were made to educate the executants. The carvers of the Evans firm, who carried out so much of Richardson's work, were from this time on frequently shown photographs of mediaeval work. Richardson's intention was undoubtedly that they should emulate its quality. But they learned only too well

*Editor's note: "Shavian" refers to the work of the English Victorian architect, Richard Norman Shaw.

to make lifeless forgeries. Within a few years they had quite lost whatever personal touch they once had.

The greater pressure of work also made it necessary for Richardson to leave the design of detail almost entirely to his draftsmen. After 1880 he had no time to train them personally, as he had trained his first assistants, [Charles Follen] McKim and White. When White left, there remained no one in the office with real imagination and taste in matters of detail. Richardson was forced to send his men to books and photographs in self-protection; archaeology was at least better than botched imitations of his own earlier ornament or Americanized Queen Anne fantasies. His own efforts were restricted to essentials: the study of plans with his clients; the study of massing in perspective; the general disposition of features in elevation; the choice and expression of materials; and the supervision of execution.

How many photographs of architecture Richardson owned before he went to Europe in 1882 there is no way of telling. But the great bulk of the existing collection he must have brought back with him at that time. The particular signs of photographic inspiration of detail certainly grew much more evident from then on.

Richardson hardly intended to practice "productive archaeology". But the general inability to understand and appreciate his personal style for what it was—the misapprehension that it was merely a Romanesque Revival—is somewhat justified by the "correct" detail on his late buildings. Lewis Mumford, in the *Brown Decades,* points out that Richardson protected himself against the possible recriminations of his clients by a specific statement in the circular explaining the character of his services: ". . . I cannot, however, guarantee that the building . . . shall conform to his (the client's) ideas of beauty or taste, or indeed to those of any person or school." Although undoubtedly Richardson was an advocate of the use of Romanesque models, he realized with how little respect for archaeology he drew his own inspiration. His work was so readily acclaimed as Romanesque only because his generation knew next to nothing about the ancient monuments in the style.

Curiously enough, Richardson's work was derided for being Romanesque by the succeeding generation also, which knew little more of the style. In my own case, indeed, a generation later still, the appreciation of Richardson's originality began at

From *The Architecture of*
H. H. Richardson and His Times

Harvard with the surprising discovery that the real Roman-
esque was rarely Richardsonian. The study of the architecture
of the early Middle Ages under so brilliant and subtle a histo-
rian of art as Kingsley Porter made clear how little Richardson
owed to that period of the past.[2] Later, the appreciation of his
debt to the Early Christian art of Syria, to the sixteenth century
styles of Northern Europe, and even to the American Colonial,
prepared the way for the obvious truth that he was not a
revivalist in any proper sense of the word at all. Richardson,
in developing his personal style, was ready to find inspiration
in any part of the past that appealed to him. The Romanesque
was perhaps most useful. On account of his French training,
the Renaissance and the Classical styles seemed sterile and
worn out. On the other hand, the Victorian Gothic had already
taken the bloom off the inspiration to be derived from the
styles of the thirteenth and fourteenth centuries. . . .

Richardson as a great individual had raised American archi-
tecture from the slough of the late sixties. But the very fact of
this individuality set a limit to the height which he could reach
single-handed. At the same time, his natural belief in the value
of personal expression in architecture and of personal inspira-
tion from the art of the past was a dangerous doctrine for men
who were not in the least geniuses. It was also something of an
anachronism in an age whose appreciations were superficial
and whose problems were increasingly technical.

. . . The rising age of commercial expansion and hurry de-
manded a new technical method. But that new technical
method was not necessarily sound, any more than the age it
served. Richardson worked best at a slow tempo and with the
characteristic methods of earlier ages. Fortunately, he was able
to do so. His clients were those who had won such success or
inherited such fortunes that they could seek refuge in the
illusion of recreating an earlier and nobler age: whether in the
twelfth century in Europe, as Henry Adams did quite con-
sciously, or in the Colonial period in America, out of vague
ancestral piety. Yet Richardson offered them better than they
asked. For he knew how to make modern houses out of the
elements of castles and farmhouses. In the best libraries, at
Quincy and Malden, and in the best railroad stations, at Au-
burndale and Chestnut Hill, the very simplicity of the problem
brought out his essential creative force. But he could not and
would not repeat himself. . . .

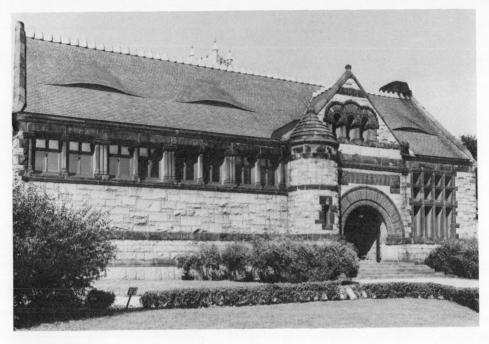

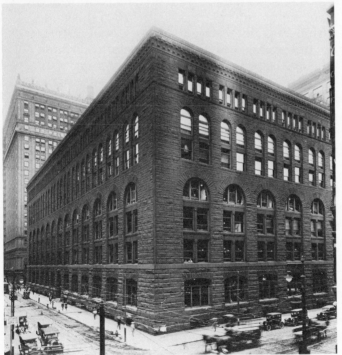

From *The Architecture of*
H. H. Richardson and His Times

It is not necessary that a great artist should grasp directly the whole of his time. Art is what is to be made and that is determined by forces over which the artist has no direct control. Even the future is not always right. Apartment housing may be an impasse; the skyscraper almost certainly is. In those problems he had handled, Richardson had set a higher standard, perhaps, than any architect of his generation in the world. Sever Hall might have been sufficient inspiration for a whole generation of college building, and the Quincy Library [Fig. 24] for small public edifices in all the towns of the nation. In his two smaller wooden houses, he had shown that a simple free treatment of shingle-covered frame construction could be applied at any scale and not merely to country mansions. At the other end of the scale, the Pittsburgh courthouse made plain that a great civic structure could be at once monumental and practical. Few architects in any age have done as much and he was to do still more.

Among his later work, one building stands supreme: the Marshall Field Wholesale Store [Fig. 25]. . . .

The year 1885 brought Richardson his last great opportunities. . . . In the Marshall Field Wholesale Store he was offered a commercial commission of sufficient size and importance for him to establish a new standard of design the very year after a new type of construction had been introduced in the field. This new standard of design was associated, as in all of Richardson's work, with traditional methods of construction. But in the next few years it helped Sullivan to find an architectural expression for the new skeleton type of construction. [It must today be a moot point how far the influence of Richardson was a help to Sullivan. His work of the late 80's seems rather to have been an interruption in the lines of development that lead from such early buildings as the Rothschild Store of 1881 and the Troescher Building of 1884 to the Wainwright Building [Fig. 26] of 1890–91 and Carson, Pirie & Scott of 1899–1904. In any case Adler and Sullivan in the Auditorium Building were more influenced by George B. Post's Produce Exchange in New York of 1881–84 than by the Field Store.]

The Marshall Field Store was commissioned in April, 1885, just a year before Richardson's death. This and the Pittsburgh courthouse were the two buildings Richardson esteemed the most important of his career. As regards the Field Store, he was certainly correct. The building was destroyed a few years ago

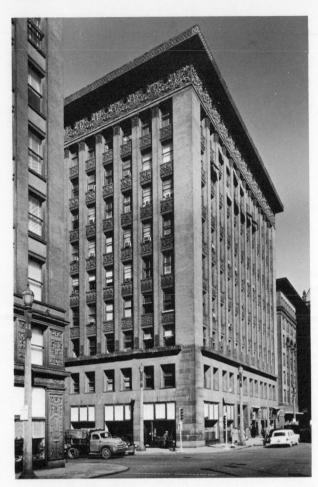

26. Dankmar Adler and Louis Sullivan, Wainwright Building, St. Louis, Missouri (1890–91). (Hedrich-Blessing, Chicago)

to make room for an outdoor parking garage. It was really sacrificed to the urban congestion the skyscraper had created. It is futile to suggest that this building should have been preserved and all the blocks around torn down to display one of the greatest monuments of architecture in America. The first skyscrapers, the Home Insurance and the Tacoma, have been torn down as well. These three monuments, historically among the most interesting buildings in America, should have made Chicago a center of pilgrimage for all who are interested in architecture. [Chicago has now become more conscious of its architectural heritage. Since 1960 many buildings, including Richardson's Glessner house, carry plaques indicating their status as historical monuments.] The money and the effort that might have saved them was poured instead into the temporary

structures of an ironical "Century of Progress" exposition. Pointless piety has preserved of the Marshall Field Wholesale Store only the carved capitals, things absolutely without value or interest in this period of Richardson's career.

The Field Store was a solid block of masonry supporting walls, with an interior court surrounded by masonry supporting walls, and the main interior partitions of masonry. [The interior partitions and probably the court walls were of brick, not of stone masonry like the exterior walls. . . .] The isolated interior piers and the floor beams were, however, of metal. In a building of only seven storeys, it was not necessary to replace the solid exterior walls of masonry with the hybrid type of masonry and metal wall. . . . It remains a question whether the general run of buildings ever should have been raised to greater heights if American cities had been properly planned and the building laws sufficiently detailed and intelligent. But the question of the height of buildings did not lie with the architect; it lay with the client. The pressure came from the rise in land values. . . .

Richardson was not reactionary technically in building the Field Building as he did: he was just short of the forefront of technical advance. . . .

But if Richardson was not here creative technically, he was, perhaps, never more creative artistically. . . .

The sure dependence on sturdy masonry for a rich effect, and the simplification of the rhythm make the exterior of the Field Store very superior to the court of the Pittsburgh building. There is almost no detail. The only carving that can be seen from a distance is the crocketted cornice. That is Gothic and not Romanesque in inspiration, and yet is vigorously and crudely cut, to be in scale with the whole mass which it terminates. . . .

The rhythm of the first four storeys is absolutely even except for the wide corner piers. These assure the solid massive appearance of the building in spite of the very large proportion of window space. These broad corners entail some sacrifice in the interior, but they give the building a unity of effect which is lacking in the Pittsburgh courthouse with its corner pavilions. The rhythm of the two upper floors is doubled and that of the attic quadrupled. By providing a low basement storey with segmental arches, and by subdividing the windows of the main floors with stone pilasters to support the intermediate

213

stone floor spandrels, the weight of the design at each level of the composition is exactly proportioned. The plain corners and the heavy cornice frame the whole design and emphasize the solidity of the total block which needs no visible roof. Here Richardson finally escaped from the picturesque and achieved the highest type of formal design.

Beyond this there is very little to add. The square blocks of stone in the spandrels of the great arches are not varied in colour; the pilaster capitals are hardly carved at all. But the scale of the masonry is gradually reduced from the enormous boldly rock-faced slabs of red Missouri granite which form the basement, to the small square blocks in the spandrels. The red sandstone of the walls above the basement gradually decreases in roughness. . . . The unmoulded voussoirs are of adequate size but not exaggerated as on the Pittsburgh jail. The lintels are proportionately heavy. The windows are properly of plate glass, since they are recessed from the arcades. The walls thus form an open cage, not a continuous surface. There are many other subtleties of omission and commission which express the personal assurance of a great architect at the height of his powers. But there is almost nothing for imitators to borrow. The design is so elementary that any attempt to copy it was bound to be inferior. . . .

Richardson's career ran parallel with early experiments in the use of metal. His death coincided with its triumph. How little the use of metal impinged upon his architecture . . . may well be summarized. The early heyday of the use of castiron in America was in the sixties. Then the dome of the Washington Capitol rose, a conspicuous symbol of the absolute power of the Congress, borrowed from the age of Baroque absolutism. Beneath its white paint the dome was all of iron, as if to make more complete the symbolism of the form by a specific suggestion of the powers of which Congress was but the governing agent.

The same not altogether unconscious symbolism appears elsewhere. Broadway in New York, from the City Hall to Union Square, is still almost solidly lined with the commercial castiron facades of six or seven storeys. . . .

[Richardson's] success with the Marshall Field Wholesale Store would undoubtedly, had he lived, have brought him more commissions for large commercial buildings. In these he would have had to come to some sort of terms with the new

From *The Architecture of*
H. H. Richardson and His Times

skyscraper construction. But he died too soon, and his career finished, as it began, within the period of reaction back to solid masonry construction after the early heyday of castiron in the sixties. . . .

The significance of Richardson can now be made clearer. He was not the first modern architect: he was the last great traditional architect; a reformer and not an initiator. Dying when he did, his architecture remained entirely within the historic past of traditional masonry architecture, cut off almost entirely from the new cycle which extends from the mid-eighties into the twenties of the present century. . . .

. . . The qualities which make his architecture great are the qualities of all the great free architecture of the past, not imitated but profoundly recreated to serve the functions of the nineteenth century.

1936, 1961

N O T E S

1. Derived undoubtedly from de Vogüe's *Syrie Centrale*.
2. The great illustration of Richardson's essential originality and the wide field of reference from which he drew suggestions was Sever Hall at Harvard, begun in 1878. It was the Syrian portal of Sever which I left to learn from Kingsley Porter—in Hunt's Greek Fogg Museum—what the styles of the early Middle Ages really had been. It was no longer possible for me to believe Sever was Romanesque, not even as Romanesque as Schulze's nearby Appleton Chapel, which had been Richardson's own first illustration of the style. In the same way, no one at Harvard since Charles H. Moore's day had believed that Memorial Hall was appreciably Gothic.

6. THE TWENTIETH CENTURY:

FROM THE ASH-CAN SCHOOL

AND THE ARMORY SHOW TO

MID-CENTURY

Until the twentieth century was well under way, American artists had always faced two equally compelling attractions: European art as both ancestral and contemporary models of excellence, and a period of European study as the means of acquiring professional validity. To the extent that a degree of independence from European precedent was even possible, there were some exceptions, to be sure, but until quite recently, despite an undercurrent of feeling that only something uniquely American in theme and spirit would ensure a true American tradition, a tendency to reflect the tenets of one European school or movement after another had become one of the familiar patterns in American art.

In the colonial era, Europe had attracted both Benjamin West and John Singleton Copley. Italy and England seem ever to have been the treasured ambience of Washington Allston, whether one regards his later residence in New England as sanctuary or exile. There were many shifts in American attachments to the European scene during the rest of the nineteenth century, but one experience would remain a constant factor in the education of many American artists: a European tour of sketching, of viewing the accessible art, and of sampling

the life and physical surroundings of many locales enticingly different from those at home. Also, by the mid-nineteenth century, some strains of contemporary European art were being viewed in America. During its heyday in the 1850s, the Düsseldorf Gallery in New York City was showing the work of artists associated with that German art center. This helped to promote a taste for the meticulously rendered genre and landscape painting characteristic of that school, and many American artists flocked to Düsseldorf to study. Other attractions were the Paris of Thomas Couture's independent atelier around the 1850s, the mid-century Barbizon school of French landscape painting, the Munich school's dark manner and bold brushwork popular with some Americans who went abroad to study in the 1870s, the Paris of the Académie Julian and the École des Beaux-Arts, and finally, by the 1880s and 1890s, the influence of French impressionism. Italy had always great appeal as a veritable museum of western art, and was particularly favored in the nineteenth century by American sculptors who could find there both marble of high quality and skilled carvers to assist them in the studio.

The experience of the American painter William Morris Hunt could be cited as symptomatic of this pattern. Hunt had gone to Europe in the mid-1840s, originally intending to study sculpture in Rome, but soon went on to Düsseldorf where he found the meticulous realism of that school not to his taste as he turned to a career in painting. In 1846 he was in Paris where he became a pupil of Couture, with whom both John La Farge and Eastman Johnson were to study briefly at a later date. Then, around 1850, Hunt became acquainted with Millet and the Barbizon school, which he helped to make popular in America after his return to the United States in the mid-1850s. George Inness, too, discovered a new freedom of color and execution in the Barbizon style, evident in much of his work of the 1850s and 1860s.

The Munich style was popularized by such painters as Frank Duveneck, who taught in Munich for several years, and William M. Chase. Since both of these artists returned to teach in the United States— Chase in New York and Duveneck in Cincinnati—a generation of American students picked it up at home. Chase, more eclectic, also added the bright palette of impressionism to his urbane technical repertoire, and the blend became one of the features of academic training in the United States.

In the late 1880s, American artists like Theodore Robinson (who became acquainted with Claude Monet at Giverny), John H. Twachtman, and Childe Hassam brought back to the United States from their studies in France the ideas and techniques of the French impressionists, soon to be translated into an American impressionism distinct from its European parent. French academic painting also had its adherents.

From the Ash-Can School and
the Armory Show to Mid-Century

So, at the beginning of the twentieth century in America, consciousness of various phases of nineteenth-century European art was much in evidence, and its marks were on American art. There was to be, as well, a reactive counter-current.

It was to some extent a reaction against transplanted European style and cosmopolitanism that fostered the emergence in New York of a group of painters who found their inspiration in the commonplace realities of the urban scene around them—its characters and human situations, its streets and back-alleys, bars, markets, and waterfronts. The boldness—to many observers, crudeness—with which some of these artists presented their urban themes earned them the title of "the Ash-Can School." Attention was drawn to them by an exhibition in 1908 at the Macbeth Gallery in New York. This showing of "Eight American Painters" included some like Arthur B. Davies, Maurice Prendergast, and Ernest Lawson whose art was quite different from that which stimulated the ash-can analogy. Davies painted gentle visions of an idyllic dreamworld, Prendergast had developed a distinctive decorative style derived from impressionist and neo-impressionist techniques, and Lawson was one of the American impressionists. For that matter, there was considerable variety among the rest of "The Eight." Robert Henri (the energetic leader of the group), John Sloan, George Luks, William Glackens, and Everett Shinn were anything but similar peas in a pod, but the common content of their art was the celebration of the city as an exciting, picturesque environment. Henri had studied abroad, at the Académie Julian and the École des Beaux-Arts, but he had begun his training at the Pennsylvania Academy of Fine Arts in Philadelphia under Thomas Anshutz, a pupil of Thomas Eakins. Sloan, Luks, Glackens, and Shinn also had Philadelphia connections, having worked there as newspaper artists, and the eye of the roving reporter in the streets could be sensed in their paintings of the New York scene. The selection taken from an interview with Stuart Davis, who had been a pupil of Henri, recalls the spirit of that episode in the history of American art.

When the critic Sadakichi Hartmann wrote "A Plea for the Picturesqueness of New York" he was appealing chiefly to photographers, but his message might well be viewed as a thematic program for the Ash-Can School, whose paintings, taken ensemble, seem like a fulfillment of the prophecy at the end of Hartmann's essay, the first selection in this section. While not overtly a plea for "Americanism" in art, this charming recitation of vignettes from a love affair with a city is at least tangential to the current of feeling which tended to identify the idea of a truly American art with the depiction of American places and situations, with a common experience that could be claimed as "native" content. Around this viewpoint clustered some of the opinions antagonistic to the influx of twentieth-century Euro-

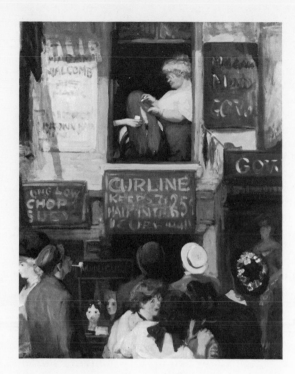

27. John Sloan, *Hairdresser's Window* (1907). Oil on canvas, 32" × 26". (Courtesy Wadsworth Atheneum, Hartford. Ella Gallup Sumner and Mary Catlin Sumner Collection)

pean abstract and expressionistic styles which were beginning to affect American artists in the early decades of the century, as painters like Marsden Hartley, Arthur Dove, Max Weber, and John Marin developed in directions responsive to the artistic revolutions in Europe. The photographer Alfred Stieglitz, by exhibiting modern European art at his gallery and showing the works of this new generation of American artists, was an important force in encouraging American art into the orbit of European modernism. The selection by William I. Homer is an excellent survey of the activities of Stieglitz, and is also useful for its treatment of the partnership between Stieglitz and his fellow photographer, Edward Steichen, and its mention of the opposing factions of the 291 circle and the group around Henri.

If the Stieglitz enterprise was the most conspicuous example of long-term support for modern American art in the early twentieth century, the New York Armory Show of 1913 is generally viewed as the most important single event in the process of introducing the American public to the innovations of European modernism. Its shock effect was pronounced. The selection dealing with this exhibition, taken from Milton W. Brown's important work, *American Painting from the Armory Show to the Depression,* is a fine account of the event and the controversy and excitement surrounding it.

From the Ash-Can School and
the Armory Show to Mid-Century

One of the most important painters to have benefitted from the encouragement given to a young generation of American artists by the 291 Fifth Avenue showings was Georgia O'Keeffe. The brief article on her art that appeared in *Camera Work* in 1917 could just as well apply to her later accomplishments. It touches fundamental qualities that have remained the substantial bedrock of her work. It is of particular interest at this point in the anthology since her unique creative vision has effectively removed the barriers between the currents of modernism and a profound experience of American locale. Her paintings inspired by long residence in New Mexico attain spiritual levels which only an intense communion with those desert places could possibly comprehend. Her own statement, in the next selection, reveals her intense feelings of kinship with this natural world and her intentions with respect to some of her subjects.

The selection from Francis V. O'Connor's "The New Deal Art Projects in New York" is an excellent outline of the federal support for the arts that formed part of the emergency relief measures taken during the depression of the 1930s. Evaluation of this era is an ongoing process, but there can be no doubt of at least one substantial effect of this program: the opportunity for artists to continue to function professionally at a time when circumstances around them threatened to interrupt their careers.

The last two selections in this section were written by two of the most colorful personalities in American art of this century: Thomas Hart Benton, the regionalist painter, and the architect Frank Lloyd Wright. Benton, in these excerpts from his autobiography, recounts some of his experiences as an art student in Paris, his involvement with modern European styles he would later reject, his friendship with the painter Stanton MacDonald Wright, his later regionalism, and his relationship with Jackson Pollock. It is a lively account, lavishly sprinkled with the peppery savor of his personality. But more than that, it provides a sampling of attitudes prevailing during the years between the Armory Show and the Abstract Expressionist years following the Second World War.

The selection by Frank Lloyd Wright is comprised of sections from *A Testament*, which offer glimpses of his beginnings as an architect, the development of his thought, and, throughout, his convictions about the mission of architecture. His creative versatility was remarkable and highly personal, and, as Henry-Russell Hitchcock expressed it, his late activity "still outpaced his juniors of the next generation and the one after . . ." and he "continued at ninety to offer an inspiration to all architects. . . ."

FROM *A Plea for the*

Picturesqueness of New York

Sadakichi Hartmann

. . . The best art is that which is most clearly the outcome of the time of its production, and the art signifying most in respect to the characteristics of its age, is that which ultimately becomes classic. To give to art the complexion of our time, boldly to express the actual, is the thing infinitely desirable. . . .

I know that a large majority will object to my arguments; those who do not feel that there is an imposing grandeur in the Brooklyn Bridge . . . who do not feel the poetry of our waterfronts, the semi-opaque water reflecting the gray sky . . . and who would laugh outright if anyone would dare to suggest that Paddy's market on Ninth Avenue or the Bowery could be reduced to decorative purposes.

Such men claim that there is nothing pictorial and picturesque in New York and our modern life, and continue their homage to imitation. The truth is that they lack the inspiration of the true artist, which wants to create and not merely to revive or adapt. They are satisfied with an incongruous mixture of what they know and see with what they have learned in school and what comes to them easily, no matter whether

at second or at third hand: it saves them experiments and shields them from failures. . . .

To open new realms to art takes a good share of courage and patience. It always takes moral courage to do what the rest of the profession does not; that of course the man possesses who starts out to conquer the beauties of New York. It takes actual physical courage to go out into the crowd. . . .

. . . The true artist works for himself, and does not care a rap for the opinion of others, as long as he knows—if that should be his aim—that his work has been infused with the spirit of to-day, with something unmistakably the outcome of the present. I would like to make his acquaintance; I might feel inclined to become his Ruskin.

I am well aware that much is lacking here which makes European cities so interesting and inspiring to the sightseer and artist. No monuments of past glory, no cathedral spires of Gothic grandeur, no historic edifices, scarcely even masterpieces of modern architecture lift their imposing structures in our almost alarmingly democratic land.

Despite this, I stick to my assertion, and believe that I can prove its truth. For years I have made it my business to find all the various picturesque effects New York is capable of—effects which the eye has not yet got used to, nor discovered and applied in painting and literature, but which nevertheless exist.

Have you ever watched a dawn on the platform of an elevated railroad station, when the first rays of the rising sun lay glittering on the rails? . . . The morning mist, in strange shapes and forms, played in the distance where the lines of the houses on both sides of the street finally united.

Have you ever dined in one of the roof-garden restaurants and watched twilight descending on that sea of roofs, and seen light after light flame out, until all the distant windows began to glimmer like sparks, and the whole city seemed to be strewn with stars? If you have not, you are not yet acquainted with New York.

Then take Madison Square. Place yourself at one of its corners on a rainy night and you will see a picture of peculiar fascination: Dark silhouettes of buildings and trees, surrounded by numerous light reflections, are mirrored in the wet pavement as in a sheet of water. But also in daytime it is highly

attractive. The paths are crowded with romping children, and their gay-colored garments make a charming contrast to the lawn and the foliage of the trees. . . .

Comparing New York with other cities, it can boast of a decided strain of gayety and vitality in its architecture. The clear atmosphere has encouraged bright colors, which, when subdued by the mist that hovers at times over all large cities, afford delightful harmonies. . . .

Almost any wide street with an elevated station is interesting at those times when the populace goes to or returns from work. The nearer day approaches these hours, the more crowded are the sidewalks. Thousands and thousands climb up or down the stairs, reflecting in their varied appearance all the classes of society, all the different professions, the lights and shadows of a large city, and the joys and sorrows of its inhabitants. . . .

A peculiar sight can be enjoyed standing on a starlit night at the block house near the northwest entrance of the Park. One sees in the distance the illumined windows of the West Side, and the Elevated, which rises at the double curve at One Hundred and Tenth Street to dizzy heights, and whose construction is hardly visible in the dimness of night. A train passes by, like a fantastic fire-worm from some giant fairyland, crawling in mid-air. The little locomotive changes into a tumult of color, red and saffron, changing every moment into an unsteady gray and blue. This should be painted. . . .

A picture genuinely American in spirit is afforded by Riverside Park. Old towering trees stretch their branches towards the Hudson. Almost touching their trunks the trains on the railroad rush by. On the water heavily loaded canal boats pass on slowly, and now and then a white river steamboat glides by majestically, while the clouds change the chiaroscuro effects at every gust of wind.

Another picture of surprising beauty reveals itself when you approach New York by the Jersey City ferry. The gigantic parallelograms of office buildings and skyscrapers soar into the clear atmosphere like the towers, turrets and battlements of some ancient fortress, a modern Cathay, for whose favor all nations contend.

The traffic in the North and the East rivers and the harbor offers abundant material; . . . I am also very fond of the vista

of the harbor from Battery Park, particularly at dawn. How strange this scene looks in the cold morning mist. There is no distance and no perspective; the outlines of Jersey City and Brooklyn fade ghost-like in the mist; soft shimmering sails, dark shadows and long pennants of smoke interrupt the gray harmony. . . .

For the lovers of proletarian socialism—who would like to depict the hunger and the filth of the slums, the unfathomable and inexhaustible misery, which hides itself in every metropolitan city—subjects are not lacking in New York. . . .

. . . One only needs to leave the big thoroughfares and go to the downtown back alleys, to Jewtown, to the village (East Twenty-ninth Street), or Frog Hollow. . . .

Wherever some large building is being constructed the photographer should appear. It would be so easy to procure an interesting picture, and yet I have never had the pleasure to see a good picture of an excavation or an iron skeleton framework. I think there is something wonderful in iron architecture, which as if guided by magic, weaves its networks with scientific precision over the rivers or straight into the air. They create, by the very absence of unnecessary ornamentation, new laws of beauty, which have not yet been determined, and are perhaps not even realized by the originators. I am weary of the everlasting complaint that we have no modern style of architecture. It would indeed be strange if an age as fertile as ours had produced nothing new in that art which has always more than others reflected the aspirations and accomplishments of mankind at certain epochs of history. The iron architecture is our style.

I still could add hundreds and hundreds of suggestions for pictures, but I fear I would tire my readers. I will therefore only mention a few haphazard. There is the Fulton fish market, a wonderful mixture of hustling human life and the slimy products of Neptune's realm, at its best on a morning during Lent; then the Gansevoort market on Saturday mornings or evenings; the remnants of Shantytown; the leisure piers; the open-air gymnasiums at Stryker's Lane and the foot of Hester Street; the starting of a tally-ho coach from the Waldorf-Astoria on its gay drive to Westchester; the canal-boat colony at Coenties Slip; the huge storage houses of Gowanus Bay. Another kind of subjects now comes to mind—the children of the tenement

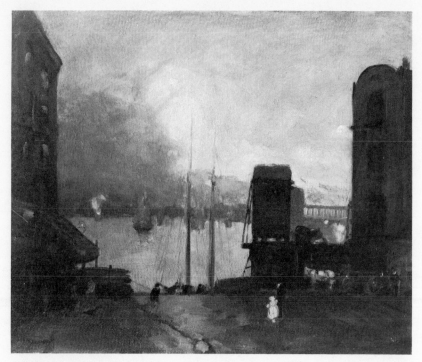

28. Robert Henri, *Cumulus Clouds—East River* (1901–02). Oil on canvas, $25\frac{1}{2}'' \times 32''$. (Private collection)

districts returning from school; or the organ-grinder, and little girls showing off their terpsichorean skill on the sidewalk to an admiring crowd.

But really what would be the use of specifying any further? Any person with his eyes open, and with sympathy for the time, place and conditions in which he lives, has only to take a walk or to board a trolley, to find a picture worthy of depiction almost in every block he goes.

I am perfectly aware that only a few of my readers endorse my assertions, and see something in my ardent plea. In thirty years, however, nobody will believe that I once fought for it, for then the beauty of New York will have been explored by thousands. . . .

1900

Stuart Davis on Robert Henri

Stuart Davis

enri came to New York with a tradition of art in the
environment, art from the environment, art from your
own personal experience as opposed to art as a formalis-
tic tradition that had been passed down through the acade-
mies. . . . When Henri opened his school his principle was to
draw from your own experience, to look not only at art, but at
the people around you as well, at the situation around you and
draw them. He didn't have any plaster-cast class. He did have
a life class. We worked in the life class five days a week . . .
where we were told to draw the model not according to some
formula, but in terms of how it looked to us as a fresh experi-
ence. The questions of finish or prettiness were of no impor-
tance. The question was whether you could communicate
some direct experience with this model in terms of its form.
. . . The academic training wasn't just to copy that model, but
to make a factual reproduction which was pre-established in a
context of artistic values. Whereas Henri said in effect, "To hell
with the artistic values. There are all kinds of those. What we
want are your own fresh reactions to what you see and in
relation to what you read, to what you know and to your gen-
eral experience."

. . . Henri also had a composition class where in addition to
making these life drawings, during the week we would make

a painting, or drawings of people, places we had been to, street scenes, landscapes, anything we wanted to. Then on Saturday we would bring in these paintings and put them up on the wall. He would talk about the paintings we brought in for three or four hours, and in the process of talking about those pictures he would criticize them not from the standpoint of some pre-established norm of excellence, but in relation to his own ideas. Or he would talk about some book he'd read and what it meant about life, and how this painting and the attitude toward it were related, or not related to the book. He'd talk about his own interests while he was talking about the painting and in that way, since he had more experience, more purposeful experience with culture in general than the crew of youths who were there, his discussions were very educational affairs. . . .

He was a frequent visitor to Europe. He was a man with an impulse to see and know things, and was able to put that impulse into execution. He had the ability, the talent, and the intelligence to use it. That's what he translated to the students in the school, and that's why instead of just an art school, it was an opening-up type of instruction through the experience and intelligence of Henri himself. . . .

When Henri spoke of writers . . . what he did was to inspire a desire on the part of the listener to go out, to look up all this stuff and to get involved with it. There was nothing like that in any other art school in New York, in Europe, or anywhere else so far as I know. It was a unique thing which inspired the students with the thought that they were somebody, that they were worth something, and that they should go out and try to use this awareness, try to develop it as opposed to just going and learning a certain discipline.

tape-recorded interview, 1962

Stieglitz and 291

William Innes Homer

Alfred Stieglitz, with the aid of Edward Steichen, was primarily responsible for introducing the American public to avant-garde European art before 1910. Stieglitz's gallery at 291 Fifth Avenue, opened in 1905, was the only center in the United States continuously devoted to the advancement of modern art before the Armory Show of 1913. The activities of the gallery (called the Little Galleries of the Photo-Secession or simply 291), in turn, were often explained and reinforced by the handsome quarterly journal *Camera Work*, which Stieglitz published between 1903 and 1917. Besides functioning as a self-motivated crusader for excellence in the arts, Stieglitz attracted a group of sympathetic colleagues in painting, photography, literature and criticism. These men and women believed, as he did, that the group spirit fostered by 291 could infuse new life into the fine arts and the art of photography in America.

As a student in Germany in the 1880s, Stieglitz admired the favorable climate he found there for art, music and fine workmanship. When he returned to the United States, however, he found American taste and craftsmanship at a disgracefully low level. Yet he continued to believe in the promise of America and tried desperately to educate his countrymen, prodding them into an awareness of culture, in the European sense, but addressing them in distinctly American terms. His search for

excellence in the arts dominated his life; it became a virtually unattainable ideal to which he devoted all the enormous strength of his ego.

To understand Stieglitz's crusade we must realize that he was motivated by remarkably strong inner convictions. The key to his personality, I believe, was his drive for perfection, his distaste for mediocrity in any form. A superb craftsman, he pursued his goals in photography with exceptional thoroughness. He was equally committed to the ideal of beauty (he spelled it with a capital B), a central criterion for the arts in the late nineteenth century and now almost totally defunct. In these beliefs he echoed the values of Whistler and the Aesthetic Movement, and like his English contemporaries, Stieglitz thought that the pursuit of artistic excellence was a sacred mission to be undertaken only by those intellectually and spiritually worthy. Unlike his influential contemporary Robert Henri, he refused to spread the doctrine of art to all, to spoil the purity of its message by delivering it to an untutored audience. Stieglitz believed in a cultural oligarchy, a group of enlightened individuals exchanging ideas and discoveries. Their artistic products, in turn, would serve as tangible models, as sources of inspiration for those Americans who were worthy of receiving their message.

Alfred Stieglitz first became involved in the fine arts through his interest in photography. After seven years of practicing photography in Germany (1883–90) he returned to the United States and was quickly recognized as a leading innovator in the medium. He was appointed to the editorship of two influential photographic journals, *American Amateur Photographer* (1893–96) and *Camera Notes,* the organ of the Camera Club of New York (1897–1902). An aggressive reformer, he utilized *Camera Notes* and the exhibitions of the Camera Club to support his crusade for excellence in photography. He was motivated by the belief that photography should be accepted equally with painting and sculpture. Though he realized that the techniques of the various media were different, he asserted that photography should be ranked with the other fine arts. Through the Camera Club of New York, Stieglitz championed a new esthetic that stressed artistic control of the formal elements of the medium, in contrast to the factual, descriptive records typical of much late nineteenth-century photography.

(In his own work he was rarely inclined toward soft-focus or excessively painterly effects, preferring to operate within the "optical" possibilities of photography.)

To promote his cause he established, in 1902, an organization called the Photo-Secession, made up of those who were sympathetic to his ideas about creative pictorial photography. Taking its name from the antiacademic secession art movements in Munich and Vienna, the Photo-Secession became a powerful force for reform in American photography. He gave this organization ideological direction and financial support.

Stieglitz voiced the ideals of the Photo-Secession in the early issues of *Camera Work.* This journal promoted not only the kind of photography he believed in, but also the latest currents in art, literature and criticism. In later issues, *Camera Work* disseminated information about recent developments in European and American painting, and for many years it was the most advanced American periodical devoted to the arts. A perfectionist in printing and typography, he personally supervised the production of every issue.

From 1903 to 1905, Stieglitz used *Camera Work* as his chief medium to promote the Photo-Secession. In 1905, however, he and his close friend Edward Steichen discussed the prospect of converting the rooms at 291 Fifth Avenue, recently vacated by Steichen, into a gallery for the Photo-Secession group. With Stieglitz's financial backing, Steichen redecorated the three small exhibition rooms in the attic of 291 Fifth Avenue to form the Little Galleries of the Photo-Secession. They opened in November 1905, featuring a show of photographs by members of the group. For more than a year the galleries were dedicated exclusively to the art of photography, but early in 1907 Stieglitz staged the first in a series of exhibitions of paintings, drawings and sculptures. Nonphotographic art soon overshadowed photographic exhibitions, and as early as 1908, 291 had become the most advanced center for the fine arts in America. Steichen later claimed that he had proposed the idea of showing photography *and* the other arts, but it is hard to validate this. In any case, it was Steichen, living in France, who served as the European representative for the gallery, suggesting exhibitions, negotiating with artists and making shipping arrangements. At the beginning Stieglitz seems to have given Steichen a free hand in proposing shows and in most instances welcomed the material he sent from Europe.

Steichen, in the early 1900s, was active both as a painter and photographer. He was aware of, and sympathetic to, some of the newer developments in modern European art of that decade, and from his vantage point in Paris he was able to inform Stieglitz of the latest artistic happenings in the city. At the same time, Steichen searched for talented young Americans working in new directions.

Edward Steichen and Alfred Stieglitz worked exceptionally well together, despite their different personalities, during the early years of 291. Stieglitz recognized the younger man's great talent as a photographer and promoted his work at every opportunity. Steichen, in turn, admired and respected Stieglitz as his mentor. Avant-garde art could not have been introduced to America so effectively without the collaboration of these two men. From 1907 to 1911 Steichen was more knowledgeable than Stieglitz about vanguard art in France, and at the beginning of this period Stieglitz relied heavily on Steichen's judgment. Stieglitz was willing, at times, to show work he did not fully understand simply to challenge the New York public, to force his audience to reassess their assumptions about art. It took him several years to assimilate the new pictorial concepts in modern European art, but his innate esthetic judgment—evident in every photograph he produced—consistently enabled him to single out and support artists of merit.

Stieglitz placed his personal stamp on 291 from the very beginning. He was present in the galleries throughout the day, and if a visitor showed any real interest in the works on display, a conversation which often started with the arts and ranged into other fields of activity would ensue. People who visited the gallery quickly realized that it was not a commercial enterprise but a "laboratory" or "experimental station" (to use Stieglitz's own terms). If someone wanted to purchase a work from the gallery, it could be arranged, but the object of 291 was not to make money.

. . . In April 1908 the rooms of the Little Galleries were vacated in favor of larger quarters across the hall. The new gallery, which came to be known simply as 291, was the setting for a series of exhibitions of modern art which, year by year, grew in importance. The work would include not only American efforts but also the latest examples of European modernism. . . . At 291, which remained open until 1917, [Stieglitz]

gave his backing to work which was either antiacademic or antirealistic, or both.

In addition to serving as a showplace for advanced European and American art, 291 played another equally important role. The gallery became a haven for young experimental artists and critics, a place where they could exchange ideas with Stieglitz and each other and receive encouragement that could be found nowhere else in the United States at that time. Almost every avant-garde American artist who had been exposed to European modernism (or who wished to be) was drawn to Stieglitz and 291. They were few in number, but those who valued the spirit of 291—Steichen, Marin, Dove, Hartley, Maurer, Haviland, De Zayas, Weber (briefly), Walkowitz, and later Picabia, O'Keeffe and Demuth—became stronger through their association with Stieglitz. He nurtured the idea of mutual cooperation among equals working in a humanistic laboratory where the open exchange of ideas would generate new discoveries and new statements in the fine arts. Stieglitz, of course, was the self-appointed director of this collective enterprise, a benevolent leader who tried to fashion a favorable esthetic, intellectual and material environment in which his artist friends could flourish. He single-handedly accepted or rejected candidates for this creative Utopia; if they passed his test and got along with him (and many did not), they could be assured of continued moral and financial support.

Stieglitz revealed his esthetic standards, before his immersion in European modernism, by offering the first exhibition outside of photography to Pamela Colman Smith in 1907 (January 5–24). Steichen, in Paris, had earlier proposed a show of Rodin drawings as the inaugural exhibition of nonphotographic work, but Stieglitz, perhaps to show his own independence, invited Miss Smith to show her drawings. He recalled: "I decided to give her an exhibition and so destroy the idea that Photo-Secession as well as myself were dedicated solely to the exhibition of photographs. . . . I preferred to make a fool of myself than to continue representing a lot of conceited photographers."[1] Pamela Colman Smith, an American-born painter and illustrator then living in England, was a unique, free spirit whose art and personality were in accord with Stieglitz's secessionist ideas, which *Camera Work* defined as "honesty of aim, honesty of self-expression, honesty of revolt

against the autocracy of convention."[2] Her art reveals influences from Beardsley, Walter Crane and the Pre-Raphaelites, and parallels the efforts of Munch and Ensor on the Continent. Her romantic style and imaginative content matched Stieglitz's own personal tastes, not Steichen's, at that moment.[3] This and subsequent exhibitions in 1908 and 1909 attracted large crowds and her work sold well. This success may have encouraged Stieglitz to continue scheduling exhibitions of paintings and drawings, along with photographs, in his gallery.

Steichen's proposed Rodin exhibition did not materialize until January 1908, when he sent Stieglitz a collection of drawings which he had obtained directly from the artist. The show gave New Yorkers their first exposure to the French master's drawings. Although a few of the critics had doubts about the artistic merit of the drawings, many reviewers praised them. Rodin had become a figure to contend with, and his name was already well known in artistic circles in America. This was the first in a series of increasingly ambitious presentations of European art which Stieglitz sponsored between 1908 and 1917, the year in which the gallery closed.

Much more controversial was the exhibition of Matisse watercolors, drawings, lithographs and etchings held at 291 in April 1908. Steichen, who had become acquainted with Matisse in Paris through Mrs. Michael Stein, selected the works and brought them to New York in person. At that time, Stieglitz knew little of Matisse but later recalled that, after seeing the works, he was able to understand most of them.[4] This exhibition introduced Matisse to America and was his first one-man show outside of Paris. He was still a controversial figure in France, so we can imagine the stir his work must have created in New York. An unsigned article in *Camera Work*, probably by Stieglitz, defended the show: "Here was the work of a new man, with new ideas—a very anarchist, it seemed, in art. The exhibition led to many heated controversies; it proved stimulating. The New York 'Art-World' was sorely in need of an irritant and Matisse certainly proved a timely one."[5] We may question how well Stieglitz understood Matisse at this time, but he certainly recognized the radical and revolutionary quality of his art. Matisse's pictorial iconoclasm was probably reason enough for Stieglitz to give him an exhibition. . . .

The next exhibition that Steichen assembled presented two talented Americans he discovered in Paris—Alfred Maurer and John Marin. Their two-man show occupied the gallery from March 30 to April 17, 1909, with the Maurers priced at $30 each and the Marins selling from $25 to $35 apiece. Maurer was undoubtedly the most radical American artist exhibited in New York up to that time, thanks in large part to the prominent influence of Matisse in his work. Many of the paintings Maurer exhibited were attacked by the critics for the same reasons that the Matisses were condemned in the exhibition of 1908. . . . Marin's entries, on the other hand, clearly derived from more traditional sources in European painting. Critics saw the similarities between Marin's work and that of Whistler, whose style was accepted in all but the most conservative American circles. [Charles H.] Caffin viewed Marin as part of the evolution which started with Cézanne and continued through Matisse, a trend influenced by Oriental art in "a more abstract way of receiving and of rendering the impression of the scene. It is not so much a visual as a spiritual impression eliminating as far as possible the consciousness of the concrete; rendering in consequence being not a representation of the original but an interpretation."[6] In his work shown at 291, Marin may have reflected other influences as well, including Impressionism, Neo-Impressionism and Fauvism. . . .

The next exhibition of paintings was devoted to an American, Marsden Hartley, who became Stieglitz's faithful protégé until the end of the First World War. Hartley, who spent much of his time in Maine, had been introduced to Stieglitz by the poet Shaemas O'Sheel, who suggested that Stieglitz give Hartley a show. Stieglitz refused at first because the end of the season was approaching and because he had already rejected Max Weber's request for an exhibition. But Stieglitz ultimately capitulated. . . . The exhibition, which ran from May 8 to 18, 1909, consisted chiefly of highly colored, decorative landscapes of Hartley's native state of Maine. Working in isolation, he had limited contact with important currents of modern European painting. However, he was an experimental and adventurous spirit who, by 1908–09, had learned valuable lessons from the unacademic art of the Italian Divisionist Giovanni Segantini and the American Impressionist John Twachtman. Hartley's contact with Stieglitz had a liberating effect on

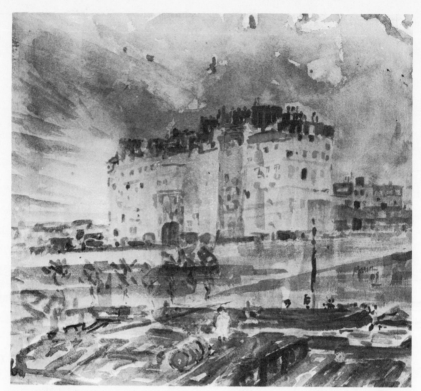

29. John Marin, *A Rolling Sky, Paris After Storm* (1908). Watercolor, 12½″ × 14¼″. (Courtesy of The Art Institute of Chicago, Alfred Stieglitz Collection)

the artist's thinking. Through the shows at Stieglitz's gallery, Hartley was exposed to paintings by Matisse and Picasso, among others. And in 1912, Stieglitz and Lizzie Bliss (through Arthur B. Davies) financed Hartley's first trip to Europe where he absorbed at first hand the latest currents in cubism, expressionism and abstraction.

From March 12 to 21, 1910, Stieglitz presented the first exhibition in the United States of American artists strongly influenced by European modernism. The show, entitled "Younger American Painters," was devoted to the work of D. Putnam Brinley, Arthur B. Carles, Arthur Dove, Laurence Fellows, Marsden Hartley, John Marin, Alfred Maurer, Edward Steichen and Max Weber. All but Dove, Weber and Hartley were then working in Europe and were known to Steichen, who recommended them to Stieglitz. Most of them were

members of the New Society of American Artists in Paris, a group of advanced artists that had assembled in Steichen's studio in February 1908. The nine artists did not represent a consolidated group or movement, the common denominator being their "departure from realistic representation, the aim toward color composition, the vitality of their work, and the cheerful key in which their canvases are painted."[7]

Several reviewers, as we might expect, attacked the exhibition. But a surprisingly large number were tolerant, even laudatory, in their remarks about the show; Stieglitz's efforts to educate the critics apparently had begun to bear fruit. Many of the reviewers regarded the artists as experimenters, opening up the frontiers of painting, working to advance the evolution of art. There seems to have been a feeling in the air that change was inevitable (to some critics, even desirable) and that the new discoveries would be in the realm of color—explosive, joyous and spontaneous. The critics were correct in identifying Matisse, and to a lesser degree Cézanne and Picasso (in the case of Weber), as the chief sources of inspiration for the advanced Americans of the group.[8]

It must have been a startling exhibition for New York in 1910. The only competing effort to show advanced American art took place in the same year, the ambitious Exhibition of Independent Artists, which opened in a West 35th Street warehouse on April 1, 1910. That show, organized by Robert Henri, John Sloan and their associates, represented about fifty percent of Henri's friends and pupils and appeared conservative by comparison to the Younger American Painters.

After 1910, Henri's influence began to diminish while Stieglitz's continued to grow. From 1911 to 1913, the year of the Armory Show, Stieglitz gave one-man shows to Cézanne, Picasso, Matisse, Weber, Carles, Hartley, Dove and Walkowitz, among others.[9] The exhibitions Stieglitz held at 291 and his publication of *Camera Work*—not to mention his personal sponsorship of promising younger American painters—made him the spiritual father of the Armory Show. It could not have happened without his pioneering efforts.

From 1913 to 1917, 291 and *Camera Work* remained active, and Stieglitz, despite periods of discouragement, continued to discover new talents and promote new ideas in the arts. In 1917, the gallery and the magazine closed down, leaving Stieglitz free for several years to pursue his own photography. But

237

his battle for modern American art was not over. He remained on the scene to fight again, first through the Intimate Gallery (1925–29) and then An American Place, which he operated from 1929 until 1946, the year of his death.

1973

NOTES

1. *Twice A Year*, No. 1 (Fall–Winter, 1938), p. 82.
2. *Camera Work* (April, 1907), p. 37.
3. Stieglitz stated that Pamela Colman Smith's drawing *Death in the House*, which she showed him when she was asking for an exhibition, "reflected absolutely my own state at the time." *Twice A Year*, op. cit., p. 82.
4. Ibid., p. 83.
5. *Camera Work* (July, 1908), p. 10.
6. *Camera Work* (July, 1909), p. 42.
7. *Camera Work* (April, 1910), p. 54.
8. Two of the Younger American Painters, Brinley and Fellows, apparently were the conservative painters within the group, and the latter has faded into obscurity. Brinley was judged as "not a radical except in his quest for color and light," (*Camera Work*, July, 1910, p. 46), and Fellows worked in a decorative mode influenced by Egyptian painting.
9. Beside the exhibitions discussed in the text, the gallery held shows of works by the following artists between 1908 and 1910: Marius de Zayas (1909, 1910), Allen Lewis (1909), Eugene Higgins (1909), Toulouse-Lautrec (1909–10), Henri Rousseau (1910). Also there was an exhibition of Japanese prints in 1909.

FROM *American Painting from the Armory Show to the Depression*

Milton W. Brown

The International Exhibition of Modern Art held in New York at the Sixty-ninth Regiment Armory from February 17th to March 15th, 1913, the exhibition known as the Armory Show, was without doubt the most important single exhibition ever held in America. It acted on the complacency of American art like a powerful shock. Smug academicians could attempt to ignore it and act as if nothing untoward had happened, but obviously something had happened, something which all the ignoring in the world could not undo. The artistic revolution, which up to then had been confined to "291" and small art groups, now became a front page event. The "madmen," "fakers," and "degenerates" of contemporary art could no longer be merely hush-hushed and ridiculed; abuse and sneers could not alter the fact that never in our entire history had art struck the public so forcefully. At the Sixty-ninth Regiment Armory, it was dragged out of the musty atmosphere of plush and horsehair and offered to the public as something alive and exciting. . . . The public, abetted by the newspapers, came to scoff, had their laugh, but left in bewilderment. Ignorance and misunderstanding were rife, but it was a grand circus nonetheless. Its effect upon the general public was a low-

ered opinion of Frenchmen and artists, but that opinion was never very high. The effect on the artist was profound and far-reaching. After the Armory Show American art was never the same again.

The history of the Armory Show is full of controversy and factionalism. The written accounts by Walt Kuhn, its secretary, Jerome Myers, and Walter Pach are not in disagreement as to facts but differ in emphasis. Naturally each man who was active at its inception and execution has a different recollection of what went on, dependent upon his own point of view and activity. And then again, the Armory Show was not the sort of thing about which people were objective.

For the origin of the idea of a large exhibition of modern art, we must go back to the Independent Show of 1910. The men who initiated that affair wanted to popularize the newer developments in American art. They believed, justly, that in America art was moribund as to patronage and exhibition. Indeed, it was a general feeling among the younger men that the public ought to be made aware of the full scope of American contemporary artistic achievement. They suffered keenly from the fact that most art buying was in the field of the old masters and of established foreign personalities, leaving the market for their own goods very restricted. They insisted with some nationalistic pride that American art should be given a hearing. Also, with pardonable personal interest, they felt that their own work should be offered to the public in an attention-catching manner. . . .

Walt Kuhn, Jerome Myers, and Elmer McRae were exhibiting in 1911 at the Madison Gallery, 305 Madison Avenue. From conversations that these three had with the director of the gallery, Henry Fitch Taylor, arose the idea of a large exhibition of American art. A group was formed, which soon consisted of twenty-five members. Alden Weir was elected president, Gutzon Borglum, vice-president, and the Association of American Painters and Sculptors was launched. The question of an exhibition place was a difficult problem which they discussed at length but could not solve. At that point Arthur B. Davies was approached either by Kuhn, as he claims, or by Myers and McRae, as Myers claims. At any rate Davies was won over, although he was reluctant at first, and at the resignation of Weir, who was neither politician enough nor radical enough for the job, Davies accepted the presidency. The intro-

duction of Davies into the picture was the turning point in the
history of the project. Unlike the great majority of American
artists, he was non-insular in his outlook, a man of culture, with
sensitive esthetic taste, wide knowledge, and a liberal mind.
He knew not only the art of the past, but also the work of the
most radical of his European contemporaries. Furthermore, he
was able, through his wide social and artistic contacts, to com-
mand the money necessary to finance a large exhibition. He
brought a fervor and singleness of purpose to the task. Unhap-
pily it was not matched by physical energy, but this was sup-
plied by Kuhn, as secretary, and several others.

Until Davies became president, the Association was domi-
nated by the Henri group who, in spite of their liberalism,
were more interested in the national aspects of the proposed
exhibition, and considered the idea of including some of the
radical European artists merely for added publicity value. But
in Davies' mind the idea grew steadily of presenting a picture
of contemporary European art to shatter the narrow provin-
cialism of American taste, and in his enthusiasm it overshad-
owed the original conception of an American exhibition. An
exhibition of modern art at the *Sonderbund* in Cologne, of
which he had seen the catalogue, seems to have clinched the
idea, and he wrote to Kuhn about it. Kuhn, as a sort of physical
extension of Davies' mind, left for Europe to see the *Sonder-
bund* show and with that trip the gathering of an exhibition
of modern art was set in motion. Kuhn tells how, travelling
through France, Germany, Holland, and England, he saw the
new and revolutionary art of Europe for the first time with
mounting enthusiasm, and with the help of Alfred Maurer,
Walter Pach, and Jo Davidson, began to arrange for its Ameri-
can showing. Soon a little frightened by the immensity of the
undertaking, he called for Davies, who came to Paris. Then
Davies, Kuhn and Pach put the finishing touches on the ar-
rangements and the material was all set for the invasion of
America.

The plan, when presented to the Association, met with a
good deal of resentful opposition. Many of the members had
been unaware of the new European experiments, or for that
matter even the older ones; made aware, they were set against
them, and afraid of their competition. But since they were
presented with an accomplished fact, and moreover since Da-
vies was the only one capable of getting financial backing for

a large show, the majority of the artists accepted the decision, although with some trepidation. Bellows took over the hanging job, Guy Pène du Bois and Frederick James Gregg saw to publicity, Allen Tucker looked after the catalog, and a committee headed by William Glackens set about assembling an American section.

The original idea of a non-jury show was given up somewhere along the road, and the selection of American exhibitors led to even greater disagreement than did the controversy over the inclusion of the European moderns. Some artists complained that the "Eight" controlled the A.A.P.S., others that Davies personally was interfering in all phases of the show. Leon Dabo, one of the leaders of the opposition, left for Europe just before the show's opening and on the eve of the opening Gutzon Borglum, in a sensational letter to the press, resigned as vice-president. The claim that Dabo and Borglum were the originators and organizers of the Armory Show, although circulated at that time, seems to have no foundation in fact.

Advance publicity had been widespread and provocative, and general interest was high. The hanging committee had done a remarkable job by converting the armory into a series of partitioned areas, the whole decorated with greenery. The size of the exhibition, containing as it did an estimated 1600 works, and the inclusion of last-minute entries created a great deal of confusion. But when the installation was completed and students were marshaled to act as guides, the presentation of modern art to the American public proved on the whole satisfactory. The works themselves proved to be sensational.

The Armory Show was not only a mammoth exhibition in a physical sense, but also a daring presentation of a new and revolutionary art. And even beyond that, it was a coherent and fairly comprehensive presentation of the nature and historic development of current artistic movements abroad.

The exhibition was actually two shows in one: a selection of modern art which was creating such a furor abroad and a cross-section of American contemporary art weighted heavily in favor of the younger and more radical group among American artists, who were, however, not as yet noticeably affected by the former. The American section was actually a representation of the works of those men who had been instrumental in the organization of the Armory Show, whereas the foreign

30. Installation view of the International Exhibition of Modern Art (Armory Show) (February 15-March 15, 1913). 69th Regiment Armory, New York. (Courtesy of The Museum of Modern Art, New York)

section was a presentation of the new and controversial movements in European art. It was the latter which was the core of the exhibition and the focus of dispute.

Considering the limited acquaintance which Americans had with these European innovations, the selection was comparatively sound. In comparison with similar large exhibitions of modern art held abroad—the *Sonderbund* show in Cologne in 1912 and the two English exhibitions at the Grafton Galleries in London in 1911 and 1912—it may even be said to have been superior. The Armory Show, perhaps because it was slightly later in date, was much more radical in content, including as it did the latest work of the Cubists.

Its major weakness, as was pointed out at the time, was the absence of much of the German tradition of Expressionism and Italian Futurism. The Futurists, however, had not been included in either the *Sonderbund* or Grafton Exhibitions. Nor

were the German Expressionists shown in the Grafton exhibitions. Their inclusion in the Cologne show was natural as an expression of national interest in a native art movement. The absence of works representative of these schools in the Armory Show seems not to have been the result of an ignorance of their existence but due to either circumstance or choice. According to F. J. Gregg, who was connected with the exhibition, Kuhn and Davies rejected the Germans because they felt them to be merely imitators of the French. The Futurists were excluded, it seems, because they insisted on being shown as a group, but they were listed in the explanatory chart prepared by Davies as "feeble realists." A Russian group (although none of the later Constructivist or Suprematist pioneers in Non-Objective art) which had appeared in the 1912 Grafton show was not included in the Armory Show because of problems in timing. Whatever the reasons, then, the exhibition was predominantly French and not as comprehensive as it might have been.

An effort was made to explain this art to the public in terms of the exhibition itself. The nineteenth-century tradition of French painting, beginning with Ingres and Delacroix, was presented as the foundation of the contemporary developments. This section included, according to Davies' own classification: the "classicists"—Ingres, Corot, Puvis de Chavannes, Degas and Seurat; the "realists"—Courbet, Manet, Monet, Sisley, Pissarro, Signac, Cassatt, Toulouse-Lautrec and Morisot; and the "romanticists"—Delacroix, Daumier, Redon and Renoir. Other nineteenth-century masters included in the show but not listed in the chart were Goya, Whistler, Rodin and Monticelli, as well as the Swiss, Hodler. A great deal of space was given to the Post-Impressionist triumvirate—Cézanne, Van Gogh and Gauguin. The contemporary section included the late Impressionists—Vuillard, Bonnard and Denis; the Fauves—Matisse, Marquet, Derain, Vlaminck, Rouault, Dufy and Friesz; the Cubists—the painters Picasso, Braque, Duchamp, Gleizes, Léger, Picabia and Villon, and the sculptors Archipenko, Duchamp-Villon and Manolo; the Orphist, Delaunay, and his American counterpart, the expatriate Morgan Russell, the Synchromist. Among those who did not easily fall into such categories were the only Expressionists—the Norwegian, Munch, the Russian, Kandinsky, and the German, E. L. Kirchner; the sculptors, Lehmbruck, Maillol and Brancusi; the "primitive" Rousseau; and Laurencin, Dufrenoy, Valloton,

From *American Painting from the Armory Show to the Depression*

Segonzac and Fresnaye. Except for the exclusion of *Die Brücke* and *Der Blaue Reiter* groups and the Futurists, this selection of contemporary European art is still the basis for our present description of modernism. One must admit that even aside from the sensation it created, the Armory Show was an excellent job of exhibition making.

Curiously enough the first two weeks were rather disappointing. Press and artistic public had been reached, but it was not until the third week that the show suddenly caught on with the general public, and then success was assured. People crowded the galleries. The academicians acted aggressively boorish. The public was amused. The press exploited the occasion as a sensation. Odilon Redon was a public success. Marcel Duchamp's *Nude Descending a Staircase* was selected by press and public as the symbol of the incomprehensibility and ridiculousness of the new art. The *Art News* offered a prize for the best explanation of the *Nude Descending a Staircase,* and soon people were finding it difficult to get close enough to look for the nude. Picabia rather than Picasso was the object of most of the ridicule directed against Cubism, perhaps because, sensing its publicity value, he had come to America for the opening and had informed the press that "Cubism is modern painting. I think, in fact I am certain, that Cubism will supplant all other forms of painting."[1] This of course struck a responsive chord, for America in the spirit of progress was intrigued by any new discovery which might supplant outmoded methods. Cézanne, Van Gogh, Gauguin and especially Matisse came in for the largest volume of vituperation from the critics who revealed themselves to be narrow-minded and venomous to an astonishing degree.

While the public expressed in laughter its feeling of shock and uneasiness in the face of the unknown, and artists either came with closed minds and left in anger or came with open minds and left in esthetic turmoil, several collectors saw the light and began to buy. Dr. Albert C. Barnes had already begun to collect Cézanne and Renoir, and he came to the show only to proclaim that he had better stuff. But just as previously Barnes had begun to buy the moderns because he was convinced by Glackens that they were a better investment than the academicians he had been buying, John Quinn now was persuaded by Walt Kuhn that modern art was a good financial gamble. Arthur Jerome Eddy, sensing something new, came

from Chicago and bought seventeen modern pictures. And Bryson Burroughs acquired a Cézanne for the Metropolitan Museum of Art, the first ever owned by an American museum.

According to one report the exhibition had an attendance of one hundred thousand, although Kuhn states that the real number will never be known, considering the free tickets issued to schools and societies. Two hundred and thirty-five pictures were sold, evenly distributed between American and European artists, and including practically all of the thirty Cubist paintings. Eventually over a quarter of a million people paid to see the exhibition in New York, Chicago and Boston, and over three hundred pictures in all were sold.

The show closed with a champagne supper and a jubilant parade and snake dance. It had been a success. Even its opponents had to admit that it had "stirred the art interest of the metropolis, and indirectly and reflectively that of the country, to an unexpected degree" and it might "perhaps ultimately create a second so-called renaissance in these United States. . . ."[2]

After being dismantled in New York, the foreign section plus the American works by members of the Association were sent on to the Art Institute of Chicago, where the excitement continued unabated, and, if anything, became even more frenzied, since a scandal-loving public had been prepared by advance reports from New York and was further piqued by the fortuitous outbreak of a morals epidemic in Chicago, which had just recently caused the removal of a Paul Chabas nude, *September Morn,* from a dealer's window and a Fraestad barnyard scene from the Art Institute. Curiosity seekers were entertained by the Institute's vengeful art teachers, who toured the galleries denouncing and ridiculing the exhibits and inciting their students to riot, with the result that Matisse, Brancusi and Walter Pach were burned in effigy. All that was needed was the discovery of six toes on a Matisse nude to make it a journalistic field day. The exhibition was without doubt a smash hit in Chicago.

Boston, however, was made of sterner stuff. There was a slight stir in the morass of Boston academicism, but Brahmin snobbery sailed through the crisis untouched. Disapproval was not clamorous, merely icy with indifference, and the exhibition lost money.

Royal Cortissoz, at the dinner given for the press had said in

From *American Painting from the Armory Show to the Depression*

graceful trepidation, "It was a good show but don't do it again."[3] However, once was enough. Modernism had been shown and it was to have its effect on America, in spite of the ridicule which was heaped upon it. . . .

<div align="right">1955</div>

N O T E S

1. "French Cubist Here," *Art News,* XI (Jan. 25, 1913), 4.
2. "An Art Awakening," *Art News,* XI (Mar. 15, 1913), 4.
3. Mar. 8, 1913, at Healy's Restaurant. Cf. *Art News,* XI (Mar. 15, 1913), 3.

The Georgia O'Keeffe
Drawings and Paintings at "291"

William Murray Fisher

W hile gladly welcoming new words into our vocabulary, words which intensify and increase our sense of the complexity of modern life, it is often quite impossible not to regret the lapse of older, simpler ones, especially as such lapse implies that the meaning and force of the words has also become obsolete. I am thinking, in this connection, of a phrase much loved by Lionel Johnson: *the old magnalities,* and I feel sure he used it so often in the hope that others would not willingly let it die. But I have met with it in no other modern writer. Is it because it no longer has significance for us? Have the old magnalities indeed crumbled to dust and ashes, together with all sense of the sublime, the worshipful, and the prophetic? Is it no longer good form, in this avid and impatient age, to mention the things that are God's? Must all tribute, then, go to Caesar? These reflections are forced upon the contemplative mind, and one must take counsel with one's own self in meeting them. And it is in so communing that the consciousness comes that one's self is other than oneself, is something larger, something almost tangibly universal, since it is en rapport with a wholeness in which one's separateness is, for the time, lost.

31. Georgia O'Keeffe, *Blue Lines No. 10* (1916). Watercolor, $24\frac{15}{16}''$ × $18\frac{15}{16}''$. (The Metropolitan Museum of Art, The Alfred Stieglitz Collection, 1949)

Some such consciousness, it seems to me, is active in the mystic and musical drawings of Georgia O'Keeffe. Here are emotional forms quite beyond the reach of conscious design, beyond the grasp of reason—yet strongly appealing to that apparently unanalyzable sensitivity in us through which we feel the grandeur and sublimity of life.

In recent years there have been many deliberate attempts to translate into line and color the *visual* effect of emotions aroused by music, and I am inclined to think they failed just because they were so deliberate. The setting down of such purely mental forms escapes the conscious hand—one must become, as it were, a channel, a willing medium, through which this visible music flows. And doubtless it more often comes from unheard melodies than from the listening to instruments—from that true music of the spheres referred to by the mystics of all ages. Quite sensibly, there is an inner law of harmony at work in the composition of these drawings and paintings by Miss O'Keeffe, and they are more truly inspired than any work I have seen; and although, as is frequently the case with "given writings" and religious "revelations," most are but fragments of vision, incompleted movements, yet even

the least satisfactory of them has the *quality* of completeness —while in at least three instances the effect is of a quite cosmic grandeur. Of all things earthly, it is only in music that one finds any analogy to the emotional content of these drawings—to the gigantic, swirling rhythms, and the exquisite tendernesses so powerfully and sensitively rendered—and music is the condition towards which, according to Pater, all art constantly aspires. Well, plastic art, in the hands of Miss O'Keeffe, seems now to have approximated that.

1917

FROM *About Myself*

Georgia O'Keeffe

A flower is relatively small. Everyone has many associations with a flower—the idea of flowers. You put out your hand to touch the flower—lean forward to smell it—maybe touch it with your lips almost without thinking—or give it to someone to please them. Still—in a way—nobody sees a flower—really—it is so small—we haven't time—and to see takes time, like to have a friend takes time. If I could paint the flower exactly as I see it no one would see what I see because I would paint it small like the flower is small.

So I said to myself—I'll paint what I see—what a flower is to me but I'll paint it big and they will be surprised into taking time to look at it—I will make even busy New Yorkers take time to see what I see of flowers.

Well—I made you take time to look at what I saw and when you took time to really notice my flower you hung all your own associations with flowers on my flower and you write about my flower as if I think and see what you think and see of the flower —and I don't.

Then when I paint a red hill, because a red hill has no particular association for you like the flower has, you say it is too bad that I don't always paint flowers. A flower touches almost everyone's heart. A red hill doesn't touch everyone's heart as it touches mine and I suppose there is no reason why it should. The red hill is a piece of the badlands where even

32. Georgia O'Keeffe, *Black Cross, New Mexico* (1929). Oil on canvas, 39″ × 30$\frac{1}{16}$″. (Courtesy of The Art Institute of Chicago)

the grass is gone. Badlands roll away outside my door—hill after hill—red hills of apparently the same sort of earth that you mix with oil to make paint. All the earth colors of the painter's palette are out there in the many miles of the badlands. The light Naples yellow through the ochres—orange and red and purple earth—even the soft earth greens. You have no associations with those hills—our wasteland—I think our most beautiful country. You must not have seen it, so you want me always to paint flowers. . . ."

1939

FROM *The New Deal Art*
Projects in New York

Francis V. O'Connor

I. THE PROJECTS IN GENERAL[1]

T he Federal Government sought to alleviate the acute eco-
nomic need of the nation's visual artists by creating four
art projects in the Depression. These were the Public
Works of Art Project (PWAP, December, 1933, to June, 1934),
the Treasury Section of Painting and Sculpture (Section, Octo-
ber, 1934, to June, 1943), the Treasury Relief Art Project
(TRAP, July, 1935, to about June, 1939), and the Works Prog-
ress Administration's Federal Art Project (WPA/FAP, August,
1935, to April, 1943).[2]

The PWAP was organized to help unemployed artists
through the winter of 1933–34. Its funds were supplied by
Harry Hopkins' Civil Works Administration and it was di-
rected by Edward Bruce of the Treasury Department, the one
government agency at the time mandated to supervise the
acquisition of works of art. Bruce, a lawyer, had been a banker,
newspaper owner, art collector and, since 1923, a professional
painter. During the first intense months of the New Deal he
represented the Treasury as a silver expert at the London
Economic Conference. While there he held a successful one-

man show. When he returned to the Treasury Department, he was found to be highly equipped for the delicate task of initiating a patronage program for unemployed artists.

The primary aim of the PWAP was to provide work for these artists in the decoration of non-Federal public buildings and parks. Art, as defined for the purpose of this project, covered sculpture, painting, design, and the products of craft. While the primary purpose of the project was to give employment to needy artists, a dual selection standard was set up. The artist had actually to be in need as well as competent. This dual standard raised the question of whether PWAP was to be administered as a relief project or one designed to acquire art for the Government. The Washington office never really clarified this point, though Edward Bruce tried. In his general instructions of December 10, 1933, he suggested that artists be employed on a weekly basis, so their performance could be checked and the "drones" eliminated.[3] On December 14, he wrote to Mrs. Juliana Force, director of the New York Region:

> It is going to take a fine sense of discrimination on all of us to select only those needy artists whose artistic ability is worthy of their employment. One phase of this work, of course, is to put men to work, but I think that we ought all remember that we are putting artists to work and not trying to make artists out of bums.[4]

Bruce wanted to stress the idea that PWAP was not a relief measure, but a public works program to employ artists to beautify public buildings in America. Thus, in March, 1934, shortly before PWAP came to an end, he was thinking of withdrawing from the Civil Works Administration by seeking an appropriation from the Public Works Administration. This would eliminate the relief feature of the project and enable Bruce to employ artists on the sole basis of quality.[5] He would realize this ambition as director of the Section.

PWAP limited the subject matter to the "American Scene" and was chary of anything experimental, unconventional, or possibly titillating. These attitudes are revealingly set forth in a satisfied letter from Edward B. Rowan, Assistant Technical Director of PWAP, to Emmanuel M. Benson dated May 24, 1934:

From *The New Deal Art Projects in New York*

Instructions sent from the central office in Washington to the various regions was that the artists be employed as quickly as possible for the decoration of public buildings (any building supported wholly, or in part, by taxation) and that the term of embellishment could be interpreted to cover any of the plastic and graphic arts' media. Naturally, some artists thought instantly of fresco, others of easel paintings, others of sculpture, lithography, etching, batik and the like. In no case was any stress laid upon either conservative or experimental work—the artist was encouraged to work in that mode which was compatible to his own individual nature. The one restriction, which I think was absolutely justified in view of the fact that the artists were working for the American Government, was that they stress in as far as possible the American scene. This was very broadly interpreted and rightly so. Every phase of the American scene was brought forth including still life and figure painting. There were very few nude paintings and my personal reaction is that this was as it should be in view of the fact that all of the works were designed for public buildings. All in all I think that the artists showed a very intelligent approach and we noted that many of those who in the past had done extremely experimental things attempted to tone down their expression with the result that there was a decided note of sincerity in the majority of the work. I hope you know me well enough to know that I have never disparaged experimental work—I personally get much pleasure from experimentation and encourage it in the case of the private painters. I feel that most of the painters felt that the time was so limited that they must get down to brass tacks and work with those things in which they were perfectly familiar. I hope you do not regard my attitude as narrow in this case but I was happy to see that there were few vaudeville stunts pulled by the artists under the Project.[6]

No doubt the limited scope of the PWAP also reduced the incidence of "vaudeville stunts." The original employment quota of 2,500 artists was divided among sixteen regions, each of which received an allocation in accordance with its population and with the number of artists who were estimated to live in it. In all, 3,749 artists were aided by the PWAP. They produced some 15,633 art and craft items. These works were sponsored for the most part by tax-supported institutions throughout the country.[7]

Due to the limited goals of the program, however, only about 25 percent of the artists in need of employment in the

country were actually given work, and of these, about 50 per cent were non-relief. These facts eventually led to the establishment of a more comprehensive relief program under the Works Progress Administration.

The total cost of the PWAP to the government was $1,-312,177, of which about 90 per cent went directly to unemployed artists.[8] Weekly wages ranged from $26.50 to $42.50 and were determined by the pay scales set up by the CWA for skilled craftsmen. While technically a program of work-relief, no direct means tests were imposed.

When the PWAP came to an end in the early summer of 1934 it was obvious that patronage of the arts was a feasible function of government. It was also obvious that a conflict existed between the goal of aiding indigent artists and that of acquiring quality works of art for the government from artists with different levels of professional experience and ability. As a result two separate art programs were eventually established. The Treasury Department, several months after the end of PWAP, set up the Section of Painting and Sculpture specifically to employ the best available professional artists to decorate government buildings. Art relief, on the other hand, had to wait until the fall of 1935 when the Works Progress Administration established the Federal Art Project. These two programs then operated concurrently, with several important administrative changes, until they were liquidated by Presidential order early in 1943.

On October 14, 1934, about five months after the end of the PWAP, Secretary of the Treasury Morgenthau established the Section of Painting and Sculpture within his Department. The Secretary's order listed five objectives for the new Section:

1. To secure suitable art of the best quality for the embellishment of public buildings;
2. To carry out this work in such a way as will assist in stimulating, as far as practicable, development of art in this country and reward what is regarded as the outstanding talent which develops;
3. So far as consistent with a high standard of art, to employ local talent;
4. To endeavor to secure the cooperation of people throughout the country interested in the arts and whose judgment in connection with art has the respect of the

From *The New Deal Art Projects in New York*

Section in selecting artists for the work to be done and criticism and advice as to their production;

5. In carrying out this work, to make every effort to afford an opportunity to all artists on the sole test of their qualifications as artists and, accordingly, to encourage competitions wherever practicable recognizing the fact, however, that certain artists in the country, because of their recognized talent, are entitled to receive work without competition.[9]

These objectives were carried out by a staff led by the same men who had supervised the PWAP: Edward Bruce as chief with Edward Rowan and Forbes Watson assisting him. Their primary objective was to secure the best possible art for the embellishment of government buildings. To do this they worked closely with Christian Joy Peoples, Director of Procurement for the Treasury Department, and Louis A. Simon, its supervising architect. Unlike the PWAP—and the WPA/-FAP later—they did not have to rely upon direct appropriations to support the activities of the Section. Instead, 1 per cent of the funds allocated by Congress for the construction of public buildings was set aside for artistic decoration. Since this was an internal procedure of the Treasury, the Section came in for less public scrutiny and Congressional harassment than did the WPA/FAP. The directors of the Section studiously cultivated this anonymity.

The Section commissioned murals and sculpture on a contract basis after selecting the artists by means of fair and financially rewarding local and national competitions. It sponsored about 1,116 murals and 300 sculptures in post offices and other Federal buildings at an expenditure of $2,571,267.[10] Each artist's work was kept under close scrutiny with payments being made only after the Section approved each stage in the creative process: preliminary designs, full-scale cartoons or models, half-way through final execution and upon completion. The Section kept a strict eye on subject matter and style and was not reticent in demanding changes as the work progressed. Such supervision tended to make most Section murals dry and uninteresting. Indeed, the best murals painted here during the thirties (if one excludes those done by the Mexican muralists) were painted by Thomas Hart Benton, an artist who, though invited several times, never chose to work for the Section. His

257

reasons are revealing: in a letter to Edward B. Rowan dated October 7, 1936, he says:

> I am going to lay this whole matter of the Federal mural business frankly before you. I have no objection to putting up the performance bond called for on the award of a Federal contract. As such this is all right. But as I see it I am not in this particular Federal case genuinely awarded a contract. That is, I am not myself a completely responsible party in the contract. You and others share responsibility with me—and to such an extent that you feel you have to watch me and pet me along to keep me from running you onto the brink of possible difficulty.
>
> I haven't liked this business from the very first. I understand your position and that of Ned Bruce and the rest of you who have helped put "Painting" on the political map of the U.S. I see that you are in a sort of "touchy" situation. I believe you are doing the best you can in that situation, especially with the inexperience you have to deal with in getting good wall pictures. I understand all this, but I can't work under it. The sketches I submitted last year are no good—and I think they are no good because I didn't feel free when I did them. I don't want to show those sketches or do the job for which they were intended. Just let me out on it and re-award the space.
>
> If you can ever give me a contract in which all responsibility is mine, in which I am completely trusted to do a good job and over which no one but myself has effective rights of approval or disapproval I'll work. Otherwise, I can't be sure I'll do a real piece of work.[11]

Benton's remarks strike home at one of the basic weaknesses of the Section—the lack of freedom it afforded the individual artist. It was this fault which seriously compromised both its immediate effectiveness and future influence.

The TRAP operated both under the Section, which supervised its creative activities, and the WPA/FAP, which provided funds and numerous work-relief artists and technicians. Its principal aim was to administer mural and sculpture projects in old Federal buildings that could not be funded by the Section. In practice the Section selected a master artist for a project and he chose assistants from the rolls of the WPA/FAP. The TRAP spent $833,784 to produce 89 murals, 65 sculptures and about 10,000 other works, mostly easel paintings and watercolors.[12]

The WPA/FAP, of all the New Deal art projects, was the

most extensive and comprehensive and had the greatest impact on the culture and consciousness of the nation. It was directed from its inception until its liquidation by Holger Cahill. Like Edward Bruce, Cahill was eminently suited to direct this vast enterprise. He was a recognized authority on American folk art and an established writer and critic. He had been in charge of public relations at the Newark Museum and director of exhibitions at the Museum of Modern Art, positions that brought him into contact with many of the country's leading artists. He was in full sympathy with the New Deal and the problems of the unemployed and his conception of the WPA/-FAP's social and aesthetic potentialities far exceeded its legal mandate to provide work-relief for indigent artists.

In October, 1935, Cahill outlined the basic procedure of the Federal Art Project on the first page of its operating manual:

> The Federal Art Project of the Works Progress Administration will employ persons of training and experience in the art field who are certified . . . as eligible to participate in the Works Program. The primary objective of the project is the employment of artists who are on the relief rolls. The Federal Art Project will draw at least 90 per cent of its personnel from relief. The project is planned in the belief that among these artists will be found the talent and the skill necessary to carry on an art program which will make contributions of permanent value to the community. Where necessary, artists may be drawn from non-relief sources, but in no case in excess of ten percent of the total number employed.

Cahill went on to outline the plan and aims of the WPA/-FAP:

> The plan of the Federal Art Project provides for the employment of artists in varied enterprises. Through employment of creative artists it is hoped to secure for the public outstanding examples of contemporary American art; through art teaching and recreational art activities to create a broader national art consciousness and work out constructive ways of using leisure time; through services in applied art to aid various campaigns of social value; and through research projects to clarify the native background in the arts. The aim of the project will be to work toward an integration of the arts with the daily life of the community, and an integration of the fine arts and practical arts.[13]

259

Implicit in these goals was Cahill's strong belief that the Government should work *with* the artist in raising artistic standards and increasing cultural awareness. This was in contrast to the aims of the Section, which sought out artists to work *for* the Government and imposed a subtle academic discipline upon them.

In general an artist was permitted to work at his own rate of production and required to submit an agreed upon number of works—or period of time in the case of a muralist—for his wages. The works were judged in terms of his known abilities and were either allocated to a public institution or the WPA/-FAP's own exhibition program for circulation among the Federal Art Galleries. There were no restrictions as to style or content and abstract and surrealist works were accepted along with more conventional works in the "social realist" or "American scene" vein.

The WPA/FAP, in effect, continued and expanded the work-relief activities of the PWAP. At its nationwide peak of more than 5,000 artists employed, it was sponsoring easel and mural painting, sculpture, graphic art, the Index of American Design, posters, art photography, a vast art teaching program, mosaics, stained glass and other arts and crafts. It also set up more than 100 Community Art Centers and Federal Art Galleries that organized art classes, lectures and shows of its best creations in regions where an original work of art had never been seen and artistic creativity was unknown. Indeed, so great was its scope and cultural impact, that the initials "WPA" have become erroneously associated with all four New Deal art programs.

The WPA/FAP produced 2,566 murals, 108,099 easel paintings, 17,744 sculptures, 11,285 designs for fine prints and 22,-000 Index of American Design plates, to give statistics for its major activities.[14] Its total national expenditures are very difficult to determine precisely but seem to have amounted to about $35,000,000. Of this roughly $14,000,000 was spent in New York.[15]

In all, the WPA/FAP did the most to sustain the nation's artists during the hard years of the Depression. It preserved their skills by providing the freedom to use them and invented with imagination and foresight projects that would have lasting value to the nation. . . .

1969

From *The New Deal Art Projects in New York*

N O T E S

1. I have relied for the most part on the following works: Edward Bruce and Forbes Watson, *Art in Federal Buildings*, Washington, D.C., 1936; Belisario R. Contreras, "Treasury Art Programs, The New Deal and the American Artist," unpublished Ph.D. dissertation, American University, 1967; Olin Dows, "The New Deal's Treasury Art Program: A Memoir," *Arts in Society*, Vol. 2, no. 4, n.d., 51–58; William F. MacDonald, "Federal Relief Administration and the Arts: A Study of the Works Progress Administration," unpublished manuscript, New York, 1949; Ralph Purcell, *Government and Art*, Washington, D.C., 1956; Erica Beckh Rubenstein, "Tax Payer's Murals," unpublished Ph.D. dissertation, Harvard, 1944, and *Preliminary Inventory of the Records of the Public Buildings Service, Record Group 121*, compiled by W. Lane Van Neste and Virgil E. Baugh, National Archives, Washington, D.C., 1958. Much material has also been drawn from the primary source documents concerning the WPA Federal Art Project preserved in Record Group 69 at the National Archives.

2. For a more detailed published history and chronology of the national New Deal art projects see my *Federal Art Patronage: 1933 to 1943*, College Park, University of Maryland Art Gallery, 1966, and my *Federal Support for the Visual Arts: The New Deal and Now; A Report on the New Deal art projects in New York City and State with recommendations for present-day Federal support of the visual arts to the National Endowment for the Arts, Roger L. Stevens, Chairman*, Washington, D.C., 1968, Greenwich, Connecticut: The New York Graphic Society, 1969.

3. Edward Bruce and Forbes Watson to Duncan Phillips, December 10, 1933; National Archives Record Group 121, entry group 106, box 3. Hereafter only entry group and box number will be given. See my *A Preliminary Report of Activities and Accomplishments with a Guide to New Deal Art Project Documentation*, Federal Support for the Visual Arts: The New Deal and Now, A Research Project, Washington, D.C., 1968, for a detailed explanation and inventory of the National Archives' holdings in the field of the New Deal projects.

4. 105:11

5. Bruce to Force, March 15, 1934; 116:5.

6. 108:2.

7. *Public Works of Art Project: Report of the Assistant Secretary of the Treasury to Federal Emergency Relief Administrator, December 8, 1933, to June 30, 1934*, Washington, D.C., 1934, p. 7.

8. *Ibid.*, p. 5.

9. Quoted in *Bulletin No. 1*, Section of Painting and Sculpture, Public Works Branch, Procurement Division, Treasury Department, Washington, D.C., March 1, 1935, pp. 3–4.

10. Rubenstein, *op. cit.*, p. 82.

11. 133:124.

12. *Final Report: Treasury Relief Art Project*, mimeographed, n.d., pp. 4–5.

13. *Federal Art Project Manual*, Works Progress Administration, October, 1935, p. 1.

14. *Final Report on the WPA Program: 1935 to 1943,* Federal Works Agency, Washington, D.C., 1946, Table XVI.

15. For a complete discussion of the expenditures of the nationwide WPA/FAP see my final report to the National Endowment, *op. cit.,* pp. 73–75.

FROM *An Artist in America*

Thomas Hart Benton

. . . Paris had a way of putting young men in highly romantic
and emotional states of mind before the War [1914–1918].
Maybe it still has. I know that I walked in an ecstatic mist for
months after I arrived, and I know that there were others like
me. Many never got out of that mist. I arrived when the doors
of appreciation were first opening to Cézanne. I looked him
over, but found Pissarro my greatest love. I tried the schools,
but hated their formulas quite as much as those of Chicago.
Old Jean Paul Laurens at Julien's looked scornfully at my
efforts to draw, and, to the snickers of the young internationals
about, waved me away toward the casts—the same damned
casts that had repelled me in the Art Institute. I fled my fellow
students just as I had done before in Chicago, and, retired in
my studio, decided that I should find my own way of being an
artist. . . .

There were others like myself who backed away from tradi-
tional training. I saw them around "the Quarter" and met
them now and then in the Dôme, which was the café most
frequented by the internationals. There was George Grosz,
Wyndham Lewis, Epstein, Rivera, Marin, Arthur Lee; there
were the Steins and others. These people were all known
around the Quarter, but I shied away from them for I soon
discovered they were all more talented and capable than I.

It did not take me very long after I arrived in Paris to realize

that my gifts were of an extremely limited nature, and that my "genius" was purely an imaginary affair. But I was proud and stubborn and I could not stand association with people who, I felt, would regard me as an inferior and patronize me. So far as my feelings were concerned, there was no difference between the shrewd, canny lawyers of Missouri and the aesthetes of Paris. I had the same uneasy defiance of both.

But I found two American friends. One, John Thompson, lived . . . in the studio next to mine. Thompson was a short, strong, tough fellow . . . older than I and more experienced as a painter but he did not patronize me. He painted as an impressionist and introduced me to the impressionist technique of representing things with little spots of pure color.

. . . We were joined at times by a moody, erratic, but gifted fellow named Carlock who died during the World War. Carlock knew more than either of us. . . . It was Carlock who first awakened me to the qualities of the masterpieces in the Louvre. I feel that I owe my first great artistic debt to Carlock, because in all the years of my floundering, he gave me, through his introduction to the values of the classic masterpieces, something to cling to and return to.

I had been in France more than a year when I met my next friend. This one was to be the only artist in all my life who, as an individual, was able to get past my suspicions of bright and clever people and to have an influence on my ways. Stanton MacDonald Wright, the California painter, was the most gifted all-round fellow I ever knew. . . . Without training of any kind, he could paint, and he also had a quick mind, capable of rapid and logical summations of all sorts. . . . We were an odd pair of friends. We were totally unlike and argued incessantly. . . . Wright was more lucid than I, more logical, and got the better of most of our arguments. This was tremendously good for me because the sting of defeat kept me alert and out of the despondent sloughs into which I was so often liable to sink after I discovered how poor was my "genius." . . . Wright associated with the intellectuals of the Quarter and relayed their opinions to me. He defended me before the busybodies among them who said that I should go back to America and try something at which I had a chance of success.

After three years I did go back. I spent a few depressed months at home in Missouri, restless and dissatisfied after the life of Paris. In 1912, after a three weeks' try of Kansas City,

From *An Artist in America*

I went to New York. I landed as if by instinct in the old Lincoln Square Arcade at Sixty-fifth Street and Broadway. That rambling building provided a refuge for everything and everybody. The doors of its long dark halls opened on every known sort of profession. . . . There were dancing schools, gymnasiums, theosophical societies, theatrical agencies, and all sorts of queer medical quackeries. There were prize fighters, dancers, models, commercial artists, painters, sculptors, bedbugs, and cockroaches. Everything was in that building. Ambitious youth and the failures and disappointments of broken-down age jostled one another along its corridors. Settling in the Arcade, I tried everything to make money, but without success, and frequently had to write home to my bitterly disappointed Dad for the wherewithal to eat. Finally I did manage, here and there, to pick up odd bits of work that I could do. . . .

Through the influence of Rex Ingram, who went from a novitiate in sculpture where I first knew him to the *Movie Art,* I got scenic jobs in the Fort Lee Studios and earned, for a while, the exalted sum of seven dollars a day. I looked up historical settings. I painted portraits of the movie queens of the day, Theda Bara, Clara Kimball Young, Violet Mercereau, and others. I knew Warner Olin and Stuart Holmes. With the latter I had a great knockdown and drag-out fight one night over a drunken party argument about who should entertain the ladies present on a player piano. . . .

While I was working in the movies, I never once regarded the material offered there as fit for serious painting. I missed the real human dramas that existed side by side with the acted ones and in my studio I painted lifeless symbolist and cubist pictures, changing my ways with every whiff from Paris.

My old friend Wright came back to America before the gathering war clouds of Europe. He came back, the founder of a new school, synchromism, which he had flung in the face of Paris, much to the dismay of his more timid countrymen who, as good followers of Frenchmen, regarded his act as gross effrontery. . . .

Wavering as I was in all the winds and isms of the time, Wright's synchromism offered enticing formulas. Synchromism was a conception of art where, in practice, all form was supposed to be derived from the simple play of color. It was a complex of the various theories of the time relating to color function, and was certainly the most logical of all. If one admit-

ted, and we all then did, that the procedures of art were suffi-
cient unto and for themselves and that the progress of art
toward "purification" led away from representation toward
the more abstract forms of music, then synchromism was a
persuasive conception. . . . In the Forum show of 1916, which
was the first exhibition of American modernists, I had a whole
row of things half-imitative of classic composition and half-
synchromist. Wright got me in that show. No one else wanted
me. But uncertain and unconvinced as my efforts were, I
achieved some status as an artist. I even sold a few pictures.

. . . I have neglected to mention the two artists whose names
during the days of success were always connected with mine.
John Steuart Curry and Grant Wood rose along with me to
public attention in the thirties. . . .

We were, the three of us, pretty well along before we ever
became acquainted or were linked under the now famous
name of Regionalism. We were different in our temperaments
and many of our ideas, but we were alike in that we were all
in revolt against the unhappy effects which the Armory show
of 1913 had had on American painting. We objected to the
new Parisian aesthetics which was more and more turning art
away from the living world of active men and women into an
academic world of empty pattern. We wanted an American art
which was not empty, and we believed that only by turning
the formative processes of art back again to meaningful subject
matter, in our cases specifically American subject matter,
could we expect to get one.

. . . The term [Regionalism] was, so to speak, wished upon us.
Borrowed from a group of southern writers who were inter-
ested in their regional cultures, it was applied to us somewhat
loosely, but with a fair degree of appropriateness. However,
our interests were wider than the term suggests. They had
their roots in that general and country-wide revival of Ameri-
canism which followed the defeat of Woodrow Wilson's uni-
versal idealism at the end of World War One and which devel-
oped through the subsequent periods of boom and depression
until the new internationalisms of the second World War
pushed it aside. This Americanist period had many facets,
some dark, repressive and suggestive of an ugly neo-fascism,
but on the whole it was a time of general improvement in
democratic idealism. After the break of 1929 a new and effec-

33. Thomas Hart Benton, *Arts of the West* (1932). Tempera with oil glaze on linen mounted on panel, 8′ × 13′. (From the collection of The New Britain Museum of American Art, Harriet Russell Stanley Fund)

tive liberalism grew over the country . . . a new and vigorous discussion of the intended nature of our society . . . and the political battles over its findings, plus a new flood of historical writing concentrated the thirties on our American image. It was this country-wide concentration more probably than any of our artistic efforts which raised Wood, Curry and me to prominence in the national scene. We symbolized aesthetically what the majority of Americans had in mind—America itself. Our success was a popular success. . . .

. . . As soon as the second World War began substituting in the public mind a world concern for the specifically American concerns which had prevailed during our rise, Wood, Curry and I found the bottom knocked out from under us. In a day when the problems of America were mainly exterior, our interior images lost public significance. Losing that, they lost the only thing which could sustain them because the critical world of art had, by and large, as little use for our group front as it had for me as an individual. The coteries of high-brows, of critics, college art professors and museum boys, the tastes of which had been thoroughly conditioned by the new aesthetics

267

of twentieth-century Paris, had sustained themselves in various subsidized ivory towers and kept their grip on the journals of aesthetic opinion all during the Americanist period. These coteries . . . could never accommodate our popularist leanings. . . . In the end they succeeded in destroying our Regionalism and returning American art to that desired position of obscurity, and popular incomprehensibility which enabled them to remain its chief prophets. The Museum of Modern Art, the Rockefeller-supported institution in New York, and other similar culturally rootless artistic centers, run often by the most neurotic of people, came rapidly, as we moved through the war years, to positions of predominant influence over the artistic life of our country. . . .

. . . The over-intellectualization of modern art and its separation from ordinary life intuitions . . . have permitted it, in this day of almost wholly collective action, to remain psychologically tied to the "public be damned" individualism of the last century and thus in spite of its novelties to represent a cultural lag. . . . Art's modern flight from representation to technical invention has only left it empty and stranded in the back waters of life. Without those old cultural ties which used to make the art of each country so expressive of national and regional character, it has lost not only its social purpose but its very techniques for expression.

It was against the general cultural inconsequence of modern art and the attempt to create by intellectual assimilation, that Wood, Curry and I revolted in the early twenties and turned ourselves to a reconsideration of artistic aims. . . . The philosophy of our popularism was rarely considered by our critics. It was much easier, especially after international problems took popular press support away from us, to dub us conventional chauvinists, fascists, isolationists or just ignorant provincials, and dismiss us. . . . The band wagon practitioners, and most artists are unhappily such, left our regionalist banner like rats from a sinking ship and allied themselves with the now dominant internationalisms of the high-brow aesthetes. The fact that these internationalisms were for the most part emanations from cultural events occurring in the bohemias of Paris and thus as local as the forms they deserted never once occurred to any of our band wagon fugitives.

Having long been separated from my teaching contacts, I

did not immediately notice the change of student attitude which went with our loss of public attention. But Wood and Curry still maintaining their university positions were much affected and in the course of time under the new indifference, and sometimes actual scorn of the young, began feeling as if their days were over.

It was one of the saddest experiences of my life to watch these two men, so well known and, when compared with most artists, enormously successful, finish their lives in ill health and occasional moods of deep despondency. . . .

Wood and Curry, and particularly Curry, were oversensitive to criticism. They lacked that certain core of inner hardness, so necessary to any kind of public adventure, which throws off the opinions of others when these set up conflicts within the personality. Thus to the profound self doubts, which all artists of stature experience, was added in these two an unhappy over-susceptibility to the doubts of others. Such a susceptibility in times of despondency or depression is likely to be disastrous. It was most emphatically so for Wood and Curry.

By the time we moved over into the forties, both Wood and Curry were in a pretty bad way physically and even psychologically. They had their good moments but these seemed to be rare and shortlived. In the end, what with worry over his weighty debts and his artistic self doubts, Wood came to the curious idea of changing his identity. Wood was a man of many curious and illusory fancies and when I went to see him in 1942 as he lay dying of a liver cancer in an Iowa hospital, he told me that when he got well he was going to change his name, go where nobody knew him and start all over again with a new style of painting. This was very uncanny because I'm sure he knew quite well he would never come out of that hospital alive. It was as if he wanted to destroy what was in him and become an empty soul before he went out into the emptiness of death. So far as I know Grant had no God to whom he could offer a soul with memories.

John Curry died slowly in 1946 after operations for high blood pressure and a general physical failure had taken his big body to pieces little by little. He made a visit to Martha's Vineyard the Autumn before he died. Sitting before the fire on a cold grey day when a nor'easter was building up seas outside, I tried to bolster his failing spirits.

34. Grant Wood, *Daughters of Revolution* (1932). Oil on masonite panel, 20″ × 40″. (The Cincinnati Art Museum: The Edwin and Virginia Irwin Memorial)

"John," I ventured, "You must feel pretty good now, after all your struggles, to know that you have come to a permanent place in American art. It's a long way from a Kansas farm to fame like yours."

"I don't know about that," he replied, "maybe I'd have done better to stay on the farm. No one seems interested in my pictures. Nobody thinks I can paint. If I *am* any good, I lived at the wrong time."

This is the way my two famous associates came to their end. . . .

Eighteen more years have passed since I wrote the preceding chapter. The note on which it ends suggests retirement. I did have, in the winter of 1950–1951, some feeling that my active years were over.

The Regionalist movement was, as I then indicated, being pushed pretty well into history. It was even being pushed *out*

of history by some. Grant Wood, John Curry, and Tom Benton, the "unholy trio," as one critic put it, had better be forgotten. The museums, so it was reported, were relegating the pictures of the Regionalists to their basements. The young painters, for the most part, had abandoned representation of the American scene, even the art of representation itself. The national exhibitions were sending me no more requests for paintings. As I had abandoned all my New York gallery connections, there was no way of showing my work there. . . .

However, I had soon come to take the demise of the Regionalist movement more philosophically than my supporters. I might, and did, deplore this demise, but I had had more than forty years of experience with artistic movements in our restless century and knew that none could retain a permanent influence. After all, Regionalism had lasted for more than twenty years, which was a considerably longer period than had any other artistic movement of our time except, perhaps, that of the kindred, socially oriented, Mexican school. This would assure it some kind of place in American art history. Besides, I had the consoling knowledge that paintings generated in a movement did not necessarily die with the movement, that attention to them was often revived. . . .

In the summer of 1956, after I had finished the mural for Kansas City's River Club, I was sitting one afternoon on the front steps of our Martha's Vineyard home when two men walked up. I recognized one of them, a former student, Herman Cherry, who had attended my classes at the Art Students' League in New York, back in the early thirties. He introduced me to his companion, the "abstract expressionist" painter Willem de Kooning, and said they had something to tell me. I invited them into the house and pointed out chairs, but they didn't sit down.

Cherry said, "Jack Pollock was killed last night in an automobile accident. We thought you should know." After that, they left. With such news there was nothing to talk about.

It is well known that Jackson Pollock began his first serious art studies under my guidance. It is less well known that he was also, for nearly ten years, on very close friendly terms with me. . . .

Following an elder brother, Charles Pollock, he came to my Art Students' League classes in the winter of 1930–1931. He

was very young, about eighteen years old. He had no money and, it first appeared, little talent, but his personality was such that it elicited immediate sympathy. As I was given to treating my students like friends, inviting them home to dinner and parties and otherwise putting them on a basis of equality, it was not long before Jack's appealing nature made him a sort of family intimate. Rita, my wife, took to him immediately as did our son T. P., then just coming out of babyhood. Jack became the boy's idol and through that our chief baby-sitter. He was too proud to take money, so Rita paid him for his guardianship sessions by feeding him. He became our most frequent dinner guest.

Although, as I have said, Jack's talents seemed of a most minimal order, I sensed he was some kind of artist. I had learned anyhow that great talents were not the most essential requirements for artistic success. I had seen too many gifted people drop away from the pursuit of art because they lacked the necessary inner drive to keep at it when the going became hard. Jack's apparent talent deficiencies did not thus seem important. All that was important, as I saw it, was an intense interest, and that he had. His chief difficulty was with the basic art of drawing. . . .

In another direction, however, in the study of design, which was carried on from reproductions of various works of the great historic periods by making reconstructions of these in the manner of the sixteenth-century cubistic exercises of Dürer, Schön, and Lucas Cambiaso, Jack quickly proved a perceptive student. He had an intuitive sense of rhythmical relations. He knew what counted. In painting also he possessed one rare and saving gift: He was an extraordinary natural colorist, and no matter how clumsy his paintings might be, they always had some coloristic beauty. Even as an utter novice he never made anything ugly.

By the winter of 1934–1935 Jack's painting, though still deficient in drawing, had developed enough competence to interest some of our more substantially fixed friends, and Rita was able to sell a few of them and relieve a little of his poverty. We purchased a number ourselves, always, however, for small sums. I had at the time a growing reputation, but my market was much restricted and money was scarce in our family. I induced Jack to try his hand at china decoration with vitrifiable color, a technique I had picked up in my various early experi-

ments. With this ceramic art he was quickly successful, producing some handsome and very salable works. I do not know how many of these survive, but a number of them, which we bought or which he gave to Rita, are still attractive decorations in our Kansas City home.

In the summers of the thirties Jack was a frequent and long-staying visitor at our place in Martha's Vineyard, where he helped me with the chores, gardening, painting trim, cutting firewood, and the like. We fixed up a little house where he could live and paint. . . .

It cannot be denied that Jack Pollock reordered and reshaped the styles that influenced him. He made the kind of stylistic amalgamations I have indicated were necessary for new artistic statements. In his case, however, these were made apart from any meaningful context, and they differ in that respect from the great artistic statements of the past, where not only procedural and aesthetic values were affirmed but human meanings communicated. Though Jack's effort has been amply justified by the plaudits of contemporary artistic circles, there remains with me a suspicion that it did not deliver all that it could have, had he lived at another moment.

It is interesting to speculate about what might have happened had Jack Pollock adhered to the Regionalist philosophy long enough to have developed a representational imagery to implement it. Drawing *can* be learned if the need for it be strong enough. I have no doubt that his contributions to Regionalism, had he continued to make them, would have been quite as original as were the purely formalistic exercises to which he finally devoted himself. They would also have had some added values. Judging from his early efforts, he would have injected a mystic strain into the more generally prosaic characteristics of Regionalism. His Western boyhood had given him a penchant for all the spooky mythology of the West with its visions of wild stallions, shadowy white wolves, lost gold mines, and mysterious unattended campfires. When, as a young man, he talked at all it was about such things. We received early reports of them from our admiring son. . . .

. . . I regarded Jack's paint-spilling innovations as absurdities when I first heard about them. I did not, however, treat them as wholly inconsequential. I think I made quite clear how much a part they played in the general repudiation of the Regionalist outlook, how they helped to make that appear, for

the younger artists of the late forties, a parochial aberration in the course of twentieth-century art. When later, after seeing some of them, I had second thoughts about Jack's actual productions—recognized their sensuous attractiveness that is—I scorned the idea of their possessing any long-term value. . . .

. . . The fully developed Pollock rhythms are open and suggest continuous expansion. There is no logical end to Pollock paintings. Nor is there any need for any because, not being representations of the objective world, they are immune to the conventions by which we isolate these and make them function as a unified whole. The Pollock structures may defy the "rules of art," but they do correspond to the actual mechanics of human vision, which is also without closed peripheries. Jack Pollock's work represents, not the objects we experience in the act of seeing, but the *way* we see them, in continuing, unending shifts of focus. . . .

1968

A Testament

Frank Lloyd Wright

ARCHITECTURE IS ALWAYS HERE AND NOW

V ictor Hugo, in the most illuminating essay on architecture yet written, declared European Renaissance "the setting sun all Europe mistook for dawn." During 500 years of elaborate reiteration of restatements by classic column, entablature and pediment—all finally became moribund. Victor Hugo, greatest modern of his time, went on to prophesy: the great mother-art, architecture, so long formalized, pictorialized by way of man's intellect could and would come spiritually alive again. In the latter days of the nineteenth or early in the twentieth century man would see architecture revive. The soul of man would by then, due to the changes wrought upon him, be awakened by his own critical necessity.

THE SEED

I was fourteen years old when this usually expurgated chapter in *Notre Dame* profoundly affected my sense of the art I was born to live with—life-long; architecture. His story of the tragic decline of the great mother-art never left my mind.

The University of Wisconsin had no course in architecture.

275

As civil-engineer, therefore, several months before I was to receive a degree, I ran away from school (1888) to go to work in some real architect's office in Chicago. I did not want to be an engineer. A visit to the pawnbroker's—"old man Perry"—made exodus possible. My father's Gibbon's *Rome* and Plutarch's *Lives* (see Alcibiades) and the mink cape collar my mother had sewed to my overcoat financed the enterprise.

There, in Chicago, so many years after Victor Hugo's remarkable prophecy, I found Naissance had already begun. The sun—architecture—was rising!

... A great protestant, grey army engineer, Dankmar Adler, builder and philosopher, together with his young partner, a genius, rebel from the Beaux-Arts of Paris, Louis H. Sullivan, were practising architecture there in Chicago, about 1887. ... I was accepted by Mr. Sullivan and went to work for "Adler and Sullivan" then the only moderns in architecture, and with whom, for that reason, I wanted to work. Adler and Sullivan were then building the Chicago Civic Auditorium, still the greatest room for opera in the world.

The tragedy befallen beloved architecture was still with me, Victor Hugo's prophecy often in mind. My sense of the tragedy had already bred in me hatred of the pilaster, the column for its own sake, the entablature, the cornice; in short all the architectural paraphernalia of the Renaissance. Only later did I come to know that Victor Hugo in the sweeping arc of his great thought had simply affirmed the truth: *Art can be no restatement. . . .*

The poet's message at heart, I wanted to go to work for the great moderns, Adler and Sullivan; and finally I went, warned by the prophecy and equipped, in fact armed, with the Froebel-kindergarten education I had received as a child from my mother. Early training which happened to be perfectly suited to the T-square and triangle technique now to become a characteristic, natural to the machine-age. Mother's intense interest in the Froebel system was awakened at the Philadelphia Centennial, 1876. In the Frederick Froebel Kindergarten exhibit there, mother found the "Gifts." And "gifts" they were. Along with the gifts was the system, as a basis for design and the elementary geometry behind all natural birth of Form.

Mother was a teacher who loved teaching; Father a preacher who loved and taught music. He taught me to see

great symphony as a master's *edifice of sound.* Mother learned
that Frederick Froebel taught that children should not be al-
lowed to draw from casual appearances of Nature until they
had first mastered the basic forms lying hidden behind appear-
ances. Cosmic, geometric elements were what should first be
made visible to the child-mind.

Taken East at the age of three to my father's pastorate near
Boston, for several years I sat at the little kindergarten table-
top ruled by lines about four inches apart each way making
four-inch squares; and, among other things, played upon these
"unit-lines" with the square (cube), the circle (sphere) and the
triangle (tetrahedron or tripod)—these were smooth maple-
wood blocks. Scarlet cardboard triangle (60°–30°) two inches on
the short side, and one side white, were smooth triangular
sections with which to come by pattern—design—by my own
imagination. Eventually I was to construct designs in other
mediums. But the smooth cardboard triangles and maple-
wood blocks were most important. All are in my fingers to this
day. . . . On this simple unit-system ruled on the low table-top
all these forms were combined by the child into imaginative
pattern. Design was recreation! . . . I soon became susceptible
to constructive pattern *evolving in everything I saw.* I learned
to "see" this way. I wanted to *design.*

. . . At the age of nineteen when I presented myself as a
novice to Mr. Sullivan I was already, and naturally, a potential
designer with a T-square and triangle technique on a unit-
system. . . .

THE CONFUSION

Among most of the architects I soon saw the great mother-
art, architecture, completely confused when not demoralized.
I saw their work as hackneyed or sentimentalized travesty of
some kind; some old or limited eclecticism or the so-called
"classic" of Beaux-Arts training encouraged by too many influ-
ential American Beaux-Arts graduates. The pilaster again!

But of the *Naissance* needed to replace moribund Renais-
sance I saw little or nothing outside the offices of Adler and
Sullivan to take the place of the futility of restatement at least.
Awakening was to come. . . .

All was the same dire artificiality. Nature thus denied was

more than ever revenging itself upon human life! . . . Modern machine-masters were ruling man's fate in his manufactures as in his architecture and arts. His way of life was being sterilized by marvelous power-tools and even more powerful machine-systems, all replacing hand labor by multiplying—senselessly —his activity and infecting his spirit. . . .

The pole-and-wire men in the name of social necessity had already forged a mortgage on the landscape of our beautiful American countryside while all our buildings, public and private, even churches, were senseless commitments to some kind of expediency instead of the new significances of freedom we so much needed. In the name of necessity, false fancy fronts hung with glaring signs as one trod along the miles of every urban sidewalk—instead of freedom, license—inextricable confusion. . . .

But soon this saving virtue appeared to me in our disgraceful dilemma: Realization that any true cultural significance our American free society could know lay in the proper use of *the machine as a tool and used only as a tool.* But the creative-artist's use of mechanical systems, most beneficial miracles, was yet wholly missing.

AWAKENING

Steel and glass themselves seemed to have come to use only to be misunderstood and misused. . . . With glass and the growing sheet-metal industries, these were, it seemed to me, only awaiting creative interpretation to become the body of our new democratic world: the same being true of new uses of the old materials—wood, brick and stone. . . .

REALIZATION

In this sense I saw the architect as savior of the culture of modern American society; his services the mainspring of any future cultural life in America—savior now as for all civilizations heretofore. Architecture being inevitably the basis of an indigenous culture, American architects must become emancipators of senselessly conforming human beings imposed

From *A Testament*

upon by mediocrity and imposing mediocrity upon others in this sanitary but soulless machine-age. Architecture, I believed, was bound to become more humanely significant. . . .

RETROGRESSION

But soon I saw the new resources not only shamefully wasted by machinesters but most shamefully wasted by our influential architects themselves; those with the best educations were most deadly. Our resources were being used to ruin the significance of any true architecture of the life of our own day by ancient ideas imposed upon modern building or ancient building ruined by so-called "modern" ideas. Thus played upon, some better architects, then called modern, were themselves desperately trying to reorganize American building and themselves as well. The A.I.A., then composed of architects who came down the hard way, was inclined to be sincere, but the plan-factory was already appearing as public enemy number one.

I had just opened my own office in the Schiller Building, 1893, when came disaster—Chicago's first World's Fair. The fair soon appeared to me more than ever tragic travesty: florid countenance of theoretical Beaux-Arts formalisms; . . . already a blight upon our progress. . . .

THE NEW ARCHITECTURE PRINCIPLES

I. The Earth Line

At last we come to the analysis of the principles that became so solidly basic to my sense and practice of architecture. . . .

PRINCIPLE ONE: KINSHIP OF BUILDING TO GROUND. This basic inevitability in organic architecture entails an entirely new sense of proportion. The human figure appeared to me, about 1893 or earlier, as the true *human* scale of architecture. Buildings I myself then designed and built—Midwest— seemed, by means of this new scale, to belong to man and at the moment especially as he lived on rolling Western prairie. Soon I had occasion to observe that every inch of height there

35. Frank Lloyd Wright, Robie House, Chicago, Illinois (1908–09). (Hedrich-Blessing, Chicago)

on the prairie was exaggerated. All breadths fell short. So in breadth, length, height and weight, these buildings belonged to the prairie just as the human being himself belonged to it with his gift of speed. . . .

As result, the new buildings were rational: low, swift and clean, and were studiously adapted to machine methods. The quiet, intuitional, horizontal line (it will always be the line of human tenure on this earth) was thus humanly interpreted and suited to modern machine-performance. Machine-methods and these new streamlined, flat-plane effects first appeared together in our American architecture as expression of new ways to reach true objectives in building. . . .

What now is organic "design"? Design appropriate to modern tools, the machine, and this new human scale. . . . Buildings before long were evidencing beautiful simplicity, a fresh exuberance of countenance. Originality.

Never did I allow the machine to become "motif"—always machine for man and never man for the machine. . . . In organic architecture I have used the machine and evolved a system of building from the inside out. . . .

From *A Testament*

II. Impulse to Grow

PRINCIPLE TWO: DECENTRALIZATION. The time for more individual spaciousness was long past due. 1893. I saw urban-decentralization as inevitable because a growing necessity, seeking more space everywhere, by whatever steps or stages it was obtainable. Space, short of breath, was suffocating in an airless situation, a shameful imposition upon free American life. Then, as now, the popular realtor with his "lot" was enemy of space; he was usually busy adding limitation to limitation, rounding up the herd and exploiting the ground for quick profit.

Indigestible competition, thus added to the big city, despoiled the villages. Over-extended verticality then congested to hold the profits of congestion was added to the congestion already fashioned on the ground.

To offset the senselessness of this inhuman act, I prepared the Broadacre City models at Taliesin in 1932. The models proposed a new space concept in social usage for individual and community building. But the whole establishment was laid out in accordance with the conditions of land tenure already in effect. Though the centers were kept, a new system of subdivision was proposed. . . .

III. Character is a Natural

THREE: Appropriate "character" is inevitable to all architecture if organic. Significance of any building would clearly express its objective, its purpose—whether store, apartment building, bank, church, hotel or pie-club, factory, circus or school. . . . This means sane appropriation of imaginative design to specific human purposes, by the natural use of nature-materials or synthetics, and appropriate methods of construction. . . . Continually new ways and shapes of building will continue to give fresh character and true significance to all modern structure.

Poetic tranquility instead of a more deadly "efficiency," should be the consequence in the art of Building: concordant, sane, exuberant, and appropriate to purpose. Durable, serviceable, economical. Beautiful. In the ever-changing circumstances of complex modern existence all this is not too easy to

accomplish and the extent of these evolving changes may not yet be fully seen but as architects we may thus reconstitute architecture in our hearts and minds and act to re-write our dated "codes" and refrain from disfiguring our American landscape by buildings or "service" systems.

IV. Tenuity Plus Continuity

FOUR: Completely new character by these simple means came to architecture; came to view, not by haphazard use, but by organic interpretation, of steel and glass. Steel gave rise to a new property: I call it *tenuity*. Tenuity is simply a matter of tension (pull), something never before known in the architecture of this world. No building could withstand a pull. Push it you might and it would stay together but pull on it and it would fall apart. With tensile strength of steel, this pull permits free use of the cantilever, a projectile and tensile at the same time, in building-design. The outstretched arm with its hand (with its drooping fingers for walls) is a cantilever. So is the branch of a tree.

The cantilever is essentially steel at its most economical level of use. The principle of the cantilever in architecture develops tenuity as a wholly new human expression, a means, too, of placing all loads over central supports, thereby balancing extended load against opposite extended load. This brought into architecture for the first time another principle in construction —I call it *continuity*—a property which may be seen as a new, elastic, cohesive *stability*. The creative architect finds here a marvelous new inspiration in design. A new freedom involving far wider spacings of more slender supports. Thus architecture arrived at construction from within outward rather than from outside inward; much heightening and lightening of proportions throughout all building is now economical and natural, space extended and utilized in a more liberal planning than the ancients could ever have dreamed of. This is now prime characteristic of the new architecture called organic.

Rigid box shapes, outsides steel-framed, belong strictly to the nineteenth century. They cannot be twentieth century architecture. Support at rigid corners becomes mere obstruction: corners themselves now insignificant become extravagant waste, mere accents of enclosure. Construction lightened by means of cantilevered steel in tension, makes continuity a

From *A Testament*

most valuable characteristic of architectural enlightenment. Our new architectural freedom now lies within this province. In the character of this new circumstance buildings now may proceed *from within outward:* Because push or pull may be integral to building design.

V. The Third Dimension: Interpretation

FIVE: To sum up, organic architecture sees the third dimension never as weight or mere thickness but always as *depth.* Depth an element of space; the third (or thickness) dimension transformed to a *space* dimension. A penetration of the inner depths of space in spaciousness becomes architectural and valid motif in design. With this concept of depth interpenetrating depths comes flowering a freedom in design which architects have never known before but which they may now employ in their designs as a true liberation of life and light within walls; a new structural integrity; outside coming in; and the space within, to be lived in, going out. Space outside becomes a natural part of space *within* the building. . . . Walls are now apparent more as humanized screens. They do define and differentiate, but never confine or obliterate space. A new sense of reality in building construction has arrived. . . .

VI. Space

SIX: Space, elemental to architecture, has now found architectural expression. Glass: air in air, to keep air out or keep it in. Steel, a strand slight and strong as the thread of the spider spinning, is able now to span extraordinary spaces. By new products of technology and increased inventive ingenuity in applying them to building-construction many superlative new space-forms have already come alive: and, because of them, more continually in sight. . . .

VII. Form

SEVEN: . . . An architect will never be content to design a building merely (or chiefly) for the picture it makes—any more than a man would buy a horse merely by its color. What kind

283

of intellect must the critic have who seeing a building judges it by "the look of it," ignorant of the nature of its construction?

For the first time in 500 years a sense of architectural form appears as a new spiritual integrity.

Heavy walls, senseless overheads and overloads of every sort, vanish—let us be glad. Light and thin walls may now depend from cantilever slabs supported from the interior on shallow, dry-wall footings, walls themselves becoming slender screens, entirely independent of use as support. Centralized supports may stand isolated, balancing load against load—seen not as walls at all, but as integral pattern; walls may be slender suspension from point to point, in fascinating pendant forms. In general, structure now becomes an affair from the inside outward instead of from the outside inward. Various geometrical forms (circular especially) in planning structure become more economical than the square of the box. Building loads may be suspended, suspension supported by slender, isolated uprights. Glass or light plastics may be used to fill in and make the whole habitable. . . . Spaces hitherto concealed or wasted or made impossible by heavy walls are revealed and made useful. Arrangements for human occupation in comfort may be so well aimed that spaciousness becomes economical as well as beautiful, appearing where it was never before thought to exist. Space now gives not only charm and character to practical occupation but beauty to the countenance and form of a valid new kind of habitation for mankind. . . .

ORGANIC UNIT

Thus environment and building are one: Planting the grounds around the building on the site as well as adorning the building take on new importance as they become features harmonious with the space-within-to-be-lived-in. Site, structure, furnishing—decoration too, planting as well—all these become as one in organic architecture. . . .

VIII. Shelter: Inherent Human Factor

EIGHT: As interior space to be lived in becomes the reality of building so shelter thus emphasized becomes more than ever significant in character and important as a feature. . . .

From *A Testament*

Organic architecture sees shelter not only as a quality of space but of spirit, and the prime factor in any concept of building man into his environment as a legitimate feature of it. Weather is omnipresent and buildings must be left out in the rain. Shelter is dedicated to these elements. So much so that almost all other features of design tend to lead by one another to this important feature, shelter, and its component shade. In order to complete the building, protecting all within it from every changing circumstance of light, of cold and heat, of wear and tear and usage, we require shelter. . . .

THE CLIENT

Thus modern architecture implies far more intelligent cooperation on the part of the client than ever before. . . . The dwelling "as-a-work-of-art" is a better place in which to be alive, to live with, and live for and by in every sense. Therefore, why not a better "investment"? The interests of architect and owner are thus mutual and binding upon both.

IX. Materials

NINE: . . . All the materials usable in building-construction are more than ever important. They are all significant: each according to its own peculiar nature.

Old or new materials have their own lively contributions to make to the form, character and quality of any building. Each material may become a happy determinant of style; to use any one material wrongly is to abuse the integrity of the whole design.

STYLE

There is no such thing as true style not indigenous. Let us now try to evaluate style. "Style *is* the man." Yes, style is, as should be, largely a matter of innate *character*. But style only becomes significant and impressive in architecture when it is thus integral or organic. Because it is innate it is style genuine —or not at all. Style is now a quality natural to the building itself. Style develops from *within*. Great repose—serenity, a

new tranquility—is the reward for proper use of each or any material in the true forms of which each is naturally most capable.

OWNERSHIP

In the hands of any prophetic architect the building is far more the owner's building than ever it was when built for him only by way of his, or her, own taste or whim. His building is the owner's now by his knowledge of the knowledge involved. So it is in the nature of architecture organic, that there can no longer be reason to deny any man his own way with his house if he really knows what he wants. The house may be designed to suit his preferences or his situation in his own way of life: but there is a difference between his preferences and his taste. If by his preferences, he reveals awareness of the principles involved and here touched upon, that will make his building genuinely his. If he seeks to understand *how* they involve, and evolve, his freedom *as individual* in this, his own, particular case his new home will declare his sovereignty as an enlightened individual. . . . "Taste" will now amount only to a certain discrimination in his approval of means to ends and appear once and for all in his choice of an architect. New light on both sides is indispensable to this new relationship, owner and architect.

Again, the *style* of each house may be much more than ever individual. Therefore the necessity for a new *cultural integrity* enters: individual sensitivity and personal responsibility are now essential. So comes a man-sized chance to choose a place not only in which to be alive, but in which to live as a distinguished entity, each individual owner genuinely a contributor to the indigenous culture of his time. . . .

WHAT IS NATURAL

As the consequence of these basic principles of design, wood and plaster will be content to be and will look as well as wood and plaster, will not aspire to be treated to resemble marble. Nor will concrete buildings, reinforced with steel, aim to resemble cut-stone or marble. Each will have a grammar of its own, true to materials, as in the new grammar of "Fallingwa-

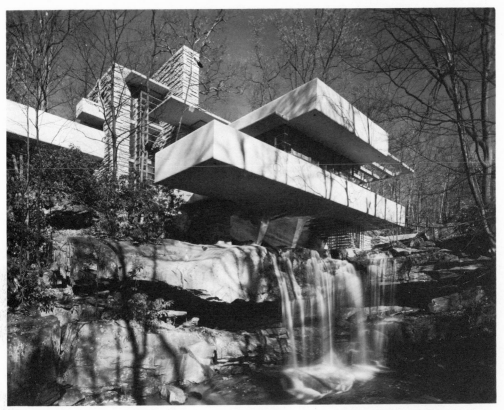

36. Frank Lloyd Wright, Edgar J. Kaufman House, "Falling Water," Bear Run, Pennsylvania (1936). (Bill Engdahl, Hedrich-Blessing, Chicago)

ter", my first dwelling in reinforced concrete. Were this simple knowledge of the grammar, the syntax, of organic design to become actual performance, each building would show its nature with such honest distinction of form as a sentient architect might afford to the awakened, appreciative owner. Building is an organism only if in accord outside with inside and both with the character and nature of its purpose, process, place and time. It will then incorporate the nature of the site, of the methods by which it is constructed, and finally the whole—from grade to coping, ground to skyline—will be becoming to its purpose. . . . Building as organism is now entitled to become a cultural asset.

This is all merely the common-sense of organic architecture.

1957

7. FROM MID-CENTURY ONWARD: THE NEW YORK SCHOOL, ITS AFTERMATHS, AND THE URBAN ENVIRONMENT

During the years following the end of the Second World War it was apparent that New York had become a dominant international center for the arts, and not merely because it was a major art market and the locus of an exceptional gathering of American talents. A number of important European artists, displaced by the events in Europe, had made their way to America, among them Fernand Léger, Piet Mondrian, Jacques Lipchitz, Marc Chagall, André Masson, Max Ernst, and George Grosz. The architect Mies van der Rohe had come to the United States in 1938 and another important architect, Walter Gropius, one of the founders of the Bauhaus, had arrived the year before, as had artist Laszlo Moholy-Nagy, who established a New Bauhaus in Chicago that same year. Bauhaus figures Josef Albers and Lyonel Feininger had been in the United States since 1933 and 1937 respectively. Hans Hofmann also came to the United States in the 1930s. Marcel Duchamp had been a frequent bird of passage since 1915. Chilean painter Roberto Matta Echaurren, who had been associated with the surrealists in Europe, came to New York in 1939, and the poet André Breton, leader of the surrealist movement and author of the first surrealist manifesto had left France and was active

in New York during the war years. Thus, in the period immediately after the war, the United States—and particularly New York—had been for some time the beneficiary of a considerable wave of European artistic emigration. Some of the emigrés later returned to Europe, but their presence, temporary or otherwise, was clearly a stimulus to American art at a propitious moment in its history.

Furthermore, American galleries and museums were offering increasingly rich fares of modern art to the public, as in the important exhibitions held at the Museum of Modern Art's new quarters erected in 1939.

Another factor in the emerging international status of art in America was, curiously enough, a legacy from the W.P.A. The recent federal support of artists working at their craft had given many talents among the younger generation who had benefitted from it a sense of community—artistic community—that was supportive of purpose and identity. This, compounded by the presence of distinguished Europeans—however occasional or slight the first-hand contacts—and the growing feeling that the vital center of art had shifted to America, helped to generate a fresh, creative spirit among American artists. As Meyer Schapiro has pointed out, there was among these artists "a mood of adventure and exhilaration" to which, increasingly, a public was responding.

All these matters are discussed in the selections by Robert Goldwater and Clement Greenberg that follow the opening series of statements by leading American artists of these post-war years.

The statements by Alexander Calder and Robert Motherwell were first presented on February 5, 1951, in a symposium held at the Museum of Modern Art during the important exhibition "Abstract Painting and Sculpture in America." Also participating in the symposium were George L. K. Morris, Willem de Kooning, Fritz Glarner, and Stuart Davis. "What Abstract Art Means to Me" was the theme to which each of the participants was to address his comments. The resulting statements were varied and decidedly personal, but Willem de Kooning's remark that "nothing is positive about art except that it is a word" caught the essence of a recurring implication in the views expressed by other participants. Calder's contribution was, however, singularly matter-of-fact. Abstaining from a discussion of what abstraction as a concept might mean to him, he explained, with refreshing simplicity and directness, what, in practice, he was concerned with when constructing his mobiles. Motherwell's statement, while more philosophical, is engagingly romantic in tone, and, indeed, he suggests that the conditions which spawned an abstract art consist of "a fundamentally romantic response to modern life" and that abstract art is an effort to fill in the abyss "between one's lonely self and the world." The first of Jackson Pollock's statements ac-

290

knowledges his debt to other artists, alludes to the presence in America (in 1944) of modern European masters, and deals tersely with the question of Americanism in American art. The second of his statements is the familiar explanation of his working procedures, "akin to the method of the Indian sand painters of the West." And one is reminded of Pollock's own western origins. The excerpts from David Smith's two articles are instructive for his point of view, as an artist, regarding aesthetics and art history, and for the comments on his own sculpture, *Hudson River Landscape.* Of particular interest, in view of the "cool" anonymity of execution courted by many artists after the Abstract Expressionist era, wherein indications of the artist's "hand"—in brushwork, for instance—are minimal, is Smith's view of the egocentric position of the artist as "the nature in the work of art" and of the creative act as "an act of personal conviction and identity."

Goldwater's article makes the important observation that the W.P.A. experience was a contributing factor in the growth of some of these artists. Objecting to the term "action painting," Goldwater finds a sensuous appeal in much of this work and, with some exceptions, a lyric quality rather than the epic spirit one might expect from the generally large scale of the paintings.

What happened in New York in the late 1940s and 1950s was not a homogeneous movement, but a sprawling turbulence that was reaching down all sorts of avenues opened up out of the various European movements of the early decades of the century. This vigorous mixture of personal creative explorations, variously identified as Abstract Expressionism, the New York School, or Action Painting, was not at all programmatic: it had no prescribed edges to acknowledge, and so its energy remained uncompromised for a relatively long time. But as the painterly wing of Abstract Expressionism produced its followers in whose hands the idiosyncratic brush- and knife-work developed what Clement Greenberg called "the Tenth Street touch," a phase of mannerism had apparently arrived. Abstract Expressionism's demise was anxiously awaited, predicted, and proclaimed from time to time, and by the sixties it was clear that new trends had developed out of the now "old" ones, and, in some instances, in reaction against them. Helen Frankenthaler, Morris Louis, Kenneth Noland, Jules Olitski, Ellsworth Kelly, and Frank Stella emerged in the wave of "post painterly abstraction," as Greenberg dubbed it. The two articles by Greenberg outline this new situation, and the selection by Lawrence Alloway defines another of the new configurations—Pop Art.

Among developments in general artistic awareness over the past several decades has been the increasing recognition of photography as a legitimate art form that had also been a shaping force in the

context of other arts, not to mention its far-reaching impact on the conditioning processes at work in society-at-large. While photography's influence on other contemporary art forms and the connections between Photorealism and Pop Art are examined in Harold Rosenberg's skeptical review of the "Sharp-Focus Realism" exhibition in the Sidney Janis Gallery in 1972, this article also evokes older issues respecting the role of illusionism in art.

Two areas of recent art have broken with the traditional expectation that the artist produce an object which can be displayed in a gallery setting, hung on a wall, or acquired as a possession. "Conceptual" art and its relatives "process" and "performance" art are all ephemera, and intentionally so, having temporary existence except as they are photographically recorded or otherwise documented. "Earthworks", like Robert Smithson's *Spiral Jetty* (1970), a whorl of rubble built out from the shore of Great Salt Lake, Utah, have more or less permanent tangibility, but falling somewhere between conceptual art and earthworks are such temporary structures as Christo's *Running Fence.* This latter work (intact from September 8 to September 22, 1976) was constructed of steel poles, cables, and panels of white nylon eighteen feet high that meandered, like a miniature, ethereal Great Wall of China, from the waters of the Pacific over twenty-four-and-one-half miles of Marin and Sonoma counties in California.

The two final articles, by architectural critic Ada Louise Huxtable, are also on the subject of artworks on the land: the man-made environment of our cities and the architectural principles which have been espoused in the shaping and reshaping of these environments. In the first of these articles, Huxtable calls attention to a new architectural revisionism which rejects the principles of the International Style. Producing a lively eclectic and romantic architecture, it is drawing freely, but not revivalistically, on historical styles as well as on the "Pop environment". Tangentially related to this free historicism in architectural design is the content of Huxtable's "The Fall and Rise of Main Street", which surveys the nationwide movement to rehabilitate the older architecture of American cities. Nineteenth-century and early twentieth-century commercial facades, now masked with slick false fronts in attempts to "modernize" the commercial image, are being restored to something like their original appearance. Efforts at historic preservation have contributed to this development and economic forces, not yet fully appreciated, may well feed its momentum, as the author notes, "in a profitable combination of art, history, and business."

FROM *What Abstract Art*

Means to Me

Alexander Calder

My entrance into the field of abstract art came about as the result of a visit to the studio of Piet Mondrian in Paris in 1930.

I was particularly impressed by some rectangles of color he had tacked on his wall in a pattern after his nature.

I told him I would like to make them oscillate—he objected. I went home and tried to paint abstractly—but in two weeks I was back again among plastic materials.

I think that at that time and practically ever since, the underlying sense of form in my work has been the system of the Universe, or part thereof. For that is a rather large model to work from.

What I mean is that the idea of detached bodies floating in space, of different sizes and densities, perhaps of different colors and temperatures, and surrounded and interlarded with wisps of gaseous condition, and some at rest, while others move in peculiar manners, seems to me the ideal source of form.

I would have them deployed, some nearer together and some at immense distances.

And great disparity among all the qualities of these bodies, and their motions as well.

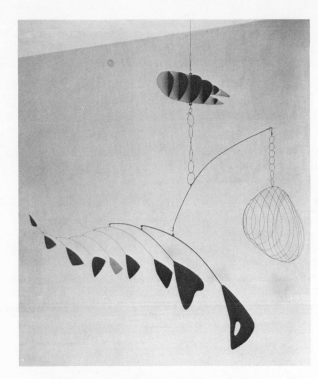

37. Alexander Calder, *Lobster Trap and Fish Tail* (1939). Hanging mobile: painted steel wire and sheet aluminum, about 8′ 6″ × 9′ 6″. (Collection, The Museum of Modern Art, New York. Commissioned by the Advisory Committee for the stairwell of the Museum.)

A very exciting moment for me was at the planetarium— when the machine was run fast for the purpose of explaining its operation: a planet moved along a straight line, then suddenly made a complete loop of 360° off to one side, and then went off in a straight line in its original direction.

I have chiefly limited myself to the use of black and white as being the most disparate colors. Red is the color most opposed to both of these—and then, finally, the other primaries. The secondary colors and intermediate shades serve only to confuse and muddle the distinctness and clarity.

When I have used spheres and discs, I have intended that they should represent more than what they just are. More or less as the earth is a sphere, but also has some miles of gas about it, volcanoes upon it, and the moon making circles around it, and as the sun is a sphere—but also is a source of intense heat, the effect of which is felt at great distances. A ball of wood or a disc of metal is rather a dull object without this sense of something emanating from it.

When I use two circles of wire intersecting at right angles, this to me is a sphere—and when I use two or more sheets of metal cut into shapes and mounted at angles to each other, I

From *What Abstract Art Means to Me*

feel that there is a solid form, perhaps concave, perhaps convex, filling in the dihedral angles between them. I do not have a definite idea of what this would be like, I merely sense it and occupy myself with the shapes one actually sees.

Then there is the idea of an object floating—not supported—the use of a very long thread, or a long arm in cantilever as a means of support seems to best approximate this freedom from the earth.

Thus what I produce is not precisely what I have in mind—but a sort of sketch, a man-made approximation.

That others grasp what I have in mind seems unessential, at least as long as they have something else in theirs.

1951

Two Statements

Jackson Pollock

My work with Benton was important as something against which to react very strongly, later on; in this, it was better to have worked with him than with a less resistant personality who would have provided a much less strong opposition. At the same time, Benton introduced me to Renaissance art. . . .

I accept the fact that the important painting of the last hundred years was done in France. American painters have generally missed the point of modern painting from beginning to end. (The only American master who interests me is Ryder.) Thus the fact that good European moderns are now here is very important, for they bring with them an understanding of the problems of modern painting. I am particularly impressed with their concept of the source of art being the Unconscious. This idea interests me more than these specific painters do, for the two artists I admire most, Picasso and Miró, are still abroad. . . .

The idea of an isolated American painting, so popular in this country during the thirties, seems absurd to me just as the idea of creating a purely American mathematics or physics would seem absurd. . . . And in another sense, the problem doesn't exist at all; or, if it did, would solve itself: An American is an American and his painting would naturally be qualified by that

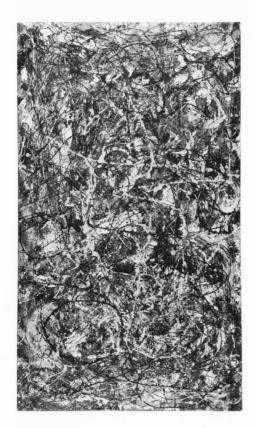

38. Jackson Pollock, *Full Fathom Five* (1947). Oil on canvas with nails, tacks, buttons, key, coins, cigarettes, matches, etc., $50\frac{7}{8}'' \times 30\frac{1}{8}''$. (Collection, The Museum of Modern Art, New York. Gift of Peggy Guggenheim)

fact, whether he wills it or not. But the basic problems of contemporary painting are independent of any country.

My painting does not come from the easel. I hardly ever stretch my canvas before painting. I prefer to tack the unstretched canvas to the hard wall or floor. I need the resistance of a hard surface. On the floor I am more at ease. I feel nearer, more a part of the painting, since this way I can walk around it, work from the four sides and literally be *in* the painting. This is akin to the method of the Indian sand painters of the West.

I continue to get further away from the usual painter's tools such as easel, palette, brushes, etc. I prefer sticks, trowels, knives and dripping fluid paint or a heavy impasto with sand, broken glass and other foreign matter added.

When I am *in* my painting, I'm not aware of what I'm doing. It is only after a sort of "get acquainted" period that I see what

I have been about. I have no fears about making changes, destroying the image, etc., because the painting has a life of its own. I try to let it come through. It is only when I lose contact with the painting that the result is a mess. Otherwise there is pure harmony, an easy give and take, and the painting comes out well.

<div align="right">1944</div>

FROM *What Abstract Art*

Means to Me

Robert Motherwell

The emergence of abstract art is one sign that there are still
men able to assert feeling in the world. Men who know
how to respect and follow their inner feelings, no matter
how irrational or absurd they may first appear. From their
perspective, it is the social world that tends to appear irrational
and absurd. It is sometimes forgotten how much wit there is
in certain works of abstract art. There is a certain point in
undergoing anguish where one encounters the comic—I think
of Miró, of the late Paul Klee, of Charlie Chaplin, of what
healthy and human values their wit displays . . .

I find it sympathetic that Parisian painters have taken over
the word "poetry," in speaking of what they value in painting.
But in the English-speaking world there is an implication of
"literary content," if one speaks of a painting as having "real
poetry." Yet the alternative word, "esthetic," does not satisfy
me. It calls up in my mind those dull classrooms and books
when I was a student of philosophy and the nature of the
esthetic was a course given in the philosophy department of
every university. I think now that there is no such thing as *the*
"esthetic," no more than there is any such thing as "art," that
each period and place has its own art and its esthetic—which

are specific applications of a more general set of human values, with emphases and rejections corresponding to the basic needs and desires of a particular place and time. I think that abstract art is uniquely modern—not in the sense that word is sometimes used, to mean that our art has "progressed" over the art of the past; though abstract art may indeed represent an emergent level of evolution—but in the sense that abstract art represents the particular acceptances and rejections of men living under the conditions of modern times. If I were asked to generalize about this condition as it has been manifest in poets, painters, and composers during the last century and a half, I should say that it is a fundamentally romantic response to modern life—rebellious, individualistic, unconventional, sensitive, irritable. I should say that this attitude arose from a feeling of being ill at ease in the universe, so to speak—the collapse of religion, of the old close-knit community and family may have something to do with the origins of the feeling. I do not know.

But whatever the source of this sense of being unwedded to the universe, I think that one's art is just one's effort to wed oneself to the universe, to unify oneself through union. Sometimes I have an imaginary picture in mind of the poet Mallarmé in his study late at night—changing, blotting, transferring, transforming each word and its relations with such care —and I think that the sustained energy for that travail must have come from the secret knowledge that each word was a link in the chain that he was forging to bind himself to the universe; and so with other poets, composers and painters . . . If this suggestion is true, then modern art has a different face from the art of the past because it has a somewhat different function for the artist in our time. I suppose that the art of far more ancient and "simple" artists expressed something quite different, a feeling of *already* being at one with the world . . .

One of the most striking aspects of abstract art's appearance is her nakedness, an art stripped bare. How many rejections on the part of her artists! Whole worlds—the world of objects, the world of power and propaganda, the world of anecdotes, the world of fetishes and ancestor worship. One might almost legitimately receive the impression that abstract artists don't like anything but the act of painting . . .

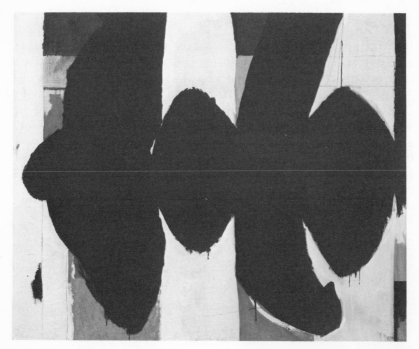

39. Robert Motherwell, *Elegy to the Spanish Republic XXXIV* (1953–54).
Oil on canvas, 80″ × 100″. (Albright-Knox Art Gallery, Buffalo, New York.
Gift of Seymour H. Knox, 1957)

What new kind of *mystique* is this, one might ask. For make
no mistake, abstract art is a form of mysticism.

Still, this is not to describe the situation very subtly. To leave
out consideration of what is being put into the painting, I
mean. One might truthfully say that abstract art is stripped
bare of other things in order to intensify it, its rhythms, spatial
intervals, and color structure. Abstraction is a process of em-
phasis, and emphasis vivifies life, as A. N. Whitehead said.

Nothing as drastic an innovation as abstract art could have
come into existence, save as the consequence of a most pro-
found, relentless, unquenchable need.

The need is for felt experience—intense, immediate, direct,
subtle, unified, warm, vivid, rhythmic.

Everything that might dilute the experience is stripped
away. The origin of abstraction in art is that of any mode of
thought. Abstract Art is a true mysticism—I dislike the word

301

—or rather a series of mysticisms that grew up in the historical circumstance that all mysticisms do, from a primary sense of gulf, an abyss, a void between one's lonely self and the world. Abstract art is an effort to close the void that modern men feel. Its abstraction is its emphasis. Perhaps I have tried to be clear about things that are not so very clear, and have not been clear about what is clear, namely, that I love painting the way one loves the body of woman, that if painting must have an intellectual and social background, it is only to enhance and make more rich an essentially warm, simple, radiant act, for which everyone has a need . . .

1951

FROM *Thoughts on Sculpture*

David Smith

. . . It is doubtful if aesthetics has any value to the creative artist, except as reading matter. It is doubtful if it has any value to his historic understanding of art, because his history of art is built upon the visual record of art and not written accounts made on a basis of speculation. . . .

The influential majority of aestheticians are at present a quarter of a century or more behind art. Thus the contemporary artist cannot be impressed by the written directives on art. His directives are emotional and intuitive, arising from contemporary life. To make art the artist must deal with unconscious controls, the intuitive forces which are his own convictions. Those especial and individual convictions that set his art apart from that of other men are what permit him to project beyond the given art history. This takes blind conviction, for if his contribution is original, it stands little chance of acceptance from the reactionary or status quo authorities.

Aesthetics usually represent the judgments which lesser minds hold as rules to keep the creative artist inside the verbal realm and away from his visual world. Actually the philosophy of art and the history of art have nothing to do with creative artist's point of view. Both are in entirely different fields. But

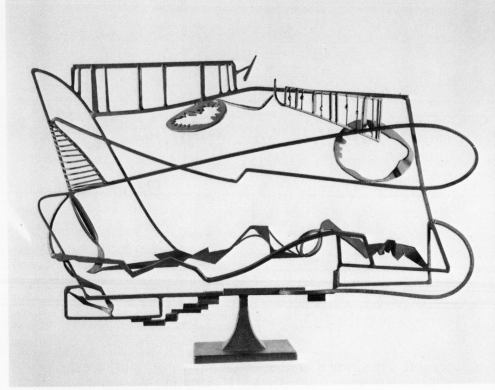

40. David Smith, *Hudson River Landscape* (1951). Steel, 49½″ × 75″ × 16¾″. (Collection of Whitney Museum of American Art)

the layman is apt to become confused if he is not able to make this differentiation. He often expects the artist to perform according to the philosopher's truth theorems or the didactic historian's speculations.

When we speak of the creative artist we must speak of affection—intense affection which the artist has for his work. An affection, along with belligerent vitality and conviction. Can the critics, the audience, the art philosophers ever possess the intensity of affection which the creator possessed? . . .

Often the artist is asked to explain his work. Naturally he cannot, but in one instance I have recalled a few motivations in the procedure of a sculpture. This work, later called *Hudson River Landscape* [Fig. 40], has been exhibited at the University of Illinois and elsewhere.

This sculpture came in part from dozens of drawings made

From *Thoughts on Sculpture*

on a train between Albany and Poughkeepsie, a synthesis of ten trips over a 75 mile stretch. Later, while drawing, I shook a quart bottle of India ink and it flew over my hand. It looked like my river landscape. I placed my hand on paper. From the image that remained, I travelled with the landscape, drawing other landscapes and their objects, with additions, deductions, directives, which flashed unrecognized into the drawing, elements of which are in the sculpture. Is my sculpture the Hudson River? Or is it the travel and the vision? Or does it matter? The sculpture exists on its own; it is an entity. The name is an affectionate designation of the point prior to travel. My object was not a word justification or the Hudson River but it may travel on any river—rivers are much the same—or on a higher level, the viewer may travel through his own form response arrived at through his own recall.

I have identified only part of the related clues. The sculpture possesses nothing unknown to any man. I want the viewer to travel by perception the path I travelled in creating it. The viewer always has the privilege of rejecting it. He can like it, or almost like it. He may feel hostile toward it, if it demands more than he is capable of extending. But its understanding can only come by affection and visual perception, which were the elements in its making. My own words cannot make it understood and least of all, the words of others.

When the artist starts to make his own statement, he must recognize that he is a product of his time, that what has gone before is his heritage, and from his particular vantage point, his purpose is to project beyond. He will identify himself with his filial epoch, which is only his present history, probably not many decades back, possibly only as far back as the oldest artists of his time. But whatever distance back he accepts as his filial heritage, his concept must press beyond the art of his time and in this sense he must always work towards that which he doesn't know. . . .

Art history is one thing to the art historian and another to the creative artist. Art history to the artist is visual. His art is not made up of historian's words of judgments. His choices are made the same way he makes the work of art—by the visual, irrational, creative. His history is a selection of his own preferences. His visionary reconstruction goes farther back in the history of man than the evidence. His history may even leave

a few openings for mythical reconstruction or epochs destroyed or lying still buried. Actually the artist by his working reference to art of the past is often the discoverer of new value, in historically unimportant epochs, and the first to pick out the art value in work which was previously viewed as ethnographic only. . . .

In contemporary work, force, power, ecstasy, structure, intuitive accident, statements of action dominate the object. Or they power the object with belligerent vitality. Probably the fact that man the artist can make works of art direct without the object meets opposition by its newness. Possibly this direct approach is a gesture of revolt representing the new freedom, unique in our time. Possibly there is a current ecstasy in the artist's new position much like that of 1910–12 Cubism.

From the artist there is no conscious effort to find universal truth or beauty, no effort to analyze other men's minds in order to speak for them. His act in art is an act of personal conviction and identity. If there is truth in art, it is his own truth. If beauty is involved, it is only the metaphor of imagination.

1954

FROM *Reflections on*

the New York School

Robert Goldwater

N early twenty years have passed [published 1960] since Jackson Pollock had his first one-man show.... and more than ten since Willem De Kooning made his debut. It is fifteen years since Arshile Gorky fused his long experiments into the influential style of his last years, and so became the partial prophet of a later achievement. . . .

This bit of chronology should be kept in mind, for its immediate implication is indeed correct: not only is there the New York School that has burst into popularity, influence, and affluence; not only has it had time to flower, to grow from indifference to prominence, from oppression to dominance; but it also has had time to change and develop, to evolve and alter and expand, to spread and succeed, to attract followers and nourish imitators. It has lived a history, germinated a mythology and produced a hagiology; it has descended to a second, and now a third artistic generation. This history . . . has in many ways contradicted the image of the New York School—the image it has had of itself, and even more the image its exegetes have given to the public—and so has presented it with peculiar and poignant problems. One of the results has been that recently, coincident with its notoriety, and in the midst of multiplying

adepts, its old masters have begun to declare that it is not, nor indeed ever was, a school, perhaps not even a movement, and certainly not a style.

. . . Once we accept some degree of abstraction as given (and abstraction applies as well to other times and places), further characteristics common to a group style are difficult to discover. This is the more true since that style is supposed to speak through form alone, and small differences therefore take on added meaning. . . .

The history of the movement is relevant both to its present status of wide acceptance and its view of itself. In the background of its formative years were combined two separate and, in most ways, antithetical experiences: first, the Federal Art Project of the W.P.A. (the government's economic assistance program), which during the thirties was literally essential to the continued existence of most of the artists who, sometime after 1945, were to become "abstract expressionists" (as well as to many others whose styles were to evolve differently); and second, the arrival in New York, during the early 'forties, of an important group of School of Paris artists (and writers), most of them in or on the fringes of the Surrealist movement. Externally, these two group events had a very different impact, each important in its own way.

While the Federal Art Project enabled artists to go on functioning as artists, and while for the sake of simple bread and butter, it was desirable to have its support (to be "on the Project"), it hardly provided a luxurious existence. Nor did it, as has sometimes been suggested, really convey—either to the artists it barely fed or to the public, which on the whole endured rather than enjoyed the little it saw of its post-office and hospital decorations—the impression that art had suddenly become essential to American society. . . . They became conscious of common interests and problems, and were forced to live with each other as they never had before. Here undoubtedly is one of the sources of that extraordinary gregarious intimacy (in New York, and during summers on Long Island) that has been the paradoxical accompaniment of the New York School's assertion of individual uniqueness.

More important, the experience of the depression years suggested to the artists that however marginal an afterthought art was to others it was essential to them. . . . They became aware that to continue to function on the margin was not only possi-

ble, but perhaps even desirable since this sort of existence gave rise to a certain valuable concentration on the work and a sense of esthetic community that in turn produced an invaluable intensity of feeling. . . .

The presence of the European artists in America, although on the surface a very different social phenomenon, had similar effects. It is certainly true, as has been said, that their actual appearance in New York had a tremendous impact, even though their relation to the larger artistic community just described was tangential at best. To see, occasionally to talk with, Mondrian, Masson, Ernst, Tanguy, Léger, Lipchitz, Duchamp, among others, was, so to speak, to join the School of Paris, to join, that is, on to the central creative tradition of twentieth century art, and through it to become part of the series of artistic revolutions that went back to Cézanne and Manet.

Even in the 'twenties there had never been as many expatriate painters and sculptors as writers. In the 'thirties isolation from Paris had intensified provincialism, both in painting fact and painters' feelings. The dominant "American scene" styles (those of Benton, Curry and Wood were the most notorious) that faithfully mirrored the political isolationism of the period, tried with dismal failure to make an asset of ignorance. The artists who remained in touch with European developments were only the more conscious of their distance from the center, and their time-lag. . . . Now in the 'forties, both before and after the United States went to war, it was Paris, from which there was so little news, that appeared separated from the new center, where styles and personalities continued to evolve. New York had become an international artistic capital.

The predominantly Surrealist group that had arrived, international in character, "bohemian" in a self-confident, intensive fashion . . . living *as if* they had no money worries, with at best a very different, more theoretical concern for social problems, had this in common with the artists who had experienced the W.P.A.: they too existed on the margin of society, though it was perhaps a brighter margin, having nothing to do with those trade-union problems that bedevilled so many of the Americans. Moreover, as the latest issue of a long line of romantics, they accepted this situation as a condition of creativity, and made of it a positive virtue, so they were immediately at home —or as little at home—as they had been in Paris or in London. They carried with them a warmth of feeling, an intensity and

concern for matters esthetic, a conviction of the rightness of their own judgments and an unconcern for any others. Artists of considerable reputation, they transmitted a sense of being at (or simply of being) the artistic center. This feeling, though it was not always entirely justified, was of the greatest value to the American artists who came into contact with them, teaching an entirely unfamiliar self-confidence which external events seemed to justify. New York was at the head of the procession, there was nowhere else to look for standards or models. The conviction of the European group of the importance of art even in the midst of cataclysm . . . was sincere and contagious. It was the proper accompaniment of their Surrealism, with its reliance upon the intuitive promptings of creation, and its trust in the subconscious impulse as the best artistic guide; . . . The antithetical attitudes of group mission and highly personal inventiveness fused in a sense of discovery and revelation that has been one of the lasting inheritances of the New York School.

Thus from strangely incompatible sources the New York artist learned to trust himself. He no longer had to look to the extra-artistic world for approval, since this was ruled out from the start; nor did he have to seek to join a distant central tradition, since this had come to him. He had learned to live with and to rely upon his own kind. . . . This self-reliance, this self-sufficient but gregarious existence (which for much of the time has been economic as well as esthetic) . . . has been one of the great strengths of the New York School, now partially dispersed by the impact of success.

This setting explains something of that sense of excitement under whose pressure the New York School first came into being and whose presence has continued to color its existence. The feeling of almost daily discovery has marked other schools in the history of modern art, but it has rarely been present in America, which has more usually been engaged in matching what others have already invented. With it went the absorption of the Surrealists' employment of accident or chance as part of the creative attitude. Much has been made of the artists' supposed loss of control over the process of creation and his deliberate abandonment of conscious methods of work. Sympathetic critics (and often the artists themselves) have repeatedly stated or implied that the artist was simply a kind of medium through which the work brought itself into being. I

From *Reflections on the New York School*

believe that these factors have been overstressed, or rather that they have been given wrong emphasis. The consciousness of being on the frontier, of being ahead rather than behind, of having absolutely no models however immediate or illustrious, of being entirely and completely on one's own—this was a new and heady atmosphere. . . .

The atmosphere of discovery being new to American artists, they made the most of it; but it was not new to the modern tradition. Their consciousness of it, their pleasure in it, and the theories erected around it are proof that they really joined and lead that tradition. The interaction between work and artist as the work grows under his hand . . . has been an integral part of the creative process at least since Redon and Gauguin; the sense that the artist adds to, rather than copies the world of nature is a central part of twentieth century tradition. And the use of the happy accident has an even longer history. But with the exception of some "scientific" experiments of the early Surrealists (of the dream notation and "exquisite corpse" variety), the modern artist, no less than the romantic of the last century who was guided by "inspiration", has always retained control of his medium and method. The choice was his, and the "happy accident" was deliberately accepted—or rejected. This has been just as true of the New York School. Both the eulogists and the detractors who have made subconscious, unguided action its central principle have taken a part for the whole. . . . The "struggle with the canvas" is a suitably intensified rephrasing of Cézanne's "inability to realize". . . . The wish for the appearance of accident is a continuation of Delacroix's desire to keep the insight and freshness of the first sketch. The "drip method", was (it is, I believe correct to refer to it in the past tense) precisely, a method, designed to do just that. Pollock's long-arm strokes as he poured paint upon flat canvas were quick decisions ("inspirational" decisions), and in a way athletic, but they were decisions made out of long experience as to just what visual rhythms would result from the muscular feel of his motion. As such they were as artistically controlled as the more usual brush movements from the wrist or elbow. With Pollock pent-up energies were released rapidly, almost instantaneously. For the slower artist there is a deliberation on the work as it proceeds; and if, alone in his studio with that work, he chooses to personify it, and so to describe his procedure as a dialogue between himself and his

work, this is but a natural projection. It remains true that at every stage the work is what he has made it.

In this way creative freedom, which involves choice, has, through a very human mixture of pride and humility, taken on the exclusive name of chance. . . . Accident becomes incorporated into method. This is all the more evident since one of the other main emphas[e]s of the New York artist has been on the struggle to create, that is to say, to be the master of his intention (if one abandons oneself to the arms of chance there is no struggle). Style and technique are to be kept in strict subordination; his aim as artist, rather than as craftsman painter or sculptor, is always paramount, and it is perhaps in this connection that the school's "expressionist" label is the most meaningful.

The liberation of the New York School was given an unfortunate emphasis in the term "action painting", the tag that has become best known to the public. Here was an epigrammatic description that stressed the artist's freedom as a creator, and the risks involved. . . . It transformed the American artist into an existentialist hero (and the post-war popularity of existentialism contributed to its success), living at a heightened level of unremitting decision, and compelled to more poignant choices than any other modern artist had ever been forced to make. The work's meaning lay not in the result, but in living the uncompromising process—or so at least went the literary refrain.

. . . If . . . it failed to distinguish between process and result and between artist and subject (indeed insisted that they were identical), it called attention to the inventive, problem-solving aspects of painting and sculpture. . . . It was nevertheless misleading, since it suggested that the work itself was unimportant, to be examined only by philistines. As in the progressive schools, it was the *being* an artist that counted. The critics neglected to note that works continued to be finished, and preserved.

For the artists, at the time, the unspecified suggestion of political, or at least social concern contained in the word "action" had its importance. Out of their experiences in the depression and the war, and out of their contact with Surrealism, came a continuing concern for the "morality" of their art and their "total commitment" to it. But this was art without sub-

From *Reflections on the New York School*

ject-matter in the conventional sense, projecting its message by the direct impact of form and structure and their general-ized associations. They wished to avoid the errors of subject-matter alone, so recently taught by the painters of the "Ameri-can scene" and "social significance", and equally the errors of the calculated production of fine "objets d'art" for the public's tasteful enjoyment. They were the very conscious heirs of a century of artistic change in which every new style was a step toward truth and somehow linked with social, as well as artis-tic, progress. They and their art were part of this morality.

They were also, during the decade 1945–55, and especially during its first five years, a small and embattled minority, mis-understood and unappreciated. . . . The result of all this was that they adopted an attitude at once uncompromising and possessive. Contrary to the European artist, who, with equal integrity, has tended to dismiss the work, once finished, into a public existence having little more to do with him, the mem-bers of the New York School were at this time retentive toward their creations. They seemed to view them as extensions of themselves, whose understanding was given to few. The ap-preciation of others somehow compromised the work's exis-tence, as if, after the manner of primitive belief, something of its vigor was drawn into the eye of the observer; popularity was suspect, and success (not yet achieved) a major crime. (How different the atmosphere to-day!) Since the artist identified with his work, intention and result were fused, and he who questioned the work, in however humble a fashion, was taken to be doubting the man.

. . . In characteristic American fashion, public acceptance came with a great rush; where before the burden of proof had been upon the artist, now it lay with the spectator, and the artist was given the benefit of the doubt, if doubt there was. The enthusiasts, accepting the premise that the work was purely a mediating term between artist and observer, were now generous where before they had been hesitant, and al-lowed themselves to be carried along by the artist's energy and conviction. The artist's "something to say" was taken literally and the work, freighted with the burden of a precise philoso-phy, was too often looked through rather than at. By adopting this attitude the spectator negated the artist's great success in restoring the primacy of the visual, and the pure pleasure and

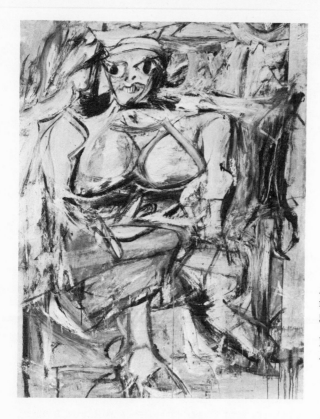

41. Willem de Koon-
ing, *Woman, I* (1950–
52). Oil on canvas, $75\frac{7}{8}''$
$\times 58''$. (Collection, The
Museum of Modern
Art, New York)

power of visual effects, and obscured for himself the infectious
and commanding quality which is one of the great achieve-
ments of abstract expressionism.

. . . One of the principal characteristics of the New York
School has been its great sensuous appeal. With certain excep-
tions (of whom De Kooning is the most obvious) this is a lyric,
not an epic, art. . . . Judged by their finished works, . . . here
are artists who like the materials of their art: the texture of
paint and the sweep of the brush, the contrast of color and its
nuance, the plain fact of the harmonious concatenation of
so much of art's underlying physical basis to be enjoyed as
such. . . .

This concentration upon sensuous substance is something
new to American art: to the extent that the Abstract Expres-
sionist is a materialist (as he has been called) and views his art
as more than pure vehicle, to that extent he is not simply an
Expressionist. It may be that the members of the New York
School have been able to enjoy themselves and so please others

314

because unlike the School of Paris they had no tradition of "well-made pictures" and *la belle peinture* to react against. Their "academy" was one of subject-matter, of realism and social realism, rather than the European one of clever, meaningless, manipulative skills, so that they have been able to rediscover the pleasures of paint. . . .

. . . Criticism, both in the United States and in Europe, but especially abroad, has overemphasized the "unfinished" character of this art. Responding more to a preconceived notion of the untutored American than to the works themselves (compare the French image of American literature), it has singled out the sensuous aspect (sometimes in praise and sometimes in blame) as almost its unique quality. Now it is perfectly true that the sense, the feel, of the artist's handwriting is something he consciously tries to preserve. The process shines through the result (this too is good "romanticism"), and lends it freshness and impact. But whether it is the dripping paint can, the loaded brush, or the slashing palette knife that is thus consciously brought to mind in the observation of the finished work, this remains an art of harmonies as well as of contrasts. The over-all effects may be large and strong, but details are subtle and soft; there are pastel colors and graduated modulations, and the small stroke and the tiny area must be noted within the sweeping line and the frequently immense size. It can be as silent with Rothko as it is voluble with De Kooning; as brooding with Clyfford Still as it is active with Jackson Pollock; as reduced with Kline as it is exploding with Hoffman[n]. It is an art which is as often delicate as it is powerful, and indeed in the best work is both at once.

. . . Because of its character, and the nature of its origins, the School's recent successes have brought with them new problems. For the older artists, not the least of these is how to preserve that sense of mission in the midst of hostility which was so important to the intensity of the first small group and to the integrity of its work; for the younger artists, it is how that original state of mind can be handed on in retrospect. . . . Others have analyzed their elders only too well and have produced works "in the manner of". Often these are initially appealing paintings, possessing, besides the construction, the brush-stroke and the palette of their models, an ease, a finish and a self-assurance missing in the originals. They are engaged in making handsome works of art which possess everything but

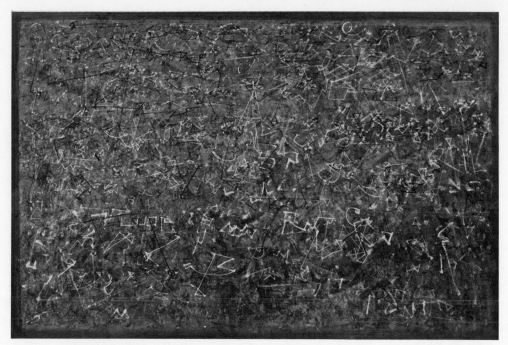

42. Mark Tobey, *Universal Field* (1949). Pastel and tempera on cardboard,
28″ × 44″. (Collection of Whitney Museum of American Art)

the urgent purpose (its revolutionary morality), from which
the style originally grew and which in the hands of its masters
prevents it from being "style". In this they have merely acted
as have followers everywhere. . . .

. . . It must be said that there has been exaggerated insistence
upon intuitive, isolated individuality, which pictures creation
as a kind of narcissistic struggle. . . . But a style has indeed been
created—and why not?—, as the Fauves, the Cubists, the Dad-
aists created a style, though this [is] looser and includes more
varied manners, by the incessant interplay of individual imagi-
nation, personal reflection and mutual observation. This is a
month-to-month, often week-to-week, evolving process, in
which the members of the group have each others' paintings
and ideas under constant scrutiny. To recognize this unceasing
give and take is to deny neither individuality nor creativity; on
the contrary, it reaffirms both. . . . There are those few whose
consistent individuality is heightened by the constant inter-
change and those more numerous who (wittingly or more
often unwittingly) succumb to the trend of the season or the

316

From *Reflections on the New York School*

year. In the locution of the artists themselves, the creative spirits are those who "have something to say".

The phrase emphasizes what is obvious, that however closely knit the artistic community, art is not produced from art alone, that the manipulation of materials, while it may occasionally be a starting point, is even, or perhaps especially, in an art largely abstract, not nearly enough by itself. But in recognizing that the artist needs "something to say", we must not distort the meaning of this description, as the device of language makes it so easy to do. The work is not transparent medium, it is, itself, what the artist has to say, and we must always come back to it. . . .

1960

FROM *Post Painterly Abstraction*

Clement Greenberg

The exhibition, "Post Painterly Abstraction," comprise[d] work by 31 American and Canadian artists. The exhibition was selected by Clement Greenberg for the Los Angeles County Museum. . . .

The great Swiss art historian, Heinrich Woelfflin, used the German word, *malerisch,* which his English translators render as "painterly," to designate the formal qualities of Baroque art that separate it from High Renaissance or Classical art. Painterly means, among other things, the blurred, broken, loose definition of color and contour. The opposite of painterly is clear, unbroken, and sharp definition, which Woelfflin called the "linear." The dividing line between the painterly and the linear is by no means a hard and fast one. There are many artists whose work combines elements of both, and painterly handling can go with linear design, and vice versa. This still does not diminish the usefulness of these terms or categories. With their help—and keeping in mind that they have nothing to do with value judgements—we are able to notice all sorts of continuities and significant differences, in the art of the present as well as of the past, that we might not notice otherwise.

The kind of painting that has become known as Abstract Expressionism is both abstract and painterly. Twenty years ago

From *Post Painterly Abstraction*

this proved a rather unexpected combination. Abstract art itself may have been born amid the painterliness of Analytical Cubism, Léger, Delaunay, and Kandinsky thirty years earlier, but there are all kinds of painterliness, and even Kandinsky's seemed restrained by comparison with Hofmann's and Pollock's. The painterly beginnings of abstract and near-abstract art would appear, anyhow, to have been somewhat forgotten, and during the 1920's and 1930's abstract art had become almost wholly identified with the flat silhouettes and firm contours of Synthetic Cubism, Mondrian, the Bauhaus, and Miró. . . . Thus the notion of abstract art as something neatly drawn and smoothly painted, something with clean outlines and flat, clear colors, had become pretty well ingrained. To see this all disappear under a flurry of strokes, blotches, and trickles of paint was a bewildering experience at first. It looked as though all form, all order, all discipline, had been cast off. Some of the labels that became attached to Abstract Expressionism, like the *"informel"* and "Action Painting," definitely implied this; one was given to understand that what was involved was an utterly new kind of art that was no longer art in any accepted sense.

This was, of course, absurd. What was mostly involved was the disconcerting effect produced by wide-open painterliness in an abstract context. That context still derived from Cubism —as does the context of every variety of sophisticated abstract art since Cubism, despite all appearances to the contrary. The painterliness itself derived from a tradition of form going back to the Venetians. Abstract Expressionism—or Painterly Abstraction, as I prefer to call it—was very much art, and rooted in the past of art. People should have recognized this the moment they began to be able to recognize differences of *quality* in Abstract Expressionism. . . . Painterly Abstraction became a fashion, and now it has fallen out of fashion, to be replaced by another fashion—Pop art—but also to be continued, as well as replaced, by something as genuinely new and independent as Painterly Abstraction itself was ten or twenty years ago.

The most conspicuous of the mannerisms into which Painterly Abstraction has degenerated is what I call the "Tenth Street touch" (after East Tenth Street in New York), which spread through abstract painting like a blight during the

1950's. The stroke left by a loaded brush or knife frays out, when the stroke is long enough, into streaks, ripples, and specks of paint. . . .

In all this there was nothing bad in itself, nothing necessarily bad as art. What turned this constellation of stylistic features into something bad as art was its standardization, its reduction to a set of mannerisms, as a dozen, and then a thousand, artists proceeded to maul the same viscosities of paint, in more or less the same range of color, and with the same "gestures," into the same kind of picture. And that part of the reaction against Painterly Abstraction which this show tries to document is a reaction more against standardization than against a style or school, a reaction more against an attitude than against Painterly Abstraction as such.

As far as style is concerned, the reaction presented here is largely against the mannered drawing and the mannered design of Painterly Abstraction, but above all against the last. By contrast with the interweaving of light and dark gradations in the typical Abstract Expressionist picture, all the artists in this show move towards a physical openness of design, or towards linear clarity, or towards both. They continue, in this respect, a tendency that began well inside Painterly Abstraction itself, in the work of artists like Still, Newman, Rothko, Motherwell, Gottlieb, Mathieu, the 1950–54 Kline, and even Pollock. A good part of the reaction against Abstract Expressionism is, as I've already suggested, a continuation of it. There is no question, in any case, of repudiating its best achievements.

Almost a quarter of the painters represented in this show continue in one way or another to be painterly in their handling or execution. . . . Clarity and openness as such, I hasten to say, are relative qualities in art. . . . The physical clarity and openness of the art in this show do not make it necessarily better than other kinds of art, and I do not claim that the openness and clarity which these artists favor are what make their works necessarily succeed. I do claim, however, that it is to these instrumental qualities that the paintings in this exhibition owe their *freshness,* as distinct from whatever success or lack of success they may have as aesthetic finalities. And I do claim—on the basis of experience alone—that openness and clarity are more conducive to freshness in abstract painting at this particular moment than most other instrumental qualities are—just as twenty years ago density and compactness were.

From *Post Painterly Abstraction*

Having said this, I want to say, too, that this show is not intended as a pantheon, as a critic's choice of the best new painters. It is meant to illustrate a new trend in abstract painting. It includes a number of artists who I do think are among the best new painters but it does not include all of these. Even if it did, it still would not be a show of "the best new painters." Thirty-one is simply too large a number for that. . . .

Among the things common to these thirty-one, aside from their all favoring openness or clarity (and all being Americans or Canadians), is that they have all learned from Painterly Abstraction. Their reaction against it does not constitute a return to the past, a going back to where Synthetic Cubist or geometrical painting left off. Some of the artists in this exhibition look "hard-edged," but this by itself does not account for their inclusion. They are included because they have won their "hardness" from the "softness" of Painterly Abstraction; they have not inherited it from Mondrian, the Bauhaus, Suprematism, or anything else that came before.

Another thing the artists in this show, with two or three exceptions, have in common is the high keying as well as lucidity, of their color. They have a tendency, many of them, to stress contrasts of pure hue rather than contrasts of light and dark. For the sake of these, as well as in the interests of optical clarity, they shun thick paint and tactile effects. Some of them dilute their paint to an extreme and soak it into unsized and unprimed canvas (following Pollock's lead in his black and white paintings of 1951). In their reaction against the "handwriting" and "gestures" of Painterly Abstraction, these artists also favor a relatively anonymous execution. This is perhaps the most important motive behind the geometrical regularity of drawing in most of the pictures in this show. It certainly has nothing to do with doctrine, with geometrical form for its own sake. These artists prefer trued and faired edges simply because these call less attention to themselves as drawing—and by doing that they also get out of the way of color.

These common traits of style go to make up a trend. . . .

1964

FROM *Avant-Garde Attitudes:*

New Art in the Sixties

Clement Greenberg

The prevalent notion is that latter-day art is in a state of confusion. Painting and sculpture appear to be changing and evolving faster than ever before. Innovations follow closer and closer on one another and, because they don't make their exits as rapidly as their entrances, they pile up in a welter of eccentric styles, trends, tendencies, schools. . . . The different mediums are exploding: painting turns into sculpture, sculpture into architecture, engineering, theatre, environment, 'participation'. Not only the boundaries between the different arts, but the boundaries between art and everything that is not art are being obliterated. At the same time scientific technology is invading the visual arts and transforming them even as they transform one another. And to add to the confusion, high art is on the way to becoming popular art, and vice versa.

Is all this so? To judge from surface appearances, it might be so. A writer in the *Times Literary Supplement* of 14 March 1968 refers to '. . . that total confusion of all artistic values which prevails today'. But by his very words this writer betrays where the real source of confusion lies: namely, in his own mind. Artistic value is one, not many. The only artistic value

anybody has yet been able to point to satisfactorily in words is simply the goodness of good art. There are, of course, degrees of artistic goodness, but these are not differing values or kinds of value. Now this one and only value, in its varying degrees, is the first and supreme principle of artistic order. . . . Of order established on its basis, art today shows as much as it ever has. Surface appearances may obscure or hide this . . . *qualitative* order, but they do not negate it, they do not render it any the less present. With the ability to tell the difference between good and bad, and between better and worse, you can find your way quite well through the apparent confusion of contemporary art. . . .

Things that purport to be art do not function, do not exist, as art until they are experienced through taste. Until then they exist only as empirical phenomena, as aesthetically arbitrary objects or facts. These, precisely, are what a lot of contemporary art gets taken for, and what many artists want their works to be taken for—in the hope, periodically renewed since Marcel Duchamp first acted on it fifty-odd years ago, that by dint of evading the reach of taste while yet remaining in the context of art, certain kinds of contrivances will achieve unique existence and value. So far this hope has proved illusory. So far everything that enters the context of art becomes subject, inexorably, to the jurisdiction of taste—and to the ordering of taste. And so far almost all would-be non-art-in-the-context-of-art has fallen rather neatly into place in the order of inferior art. This is the order where the bulk of art production tends to find its place, in 1968 as in 1868—or 1768. Superior art continues to be something more or less exceptional. And this, this rather stable quantitative relation between the superior and inferior, offers as fundamentally relevant a kind of artistic order as you could wish. . . .

. . . Approached strictly as a matter of style, new art in the 1960s surprises you—if it *does* surprise you—not by its variety, but by the unity and even uniformity it betrays *underneath* all the appearances of variety. There are Assemblage, Pop, and Op; there are Hard Edge, Colour Field, and Shaped Canvas; there are Neo-Figurative, Funky, and Environmental; there are Minimal, Kinetic, and Luminous; there are Computer, Cybernetic, Systems, Participatory—and so on. (One of the really new things about art in the 60s is the rash of labels in which it has broken out, most of them devised by artists themselves

—which is likewise new; art-labelling used to be the affair of journalists.) Well, there are all these manifestations in all their variegation, yet from a steady and detached look at them through their whole range some markedly common stylistic features emerge. Design or layout is almost always clear and explicit, drawing sharp and clean, shape or area geometrically simplified or at least faired and trued, colour flat and bright or at least undifferentiated in value and texture within a given hue. Amid the pullulation of novelties, advanced art in the 60s subscribes almost unanimously to these canons of style—canons that Woelfflin would call linear.

Think by contrast of the canons to which avant-garde art conformed in the 50s: the fluid design or layout, the 'soft' drawing, the irregular and indistinct shapes or areas, the uneven textures, the turbid colour. It is as though avant-garde art in the 60s set itself at every point in opposition to the common stylistic denominators of Abstract Expressionism, *art informel, tachisme.* And just as these common denominators pointed to what was one and the same period style in the latter 40s and the 50s, so the common denominators of new art in the 60s point to a single, all-enveloping period style. And in both cases the period style is reflected in sculpture as well as in pictorial art.

That avant-garde art in the latter 40s and in the 50s was one, not many, in terms of style is now pretty generally recognized. Lacking the perspective of time, we find it harder to identify a similar stylistic unity in the art of this decade. It is there all the same. All the varied and ingenious excitements and 'experiments' of the last years, large and small, significant and trivial, flow within the banks of one, just one period style. Homogeneity emerges from what seemed an excess of heterogeneity. Phenomenal, descriptive, art-historical—as well as qualitative—order supervenes where to the foreshortening eye all seemed the antithesis of order.

If this gives pause, the pause should be taken advantage of to examine more closely another popular idea about art in this time: namely, that it moves faster than ever before. The art-historical style of this period that I have so sketchily described —a style that has maintained, and maintains, its identity under a multitude of fashions, vogues, waves, fads, manias—has been with us now for nearly a decade and seems to promise to stay

From *Avant-Garde Attitudes: New Art in the Sixties*

with us a while longer. Would this show that art is moving and changing with unprecedented speed? . . .

In the present context I would say that the duration of an art-historical style ought to be considered the length of time during which it is a leading and dominating style, the time during which it is the vessel of the largest part of the important art being produced in a given medium within a given cultural orbit. This is also, usually, the time during which it attracts those younger artists who are most highly and seriously ambitious. With this definition as measure, it is possible to see as many as five, and maybe more, distinctly different styles or movements succeeding one another in French painting of the nineteenth century.

First there was David's and Ingres's Classicism. Then from about 1820 into the mid-1830s, Romanticism. Then Corot's naturalism; and then Courbet's kind. In the early 1860s Manet's flat and rapid version of naturalism led the way, to be followed within less than ten years by Impressionism. Impressionism held on as the leading manner until the early 1880s, where the Neo-Impressionism of Seurat and then the Post-Impressionism of Cézanne, Gauguin, and Van Gogh became the most advanced styles. Things get a little mixed up during the last twenty years of the century, though it may be only in seeming. At any rate Bonnard and Vuillard in their early, Nabi phase appear during the 1890s, and Fauvism enters the competition by at least 1903. As it looks, painting moved faster between the mid-1880s and 1910 or so than at any other time within the scope of this hasty survey. Cubism took the lead away from Fauvism within hardly a half a dozen years of the latter's emergence. Only then did painting slow down again to what had been its normal rate of change between 1800 and the 1880s. For Cubism stayed on top until the mid-1920s. After that came Surrealism (I say Surrealism for lack of a better term: Surrealism's identity as a *style* still remains undetermined; and some of the best *new* painting and sculpture of the latter 20s and the 30s had nothing to do with it). And by the early 1940s Abstract Expressionism and its cognates, *tachisme* and *art informel,* were on the scene.

Admittedly, this historical rundown simplifies far too much. Art never proceeds that neatly. . . . But, for all the exceptions that can rightly be taken to my chronological schema and what

it implies, I do think that there is enough unquestionable evidence to support my point, which is that art-historical styles in painting (if not in sculpture) have tended since the beginning of the nineteenth century (if not before) to hold their positions of leadership for on an average of between ten and fifteen years.

The case of Abstract Expressionism does more than bear out this average; it exceeds it, and would go to show that art actually moved and changed more slowly over the last thirty years than in the hundred years previous. Abstract Expressionism in New York, along with *tachisme* and *art informel* in Paris, emerged in the early 40s and by the early 50s was dominating avant-garde painting and sculpture to a greater extent even than Cubism had in the 20s. . . . Well, Abstract Expressionism collapsed very suddenly back in the spring of 1962, in Paris as well as New York. It is true that it had begun to lose its vitality well before that, but nevertheless it continued to dominate the avant-garde scene, and by the time of its final retreat from that scene it had led art for close to twenty years. The collapse of Abstract Expressionism was as sudden as it was because it was long overdue, but even had its collapse come five or six years earlier (which is when it should have come) the span of time over which Abstract Expressionism held its leadership would still have been over the average for art styles or movements within the last century and a half.

Ironically enough, the seemingly sudden death of Abstract Expressionism in 1962 is another of the things that have contributed to the notion that art styles turn over much faster, and more abruptly, now than they used to. The fact is that the demise of Abstract Expressionism was an unusually lingering one.

Nor did the art-historical style that displaced it come into view nearly so suddenly as the events of the spring of 1962 made it appear. The 'hard' style of the 60s had already emerged with Ellsworth Kelly's first New York show in 1955, and with the renascence of geometricizing abstract art in Paris in the mid-50s as we see it in Vasarely. Thus there was an overlapping in time. There was an overlapping or transition in terms of style too: the passage from the 'painterly' to the 'linear' can be witnessed in the painting of Barnett Newman, for example, and in the sculpture of David Smith, and in an artist like Rauschenberg (to name only Americans). . . .

43. Ellsworth Kelly, *Red Blue* (1962). Oil on canvas, 90″ × 69½″. (Contemporary collection of The Cleveland Museum of Art)

What at first did surprise me in the new art of the 60s was that its basic homogeneity of style could embrace such a great heterogeneity of quality, that such bad art could go hand in hand with such good art. It took me quite a while to remember that I had already been surprised by that same thing in the 50s. ... All the same, some of my surprise at the great unevenness in quality of new art in the 60s remained, and remains. Something new is there that was not there in Abstract Expressionism when it first emerged. All art styles deteriorate and, in doing so, become usable for hollow and meretricious effects. But no style in the past seems to have become usable for such effects while it was still an up-and-coming one. That is, as best as I can remember. Not the sorriest *pasticheur* or band-wagon-jumper of Impressionism, Fauvism, or Cubism in their first years of leadership fell below a certain level of artistic probity. The vigour and the difficulty of the style at the time simply would not let them. Maybe I don't know enough of what happened in those days. I will allow for that and still maintain my point. The new 'hard' style of the 60s established itself by

producing original and vigorous art. This is the way new styles have generally established themselves. But what was new, in scheme, about the way that the 60s style arrived was that it did so carrying not only genuinely fresh air but also art that *pretended* to be fresh, and was able to pretend to be that, as in times past only a style in decline would have permitted. Abstract Expressionism started out with both good and bad, but not until the early 1950s did it lend itself, as a style, to *specious* as distinct from failed art. The novel feature of the 'hard' style of the 60s is that it did this from the first. This fact says nothing necessarily compromising about the best 'hard-style' art. That best is equal to the best of Abstract Expressionism. But the fact itself would show that something really new, *in scheme,* has happened in the new art of the 60s. This schematically new thing is what, I feel, accounts for the greater nervousness of art opinion that marks the 60s. One knows what is 'in' at any given moment, but one is uneasy about what is 'out'. . . . Just who and what will remain from the 60s, just which of the competing sub-styles will prove out as of lasting value—this remains far more uncertain. Or at least it does for most critics, museum people, collectors, art-buffs, and artists themselves—for most, I say, if not exactly for all. This uncertainty may help explain why critics have lately begun to pay so much more attention to one another than they used to, and why even artists pay them more attention.

Another cause of the new uncertainty may be the fact that avant-garde opinion has since the mid-50s lost a compass bearing that had served it reliably in the past. There used to be self-evidently academic art, the art of the *salons* and the Royal Academy, against which to take position. Everything directed against or away from academic art was in the right direction; that was once a minimal certainty. The academy was still enough there in Paris in the 20s, and perhaps even in the 30s, to assure avant-garde art of its own identity. . . .

But since the war, and especially since the 50s, confessedly academic art has fallen out of sight. Today the only conspicuous fine art—the exceptions, however numerous, are irrelevant—is avant-garde or what looks like or refers to avant-garde art. The avant garde is left alone with itself, and in full possession of the 'scene'. . . . Where everything is advanced nothing is; when everybody is a revolutionary the revolution is over.

Not that the avant garde ever really meant revolution. Only

the journalism about it takes it to mean that—takes it to mean a break with the past, a new start, and all that. The avant garde's principal reason for being is, on the contrary, to maintain continuity: continuity of standards of quality—the standards, if you please, of the Old Masters. These can be maintained only through constant innovation, which is how the Old Masters had achieved standards to begin with. Until the middle of the last century innovation in Western art had not had to be startling or upsetting; since then, for reasons too complex to go into here, it has had to be that. . . .

Today everybody innovates. Deliberately, methodically. And the innovations are deliberately and methodically made startling. Only it now turns out . . . that art can have a startling impact without really being or saying anything startling—or new. The character itself of being startling, spectacular, or upsetting has become conventionalized, part of safe good taste. A corollary of this is the realization that the aspects under which almost all artistic innovation has made itself recognized these past hundred years have changed, almost radically. What is authentically and importantly new in the art of the 60s comes in softly as it were, surreptitiously—in the guises, seemingly, of the old, and the unattuned eye is taken aback as it isn't by art that appears in the guises of the self-evidently new. No artistic rocketry, no blank-looking box, no art that excavates, litters, jumps, or excretes has actually startled unwary taste in these latter years as have some works of art that can be safely described as easel-paintings and some other works that define themselves as sculpture and nothing else.

Art in any medium, boiled down to what it does in the experiencing of it, creates itself through relations, proportions. The quality of art depends on inspired, felt relations or proportions as on nothing else. There is no getting around this. A simple, unadorned box can succeed as art by virtue of these things; and when it fails as art it is not because it is merely a plain box, but because its proportions, or even its size, are uninspired, unfelt. The same applies to works in any other form of 'novelty' art: kinetic, atmospheric, light, environmental, 'earth', 'funky', etc., etc. No amount of phenomenal, describable newness avails when the internal relations of the work have not been felt, inspired, discovered. The superior work of art, whether it dances, radiates, explodes, or barely

manages to be visible (or audible or decipherable), exhibits, in other words, rightness of 'form'.

To this extent art remains unchangeable. Its quality will always depend on inspiration, and it will never be able to take effect *as art* except through quality. The notion that the issue of quality could be evaded is one that never entered the mind of any academic artist or art person. It was left to what I call the 'popular' avant garde to be the first to conceive it. That kind of avant garde began with Marcel Duchamp and with Dada. Dada did more than express a war-time despair of traditional art and culture; it also tried to repudiate the difference between high and less than high art; and here it was a question less of wartime despair than of a revulsion against the arduousness of high art as insisted upon by the 'unpopular' avant garde, which was the real and original one. Even before 1914 Duchamp had begun his counter-attack on what he called 'physical' art by which he meant what is today vulgarly termed 'formalist' art.

Duchamp apparently realized that his enterprise might look like a retreat from 'difficult' to 'easy' art, and his intention seems to have been to undercut this difference by 'transcending' the difference between good and bad in general. (I don't think I'm over-interpreting him here.) Most of the Surrealist painters joined the 'popular' avant garde, but they did not try to hide their own retreat from the difficult to the easy by claiming this transcendence; they apparently did not feel it was that necessary to be 'advanced'; they believed that their kind of art was simply better than the difficult kind. And it was the same with the Neo-Romantic painters of the 30s. Yet Duchamp's dream of going 'beyond' the issue of artistic quality continued to hover in the minds at least of art journalists. When Abstract Expressionism and *art informel* appeared they were widely taken to be a kind of art that had at last managed to make value discriminations irrelevant. And that seemed the most advanced, the furthest-out, the most avant-garde feat that art had yet been able to perform.

Not that Duchamp's ideas were particularly invoked at the time. Nor did Abstract Expressionism or *art informel* belong properly with the 'popular' avant garde. Yet in their decline they did create a situation favourable to the return or revival of that kind of avant-gardism. And return and revive it did in New York, notably with Jasper Johns in the later 50s. Johns is

From *Avant-Garde Attitudes: New Art in the Sixties*

—rather was—a gifted and original artist, but the best of his paintings and bas-reliefs remain 'easy' and certainly minor compared with the best of Abstract Expressionism. Yet in the context of their period, and in idea, they looked equally 'advanced'. And under cover of Johns' idea Pop art was able to enter and give itself out as perhaps even more 'advanced'— without, however, claiming to reach the same levels of quality that the best of Abstract Expressionism had. The art journalism of the 60s accepted the 'easiness' of Pop art implicitly, as though it did not matter, and as though such questions had become old-fashioned and obsolete. Yet in the end Pop art has not succeeded in dodging qualitative comparisons, and it suffers from them increasingly with every day that passes. Its vulnerability to qualitative comparisons—not its 'easiness' or minor quality as such—is what is seen by many younger artists as constituting the real failure of Pop Art. This failure is what, in effect, 'novelty' art intends to remedy. . . .

. . . The idea of the difficult—but the mere idea, not the reality or substance—. . . is evoked by a row of boxes, by a mere rod, by a pile of litter, by projects for Cyclopean landscape architecture, by the plan for a trench dug in a straight line for hundreds of miles, by a half-open door, by the cross-section of a mountain, by stating imaginary relations between real points in real places, by a blank wall, and so forth. As though the difficulty of getting a thing into focus as art, or of gaining physical access to it, or of visualizing it, were the same as the difficulty that belonged to the first experience of a successfully new and deeply original work of art. . . .

1968

FROM *American Pop Art*

Lawrence Alloway

The term *Pop art* originated in England and reached print by the winter of 1957–58.[1] Pop art and Popular art were both used at this time to refer approvingly to the products of the mass media. It was part of a tendency to consider mass-produced sign-systems as art, part of an expansionist aesthetic. . . .

In the early 60s the term became attached to the fine arts exclusively, usually for paintings with a source in popular culture. This second usage of Pop art was, therefore, counterexpansionist, concentrating the once-broad term on a particular kind of art. This is the definition of the term assumed here. Throughout the 60s, use of the term spread. . . . The expansionist aspect of the earlier use of the term became identified with Allan Kaprow's term *Happening*. As Kaprow wrote, "A walk down 14th Street is more amazing than any masterpiece of art," being "endless, unpredictable, infinitely rich."[2] The Happening stays close to "the totality of nature," whereas Pop artists work from the artifacts of culture and retain the compact identity of art no matter how extensively they quote from the environment.

. . . In the postwar period an uncoordinated but consistent view of art developed, more in line with history and sociology than with traditional art criticism and aesthetics. In London

From *American Pop Art*

and New York, artists then in their twenties or early thirties revealed a new sensitivity to the presence of images from mass communications and to objects from mass production assimilable within the work of art. . . . Instead of the notion of painting as technically pure and organized as a nest of internal correspondences, Rauschenberg proposed that the work of art was a partial sample of the world's continuous relationships. It follows that works demonstrating such principles would involve a change in our concept of artistic unity: art as a rendezvous of objects and images from disparate sources, rather than as an inevitably aligned setup. The work of art can be considered as a conglomerate, no one part of which need be causally related to other parts; the cluster is enough. . . .

As popular culture became conspicuous after World War II, as history and sociology studied the neglected mass of the past and the neglected messages of the present, art was being changed, too. . . . As an alternative to an aesthetic that isolated visual art from life and from the other arts, there emerged a new willingness to treat our whole culture as if it were art. This attitude opposed the elite, idealist, and purist elements in eighteenth- to twentieth-century art theory. What seems to be implicit here is an anthropological description of our own society. Anthropologists define culture as all of a society. This is a drastic foreshortening of a very complex issue in anthropology, but to those of us brought up on narrow and reductive theories of art, anthropology offers a formulation about art as being more than a treasury of precious items. It was a two-way process: the mass media entered the work of art, and the whole environment was regarded, reciprocally, by the artists as art, too. Younger artists did not view Pop culture as relaxation, but as an ongoing part of their lives. They felt no pressure to give up the culture they had grown up in (comics, pop music, movies). Their art was not the consequence of renunciation but of incorporation.

Pop art is neither abstract nor realistic, though it has contacts in both directions. The core of Pop art is at neither frontier; it is, essentially, an art about signs and sign-systems. Realism is, to offer a minimal definition, concerned with the artist's perception of objects in space and their translation into iconic, or faithful, signs. However, Pop art deals with material that already exists as signs: photographs, brand goods, comics—that is to say, with precoded material. The subject matter of Pop

44. Andy Warhol, *Marilyn Monroe Diptych*, (1962). Oil on canvas, 82" × 114" (two panels, 82" × 57" each). (From the collection of Mr. and Mrs. Burton Tremaine)

art, at one level, is known to the spectator in advance of seeing the use the artist makes of it. Andy Warhol's Campbell's Soup cans, Roy Lichtenstein's comic strips are known either by name or by type, and their source remains legible in the work of art.

What happens when an artist uses a known source in popular culture in his art is rather complex. The subject of the work of art is doubled: if Roy Lichtenstein uses Mickey Mouse in his work, Mickey is not the sole subject. The original sign-system of which Mickey is a part is also present as subject. The communication system of the twentieth century is, in a special sense, Pop art's subject. Marilyn Monroe, as used by Andy Warhol, is obviously referred to, but in addition, another channel of communication besides painting is referred to as well. Warhol uses a photographic image that repeats like a sheet of contact prints and is colored like the cheap color reproduction in a Spanish-language film magazine [Fig. 44].

334

From *American Pop Art*

There has been some doubt and discussion about the extent to which the Pop artist transforms his material. . . . I showed early comic strip paintings by Lichtenstein to a group of professional comic strip artists who considered them very arty. They thought his work old-fashioned in its flatness. Lichtenstein was transforming after all, though to art critics who did not know what comics looked like, his work at first appeared to be only a copy. In fact, there was a surreptitious original in the simulated copy. Pop art is an iconographical art, the sources of which persist through their transformation; there is an interplay of likeness and unlikeness. . . .

The success of Pop art was not due to any initial cordiality by art critics. On the contrary, art critics in the late 50s and early 60s were, in general, hostile. One reason for this is worth recording, because it is shared by Clement Greenberg and Harold Rosenberg, to name the supporters of irreconcilable earlier modernisms. Greenberg, with his attachment to the pure color surface, and Rosenberg, with his commitment to the process of art, are interested only in art's unique identity. They locate this at different points—Greenberg in the end product and Rosenberg in the process of work, but Pop art is not predicated on this quest for uniqueness. On the contrary, Pop art constantly reveals a belief in the translatability of the work of art. Pop art proposes a field of exchangeable and repeatable imagery. It is true that every act of communication, including art, has an irreducible uniqueness; it is equally true that a great deal of any message or structure is translatable and homeomorphic. Cross-media exchanges and the convergence of multiple channels is the area of Pop art, in opposition to the pursuit of an artistic purity.

Thus Pop art is able to share, on the bases of translatability and commonality, themes from popular culture. Any event today has the potential of spreading through society on a multiplicity of levels, carried by a fat anthology of signs. . . .

A unifying thread in recent art, present in Pop art, can be described as process abbreviation. In the past, an ambitious painting required a series of steps by the artist: from a conceptual stage, through preliminary sketches, to drawing, to underpainting, to glazing, and, maybe, to varnishing. These discrete steps were not experienced in isolation by the artist, of course, but such was basically the sequence of his operations. In one way and another, modern art has abbreviated this process. For

335

instance, Pop artists have used physical objects as part of their work or rendered familiar articles with a high degree of literalness. Though Lichtenstein works in stages, he simulates an all-at-once, mechanical look in his hand-done painting. The finished work of art is thus separated from traces of its long involvement in planning and realizing, at least in appearance and sometimes in fact. Warhol's silk-screen paintings achieve a hand-done look from the haste and roughness with which the identical images are printed. Photographs, printed or stenciled, in the work of art give the most literal definition available in flat signs to the artist. Similarly, in the nineteenth century, the daguerreotype was described as a means "by which objects may be made to delineate themselves."[3]

Where process abbreviation is found in Pop art, it reduces personal nuances of handling by the artist in favor of deadpan or passive images. This deceptive impersonality amounts to a game with anonymity, a minimizing of invention, so that the work is free to support its interconnections with popular culture and with the shared world of the spectator. Photographs appear as unmediated records of objects and events, as the real world's most iconic sign-system. In addition to this property, which Rauschenberg and Warhol have exploited, photographs have a materiality of their own, a kind of visual texture which is generated mechanically, but which we read as the skin of reality, of self-delineated rather than of interpreted objects. This zone of gritty immediacy, of artificial accuracies, has been explored by Pop artists as part of their attention to multileveled signs.

What is characteristic and entirely American about Pop art is the high level of technical performance. Johns' mastery of paint handling, Rauschenberg's improvisatory skill, Lichtenstein's locked compositions, Warhol's impact as an image maker, reach the point that they do because of the high level of information about art in New York. In the background are the abstract expressionists, setting an aesthetic standard of forceful presence and impeccable unity. In addition, the Pop artists' peers were largely abstract painters, like Frank Stella and Ellsworth Kelly, and Pop artists shared with them a sense of how paintings should cohere holistically. This has sometimes been taken to mean that the Pop artists were essentially abstract painters, that the iconography was not essential. In fact the link is generational, and it seems to be a fact that preplan-

From *American Pop Art*

ning and tidy execution, as a result of Johns' and Stella's influence, were taken up as ways to refute the free-work methods of de Kooning and Pollock. Pop art in the United States, more than elsewhere in the world, is a learned and physically exacting style, partly because it had to measure up to and survive the competition of peer group rivals in other styles. In retrospect, it is extraordinary that recognition of the complex formality and sensuality of Pop art should have been so long delayed by the supposed banality of the subject. High style and low subjects, as it is now easier to see, are combined in American Pop art, and neither term can be removed without damage to the artists' achievements. The words in Johns do have a meaning, though not a simple one; the images in Rauschenberg have iconographical connections, though not causal ones. . . .

Pop art is a cluster, not a point. . . .

1974

NOTES

1. Lawrence Alloway, "The Arts and the Mass Media," *Architectural Design* (February 1958), pp. 84–5.
2. The term appeared in 1959 (Kaprow's *18 Happenings in 6 Parts* at the Reuben Gallery) and proliferated in the 60's. Pop art and Happenings are often treated together as object-based and performance-based aspects of an environmental sensibility.
3. "The Painter and the Photograph," text by Van Deren Coke (Albuquerque: University of New Mexico, 1964), p. 6.

Reality Again:
The New Photorealism

Harold Rosenberg

The exhibition at the Sidney Janis Gallery entitled "Sharp-Focus Realism" repeated an event staged by the same gallery a decade earlier. The first show, called "New Realists," constituted an announcement that what later came to be known as Pop Art had reached a level of acceptance at which it could challenge the dominance of Abstract Expressionism. The photorealist replay no doubt anticipated a comparable success in displacing the various forms of abstract art favored in the sixties. The signs of a takeover had been multiplying for some time. Contributors to "Sharp-Focus Realism," such as Malcolm Morley, Richard Estes, Duane Hanson, Lowell Nesbitt, Howard Kanovitz, Robert Graham, and Philip Pearlstein, with their ocean liners, shop windows, lifelike effigies, and oversize nudes, had been elbowing abstractionists in uptown galleries, Soho, and the museums for much of the past ten years. The new representational art had also spread out of town; the Chicago Museum of Contemporary Art and adjacent galleries on Ontario Street suddenly filled up with flesh-colored polyester dummies seated at tables or lying crushed and bleeding alongside shattered motorbikes, amid paintings of panel trucks, entrances to diners, closeups of torsos, and photo-

338

graphic segments of landscape. With this gradual buildup, the element of surprise in the "sharp-focus" exhibition was bound to be weaker than Janis' unveiling of Pop. Like its predecessor, it aroused the feeling that history was being made—but that in this instance it was being made rather listlessly. In any case, Pop arrived with a bigger bang. As striptease has demonstrated, no repetition can equal the impact of the first disclosure. Abstract artists whom I met at the opening appeared resigned rather than indignant. Pop had established itself as an art form, and—under the leadership of Warhol, Christo, and other showmen—painting and sculpture had been increasingly amalgamating with the mass media. It was obvious that whatever its future as a reaction against abstract art, photorealism was nothing monstrous but a rational extension of picture-making in popular styles.

Part of the shock of the 1962 exhibition derived from the identification of the Janis Gallery with de Kooning, Pollock, Kline, Guston, Gottlieb. In the creations of the pioneer Abstract Expressionists, a principle was manifest—the avant-garde principle of transforming the self and society. The "objectivity" of Pop was a deliberate abandonment of this principle, and it had the effect of a betrayal. If Pop succeeded, the epoch of art's rebelliousness and secession from society would have come to an end. Today, the consciousness of drastic oppositions has faded from American art; all modes have been legitimated, and preference for one over another, if any, is determined by taste or some theory of art history. With the presence in the sixties of Oldenburg and Segal as Pop stars of the Janis Gallery, "Sharp-Focus Realism" could hardly amount to a confrontation. Nor has the abstract art of the past decade been of a quality to evoke the passionate allegiance aroused by Abstract Expressionism. After years of being presented with displays of stripes, color areas, factory-made cubes, accompanied by sententious museum-catalogue and art-magazine puffs, the art world might well have reached the frame of mind to welcome a supersize colored postcard of a Rose Bowl parade.

The man in shirtsleeves near the gallery entrance was Sidney Janis—except that he was too heavy and too relaxed, and, besides, he was made of plastic by Duane Hanson. Janis was standing in a corner of the next room, but this time he was a painting by Willard Midgette. Through the crowd I saw Janis

flit into his office, but he looked too tan and a bit more wizened than I remembered, as if he had been modelled by John De Andrea, creator of two nubile nudes of painted polyester and Fiberglas in another part of the gallery. That vanishing figure, however, was the real Janis. It is difficult to be sure which of the Janises was the most substantial; nothing can match super-realistic art in subverting one's sense of reality. The interval during which a painting is mistaken for the real thing, or a real thing for a painting, is the triumphant moment of trompe-l'oeil art. The artist appears to be as potent as nature, if not superior to it. Almost immediately, though, the spectator's uncertainty is eliminated by his recognition that the counterfeit is counterfeit. Once the illusion is dissolved, what is left is an object that is interesting not as a work of art but as a successful simulation of something that is not art. The major response to it is curiosity: "How did he do it?" One admires Hanson's *Businessman* neither as a sculpture nor as a concept but as a technical feat that seems a step in advance of the waxworks museum.

Illusionistic art appeals to what the public knows not about art but about things. This ability to brush art aside is the secret of the popularity of illusionism. Ever since the Greeks told of painted grapes being pecked by real birds, wonder at skill in deceiving the eye has moved more people than has appreciation of aesthetic quality. But for art to depend exclusively upon reproducing appearances has the disadvantage of requiring that the painting or sculpture conform to the common perception of things. De Andrea's *Two Women* [Fig. 45] missed being mistaken for human nudes because they were too small and had hair that looked like a wig. According to the exhibition catalogue, the figures are "life size," but, as I have noted, illusionistic art tends to generate impressions that are not in accord with the facts. Regardless of whether or not they are as large as average women, on the floor, nude, surrounded by a crowd, they are too small to be credible. And while it is true that girls do wear wigs, hair that looks artificial is inappropriate on simulated girls. If, however, De Andrea's women are not "real," even for a moment, what are they? They are pretty figurines, but precisely to the extent that they seem made of flesh, they are a bit grisly in their prettiness, like a beautiful woman known to be suffering from a fatal disease. In their case, the disease is the failure to be alive, even in the spectator's first impression, plus the failure to be art.

340

45. John De Andrea, *Two Women* (1971). Fibreglas and polyester, resin, polychromed in oil, lifesize. (Courtesy O.K. Harris Gallery, New York)

Among the other puppets in "Sharp-Focus Realism" was Jann Haworth's *Maid*, a doll that could look human only to those who had forgotten the look of human beings, and this forgetting was prevented by a photograph, in the catalogue, of Miss Haworth seated beside her creation. George Segal's white plaster figures are spectres that recall to onlookers the people from whom the casts were made; in them, obvious artifice holds reality at arm's length and thus keeps it intact. In Haworth's "sharp-focus" maid, the absence of art eliminates reality, too, and leaves only a costumer's stereotype. Robert Graham's miniature nudes, realistic in their anatomy and skin shades, inhabit glass enclosures that are perhaps intended to suggest terrariums in which a new race of tiny human creatures, protected from pollution, is being bred. Of the sculptures in the show, Hanson's *Businessman* came closest to fooling the eye, no doubt through the assistance of authentic posture and clothing; De Andrea's *Sitting Black Boy* was, by being naked, unable to rise to this level of deception.

The most successful visual counterfeits, however, were

achieved not with free-standing figures but with paintings of objects against a flat background, as in the simulation by Claudio Bravo of a rectangular package tied with cord. With this type of subject, traditional techniques of Harnett, Peto, Raphaelle Peale, and still earlier illusionists are brought into play: lights and shadows produced by intersecting cords and folds and wrinkles in paper make objects appear to stand forward in space. Stephen Posen's *Purple (Split)* was also a painting of a package, though a more complex one than Bravo's; it simulated a pile of cartons of various sizes and shapes covered by a purple sheet that fell in folds about them, and it seemed to jut out from the wall. Boxes on a wall are a purely arbitrary motif, and Posen no doubt chose it in order to display his virtuosity in painting drapery and creating three-dimensional forms on a flat surface. Marilyn Levine's suitcase and boots in stoneware were translations of objects into a different substance without altering their appearance—essentially, this is conceptual art that brings to the eye nothing not present in nature but instructs the spectator that things may not be what they seem.

In Janis's 1962 exhibition, the new Pop Art was mingled with half a dozen older modes of representational art. As is evident in the works I have been describing, "Sharp-Focus Realism" shaded off similarly into familiar categories of image-making. While Hanson's *Businessman* is naturalism pepped up with new materials, Bravo's lifelike package could have been produced a century ago. Evelyn Taylor's *Untitled* is a Magic Realist canvas in which, as is characteristic of this style, figures and objects stand apart from one another as if they were suspended in an invisible aspic. Paul Staiger's *The Parking Lot at Griffith Planetarium* and Noel Mahaffey's *St. Louis, Missouri* could have come out of an advertising agency's photographic and design departments without the bother of having been translated onto canvas. Philip Pearlstein's *Nude with Outstretched Arms, Green Sofa* is an academic painting that thumbs its nose at academic composition by cropping the model's head just above the eyes and retaining a stray thumb.

The nucleus of novelty in the exhibition was a group of paintings that shared an aggressive glitter precipitated by camera closeups; it is the duplication of photographs upon canvas that constitutes the new realism. They included Richard Estes's *Diner,* Ralph Goings's *Rose Bowl Parade,* David

Reality Again: The New Photorealism

Parish's *Motorcycle,* Tom Blackwell's *'34 Ford Tudor Sedan,* John Salt's *Blue Wreck and Truck,* Malcolm Morley's *Amsterdam in Front of Rotterdam,* Don Eddy's *Showroom Window I,* Robert Cottingham's *Shoe Repair*—businesses, motors, entertainment. Each of the paintings is a composition of shining shapes, reflected lights, and clearly defined details skimmed by the camera lens from surfaces of polished aluminum, steel, and glass, painted fenders, electric signs, crowds, and closely packed buildings photographed from above (Mahaffey's *St. Louis* fits the canon in this respect.) "Sharp-Focus Realism" represents a renewed relation not between art and reality, or nature, but between art and the artifacts of modern industry, including the apparatus of reproduction used by the mass media. The new paintings and sculptures converge with Pop in that both modes, while seeming to base art on life, actually convert it into variations on existing techniques of visual communication. Pop Art fed on the comic strip, grocery labels, news photos, commodities, packaging, billboards. The current "realism" explores such other veins of the media as the photographic travel and publicity poster, the service booklet and the product catalogue, the showroom, the storefront, the picture-weekly glossy—all presided over, one might say, by Hanson's dummy businessman.

Photo-into-art creations are alien to older forms of representation and ought to be exhibited and appreciated apart from them. A painting by Edward Hopper, for instance, embodies the sensibility of a single individual developed over years of looking and drawing, and the same, with all due attention to differences in quality, is true of such contemporaries as Pearlstein, Alice Neel, Lennart Anderson, Gabriel Laderman. In contrast, a sculpture by Hanson or a canvas by Estes or Goings is welded to the objectivity of the camera, and to the extent that photographs of things have become more real to Americans than the things themselves they achieve superior credence precisely through their obvious artificiality. Estes, to my mind, is the most consistently satisfying of these artists in that he candidly treats painting as a photographic problem of reflecting objects as they appear, while composing in series of brightly colored verticals and horizontals. Pop Art introduced a mood of cool neutralism as an antidote to the emotional heat of Abstract Expressionism. This frame of mind has been inherited by photorealism, but without the counterawareness of

343

Expressionist subjectivity; the new coolness came in from the cold. An outstanding quality of sharp-focus is the absence in it of any tension aroused by the art of the past.

Pictures that copy appearances have been an obsession of American art since the early draftsmen of the exploring expeditions. Current conceptions of art as "information" reinforce this obsession. In copying in paint its photocopies of nature, the present generation of realists seems to feel freer of the demands of art than any of its predecessors. By all evidence, a new stage has been reached in merging painting and sculpture into the mass media. Though William Harnett is a model of the current illusionism, its tutelary spirit is Andy Warhol.

1972

FROM ... *And This Is About*
Conceptual Art

Rudolph Arnheim

When I was lonely I used to look at the moon and tell myself that the same moon could be seen at the same moment across the sea by the persons I loved. In that comforting thought there was a germ of poetry, good enough perhaps for the notebook of a writer; but it was no poem.

Had I asked my friends abroad to take a photograph of the moon at the same time that I was taking one myself, and had I then pasted the snapshots on a piece of paper together with a short description of the procedure and offered the whole thing to a gallery for sale at $1,000, I would have created a work of conceptual art.

Much too long have we played the fruitless game of trying to decide which objects are art and which are not. This has left us wholly unprepared when anyone choosing to be an artist presents any object or action for exhibition. Criteria derived from painting and sculpture have been applied although they have not fit. The discrepancy is startling enough to keep the undernourished thing alive.

How about trying the opposite approach for a change: Instead of carrying the discards of daily behavior to the exhibi-

tion rooms of art, how about looking for art around us and within us?

Artists have become alarmed about art having to subsist in a diving bell. They are expected to breathe art in their studios, and their public has tried to do the same in museums. But outside the studio and the museum there is no art. This state of affairs cannot continue because art has never grown from anything but the poetical overtones of all daily living.

What is needed is a revival of that pervasive symbolism so common in unimpaired cultures. Not long ago in Grand Central Station I noticed an elderly woman lugging a suitcase. "Heavy, isn't it?" I said. And she, with an Old World accent, "The whole life is heavy!"

In this woman the poetical basis of art still existed. For her, the depth of wisdom still resided in the surface of appearance. Without this basic coincidence there can be no art; and some artists have undertaken to restore it. But how are they going about it? They are rejecting one kind of art object, only to replace it with another. They are not willing to issue a decree: "The production of art objects is suspended while our minds are being reconditioned."

They believe that they are replacing percepts with concepts; but that is bad psychology. What these artists are really doing is replacing paintings and sculptures with mental images. And they forget that mental images are nothing new. In fact, art has never been anything else: not canvas or wood or stone, but mental images created by those objects. And art remains mental imagery, even if one calls it conceptual and pretends to have given up the world of the senses.

The basic tie to the senses can be camouflaged with the tough language of exact science, which supposedly deals with concepts. In their statements, conceptual artists sport precise measurements and specifications: "On Jan. 9, 1969, a clear plastic box measuring $1'' \times 1'' \times \frac{3}{4}''$ enclosed within a slightly larger cardboard container was sent by registered mail . . ." When such precision is irrelevant, it parodies science, as Rabelais and Sterne did so long ago, or it attempts to profit from the authority of impersonal matter-of-factness. A box was mailed. The data speak. At best, the artist conjures up those beautiful, unconceptual reveries that sprout from scientific descriptions.

The thought experiments proposed by conceptual artists are no more alien to the senses than the imagery of traditional art.

From ... *And This Is About Conceptual Art*

They are useful exercises of the imagination. They should not be called "works" because that term conceals the modesty of the accomplishment, and they are not works but scores, records, instructions.

They should be published in newspapers, next to the columns on physical fitness and good eating habits. They are not gallery material but simple lessons to be practiced by everybody until our minds can listen again to the symbolic speech of things around us. Once we profit from the training, art objects may make sense again.

1974

FROM *The Gospel According to Giedion and Gropius Is Under Attack*

Ada Louise Huxtable

M odern architecture is at a turning point. A half century after the revolution that ushered in the modern movement and changed the look and character of the built world, we are in the midst of a counter revolution. Although the streets of cities everywhere are lined with the glass and steel towers that testify to the genius and influence of Mies van der Rohe, and the sculptured concrete forms of Le Corbusier have transformed our surroundings, from public buildings to housing, the theory and practice of modernism are under serious attack.

There is no controversy about the monuments themselves. Such structures as Le Corbusier's Marseilles apartments and chapel at Ronchamps are among the ranking prototypes of 20th-century high-rise and symbolic construction; the prophetic vision of Mies's post-World War I glass skyscrapers have been fulfilled handsomely in Chicago in the 1960's. The equally prophetic humanism of Alvar Aalto, the early work of Walter Gropius, and all of the landmark examples of the leaders of the International Style remain among the icons of the profession.

But other icons are being broken. . . . The gospel according

348

From *The Gospel According to Giedion and Gropius Is Under Attack*

to Giedion and Gropius that preached functional and formal purity and rejection of the past . . . is being increasingly debated and denied. There is in process now a complex, provocative and generation-splitting restructuring of . . . the "architectural belief systems" of the 20th century. The philosophy, art and practice of architecture are changing.

The evidence of these changes is clear. Last fall, the Museum of Modern Art, which introduced the International Style to the United States in 1932 and retained its ideological fervor for 40 years, staged a huge Beaux Arts show—a literal exhumation of the specific style and teaching that modernism rebelled against. . . .

Among architects, a group of "young Turks" has embraced this "radical" re-viewing of the past, and much more. In Philadelphia and at Yale, academic movements strongly influenced by architects Louis Kahn and Charles Moore and historian Vincent Scully, have produced a generation of heretics. Their approach is romantic, eclectic, and fiercely intellectual, a farcry from the hard-line, functional esthetic of the 1920's and 30's that was to save society as it created art.

Today, New York architect Richard Meier builds houses of exquisite Corbusian nostalgia that are anything but "machines to live in." The Philadelphia firm of Venturi and Rauch draws equally from the near and distant past and the vernacular scene for low-key designs that are viewed by some as legpulling satire and by others as serious innovation. . . . The younger Chicago architects are reviving local 1930's modernism with aesthetic nostalgia rather than with functionalist doctrine. . . . The broad outlines of the new architecture—for there are diverse and interlocking trends—are part of a culture that is currently rejecting or questioning older values, discovering a new populism and pluralism, and is increasingly informed and selective in its taste.

The result is neither static nor stagnant; this is a period of vital exploration. But there is little agreement about what is going on. The older generation sees the new directions as blasphemous and the younger generation sees them as the creative reopening of the limits of design.

The counter revolution had to happen, not just because history and art never stand still, but because so much else has happened in these fifty years in which the modern style has become the established way of building. Modern architecture

349

. . . glorified new structural materials and systems, and developed a style based on the expressive use of these elements.

At the same time, it was closely allied to the growth of abstraction in the other arts, with its insistence on flat surfaces, simple geometric shapes and primary colors. There were laws, written and unwritten. Ornament was crime. Form followed function. Industrial processes and materials, or the machine esthetic, replaced handcrafts. The break with the past was to be total.

But rules are made to be broken. The present generation of architects, using the advances in structural technology freely, detours significantly from the earlier functional straitjacket. It is no longer considered essential to reveal or express basic structure; the best recent work of Kevin Roche, for example, conceals it with a flat glass and metal skin whose elements express a quite different scale, without sacrificing a rational relationship between the two. There is a rising emphasis on the use of structure and technology to create an esthetic of formal drama for its own sake, related to function, but quite independent of it.

The forms that once followed function are treated as abstract sculpture. Elements of technology—industrial trusses, exposed ducts, factory glazing—are used as a decorative vocabulary of symbolic objects and intrinsic ornament rather than as objects of utility. . . .

The idea of a building and its uses expressed with basic simplicity and clarity is often replaced, in the work of younger practitioners, by ambiguity and playfulness. The kind of complexity and even arbitrariness in the way the components of a building are combined and the calculated effects that result suggest the architecture of Mannerism or the Baroque rather than the puritanical pieties of modernism. In fact, an eclectic mannerism . . . is replacing the "purism" and "functionalism" of the 20th-century architectural revolution. . . .

. . . The modernists promised Utopia; their vision was of a cleaner, brighter, more efficient and orderly universe in which architecture and technology would create healthful and happy housing for all countries and classes. It was to be free of all hypocrisy and cant and any reference to history. . . . It was truly believed that architecture was to be a social tool in a marriage of morality and art that would have confounded even Ruskin,

and architects were to be the missionaries of a new and better world.

It did not work because it promised too much, and what it promised was unreal. . . . The question asked by a new generation of students is how such high ideals could have produced so much inhumanity.

The dream of modernism was caught in other 20th-century revolutions, in racial, social and moral upheavals far beyond the architects' control that made their panaceas seem touchingly naive. It was crushed by economics, which reduced a reductionary esthetic still further, from the bare beauty of the new technology to the cheap, stripped expediency of businessmen and bankers. It was distorted and turned into clichés by speculators and jerry-builders.

The basic belief that functional and mechanical logic led naturally to elegance and beauty was disproved in a million sterile downtown "renewals." And the kind of architectural sociology that replaced the 19th-century row houses of the Gorbals in Glasgow, for example, with modern high-rise towers, simply exchanged one kind of slum for another. . . . If modernism rejected history, it also rejected reality. It still retained the traditional idea of the building as monument, ignoring great masses of lesser construction, and imposed its monuments on their surroundings with a stunning lack of environmental empathy.

Environment, in fact, was the important missing concept. There was little concern for the need to relate building elements to each other in a social, functional and esthetic pattern beyond the most abstract planning diagrams. The organic strengths and accretions of the ad hoc environment were anathema. . . .

. . . And then came a new generation, which had no bad associations with history, for whom old buildings did not mean oppressive ideas or conditions, and who did not share the taboos of their fathers.

Looking for enrichment, both visually and emotionally, this generation has indulged in a romantic revivalism that accommodates both the most superficial nostalgic kitsch and the most informed historicism. It is an orgy of rediscovery.

Architects have developed a new set of attitudes and interests based on new perceptions of history and the environment.

The two are inextricably linked. To see the environment whole, one must see history whole, and it has become necessary to deal sensitively with older buildings and values. It has become equally necessary to acknowledge the rationale and the result of disorderly, but vital organic growth.

Today's architect, therefore, does not find history expendable. . . . In fact, historicism, and in particular, historical revisionism, is one of the leading factors in the new architecture. . . . There is a selective preoccupation with those periods that serve the almost perverse complexity of the contemporary condition: Mannerism, the Baroque, Romantic Classicism. There is great interest in those styles that were declared despicable, dead, or non-existent by the modernists: the Beaux Arts, Victoriana, Art Deco and all the products of the near-past that were deleted by revolutionary taste or doctrine. There is a fascinating rewriting of recent history to restore suppressed styles and periods. . . .

But this process, too, is not without its own architectural belief system. The philosophy of eclectic revivalism was synthesized by Robert Venturi in a slim, catalytic book called "Complexity and Contradiction in Architecture" published by the Museum of Modern Art in 1966. . . .

Venturi's point, now generally accepted, was that the art of architecture was an inclusionary whole, made up of all of history and all of the elements of the environment, and that examination of this continuity, with its contrasts and intricacies, had much to teach the designer about the richness of esthetic and functional relationships. He called strict modernist doctrine exclusionary in its renunciation of these models and effects. He endorsed a vital and messy disorder over an orderly sterility, and suiting his own taste for a sensitive, suggestive esthetic, incorporated mannerist elements of symbolism and ambiguity into his style.

An even earlier eclectic precedent is to be found in the frankly sybaritic borrowings from Soane and Ledoux and other 19th century Romantic Classicists in the work of Philip Johnson in the 1950's and 60's, to an obligato of embarrassment and abuse from the righteous. The buildings weren't always very good, and some were even quite bad, but these experiments led to Johnson's liberated, crystalline geometry that is in the front ranks of today's creative work.

The liberating example of Louis Kahn, puzzling at first but

From *The Gospel According to Giedion and Gropius Is Under Attack*

increasingly understood and hailed as architectural horizons widened, is now seen to be of paramount importance. Kahn, trained in the Beaux Arts, never scuttled its lessons; his underlying love of classicism and solidity created a unique modern style. He managed to incorporate a sense of the timeless qualities of architecture, from antiquity on, in his striking contemporary work, opening the eyes and minds of an entire generation of students to the universality of the building art. . . .

. . . Rearranging and incorporating of motifs becomes a style in itself, abstract to the point of sculpture, aggressively and hermetically esthetic at a time of declared emphasis on social utility and human needs. This is consummate mannerism. And it is also an élite style when élitism is a pejorative word. It is producing some of today's most skilled and handsome building, as well as some architectural navel watching, and there is the danger of an exotic dead end.

What is most significant about this kind of history is that it is being transmuted into something totally new. It is all revisionist, whether it is a group of architects rewriting the history of the Chicago School, or another group using rediscovered design principles in an uncommon or unusual way. No one intends to engage in conventional revivals; there will be no neo-Gothic or neo-Baroque or copies of medieval or mannerist monuments or traditional systems of ornament. But architects raised on "less is more" are hungrily groping for a little more.

They are avid for the revelations of space and facade afforded by the classical Beaux Arts; they are admiring of the picturesque use of light, level and surface enrichment as tools of functional purpose and sensuous response in High Victorian styles; they can fall in love with a 1920's facade. The recycling of old buildings is no accident at this time. But these lessons are not being taken literally, and their interest comes from much more than nostalgia. What is being sought are ways to achieve an enlargement and elaboration of modern vision, technique and effect.

Interpretively, everything is "in" that the modernists threw out. This principle of inclusionism, or almost anything goes, extends to another parallel new interest: the vernacular or Pop environment. The architectural avant garde is equally intrigued by the rediscovery of history and the new discovery of the popular landscape—the hagiography of signs and symbols, motels, fast sales and fast food, of the highway, the suburb and

the city. Chaotic commercial accretions are carefully dissected for function and symbolism.

Here, too, Robert Venturi and his wife, Denise Scott Brown, must be credited. They achieved the apotheosis of the "dumb and ordinary" building and environment—an event that has a clear parallel in Pop Art. The architectural message was delivered in the 1960's through articles and a book, "Learning from Las Vegas." This was a much harder bullet for most architects to bite than the rehabilitation of history in "Complexity and Contradiction."

But this perception of the vernacular environment adds another valuable chapter to history. . . . The Venturis have translated their observations into debatable, didactic principles for the practice of architectural design. . . . In their kind of inversion, the builders' economic and functional justifications for junk become the architect's guidelines for art. A stunning contradiction is produced: élite populism. What is most significant, however, is that this intellectual exercise, too, is a form of eclecticism, with an input into the design process similar to neohistoricism. It is, in fact, part of the same architectural package. . . .

. . . The ultimate example of this popular mechanics approach is probably Paris's Centre Pompidou, the prizewinning design by Piano and Rogers, . . . that will be Paris's contemporary cultural showplace. Described in Architectural Design (a British periodical that regularly feels the pulse of the avant garde) as an "urban machine, fluid and flexible," it is to be a place where specialists and laymen "design their own needs into the building, as free as possible from the limitations of architectural form."

Old dreams die hard. We have come full circle. Here again is the modernists' wonderful machine for living and doing other things in, married this time, with remarkable ingenuity, to the new populism: everyone is to share in giving the building its identity. Since its identity has already been firmly established by the architects, in a *macho* structural steel-and-glass esthetic of elaborate, mechanistic symbolism and indelible style, this may be paternalistic populism. And we are back to the monument again.

All of these trends represent attitudes and styles only possible at a time of the near-total reevaluations that are currently running through most of the institutions of contemporary soci-

From *The Gospel According to Giedion
and Gropius Is Under Attack*

ety. This new architecture is a part of its time. . . .

The words that tie these many directions together are revisionism and romanticism. Austerity is now a matter of economics more often than of taste, and never of decree. History and hedonism are back. Architecture is admittedly not going to save the world and it has a far gentler moral stance. It may still improve parts of the environment noticeably, and it has developed a commendable social awareness.

But two things are being reordered radically today: the history of the modern movement and the theories and principles upon which the contemporary practice of architecture rests. The nostalgia, the revivalism, the symbolism, the arcane and arbitrary uses of the past, the canonization of the recent and the ordinary, bespeak a cultural sophistication rather than a cultural copout. These references are being employed carefully and creatively, with immense calculation and rigorous intellect, for a cool and challenging art.

1976

FROM *The Fall and Rise of*

Main Street

Ada Louise Huxtable

M ain Street—as American as apple pie; a stage set by
Sinclair Lewis frozen in time and cultural mythology.
Four-story brick fronts; shops below, offices above. The
drug-store, the quick lunch, the five-and-ten, the movie thea-
ter. Eternal, unchanging middle America.

Small town or big city; weekly Rotary and Chamber of Com-
merce brown-gravy lunches at the local hotel. Hanging out;
the last picture show. The street-corner ennui of vacuous Sat-
urday nights and long summer afternoons from which millions
have fled; the illusion of a simpler, better world to which mil-
lions have returned. Main Street is the American way of life.

But Main Street has proved no more stable or invulnerable
to change than any other part of the urban environment. It has
had its own life cycle. In the 1950's, downtown declined. The
suburban explosion and the marketing revolution after World
War II dealt it a lethal blow,

A mobile society that had established a new set of rituals
focused on the drive-in anything, transferred the Saturday-
night rite of passage to the "climate controlled" covered shop-
ping mall in all of its frigid, canned-music-drenched, plastic
glamour. On old streets, old buildings were torn down for
parking lots, in a bleak, gap-toothed kind of mutilation. Main
Street had become a sad, shabby relic, empty shopfronts alter-
nating with faded displays that looked as if time had stopped
on one of those 1940's summer afternoons.

From *The Fall and Rise of Main Street*

. . . Declared dead, Main Street refused to die. The country has entered on a unique nostalgia kick and Main Street was ripe for remembrance and revival. . . . The architectural historians gave status to its 19th-century styles. Preservationists fought for it. Recycling its buildings has become fashionable and profitable. The Venturis, gurus of the Pop environment, announced that "Main Street is almost right."

The Main Street renaissance is significant esthetic and economic history. Its new vitality can be looked on as a radical change in the American perception of the urban scene. The shift to restoration came out of disillusionment with the results of urban renewal, with its emphasis on demolition and new construction, a growing awareness of the effect of the loss of the past, combined with new approaches to planning and to economic revitalization. . . .

Main Street U.S.A. is essentially a 19th-century phenomenon; its prosperity and vitality were intensified as towns and cities grew. False-front, wood-framed frontier streets developed into solid brick and stone mercantile avenues. The street was pedestrian in scale, geared to the horse and buggy and the family enterprise. Its style was solidly Victorian. . . . Ornate cast-iron-fronted structures borrowed Roman and Venetian references for elaborate and handsome "palaces of trade." A common commercial vernacular tied together anything from Georgian and Greek Revival to High Victorian Gothic. A sequence of fashionable facades became the unified 19th-century blockfront.

These pleasantly scaled blocks displayed a steady rhythm of curved or simply pedimented windows, loosely labeled "Renaissance," varied yet unified by good proportionate relations. Increasingly large glass fronts in the ground-floor stores reflected American progress in plate-glass manufacture. The range was from sophisticated to provincial and it was, in the American tradition, largely speculative construction. But this was sound building that served its purpose with character, humanity and style.

When the automobile opened the countryside and carried people and businesses away, it clogged old streets and devoured parking space and destroyed the accustomed way of doing things. Property owners and merchandisers sought desperately for remedies. Because the watchword of the American competitive business ethic has always been "modernize," they embarked on an orgy of remodeling.

O modernization, what crimes are committed in thy name! The 1950's was a period of wholesale destruction. The debacle was aided, abetted and accelerated by building-products manufacturers who promoted the use of plastic and metal panels for the total resurfacing of old buildings for a "new look." This had the curious advantage of deliberately reproducing the worst feature of the new shopping centers with which they were trying to compete: their total lack of architectural distinction. . . . Entire blocks of modestly elegant vintage architecture disappeared, covered with panels and grilles, plain and anodyzed, waffled and corrugated, garish and humdrum. Fortunately, the old fronts were usually just concealed, not demolished.

It didn't work, of course, because it failed to address the deeper problems of social and urban change and everyone went rushing off to the shopping center anyway. It had become the town center and the civic center for the new consumer culture.

But people are coming back to Main Street now, lured by a different kind of renewal. In an act of poetic, or architectural, justice, many of those prefab false fronts are being removed. In the mid-1960's, Columbus, Ind., asked the architect Alexander Girard to look at its old Washington Street buildings in terms of their architectural assets. Girard devised a clean-up, paint-up program that emphasized color and design and the stylistic identity of the structures.

Almost spontaneously, other communities embarked on similar activities, and although the approach was basically cosmetic, it was the first step toward the more comprehensive concept of reuse. . . . Sometimes the efforts err on the side of faux-Williamsburg, but the point is that this is restoration, not destruction; it is a search for values as well as appearances.

Most important, it has been rediscovery. What has been rediscovered is the street-scape, or the quality of the street environment and the buildings that it comprises. What is valued again is history, or a sense of identity and place, and architecture, an essential component of both.

The next step has been to put the renovated buildings into a more competitive, convenient and inviting context. Thus was the Main Street shopping mall born. The most successful renovation is carried out within the framework of a larger, more comprehensive renewal plan that links economic revital-

From *The Fall and Rise of Main Street*

ization to an improvement in the quality of the environment. Restoration is now balanced with new construction and circulation and open-space patterns in programs of increasingly sophisticated and successful interrelationships.

The results are showing in cities and towns too numerous to list. . . . Old buildings of character are treated as key elements of the new plans. The bulldozer and carpet-bagger planner are almost obsolete.

There are many methods of revival: studies and development plans done through city agencies and private groups, often working together, boot-strap renewal through individual preservation efforts, enlightened developer initiative, and even special district designation. . . .

Market Street in Corning, N.Y., a city 60 percent destroyed by floods after Hurricane Agnes in 1972, is a demonstration project of the use of restoration and new construction. . . .

There are some very special streets in American cities, long recognized as anchors of place and identity, that have suffered serious vicissitudes. They are coming back almost by spontaneous regeneration. Magazine Street in New Orleans is one—a pot-pourri of faded, offbeat pleasures and a derelict grandeur that runs six miles from Canal Street in the business district to the river. Figaro, a lively local newspaper that should know, calls it the *real* New Orleans and describes its variety perfectly: "It slices through all kinds of things Orleanean: the warehouses and coffee plants, the seedy bars of the Irish Channel, the heart of the Latin community, the working-class neighborhoods."

Long blocks are now a "miragelike" mix of restoration and neglect, antebellum lace-and-scroll woodwork and colonnades, Coca-Cola signs, washeterias, antique shops, shabby dwellings and fashionable enterprises. Take your choice of Uncle Bill's Pool Hall or Tucci's elegant restaurant; enjoy the balconied and arcaded, indigenous and irreplaceable architecture in casual, insouciant decay. But, make no mistake, Magazine Street is reviving.

Atlantic Avenue in Brooklyn is the Magazine Street of New York. Its vernacular is the small red-brick row, and it, too, has become the place for the cognoscenti to find marginal antiques and special foods. Rundown and shabby, it still charms by revealing the architectural scale and style of the 19th century. Surrounded by restored brownstone neighborhoods, it is en-

46. Line drawing of Market Street, Corning, New York. (© 1976 by The
New York Times Company. Reprinted by permission)

joying a commercial revival. New boutiques and restaurants
enliven it; Middle Eastern shops supply the city with baklava,
slab bread and olives.

. . . New York has employed an unusual device—the special
zoning district—to protect both its physical character and its
existing amenities. The city's planners have established an At-
lantic Avenue Special District, with zoning regulations de-
signed to retain its scale and style.

The city's study found 109 19th-century buildings with 36
historic storefronts. Zoning guidelines direct their renovation
and restoration and specify details of future construction. The
original building materials, shop windows and fenestration of
the historic structures must be kept. Old cornices must be
preserved or replaced. Bulk and placement are controlled in
new construction, encouraging low buildings following the ex-
isting street line, with generous storefronts and windows. To
avoid spot-spoiling by parking lots, no demolition of a 19-cen-
tury building is allowed unless it is unsafe and a permit for new
construction has already been issued.

This country's waterfront streets have been a particularly
evocative catalogue of history and style. In a move to save one
of the last extant stands of this kind of river-front architecture,
Louisville, Ky., has declared its Main Street from Sixth to Ninth
a historic district. Admirable community commitment has in-
cluded $2.5 million in preservation funds. . . . So far so good.

But now the curious aim is to "recreate Main Street of 1874"
and Louisville has entered the sticky trap of "restoring back."
It is opting for make-believe, or a cross between Williamsburg
and Disneyland: printing presses will turn out the news of 100
years ago, craftsmen will make products of the time, there will

360

be a mule-drawn streetcar, hitching posts, gas lamps and an assortment of quaint appurtenances.

"The possibilities are endless," consultant Alfred Stern has pointed out. There is talk of illuminating buildings at night, each in turn, while recorded five-minute tapes recite "I am the Such-and-Such Building," followed by a little first-person historical plug. Indeed, the possibilities are endless, alas. . . .

. . . The whole point of the Main Street revival . . . is not a stage-set, historical "enclave." Strong commercial activity, the restoration of use and vitality to downtown, are as important as the restoration of buildings. There has been an amazing degree of success, affecting both the main drag of small towns and the older streets of large cities, attesting to a commonality of aim and effort. . . . What has happened is that the perceived self-interest of businessmen has married the concerns of the preservationists and the urban environmentalists. Their ends have been found to be mutually reinforcing rather then mutually exclusive.

Main Street is learning to build on its assets, rather than to destroy them. . . . Local patronage is not automatically drawn away from downtown to the new centers. . . . What is thrown up in a field overnight cannot compete with a century of style.

The financial formula of revitalization is beginning to work so well, in fact, and to look so good, that it is about to be corrupted. There is already the foisting upon gullible communities of packages of "amenities" and carnivalized pedestrianization with jazzy kiosks, planters and graphics, guaranteed to turn into grimy, alien clutter. (The downtown Washington, D.C., area in front of the National Portrait Gallery, for example, now scheduled for a pedestrian mall, should be treated with immense restraint.)

It is not gimmicks that are doing the job. It is a genuine breakthrough in a profitable combination of art, history and business that has united entrepreneurs, esthetes and a public increasingly responsive to the meaning and pleasure of place. . . . On Main Street, art and life have turned out to be the same thing.

1976

Bibliography

Apart from sections I and II below, this bibliography is intended primarily as an index to further readings relating only to the selections in the anthology. For more comprehensive bibliographies, the student is referred to those appended to some of the more recent surveys of American art listed below in section II. However, two fine bibliographies should be cited here, keeping in mind their publication dates: the extensive bibliographical notes in the 1960 edition of Oliver Larkin, *Art and Life in America,* pp. 491–525; and Elizabeth McCausland, "Selected Bibliography on American Painting and Sculpture from Colonial Times to the Present," *Magazine of Art,* XXXIX (November 1946), 329–349. For the twentieth century, the bibliography in the 1975 edition of Barbara Rose, *American Art Since 1900,* is especially useful, to which the citations in the chapter notes should be added, as well as the bibliography in her companion volume, *Readings in American Art, 1900–1975.*

I. SELECTED REFERENCE WORKS

Archives of American Art: A Checklist of the Collection. New York, Washington, D.C.: Archives of American Art, Smithsonian Institution, 1975.

Archives of American Art: A Directory of Resources. Edited by Garnett McCoy. New York, London: R.R. Bowker Co., 1972.

Art Index. New York: H.H. Wilson Co., 1929–.

Catalogue of the Avery Memorial Architectural Library of Columbia University. 12 vols. Boston: G.K. Hall, 1958.

Cowdrey, Mary Bartlett. *American Academy of Fine Arts and American Art-Union, 1816–1852.* New York: New-York Historical Society, 1953.

———. *National Academy of Design Exhibition Record, 1826–1860.* New York: Printed for the New-York Historical Society, 1943.

Bibliography

Cummings, Thomas Seir. *Historic Annals of the National Academy of Design, New York Drawing Association, etc.* . . . Philadelphia: G.W. Childs, 1865. (Microfilm copy, Ann Arbor: University Microfilms, 1956).

Groce, George C. and Wallace, David H. *The New-York Historical Society's Dictionary of Artists in America 1564–1860.* New Haven: Yale University Press, 1957.

Hamer, Philip M. (ed.). *A Guide to Archives and Manuscripts in the United States.* Compiled for the National Historical Publications Commission. New Haven: Yale University Press, 1961.

Hitchcock, Henry-Russell. *American Architectural Books; A List of Books, Portfolios, and Pamphlets on Architecture and Related Subjects Published Before 1895.* Minneapolis: University of Minnesota Press, 1976.

Index to Art Periodicals. Compiled by Ryerson Library of The Art Institute of Chicago. 11 vols. Boston: G.K. Hall Co., 1962–. Supplement, 1975.

Johnson, Allan and Malone, Dumas (eds.). *The Dictionary of American Biography.* 20 vols. New York: Charles Scribner's Sons, 1928–36. Later Supplements.

Poole, William F. *An Index to Periodical Literature.* New York, London: 1853. 3rd ed., Boston: 1882. Supplements, Boston: 1888, 1895, 1897, 1903.

Rutledge, Anna Wells. *Cumulative Record of Exhibition Catalogues, The Pennsylvania Academy of Fine Arts, 1807–1870.* Philadelphia, 1955.

II. GENERAL WORKS

The following general works are listed in the order of their publication. The student may find this a useful index to changing opinions as well as inertia in the generalized literature of American art.

Dunlap, William. *A History of the Rise and Progress of the Arts of Design in the United States.* 2 vols. New York: George P. Scott and Co., 1834. (New edition, edited by Frank W. Bayley and Charles E. Goodspeed. 3 vols. Boston: C.E. Goodspeed, 1918. Revised and enlarged edition, edited by Alexander Wyckoff, preface by William P. Campbell. 3 vols. New York: Blom, 1965).

Tuckerman, Henry T. *Artist-Life: or Sketches of American Painters.* New York: D. Appleton and Co. Philadelphia: Geo. S. Appleton, 1847.

Jarves, James Jackson. *Art Hints, Architecture, Sculpture, and Painting.* New York: Harper and Bros., 1855.

———. *The Art-Idea.* New York: Hurd and Houghton, 1864. (Reissued, edited by Benjamin Rowland, Jr. Cambridge, Mass.: The Belknap Press of Harvard University Press, 1960.)

Tuckerman, Henry T. *Book of the Artist.* New York: Putnam, 1867. (Reprinted, New York: James F. Carr, 1966.)

BIBLIOGRAPHY

Benjamin, S.G.W. *Art in America; A Critical and Historical Sketch.* New York: Harper and Bros., 1880.

Sheldon, George W. *Recent Ideals of American Art.* New York: D. Appleton, 1890. (Reprinted, New York: Garland, 1977)

Hartmann, Sadakichi. *A History of American Art.* 2 vols. Boston: L.C. Page, 1902. Revised edition, Boston: L.C. Page, 1932.

Taft, Lorado. *The History of American Sculpture.* New York and London: The Macmillan Co., 1903. Later editions in 1917, 1924, and 1930.

Isham, Samuel. *The History of American Painting.* New York: The Macmillan Co., 1905. (New edition with supplement by Royal Cortissoz. New York: The Macmillan Co., 1937.)

Caffin, Charles H. *The Story of American Painting.* New York: Frederick A. Stokes, 1907.

Kimball, Fiske. *American Architecture.* Indianapolis and New York: The Bobbs-Merrill Co., 1928.

La Follette, Suzanne. *Art in America.* New York: Harper, 1929.

Neuhaus, Eugen. *The History and Ideals of American Art.* Stanford, California: Stanford University Press, 1931.

Cahill, Holger and Barr, Alfred H., Jr. (eds.) *Art in America, A Complete Survey.* New York: Reynal and Hitchcock, 1935.

Burroughs, Alan. *Limners and Likenesses: Three Centuries of American Painting.* Cambridge, Mass.: Harvard University Press, 1936.

Born, Wolfgang. *Still Life Painting in America.* New York: Oxford University Press, 1947.

———. *American Landscape Painting.* New Haven: Yale University Press, 1948.

Barker, Virgil. *American Painting: History and Interpretation.* New York: Macmillan, 1950.

Flexner, James T. *A Short History of American Painting.* Boston: Houghton Mifflin, 1950.

Baur, John Ireland Howe. *American Painting in the Nineteenth Century; Main Trends and Movements.* New York: Praeger, 1953.

Richardson, Edgar P. *Painting in America.* New York: Crowell, 1956.

Larkin, Oliver W. *Art and Life in America.* Holt, Rinehart and Winston, 1949. Revised and enlarged edition, 1960.

McCoubrey, John W. *American Tradition in Painting.* New York: Braziller, 1963.

Richardson, Edgar P. *A Short History of Painting in America.* New York: Crowell, 1963.

Green, Samuel M. *American Art, A Historical Survey.* New York: Ronald Press, 1966.

McLanathan, Richard. *The American Tradition in the Arts.* New York: Harcourt, Brace and World, 1968.

Novak, Barbara. *American Painting of the Nineteenth Century.* New York: Praeger, 1969.

Bibliography

Mendelowitz, Daniel M. *A History of American Art.* 2nd ed. New York: Holt, Rinehart and Winston, 1970.

Baigell, Mathew. *A History of American Painting.* New York, Washington: Praeger, 1971.

Wilmerding, John. (ed.) *The Genius of American Painting.* New York: William Morrow and Co., 1973.

200 Years of American Sculpture. Exhibition catalogue published for Bicentennial Exhibition organized by the Whitney Museum of American Art. Boston: David R. Godine, 1976.

Wilmerding, John. *American Art.* Pelican History of Art. Baltimore: Penguin, 1976.

Taylor, Joshua C. *America as Art.* Washington, D.C.: Smithsonian, 1976.

Brown, Milton W.; Hunter, Sam; Jacobus, John; Rosenblum, Naomi; Sokol, David M. *American Art.* Englewood Cliffs, N.J. and New York: Prentice-Hall and Abrams, 1979.

III. SELECTED BIBLIOGRAPHY RELATED TO SELECTIONS IN ANTHOLOGY

SECTION ONE

American Art: 1750–1800; Towards Independence. Published for Yale University Art Gallery and the Victoria and Albert Museum. Boston: New York Graphic Society, 1976.

Christensen, Edwin O. *The Index of American Design.* New York: Macmillan, 1950.

Copley, John Singleton. *Letters and Papers of John Singleton Copley and Henry Pelham, 1739–1776.* Boston: Massachusetts Historical Society, 1914. (Reprinted, New York: Kennedy Graphics, 1970.)

Flexner, James Thomas. *First Flowers of Our Wilderness: American Painting.* Boston: Houghton Mifflin, 1947.

Goodrich, Laurence B. *Ralph Earl: Recorder of an Era.* Albany: State University of New York, 1967.

Hagen, Oskar. *The Birth of the American Tradition in Art.* New York: Charles Scribner's Sons, 1940.

Jones, Howard Mumford. *O Strange New World: American Culture, The Formative Years.* New York: Viking, 1964.

Kimball, Fiske. *Domestic Architecture of the American Colonies and of the Early Republic.* New York: Charles Scribner's Sons, 1922.

———. *Thomas Jefferson, Architect.* Boston, printed for private distribution at Riverside Press, Cambridge, Mass., 1916. (Reprinted New York: Da Capo Press, 1968.)

———. *Thomas Jefferson and the First Monument of the Classical Revival in America.* Harrisburg, Pa., and Washington, D.C., 1915.

BIBLIOGRAPHY

Lipman, Jean and Winchester, Alice. *The Flowering of American Folk Art 1776–1876.* New York: Viking Press, 1974.

Little, Nina Fletcher. *American Decorative Wall Painting, 1700–1850.* New enlarged edition. New York: E.P. Dutton, 1972.

Miller, Perry. *Errand into the Wilderness.* New York: Harper, 1964.

———. *The Life of the Mind in America, From the Revolution to the Civil War.* New York: Harcourt, Brace and World, 1965.

Mitchell, Charles. "Benjamin West's 'Death of General Wolfe' and the Popular History Piece." *Journal of the Warburg and Courtauld Institutes,* VII (1944), 20–33.

Morrison, Hugh. *Early American Architecture from the First Colonial Settlements to the National Period.* New York: Oxford University Press, 1952.

Mumford, Lewis. *Sticks and Stones.* New York: Boni and Liveright, 1924. (Revised edition, New York: Dover Publications, 1955)

Prown, Jules D. *John Singleton Copley.* 2 vols. Cambridge, Mass.: Harvard University Press, 1966.

Spencer, Harold. "The American Earls." Introductory essay in *The American Earls.* Storrs, Conn.: The William Benton Museum of Art, 1972, pp. xiii–xxxii.

Wind, Edgar. "The Revolution of History Painting," *Journal of the Warburg and Courtauld Institutes,* II (1938–39), 116–127.

SECTION TWO

Allston, Washington. *Lectures on Art and Poems.* New York: Baker and Scribner, 1850.

Coburn, Kathleen. "Notes on Washington Allston from the Unpublished Notebooks of Samuel Taylor Coleridge," *Gazette des Beaux-Arts,* s.6, XXV (April 1944), 249–252.

Emerson, Ralph Waldo. *Aesthetic Papers.* Edited by Elizabeth Peabody. Boston: Peabody; New York: G.P. Putnam, 1849.

———. *Emerson's Nature: Origin, Growth, Meaning.* Edited by Merton M. Sealts, Jr. and Alfred R. Ferguson. 2nd ed. Carbondale: Southern Illinois University Press, 1979.

———. *Nature.* Boston: J. Munroe and Co., 1836.

Flagg, Jared B. *The Life and Letters of Washington Allston.* New York: Scribner's, 1892.

Gerdts, William H. "Washington Allston and the German Romantic Classicists in Rome," *The Art Quarterly,* XXXII, 2 (Summer 1969), 167–196.

Greenough, Horatio. *Form and Function.* Edited by Harold A. Small with Introduction by Erle Loran. Berkeley: University of California Press, 1947.

———. *Letters of Horatio Greenough, American Sculptor.* Edited by Nathalia Wright. Madison: University of Wisconsin Press, 1972.

Bibliography

_____. *The Travels, Observations, and Experience of a Yankee Stonecutter.* New York: G.P. Putnam, 1852. Published under pseudonym "Horatio Bender." (Facsimile reproduction with introduction by Nathalia Wright. Gainesville, Fla.: Scholars' Facsimiles and Reprints, 1958.)

Hawthorne, Nathaniel. "The Artist of the Beautiful." In *Mosses from an Old Manse.* New York: Wiley and Putnam, 1846.

Peabody, Elizabeth. *Last Evening with Allston, and Other Papers.* Boston: D. Lothrop and Co., 1886.

Richardson, Edgar P. *American Romantic Painting.* New York: E. Weyhe, 1944.

_____. *Washington Allston: A Study of the Romantic Artist in America.* Chicago: University of Chicago Press, 1948. (New edition, New York: Apollo, 1967.)

Soria, Regina. "Washington Allston's Lectures on Art: the First American Art Treatise." *Journal of Aesthetics and Art Criticism,* XVIII, 3 (March 1960), 329–344.

The American Art Journal, IV, 2 (November 1972). Issue devoted to American sculpture of the nineteenth century.

Tuckerman, Henry T. *Memorial to Horatio Greenough . . .* New York: G.P. Putnam and Co., 1853.

SECTION THREE

Born, Wolfgang. "Sources of American Romanticism." *Antiques,* XLVIII (November 1945), 274–277.

Catlin, George. *Letters and Notes on the Manners, Customs, and Conditions of the North American Indians.* New York: Wiley and Putnam, 1841. (Numerous later editions)

Cikovsky, Nicolai, Jr. *George Inness.* New York, Washington, London: Praeger, 1971.

_____. "George Inness and the Hudson River School: the Lackawanna Valley." *American Art Journal,* II, 2 (Fall 1970), 36–57.

Craven, Wayne. "Asher B. Durand's Career as an Engraver." *American Art Journal,* III, 1 (Spring 1971), 39–57.

Durand, John B. *The Life and Times of A. B. Durand.* New York: Scribner's, 1894.

Flexner, James T. *That Wilder Image: The Paintings of America's Native School from Thomas Cole to Winslow Homer.* Boston: Little, Brown, 1962.

Gardner, Albert Ten Eyck. "Scientific Sources of the Full-length Landscape: 1850." *Metropolitan Museum Bulletin,* IV (1945), 59–65.

Hendricks, Gordon. *A Bierstadt.* Fort Worth, Texas: Amon Carter Museum, 1972.

Howat, John K. *The Hudson River and Its Painters.* New York: Viking Press, 1972.

BIBLIOGRAPHY

Huntington, David C. *The Landscapes of Frederic Edwin Church; Vision of an American Era.* New York: G. Braziller, 1966.

Huth, Hans. *Nature and the American.* Berkeley: University of California Press, 1957.

Inness, George, Jr. *Life, Art, and Letters of George Inness.* New York: The Century Co., 1917.

Ireland, LeRoy. *The Works of George Inness: An Illustrated Catalogue Raisonné.* Austin, Texas, and London: University of Texas Press, 1965.

Kuspit, Donald. "19th-Century Landscape: Poetry and Property." *Art in America,* LXIV (January 1976), 64–66.

Marx, Leo. *The Machine in the Garden: Technology and the Pastoral Ideal in America.* New York: Oxford University Press, 1964.

Noble, Louis L. *Church's Painting. The Heart of the Andes.* New York: D. Appleton, 1859.

———. *The Life and Works of Thomas Cole.* Edited by Elliot S. Vessell. Cambridge, Mass.: The Belknap Press of Harvard University Press, 1964.

Novak, Barbara. "American Landscape: the Nationalist Garden and the Holy Book." *Art in America,* LX (January 1972), 46–57.

———. "The Double-edged Axe." *Art in America,* LXIV (January 1976), 44–50.

———. "Grand Opera and the Small Still Voice: American Landscape Painting." *Art in America,* LIX (March–April 1971), 64–72.

Powell, E.A., 3rd. "Thomas Cole and the American Landscape Tradition." *Arts,* LII (February 1978), 114–123; (March 1978), 110–117; (April 1978), 113–117.

Sanford, Charles L. *The Quest for Paradise: Europe and the American Moral Imagination.* Urbana: University of Illinois Press, 1961.

Seaver, Esther I. *Thomas Cole, 1801–1848, One Hundred Years Later.* Hartford, Conn.: Wadsworth Atheneum, 1948.

Smith, Henry Nash. *Virgin Land: The American West as Symbol and Myth.* Cambridge, Mass.: Harvard University Press, 1950. (Reissued with new preface, 1970.)

Stebbins, Theodore E., Jr. *The Life and Works of Martin Johnson Heade.* New Haven and London: Yale University Press, 1975.

Sweet, Frederick A. *The Hudson River School and the Early Landscape Tradition.* Chicago: The Art Institute of Chicago, 1945.

Wilmerding, John. *Fitz Hugh Lane.* New York, Washington, London: Praeger, 1971.

SECTION FOUR

Beam, Philip C. *Winslow Homer at Prout's Neck.* Boston and Toronto: Little, Brown and Co., 1966.

Bloch, E. Maurice. *George Caleb Bingham, The Evolution of an Artist.* A

Bibliography

Catalogue Raisonné. 2 vols. Berkeley and Los Angeles: University of California Press, 1967.

Bregler, Charles. "Thomas Eakins as a Teacher." *The Arts,* XVII (March 1931), 378–386; XVIII (October 1931), 28–42.

Cooke, Hereward Lester, "Winslow Homer's Watercolor Technique." *The Art Quarterly,* XXIV, 2 (Summer 1961), 169–194.

Downes, William H. *The Life and Works of Winslow Homer.* Boston, New York: Houghton Mifflin, 1911.

Eakins, Thomas. *Animal Locomotion, The Muybridge Work at the University of Pennsylvania; The Method and the Result."* Philadelphia: J.B. Lippincott Co., 1888.

––––––. "On the Differential Action of Certain Muscles Passing More Than One Joint." *Proceedings of the Academy of Natural Sciences of Philadelphia,* XLVI (1894), 172–180.

Eddy, Arthur Jerome. *Recollections and Impressions of James A. McNeill Whistler.* Philadelphia and London: J.B. Lippincott Co., 1903.

Goodrich, Lloyd. *Albert P. Ryder.* New York: Braziller, 1959.

––––––. "Realism and Romanticism in Homer, Eakins, and Ryder." *The Art Quarterly,* XII (Winter 1949), 17–29.

––––––. *Thomas Eakins, His Life and Work.* New York: Whitney Museum of American Art, 1933.

––––––. *Winslow Homer.* Published for the Whitney Museum of American Art. New York: Macmillan, 1944.

Hartley, Marsden. "Albert P. Ryder." *The Seven Arts,* II (May 1917), 93–96.

Pennell, Elizabeth R. and Joseph. *The Life of James McNeill Whistler.* 2 vols. London: W. Heinemann; Philadelphia: J.B. Lippincott, 1908. (New revised 5th edition. Philadelphia: Lippincott; London: W. Heinemann, 1911.)

Porter, Fairfield. *Thomas Eakins.* New York: George Braziller, 1959.

Robinson, John. "Personal Reminiscences of Albert Pinkham Ryder." *Art in America,* XIII (June 1925), 176, 179–187.

Ryder, Albert Pinkham. "Paragraphs From the Studio of a Recluse." *Broadway Magazine,* XIV (September 1905), 10–11.

Sherman, Frederic Fairchild. "Notes on the Art of Albert P. Ryder." *Art in America,* XXV (October 1937), 167–173.

Taylor, Hilary. *James McNeill Whistler.* New York: Putnam's, 1978.

The Hudson and the Rhine: Die amerikanische Malerkolonie in Düsseldorf im 19. Jahrhundert. Düsseldorf: Kunstmuseum Düsseldorf, 1976.

Whistler, James Abbott McNeill. *Ten O'clock.* Boston and New York: Houghton Mifflin, 1888.

––––––. *The Gentle Art of Making Enemies.* London: W. Heinemann, 1890.

Wilmerding, John. *Winslow Homer.* New York, Washington, London: Praeger, 1972.

––––––. "Winslow Homer's English Period." *The American Art Journal,* VII, 2 (November 1975), 60–69.

BIBLIOGRAPHY

SECTION FIVE

Bogardus, James. *Cast Iron Buildings: Their Construction and Advantages.* New York: J.W. Harrison, 1858.

_____ and Badger, D.D. *Origins of Cast Iron Architecture in America.* New York: Kennedy Galleries, Da Capo Press, 1970 (Reprint of 1856 edition.)

Coles, William A. and Reed, Henry Hope, Jr. (eds.) *Architecture in America: A Battle of Styles.* New York: Appleton, 1961.

Hitchcock, Henry-Russell. *Architecture: Nineteenth and Twentieth Centuries.* 3rd ed. Pelican History of Art. Baltimore: Penguin, 1968.

_____. *Richardson as a Victorian Architect.* Published for Smith College, The Katharine Asher Engel Lectures, 1965. Baltimore: Barton-Gillet Co., 1966.

_____. *The Architecture of H.H. Richardson and His Times.* New York: Museum of Modern Art, 1936. (Hamden, Conn.: Archon Books, 1961)

Morrison, Hugh. *Louis Sullivan, Prophet of Modern Architecture.* New York: The Museum of Modern Art and W.W. Norton and Co., 1935.

Mumford, Lewis. *The Brown Decades; A Study of the Arts in America, 1865–1895.* New York: Harcourt, Brace and Co., 1931.

O'Gorman, James F. "Henry Hobson Richardson and Frank Lloyd Wright." *The Art Quarterly,* XXXII, 3 (Autumn 1969), 292–315.

Schuyler, Montgomery. *American Architecture and Other Writings.* 2 vols. Edited by William H. Jordy and Ralph Coe. Cambridge, Mass.: The Belknap Press of the Harvard University Press, 1961.

Scully, Vincent. *American Architecture and Urbanism.* New York and Washington: Praeger, 1969.

_____. *The Shingle Style and the Stick Style: Architectural Theory and Design from Richardson to the Origins of Wright.* Rev. ed. New Haven: Yale University Press, 1971.

Sullivan, Louis. *Kindergarten Chats and Other Writings.* New York: George Wittenborn, 1947.

_____. *The Autobiography of an Idea.* New York: Press of the American Institute of Architects, 1924.

SECTION SIX

America and Alfred Stieglitz. Edited by W. Frank, L. Mumford, D. Norman, P. Rosenfeld, H. Rugg. New York: Doubleday, Doran and Co., 1934.

Baigell, Matthew. *Thomas Hart Benton.* New York, Abrams, 1975.

Benton, Thomas Hart. *An American in Art: A Professional and Technical Autobiography.* Lawrence: University of Kansas Press, 1969.

_____. *An Artist in America.* 3rd rev. ed. Columbia: University of Missouri Press, 1968.

Bibliography

Boyle, Richard J. *American Impressionism.* Boston: New York Graphic Society, 1974.

Brooks, Harold Allen. *The Prairie School; Frank Lloyd Wright and His Midwest Contemporaries.* Toronto: University of Toronto Press, 1972.

Brown, Milton W. *American Painting from the Armory Show to the Depression.* Princeton: Princeton University Press, 1955.

―――. *The Story of the Armory Show.* New York: Joseph H. Hirshhorn Foundation, New York Graphic Society, 1963.

Brownell, William C. "The Younger Painters of America." *Scribner's Monthly Illustrated Magazine,* XX, 1 (May 1880), 1–15; 3 (July 1880), 321–335.

Dennis, James M. *Grant Wood: A Study in American Art and Culture.* New York: Viking, 1975.

Domit, Moussa M. *American Impressionist Painting.* Washington, D.C.: National Gallery of Art, 1973.

Garland, Hamlin. *Crumbling Idols.* Chicago and Cambridge: Stone and Kimball, 1894.

Goodrich, Lloyd and Bry, Doris. *Georgia O'Keeffe.* Published for the Whitney Museum of American Art. New York, Washington, London: Praeger, 1970.

Henri, Robert. *The Art Spirit.* Compiled by Margery Ryerson. Rev. ed. Philadelphia: Lippincott, 1951.

Hitchcock, Henry-Russell. *In the Nature of Materials, 1887–1941: The Buildings of Frank Lloyd Wright.* New York: Duell, Sloan and Pearce, 1942. (New edition, New York: Da Capo Press, 1973.)

Homer, William Innes. *Alfred Stieglitz and the American Avant-garde.* Boston: New York Graphic Society, 1977.

―――, with Organ, Violet. *Robert Henri and His Circle.* Ithaca and London: Cornell University Press, 1969.

―――. "The Exhibition of 'The Eight': Its History and Significance." *The American Art Journal,* I, 1 (Spring 1969), 53–64.

Hoopes, Donelson F. *The American Impressionists.* New York: Watson-Guptill, 1972.

Manson, Grant C. *Frank Lloyd Wright to 1910: The First Golden Age.* New York: Reinhold, 1958.

Norman, Dorothy. *Alfred Stieglitz: An American Seer.* New York: Random House, 1973.

O'Keeffe, Georgia. *Georgia O'Keeffe.* New York: Viking Press, 1976.

Scott, David. *John Sloan.* New York: Watson-Guptill, 1975.

Scully, Vincent. *Frank Lloyd Wright.* New York: Braziller, 1960.

Sloan, John. *Gist of Art.* New York: American Artists Group, 1939.

―――. *John Sloan's New York Scene: From the Diaries, Notes, and Correspondence, 1906–13.* New York: Harper and Row, 1965.

Smith, N.K. *Frank Lloyd Wright: A Study in Architectural Content.* Englewood Cliffs, N.J.: Prentice-Hall, 1966.

BIBLIOGRAPHY

Wright, Willard Huntington. "The Aesthetic Struggle in America." *The Forum,* LV (January-June 1916), 201–220.

Young, Mahonri S. *Early American Moderns: Painters of the Stieglitz Group.* New York: Watson-Guptill, 1974.

_____. *The Eight: The Realist Revolt in American Painting.* New York: Watson-Guptill, 1973.

SECTION SEVEN

Alloway, Lawrence. *Topics in American Art Since 1945.* New York: W.W. Norton and Co., 1975.

Ashton, Dore. *The New York School.* New York: Viking Press, 1973.

Battcock, Gregory (ed.). *Minimal Art: A Critical Anthology.* New York: Dutton, 1968.

Baur, John I. H. *Revolution and Tradition in Modern American Art.* Cambridge, Mass.: Harvard University Press, 1951.

Blake, Peter. *God's Own Junkyard; The Planned Destruction of America's Landscape.* New York: Holt, Rinehart and Winston, 1964.

Chipp, Herschel B. *Theories of Modern Art: A Source Book by Artists and Critics.* Berkeley: University of California Press, 1969.

Fine, Elsa Honig. *The Afro-American Artist.* New York: Holt, Rinehart and Winston, 1973.

Fried, Michael. *Three American Painters: Kenneth Noland, Jules Olitski, Frank Stella.* Cambridge, Mass.: Fogg Art Museum, 1963.

Geldzahler, Henry (ed.). *New York Painting and Sculpture, 1940–1970.* New York: Dutton, 1969.

Giedion, Siegfried. *Space, Time, and Architecture.* Cambridge, Mass.: Harvard University Press, 1963.

Greenberg, Clement. *Art and Culture: Critical Essays.* Boston: Beacon Press, 1961.

_____. "Post Painterly Abstraction." *Art International,* VIII, 5 (Summer 1964), 63–65.

Gropius, Walter. *The New Architecture and the Bauhaus.* Trans. from the German by P. Morton Shand. London: Faber and Faber, 1935.

Heizer, Michael. "The Art of Michael Heizer." *Artforum* VIII (December 1969), 32–39.

Hess, Thomas B. *Abstract Painting: Background and American Phase.* New York: Viking Press, 1951.

_____. *Barnett Newman.* New York: Museum of Modern Art, 1971.

_____. *Willem De Kooning.* New York: George Braziller, 1959.

Hitchcock, Henry-Russell, and Johnson, Philip. *The International Style: Architecture Since 1922.* New York: W.W. Norton, 1932. (New edition, New York, 1966)

Jacobs, Jane. *The Death and Life of Great American Cities.* New York: Random House, 1961.

Bibliography

Lippard, Lucy R. *Pop Art.* New York: Praeger, 1966.

McCausland, Elizabeth. *Marsden Hartley.* Minneapolis: University of Minnesota Press, 1952.

Meyer, Ursula. *Conceptual Art.* New York: Dutton, 1972.

O'Connor, Francis V. *Jackson Pollock.* New York: Museum of Modern Art, 1967.

O'Hara, Frank. *Robert Motherwell.* New York: Museum of Modern Art, 1966.

Reich, Sheldon. *John Marin: A Stylistic Analysis and Catalogue Raisonné.* Tucson: University of Arizona Press, 1970.

Ritchie, Andrew C. *Abstract Painting and Sculpture in America.* New York: Museum of Modern Art, 1951.

Rose, Barbara. *American Art Since 1900: A Critical History.* New York: Praeger, 1967.

Rosenberg, Harold. *The Anxious Object: Art Today and Its Audience.* New York: Horizon, 1964.

Seitz, William C. *The Art of Assemblage.* New York: Museum of Modern Art, 1961.

_____. *The Responsive Eye.* New York: Museum of Modern Art, 1965.

Selz, Peter. *Mark Rothko.* Garden City, N.Y.: Distributed for Museum of Modern Art by Doubleday, 1961.

Smithson, Robert. "Robert Smithson's Amarillo Ramp." *Avalanche* (Summer/Fall 1973), 16–21.

Sweeney, James J. *Alexander Calder.* New York: Museum of Modern Art, 1951.

Szarkowski, John. *Mirrors and Windows: American Photography Since 1960.* New York: Museum of Modern Art, 1978.

The New American Painting, As Shown in Eight European Countries, 1958–1959. New York: Museum of Modern Art, 1959.

Tillim, Sidney. "Earthworks and the New Picturesque." *Artforum,* VII, 4 (December 1968), 42–45.

Tuchman, Maurice. *Art and Technology: A Report on the Art and Technology Program of the Los Angeles County Museum of Art, 1967–71.* New York: Viking Press, for the Los Angeles County Museum of Art, 1971.

Venturi, Robert. *Complexity and Contradiction in Architecture.* 2nd ed. New York: Museum of Modern Art; distributed by N.Y. Graphic Society, Boston, 1977.

_____; Brown, Denise Scott; and Izenour, Steven. *Learning From Las Vegas: The Forgotten Symbolism of Architectural Form.* Cambridge, Mass.: M.I.T. Press, 1977.

INDEX

Index

Page numbers of illustrations appear in boldface.

E

Eakins, Thomas, 133, 134, 135, 157, 160, 161, 162, 165, 168, 219
 aestheticism of, 135
 realism of, 160–62, 165
 shift in subject matter, 162–64
 subject matter of, 135
Earl, Ralph, 22
Early Christian art, 209
"Earthworks", 292
Echaurren, Roberto Matta, 289
Ecole des Beaux-Arts, 134, 206, 218, 219
Economic and Social History of New England, 6
Eddy, Arthur Jerome, 245
Eddy, Don, 343
Eidlitz, L., 182
"The Eight", 158, 219, 242
"Eight American Painters" Exhibition, 219
Eight Bells (Homer), 159
Elegy to the Spanish Republic XXXIV (Motherwell), **301**
Elevators, 196
Elgin marbles, 154
Emerson, Ralph Waldo, 39, 69–78, 80, 129
English school of art, 107
Ensor, 234
Environment, in post-W.W.II architecture, 351–52
Environmental art, 323
Epstein, 263
Ernst, Max, 289, 309
"Essay on American Scenery" (Cole), 80
Estes, Richard, 338, 342, 343
Exhibition of Independent Artists, 237
Expressionists, Expressionism, 243, 244, 314

F

"Falling Water" (Wright), 286, **287**
Fauves, Fauvism, 244, 316, 327
Federal Art Project, 308
Federal government
 art projects of, 253–60
 influence on building, 9
 support for the arts, 221
Feininger, Lyonel, 289
Fellows, Laurence, 236
Fiberglas, 340
Flowers, in O'Keeffe's art theories, 252
Force, Juliana, 254
Forests, 85–87
Form
 in Allston's theories, 45–50
 Durand's views on, 92
 as organic principle, 283–84
 transcendental views of, 71
Fort Lee Studios, 265
Forum Show (1916), 266
Frankenthaler, Helen, 291
Freisz, 244
French Renaissance, 207
French school, 107–08, 109, 116–17, 120
Fresnaye, 245
Froebel, Frederick, 276, 277
Frog Hollow, 225
Francesca di Rimini (Scheffer), 148
Full Fathom Five (Pollock), **297**
Fulton fish market, 225
Funky art, 323
Futurists, Futurism, 243, 244, 245

G

Gallery of Old Masters (Munich), 142
Ganesvoort market, 225
Gauguin, 244, 245, 311, 325
Gay, W. Allen, 127
Gentle Art of Making Enemies (Whistler), 134
Gentleman's Magazine, 18

INDEX